Cosmopolitanism and W
Fashion in Ghana

Drawing on extensive archival research and interviews, this book delves into the rich world of Ghanaian fashion, demonstrating how, over time, local dress styles and materials have been fused with global trends to create innovative, high fashion garments that reflect a distinctly Ghanaian cosmopolitanism.

Ghana has a complex and diverse fashion culture which was in evidence before Independence in 1957 and has continued to grow in reputation in the postcolonial period. In this book, Christopher Richards reflects on the contributions of the country's female fashion designers, who have employed fashion to innovate existing, culturally relevant dress styles, challenge gendered forms of dress, and make bold statements regarding women's sexuality. Treated as artworks, the book examines specific garments to illustrate the inherent complexity of their design and how fashion is often embedded with a blending of personal histories, cultural practices and global inspirations.

Reflecting in particular on the works of Laura Quartey, Letitia Obeng, Juliana Kweifio-Okai, Beatrice Arthur and Aisha Ayensu, this book makes an important and timely contribution to art history, fashion studies, anthropology, history, women's studies and African Studies.

Christopher L. Richards is an assistant professor in the Art Department at Brooklyn College, City University of New York, USA.

Cosmopolitanism and Women's Fashion in Ghana

History, Artistry and Nationalist Inspirations

Christopher L. Richards

Routledge
Taylor & Francis Group

LONDON AND NEW YORK

First published 2022
by Routledge
2 Park Square, Milton Park, Abingdon, Oxon OX14 4RN

and by Routledge
605 Third Avenue, New York, NY 10158

Routledge is an imprint of the Taylor & Francis Group, an informa business

© 2022 Christopher L. Richards

British Library Cataloguing-in-Publication Data
A catalogue record for this book is available from the British Library

Library of Congress Cataloging-in-Publication Data
Names: Richards, Christopher L., author.
Title: Cosmopolitanism and women's fashion in Ghana: history,
artistry and nationalist inspirations / Christopher L. Richards.
Description: Abingdon, Oxon; New York, NY: Routledge, 2022. |
Includes bibliographical references and index. |
Identifiers: LCCN 2021025661 (print) | LCCN 2021025662 (ebook) |
ISBN 9780367694203 (hardback) | ISBN 9780367708801 (paperback) |
ISBN 9781003148340 (ebook)
Subjects: LCSH: Fashion–Ghana. | Fashion designers–Ghana. |
Fashion and art. | Cosmopolitanism–Ghana.
Classification: LCC GT1589.G4 R53 2022 (print) |
LCC GT1589.G4 (ebook) | DDC 391.009667–dc23
LC record available at https://lccn.loc.gov/2021025661
LC ebook record available at https://lccn.loc.gov/2021025662

ISBN: 978-0-367-69420-3 (hbk)
ISBN: 978-0-367-70880-1 (pbk)
ISBN: 978-1-003-14834-0 (ebk)

DOI: 10.4324/9781003148340

Typeset in Bembo
by Newgen Publishing UK

This book is dedicated to the ever-present and supportive triumvirate of my parents, Nancy and Mike, and my Ghanaian mother, Auntie Emily Asiedu.

Contents

Figures

Acknowledgments

Little did I know that my 2009 trip to Ghana, in which I had hoped to meet and interview *Cameroonian* designers, would ultimately result in a book on the sartorial contributions of creative and talented Ghanaian women. In the decade since my project was informally initiated, I have collaborated with countless individuals, institutions and archives, resulting in exchanges that have both directly and obliquely informed and enriched this book. It is impossible for me to remember each individual who, in some way, contributed to the development and production of this publication; let this introduction function as a means for expressing my deepest gratitude and appreciation to those unrecognized individuals who helped shaped my thoughts, experiences and research on Ghanaian fashion. I can't help but think of all the taxi drivers who, after much humorous bartering in Twi, would whisk me off to one of Accra's many distant neighborhoods for interviews, fashion shows or archival research. Equally important were the market women, who I would informally query about the latest wax print designs and who consistently welcomed me into their colorful stalls, ready to share information and a conversation with the obruni who spoke Twi with a distinctive, American twang. I am appreciative of these, and many other unnamed Ghanaians, who provided the invisible and often overlooked framework for my research. In addition to this group of anonymous individuals, I know I will inevitably and unintentionally forget known contributors to this project. Please know that it is never my intention to overlook an individual's input; if you helped shape this project and your name does not appear in the acknowledgments, know that I remain eternally grateful for your time, assistance and perspective.

In returning to the origins of my research, the first person deserving of praise is my cousin, Tamara Hull. As a former Peace Corps volunteer, she accompanied me on my first trip to Ghana, providing much-needed support as I navigated the complexities of living and conducting research in an African nation. It was often at night, when I found myself questioning my sanity for even thinking I could embark on such a scholarly journey, that I found strength and reassurance in her presence. Tamara was an integral part of my introduction to Ghana and without her, the path to this book's completion would have had a much rockier and less joyful start.

Of course, I am indebted to the women who directly informed this book: Dr. Letitia Obeng; Kathleen Ayensu, daughter of Laura Quartey; Edith François, sister of Chez Julie; Brigitte Naa-Ode Kragbé, daughter of Chez Julie, Beatrice "Bee" Arthur, designer of B'ExotiQ; Vanessa Bannerman, COO and Director of Merchandising, Christie Brown; Aisha Ayensu, Creative Director, Christie Brown; Nana Konadu Agyeman Rawlings, former First Lady of Ghana. These women have answered my endless questions with grace, honesty and candidness; they have willingly accepted me into their homes and businesses, sharing their recollections, family photographs and innovative, often precious, garments. Several of them provided me with crucial feedback during the draft stage of this publication. I must add to this list Gladys Bonuedie, the retail manager of Christie Brown, who unfailingly assisted in arranging meetings, finding garments and always welcomed me into the Christie Brown boutique. A special thanks to the family of Chez Julie; I am still amazed and humbled that her children believed that this unknown, American researcher, who persistently returned to their family compound over the course of several days, was trustworthy and deserving of their time and retelling their mother's legacy. I hope that the aforementioned women are proud of the resulting narrative that will unfold in subsequent pages and that my prose encapsulates the creativity and importance of their contributions, and those of their relatives.

There are many designers who do not appear in this book, but who helped shape my understanding of Ghana's vibrant fashion culture. They answered innumerable questions, allowed me to rifle through their archives, inspect their workshops and simply sit in their boutiques, becoming a veritable "fly on the wall" as I silently observed the fashion consumption of Accra's elite. These designers include: husband–wife team Kabutey and Sumaiya Dzietror (PISTIS), Nelly Aboagye (Duaba Serwa), Titi Ademola Perez (Kiki Clothing), Adoley Addo (JIL), Brigitte Merki, Aya Morrison and Kati Torda (Sun Trade Beads). Ajepomaa Oklah, the designer behind Ajepomaa Design Gallery, became an important friend and confidant during my multiple trips to Accra and I enjoyed the many moments we shared together, whether shopping at the latest pop-up, attending an infamous house party or spending time with her two adorable children. I owe additional thanks to Ben Nonterah of Nonterah Design Studio; Ben always made time for me, whether taking me on buying trips to Makola market or allowing me to sit for hours in his boutique. Like Ajepomaa, I value our friendship and I will forever be indebted to him for saving me from the clutches of the predatorial Ghanaian immigration police (but that's a story for another book)!

There are two additional designers that deserve individual expressions of gratitude: Kofi Ansah and Joyce Ababio. Kofi Ansah was one of the first designers I interviewed during my 2009 trip. In spite of his fame and notoriety, he welcomed me into his studio and would converse with me for several hours; our initial conversations remain highly influential in my continued interrogations of Ghanaian and African fashion. I would be remiss not to acknowledge the importance of Joyce Ababio, both as a female designer from

the 1990s and as the founder of the Joyce Ababio College of Creative Design. Like Ansah, she reinvigorated the use of kente cloth in late 20th century Ghana, but her greatest contributions are the countless students she has trained to become seamstresses, tailors and fashion designers. Although I only interviewed her once, her information was equally influential and her career is certainly deserving of careful exploration, although including her in this publication was simply not meant to be.

There are two archivists, thousands of miles apart, that have enhanced this publication beyond measure. The first is William Ashaley, the main archivist for the *Daily Graphic* newspaper in Accra. With the help of his small, but attentive staff, I spent hours poring over seemingly unending volumes of historical newspapers, delighting at all of my unexpected findings. There was never a request that was denied and without their help, my historical exploration of Accra's fashion culture would be nonexistent. I feel privileged that I was provided unprecedented access to such a rich and informative archive, and thankful that it was so accessible and informative.

The second archivist is Bongi Maswanganyi, of Bailey's African Historical Archive in Johannesburg, South Africa. When I initially visited the archive during my 2014–2015 Mellon postdoctoral fellowship, I had no idea that I would find a collection of *Drum – Ghana* magazines, nor that they would completely upend my understanding of the origins of Accra's contemporary fashion culture. Bongi was immensely helpful in the initial research stages and in securing copyright permissions; the information I gleaned from this archive, without question, added more complexity and nuance to this book's historical narrative, along with providing unprecedented photographs and documentation of Ghana's earliest fashion designers. I never dreamed I would find Ghanaian fashion in South Africa, but I'm certainly glad that I did!

I am absolutely indebted to my Ph.D. advisors Victoria Rovine, Robin Poynor, Maya Stanfield-Mazzi and Brenda Chalfin. As a team, they helped hone my research and writing, providing me with continued thoughtful feedback that aided in developing my own scholarly voice, providing me with the knowledge and confidence to continue writing and publishing in the field of African art history. I am particularly grateful to Vicki, who has served as a role model to me throughout my career. I aspire to her level of scholarship and hope that she is proud of the emerging scholar that she has so greatly influenced. I must add that although unrelated to the topic of this book, Anitra Nettleton has been a continued supporter of my research and through my postdoctoral fellowship, allowed me to expand my interest in African dress and fashion to include forms of South African sartorial expression, primarily beadwork and the designs of Laduma Ngxokolo.

I am equally indebted to Susan Cooksey, Rebecca Nagy and the rest of the staff at the Samuel P. Harn Museum of Art in Gainesville, Florida, including Jessica Uelsmann, Tami Wroath, Tim Joiner, Liz Rodgers, Natasha Alexander and Betsy Bemis, who assisted in the development, promotion and installation of my guest-curated exhibition *Kabas and Couture: Contemporary Ghanaian*

Fashion. Both Susan and Rebecca have been unwavering supporters of my research, providing me with the opportunity to realize my first exhibition on Ghanaian fashion (which was, for the record, the first exhibition in the United States to focus on the fashion culture of a single African nation). I've always been buoyed by Susan's reminder that a well-known scholar claimed I had "my nose to the wind." The exhibition would not have been possible without the generosity of Dr. Madelyn M. Lockhart, who unfortunately passed away before the exhibition opened to the public. With its focus on primarily women designers, *Kabas and Couture served* as a precursor to this publication and allowed me to recalibrate my research for a more popular audience; it was certainly an important and integral step in realizing this book.

To all my friends and colleagues who have supported me, in ways great and small, I offer you my thanks. This includes scholars like Jordan Fenton, Lynne Cooney, Amanda Strasik, Carlee Forbes, and Meghan Kirkwood, who would commiserate with me about the delights and tribulations of publishing and "talk shop" about issues and concerns in the field of African art. Librarians Tom Caswell and Tisha Mauney offered their own encouragement and friendship, while never hesitating to purchase and scan books for me, another example of the many seemingly invisible, yet integral individuals who contributed to the development of this publication. To all the scholars that have come before me and informed my work, I am deeply appreciative of your contributions and hope that my own book enhances the small, but growing field of African dress and fashion.

Without question my family, including Caroline and Don Stanhope, Mary and Paul Gilles, and my parents Nancy and Mike, has provided unwavering support throughout my fledgling academic career, offering unending encouragement and functioning as my unofficial "cheering squad." My mother has been particularly influential; she has read every draft of every chapter, offering her own thoughts and feedback, ensuring that my writing is understandable, engaging and thoughtful. I am grateful for my family's continued love and support that has allowed me to confidently embark on my scholarly endeavors. My family, along with Dennis Bayquen, have been my most consistent champions, ensuring that everyone they know is fully aware of this publication; perhaps the best form of promotion is word of mouth!

I have saved my final expression of gratitude for perhaps the most important individual to my research: Emily Asiedu. She is deserving of the most praise, for she has opened her home to a continued stream of European and American researchers, myself included, and provided them with a comfortable, loving and intellectual environment to live and work, a bonafide, albeit informal incubator for scholarly research. I distinctly remember the feelings of uncertainty and apprehension when I initially reserved a room in her home; our phone conversation was short and Auntie Emily seemed slightly gruff and abrupt. I could not have anticipated how much love I would grow to have for Auntie Emily, who cared for me, encouraged me and ensured that I always had a full meal of fufu every Sunday. I will readily admit that without Auntie Emily, I don't think

this book would have come to fruition. Auntie Emily's unending support and encouragement, and being able to feel "at home" in a foreign country, was of upmost importance, and it allowed me and my research to flourish, in spite of expected setbacks, frustrations and even the occasional illness. I have shared so many memorable moments with Auntie Emily, but my favorites were often when I joined her on the verandah for a moment of silent observation and contemplation. Although she appears only briefly in this book, to me Auntie Emily is a powerhouse of Ghanaian womanhood. I am continually in awe and forever inspired by her, and am thankful that she was such an integral part of my experience in Ghana; I give her my deepest and most heartfelt thanks.

In considering the numerous collaborations that coalesced into creating this book, I am left with a new, personal mantra, one that is woven throughout the pages of this book, doubling as a conclusion to my acknowledgments and a preamble to the forthcoming prose: *it is time for the unsung heroes to sing*.

1 Introduction

The many modes of (African) fashion

I attended my first African fashion event in 2009: *Ghana Fashion Weekend*. Held at the Accra International Conference Centre, the event was organized by the late Sima Ibrahim, former model and CEO of Exopa Modeling Agency. I still remember my feelings of excitement and self-consciousness on the inaugural day of the event as my cousin and I were escorted, each by our own model, down a sloping red carpet, only to be greeted by a space overfilled with chairs and completely devoid of people. I later learned the importance of not arriving early for an event in Accra, particularly a fashion show.

At the time, the significance of the event escaped me. I was dazzled by the constant parade of bold, intricate and imaginative fashions, yet I could not foresee the expansions and revisions that were set to take place (Figure 1.1).

As time passed and my research became more robust, I realized this inadvertently final presentation of *Ghana Fashion Weekend* marked an important moment in Accra's fashion history. The event included a diverse array of designers from across the continent, many of whom were highly successful and celebrated designers of the time, such as Kofi Ansah (Ghana), St. Ossei (Ghana) and Alphadi (Niger).[1] These individuals represented a particular generation that aided in the revitalization of African fashion during the late 1980s and early 1990s, while simultaneously contributing to the stimulation of a nascent, global interest in African sartorial expressions. The event's emphasis on accomplished, celebrated designers had an additional, unintended effect. It created a distinction between an older, more established generation of designers and their younger, largely excluded counterparts, a generation of emerging designers who in the following years began to reinvent the form and presentation of African fashion, particularly in Ghana. As a doctoral student, the event served as a powerful turning point in the trajectory of my research: it demonstrated that Accra had an active and diverse fashion culture that had largely escaped extensive documentation, galvanizing me to commit my fledgling academic career to the exploration of Ghanaian fashion.

This book serves as the culmination of my research, conducted during six trips to Accra from 2009 to 2017, including a seven-month period of intensive research in 2012. The focus has shifted considerably since my dissertation; I no longer feel the need to document the entirety of Accra's

DOI: 10.4324/9781003148340-1

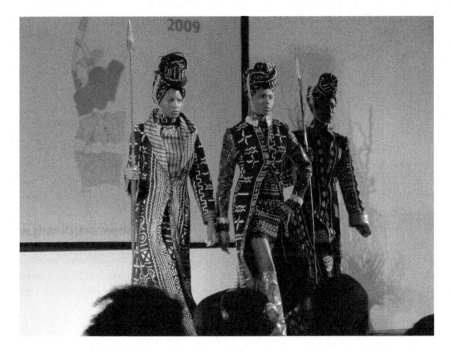

Figure 1.1 Kofi Ansah's Bogolan ensembles, presented at the 2009 *Ghana Fashion Weekend* in Accra (Image: Christopher Richards).

fashion designers and the city's sartorial fluctuations. Instead, I have embraced imperfection, choosing to highlight the most culturally and artistically significant female designers from the twentieth and twenty-first centuries. My decision was influenced by several confluences: the existing publications on African and Ghanaian fashion that focus primarily on male designers and the continued, international promotion of young, emerging African designers who are almost exclusively male.

This emphasis on male designers is not a new phenomenon; the lack of gender diversity in global fashion has been actively discussed and debated by journalists and scholars. First recognized by fashion scholar Valerie Steele in 1991, she admitted: "It's true: Men do dominate women's fashion" and that "almost all the big names are male."[2] Ten years later, sociologist Diana Crane acknowledged that "women designers have been in the past and continue today to be outnumbered by male designers in the field of fashion design for women."[3] She further argued that men have benefited from "organizational constraints and highly competitive market conditions," affording them the ability to dominate the realm of women's fashions.[4] Although women's contributions to fashion are more celebrated than ever before, exemplified by recent exhibitions and publications on Elsa Schiaparelli (2018), Guo Pei (2018) and Rei Kawakubo

(2017), many women remain on the periphery of the fashion industry and its history.

This gender imbalance is equally applicable to Ghana, where men's contributions to the country's fashion culture are better documented and more globally acknowledged than those of their female counterparts. This is not to suggest that fashion designers like Kofi Ansah, St. Ossei, Ben Nonterah and Mawuli Okudzeto are not significant; indeed, they have contributed immensely to Accra's vibrant fashion culture and have often functioned as international fashion "ambassadors," showcasing the originality of Ghanaian fashion to a largely global audience. However, the contributions of women designers, particularly in a historical context, are often understated. This book attempts to amend this imbalance by focusing exclusively on Ghanaian women and elucidating their roles as originators and purveyors of fashion, particularly in a historical context. By focusing on women, I am not attempting to reaffirm existing stereotypes, such as women being more suited or sensitive to creating attire for women, nor am I suggesting that female identity has a particular influence on the selected women's designs; I am simply acknowledging and celebrating women's contributions because they are significant and they have, up until now, been largely undocumented.

Space does not permit the inclusion of every woman who has contributed to the development of Ghana's fashion culture. There are generations of both anonymous and known women who have made important contributions to Accra's sartorial landscape, individuals like Joyce Ababio, designer and founder of the Joyce Ababio College of Creative Design, Nora Bannerman, Brigitte Merki, Titi Ademola (KIKI Clothing), Brigitte Naa-Ode Kragbé (Nahode Okai), Ajepomaa Oklah (Ajepomaa Design Gallery), Adoley Addo (JIL Boutique), Aya Morrison, Sumaya Muhammad (PISTIS) and Nelly Aboagye (Duaba Serwa). The designers in this publication were chosen based on the following, non-gendered criteria: their documented and sustained success both locally and globally, the existence of a sufficient array of garments for closer examination, and a commitment to producing original and innovative designs that engage with established Ghanaian dress practices, while simultaneously affirming a decidedly cosmopolitan identity.

Although firmly rooted in art history, with careful analyses of particular designs as forms of artistic expression, this publication draws upon the fields of dress and fashion history, anthropology, African studies and women's studies, indirectly illustrating the cross-disciplinary nature of investigations into fashion and dress practices. My research equally expands and complicates these fields, attesting to the potency of fashion and its relevance in understanding both historical and contemporary African cultures and histories.

"Fashion matters" in Ghana

As posited by Victoria Rovine in the introduction of *African Fashion, Global Style*: "fashion matters."[5] Such a statement may seem self-evident, and yet

the importance of fashion, particularly on the African continent, cannot be overstated. This is particularly true in Ghana, where even the most seemingly superficial sartorial decisions are often embedded with layers of social, cultural and historical significance. These vestiary gestures, as diverse as the individuals who compose them, illustrate the inherent complexity and primacy of African fashion, a form of expression that often defies existing social divisions of class, age, gender and ethnicity. I will share two examples that attest to both the explicit and embedded significance of fashion in the context of Ghana's capital.

To gain a better sense of Accra's dynamic everyday fashions, I often watch the informal procession of Ghanaians (and some foreigners) strolling in the Kokomlemle neighborhood from Emily Asiedu's second-story verandah, giving new meaning to the concept of "pedestrian" fashion.[6] For a brief moment in July 2017, I was unexpectedly joined by two of Asiedu's nephews. Their intent differed from my own; whereas I was surveying for fashions, they were searching for and greeting neighborhood friends. As we stood, elbows resting on the railing, a young, well-dressed man walked into view. He was wearing examples of global fashion: trousers and a short-sleeve shirt, and his overall appearance was well-groomed and stylish. Recognizing him, Auntie's nephews shouted greetings and initiated a brief, but lively exchange. As I listened, the phrase volleyed back and forth was "abɔ dam," which in Twi describes someone who is mentally unstable, insane or "mad." I was surprised to hear them laughingly repeat this phrase, as it is often employed as an insult. Puzzled, I asked one of Auntie's nephews why they kept repeating "abɔ dam." He explained that the dapper young man was a mechanic at the nearby repair shop; the nephews were asking about the absence of his uniform, which would typically be worn, dirty and unsightly. The young man explained that he only wore his uniform once he arrived at the mechanics' shop, where he would change from his more stylish ensemble and "become mad."

I was stunned, not by the association of disheveled dress with madness, as this is readily acknowledged by Ghanaians, but by the young man's commitment to presenting himself in a stylish manner for such a seemingly mundane and momentary routine.[7] In spite of the short distance to his place of employment, this young man ensured that he presented himself in clean, pressed and fashionable clothing in order to maintain his sartorially constructed social identity. The exchange suggests the additional ability of assuming or "putting on" an identity, even temporarily, through the changing of attire. Although the young man's assertion of "becoming mad" by donning his uniform was slightly sardonic, it implies that he could become someone else, or at least, act in different, potentially socially unacceptable ways, by simply altering his dress. By not wearing his uniform in a highly public setting, he was subverting his identity as a manual worker and asserting his desired identity as a professional, globally aware individual. In this fleeting moment, fashion mattered. It mattered how the young man presented himself to the public; his dress signified his desired social status and served as a means to challenge established preconceptions regarding his profession.

On July 1, 2016, I witnessed a second sartorial parade, albeit one more grandiose than the informal street stylings of Kokomlemle. I attended the funeral of Ruth Botsio, a celebrated fashion icon, trendsetter and the wife of independence-era politician and diplomat Kojo Botsio.[8] I became aware of the funeral a week prior to the event when I spotted an eye-catching wax print fabric at a seamstress' shop. The fabric was black, with a kente-inspired design in bright pink. The pairing of pink and black was highly unusual; intense pink is not common in wax print and a predominantly black fabric rarely features accent colors outside of white, red or maroon. I began asking about this anomaly and was eventually informed that it was a special commission for Ruth Botsio's impending funeral. The following week, I joined several other onlookers outside the gates of the Christ the King Church to watch as waves of attendees entered the courtyard, all bedecked in their own interpretations of Botsio's striking black and pink funeral cloth (Figure 1.2).

Again, I found myself stunned, not only at the variety and inventiveness of the garments on display, but at the malleability of Ghana's "traditional" sartorial practices. Existing scholarship and experience taught me that, for funerals, Ghana's dress code was strict and limited: clothing could be black, black and red, or black and white; anything outside of these color schemes would be considered inappropriate. In this instance, established dress forms were challenged, resulting

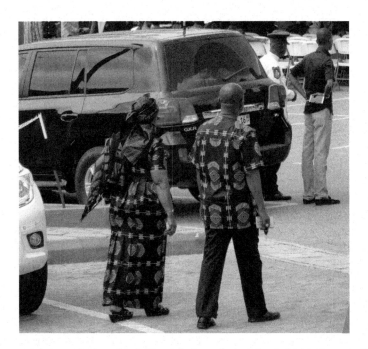

Figure 1.2 Attendees at Ruth Botsio's funeral on July 1, 2016 (Image: Christopher Richards).

in an innovation that defied existing precedents with the potential to diversify Ghana's acceptable funeral attire (I have since seen at least one funeral print that incorporated magenta into the overall color scheme of black and red). Moreover, Botsio's black and pink funeral print functioned as a symbol of her identity and legacy. Botsio's favorite color was purportedly pink, hence the revised color scheme of the cloth, and the phrase "Beloved Mother" on the fabric's selvedge, became a literal (and wearable) acknowledgment of one of her many social roles. The potency of the fabric extended to the individuals who wore it; those able to procure, tailor and wear the material immediately expressed their participation in the funeral (an invitation was not required), signifying a personal connection to the deceased. Like the aforementioned mechanic, individuals could potentially "put on" an identity simply by donning the unusual funeral cloth, suggesting an affiliation with Botsio as an individual, her family and their elite social circle.

Once again, in this equally fleeting moment, fashion mattered. It mattered that Botsio's personality and reputation as a fashion innovator was expressed through a printed fabric, and subsequently through a myriad ensembles, suggesting the inherent power of Botsio as a fashionable figure and her posthumous ability to disrupt and reimagine established dress practices, even if only for the span of her funeral. For the attendees, by donning the fabric they were able to visually assert a connection to Botsio, signaling their own elite social and political status, whether real or aspirational.

These two examples serve as exemplars of countless moments that demonstrate how "fashion matters." Whether these occurrences are composed of a singular vestiary gesture, as indicated by the mechanic, or encompass a complex choreography of sartorial performance, as illustrated by Botsio's funeral attendees, they remain clear indicators of the potency and primary of fashion within the larger context of Accra. Furthermore, these examples suggest that fashion is not an exclusively elite preoccupation; in Ghana, fashion matters to a diverse range of individuals, regardless of their socioeconomic status. While the importance of fashion remains undeniable, defining what constitutes fashion is repeatedly debated, with definitions often excluding African countries and their respective cultures.

Defining fashion

Fashion is frequently, and inaccurately, characterized as a primarily Western phenomenon linked to the rise of capitalism in Europe and America. Publications by Allman (2004), Gott and Loughran (2010), Hansen and Madison (2013), Rabine (2002), Roces and Edwards (2007) and Rovine (2001, 2010, 2015) have challenged this misconception, arguing for a more inclusive and equitable understanding of fashion by gradually removing the implicitly racist and colonialist strands that are interwoven into this exclusively Eurocentric definition. In an effort to further rewrite these established misconceptions, I define fashion as a "form of dress frequently associated with elite status in a given culture, which

embodies change through the innovation of existing and historically significant materials and styles of dress."[9] Change is a key element in understanding fashion; sartorial shifts can be dramatic and instantaneous, or subtle and gradual. Regardless of the frequency and intensity of the changes, fashion is constantly being revised and reimagined in a process that emphasizes cyclical production over an assumed, linear progression. Fashion is also inherently cross-cultural; "fashion designers continually look beyond the confines of their own localities for creative inspiration," hoping to construct "original and avant-garde garments that blend global styles, materials and dress practices with familiar and established elements of their respective dress systems."[10]

An expansive conception of fashion does not preclude further categorization; the focus of this book is primarily designer fashions, garments that fulfill the general qualifications of fashion, but can be further distinguished as garments by known and celebrated individuals recognized for a particular, consistent aesthetic. With designer fashions, the brand name often eclipses the identity and contributions of their creator, suggesting the inherent value of designer fashions lies in the social and cultural cachet of the brand's constructed image. The most telling Ghanaian example is of fashion designer Juliana Kweifio-Okai, whose own identity was subsumed by that of her label as she became popularly known and referred to as Chez Julie. In a global context, designer fashions often refer to garments made exclusively for runway shows, industrially produced as part of seasonal collections to be sold in boutiques or online, and custom-ordered by clientele. What further distinguishes designer fashions from other subcategories is that the brand name or identifiable aesthetic is more important than the artistry or quality of the item. Frequently, designer fashions *are* more detailed and well-made than other forms of mass-produced fashion, but in other instances, particularly in terms of the current global fashion culture, a brand and its presumed heritage is more important than the craftsmanship and quality of a particular article of designer fashion.

It is necessary to acknowledge that, in spite of its elitist tendencies, fashion often extends beyond the limited and insular sphere of elite consumption, permeating the lives of everyday individuals. This is particularly true in Ghana, where fashion is considered, discussed, created, imitated and enacted by a diverse range of individuals. The predominance of tailors and seamstresses found throughout the country encourages an environment of sartorial creativity and innovation; individuals can select from a dizzying array of imported and local materials and adapt existing silhouettes to create garments that reflect local and global fashion trends, while simultaneously displaying the creator's (or the commissioner's) individual perspective. The reflections of former First Lady Nana Konadu Agyeman Rawlings attest to the permeation of fashion:

> people were fashionable in the cities, but in the rural areas, they were fashionable in their own way. Sometimes they would put on just a cloth, but the style would be different or there would be piping, so they were fashionable.[11]

Rawlings' observation is clear, yet profound. She acknowledges the diversity of Ghanaian fashion and that localized forms of dress are equally susceptible to experimentation and innovation, qualifying them as fashion and legitimizing their role in the global fashion network.

The culture of seamstresses and tailors, found throughout the African continent, is important to acknowledge, as it allows for a more democratic engagement with designer fashions and a given country's fashion culture, albeit through the act of mimicry. The predominance of seamstresses and tailors allows for facsimiles of designer fashions to be easily produced, meaning that designers and their creations can have direct and immediate impacts on the everyday dress practices of Accra's citizens. As discussed in Chapter 6, Ayensu's use of fabric-covered buttons for her brand's accessories and garments resulted in the widespread imitation of these adornments, one that has even reached overseas markets.

The beginnings of scholarship on African fashion – dress and adornment

Fashion is ultimately a subcategory of dress, concisely defined by Joanne Eicher as "visual as well as other sensory modifications (taste, smell, sound and feel) and supplements (garments, jewelry and accessories) to the body."[12] A focus on the cultural significance of dress, and more specifically, the woven textiles and elaborate ornaments worn to enhance the body, formed the underpinnings for early anthropological and art-historical explorations of the dressed and adorned African body. Eicher was one of the first scholars to compile an exhaustive bibliography on African dress and textiles, predated only by her coedited volume *Dress, Adornment and the Social Order*, which explored the multidisciplinary and cross-cultural importance of dress in relation to social organization and the presentation of self. Roy Sieber's *African Textiles and Decorative Arts*, published in conjunction with an exhibition at the Museum of Modern Art, was one of the first publications to exclusively explore the diversity and complexity of African dress and adornment. One of Sieber's conjectures remains remarkably relevant: "the art of personal adornment is *pan*-African and may, indeed, reveal the breadth and range of aesthetic life of traditional Africa with greater accuracy than the limited formulations that currently serve in the West…as African art."[13] The publications of Eicher and Sieber, coupled with Picton and Mack's *African Textiles* (1979), marked an important shift: the inclusion and examination of African forms of dress, textiles and personal adornment in the study of African art and culture.

As research in the field of African dress and adornment expanded, publications focusing on specific countries, cultures, and forms of textiles became more prominent. These include works by Borgatti (1983), Eicher (1976), Gilfoy (1987, 1988), Lamb (1975, 1981, 1984), Polakoff (1980), Spencer (1983) and Wass (1975), many of which were published in conjunction with exhibitions. The May 1982 issue of *African Arts*, replete with nine essays addressing various

forms and expressions of African dress, marked a pivotal moment specifically for the academic exploration of African art history: the acceptance of dress as a legitimate and important aspect of African artistic expression. The issue included essays from Eicher, Fred Smith, Lisa Aronson, Christopher Roy, Patrick McNaughton and Daniel Biebuyck, addressing subjects ranging from Frafra dress to several forms of West African weaving. Following the 1980s, the study of African textiles continued to expand, with scholars beginning to use textiles and forms of dress as a lens to explore specific cultural practices, political shifts, identity and gender politics, even religious affiliation. Most recently, scholars like LaGamma and Giuntini (2008) have begun to situate textiles in relation to the practices of contemporary African artists, elucidating how specific textile forms and techniques are referenced and reinterpreted by artists such as El Anatsui, Atta Kwami, Yinka Shonibare and Sokari Douglas Camp.

Scholarship on African fashion

Although the examination of textiles and personal adornment has gained considerable traction as a crucial aspect of African culture and history since the late 1960s, the notion of fashion remained largely outside the parameters of scholarly inquiries regarding African dress and adornment. Allusions to fashion are evident in Doran Ross' *Wrapped in Pride* (1998), but it wasn't until the late 1990s that African fashion – garments and designs that reflected particular viewpoints, iconographies and histories associated with specifically African countries and cultures – emerged as its own field of study. *Revue Noire*'s pivotal special issue on African fashion (1997) was one of the first publications to acknowledge the diversity and importance of African fashion. It highlighted an array of designers from across the continent, with a particular emphasis on Malian Chris Seydou who, at the time, was lauded posthumously as one of the first and most celebrated African designers to blend indigenous African textiles with global fashion trends. Following *Revue Noire*, several books were authored, including works by Geoffroy-Schneiter (2006), Mendy-Ongoundou (2002) and Van der Plas (1998). Like *Revue Noire*, these publications took a broad approach to African fashion, highlighting designers who were currently active and internationally recognized. These publications were largely popular in their approach, which belied the complex significance of African fashion as artistic expression.

Leslie Rabine's *The Global Circulation of African Dress* (2002) was one of the earliest academic explorations of African fashion, asserting its prominence and importance to the overarching global fashion system, particularly its ability to reflect the needs, desires and identities of African and African-American consumers. Following Rabine's publication, Jean Allman's edited volume *Fashioning Africa: Power and Politics of Dress* (2004) provided a multidisciplinary examination of fashion and dress practices across the African continent. Allman's contribution to the publication is particularly significant; it examined Ghana's government-sanctioned, post-independence promotion of "properly" dressed female bodies

as indicators of modernity and progress, acknowledging the linkages between dress and politics and the primacy of women in the conceptualization of a modern and independent African nation. Additional publications focusing specifically on African fashion have been authored by Gott and Loughran (2010), Hansen and Madison (2013) and Jennings (2011). Victoria Rovine's most recent publication *African Fashion Global Style: Histories, Innovations, and Ideas You Can Wear* (2014) serves as the unofficial primer to the subject of African fashion, arguing for its importance and legitimacy as a form of artistic expression and exploring its myriad manifestations throughout history and across the continent; the publication further addresses how European designers have crafted imagined conceptions of Africa through particular, historically significant, collections.

The exploration of African fashion has recently permeated museums, resulting in exhibitions that add to existing scholarship in unexpected and innovative ways. Beginning with my own exhibition, *Kabas and Couture: Contemporary Ghanaian Fashion* (2015), which was the first American exhibition to explore the fashions of a specific African nation, museums across the United States and Europe have begun to acknowledge the significance of contemporary African fashion, including The Museum at FIT's *Black Fashion Designers* (2017); Brighton Museum's *Fashion Cities Africa*; *African-Print Fashion Now!* (2017) at the Fowler Museum; and the Museum of Modern Art's *Items: Is Fashion Modern?* (2017).

While publications, exhibitions and the overall popularity of African fashion have increased dramatically in recent years, there are limited studies on fashion designers from a specific country, and even fewer that trace the trajectory of contemporary African fashion to its historical roots. The intent of this book is to expand and complicate the scholarly inquiry of African fashion, illustrating the need for similar research focused on specific regions and capitals, unfurling the complexities of African fashion and unequivocally demonstrating that Africans, across the continent, have been developing, promoting and navigating their own complex fashion systems for decades, if not centuries. As part of this book's conclusion, the conceptualization of African fashion will be interrogated and challenged, ultimately arguing for a more expansive and nuanced understanding of what constitutes "African" fashion.

Fashion as art

As fashion becomes increasingly accessible to a global audience and more actively incorporated into art-museum exhibitions, a particular question continues to be discussed, debated and evaded: is fashion art? In some writings, such as Saillard and Zazzo's *Paris Haute Couture*, specific forms of fashion are unabashedly categorized as art; in others, like Hank Hines' essays for *Dalí & Schiaparelli*, affinities between art and fashion are acknowledged, yet the two creative spheres remain distinct. This section will provide a brief overview of the burgeoning practice of exhibiting fashion in a museum setting, followed by an assessment of how fashion can be considered art through three specific

guises: the craftsmanship of haute couture, the sheer artistry and creativity of a given design, and the historical and cultural significance of a fashion innovation. This section relies primarily on examples of European and American fashion, as these are more widely known and recognized by fashion scholars and academics alike. The proposed categories for understanding fashion as art will subsequently be applied to the Ghanaian designers and their garments discussed in this book.

Although their prototypes were established in the early 1900s, fashion exhibitions are experiencing unprecedented popularity across North America and Europe in the twenty-first century, capturing new and varied audiences with the opportunity to regard, with a mixture of awe and aspiration, all manner of fashionable garments.[14] The Metropolitan Museum of Art's 2011 exhibition *Alexander McQueen: Savage Beauty* served as a watershed moment in the history of exhibiting fashion: it became the Costume Institute's most visited exhibition and held one of the highest attendance records for exhibitions organized by the Met (a record that has since been surpassed by the exhibition *China: Through the Looking Glass*). Following this blockbuster exhibition, museums across the globe began organizing exhibitions focusing specifically on fashion, a trend first acknowledged in the writings of Fiona Anderson (2000), Lou Taylor (2004) and Valerie Steele (2008). Fashion exhibitions have been mounted by institutions without significant collections of fashion, such as the Museum of Modern Art (MOMA) and the Dalí Museum in St. Petersburg, Florida; other institutions, like The Museum at FIT, the Victoria & Albert Museum, the Palais Galliera, the Musée des Arts Décoratifs and the aforementioned Costume Institute at the Metropolitan Museum of Art, have continually organized fashion exhibitions, setting the standard for the methodology and theoretical frameworks for exhibiting fashion.

A short survey from the last several years illustrates the sustained popularity of fashion exhibitions; an examination of the Met's Costume Institute alone demonstrates that, since 2014, they have frequently organized two annual fashion exhibitions, including *Charles James: Beyond Fashion* (2014), *Death Becomes Her: A Century of Mourning Attire* (2014–2015), *China: Through the Looking Glass* (2015), *Jacqueline de Ribes: The Art of Style* (2015–2016), *Manus x Machina: Fashion in An Age of Technology* (2016), *Masterworks: Unpacking Fashion* (2016–2017) and *Rei Kawakubo/Comme des Garçons* (2017). Between 2011 and 2015, *The Fashion World of Jean Paul Gaultier: From the Sidewalk to the Catwalk* traveled to ten international institutions, including the Brooklyn Museum in Brooklyn, New York, the Dallas Museum of Art in Dallas, Texas, and the Grand Palais in Paris, France. The Denver Art Museum has mounted several fashion exhibitions, including *Dior: From Paris to the World* (2018), *Shock Wave: Japanese Fashion Design* (2016–2017) and *Yves Saint Laurent: The Retrospective* (2012). The Los Angeles County Museum of Art organized *Reigning Men: Fashion in Menswear* (2016) and the Philadelphia Museum of Art developed retrospectives highlighting two historically significant designers: *Shocking!: The Art and Fashion of Elsa Schiaparelli* (2003–2004) and *Patrick Kelly: Runway of Love* (2014).

African fashion has become a growing subfield of fashion exhibitions, with one of the earliest organized by The Hague in 2002, *Fashion and Ghana*. A selection of the more recent African fashion exhibitions includes *Kabas and Couture: Contemporary Ghanaian Fashion* (2015), *Black Fashion Designers* (2016), *Vlisco: African Fashion on a Global Stage* (2016–2017), *Fashion Cities Africa* (2016–2017), *African-Print Fashion Now!* (2017), *Making Africa: A Continent of Contemporary Design* (2017–2018) and *Items: Is Fashion Modern?* (2017–2018).

In spite of the increasing proliferation of fashion exhibitions within the confines of art museums, which inherently promotes fashion as a viable art form, the question of whether fashion is art, and to what end, remains a considerable conundrum. Fashion curator Andrew Bolton suggests that the debate of fashion as art can be traced to the mid-eighteenth century, when the importance of hand-sewn and embellished fashion was galvanized by the extravagant practices of the French royal court. Bolton refers to Denis Diderot and Jean le Rond d'Alembert's 1751 *Encyclopédie, ou Dictionnaire raisonné des sciences, des arts et des métiers*, in which Diderot and d'Alembert argued that specific *métiers*, including trades aligned with the production of dressmaking, should be regarded as equal to the arts and sciences.[15] Their perspective was revolutionary, as it asserted that handcrafted embellishments were not simply forms of manual labor, but expressions of artistry and creativity.[16] The six métiers related to dressmaking originally codified by Diderot and d'Alembert are still utilized in contemporary haute couture: embroidery, featherwork, artificial flowers, pleating, lacework and leatherwork.

As early as 1967, the Metropolitan Museum of Art affirmed that fashion is an art form, or that it can be considered, discussed and appreciated in a manner similar to fine art. In an essay introducing the exhibition *The Art of Fashion*, the Costume Institute's Executive Director argued that fashion "has components found in works of art: it has form, color, and texture; it is symbolic, it serves an important function in ritual and superstition, and it also communicates."[17] Weissman further acknowledged that: "the art of fashion is so intrinsically woven into the fabric of the story of man that one can hardly be separated from the other."[18]

Art inseparable from fashion: haute couture

Since Weissman's recognition of fashion as a form of artistic expression, there have been several explications as to how forms of fashion are indeed indicative of the appellation of "Art." The most common assessment relates to a specific, highly specialized subset of historical and contemporary fashion culture: haute couture. Fashion scholar Olivier Saillard succinctly asserts: "haute couture is an art form – inseparable from fashion."[19] French designer Christian Dior eloquently explicated the notion of haute couture as art:

> haute couture dresses have the unique and unexpected quality of a work of art. They are among the last things to be made by hand, by the human

hand whose value is irreplaceable, for it gives everything it makes what no machine can bring: poetry and life.[20]

The crux of haute couture is, as indicated by the words of Dior and the earlier writings of Diderot and d'Alembert, its high level of craftsmanship. Each haute couture garment is made entirely by hand, under the exacting supervision of a cadre of the most skilled artisans who ensure a standard that is extravagant in its precision. As Saillard explains, "hidden beneath the austere lines of a sculpted jacket or under hems and invisible seams, haute couture quietly reigns."[21] Saillard's description implies a second hallmark of haute couture: custom measurements. Each haute couture garment is made for a particular person; as invoked by Martin and Koda: "the couture garment is a fulfillment of mutually agreeing ideas that are contingent upon and wrought on the human body."[22] Martin and Koda suggest that, without a sartorial consensus between the couturier and the patron, haute couture would not exist. Thus, haute couture is distinguishable from other forms of fashion due to the sheer artistry of its creation, as expressed through its hand-sewn and embellished surfaces and its customization to individual owners. This approach suggests that all haute couture, whether reflecting the Orientalist fantasies of Paul Poiret or the theatrical opulence of John Galliano, is ultimately a form of art.

"… Like a Modern Canvas": fashion as art – the designs of Schiaparelli and Pei

In 1932, the *New Yorker* writer Janet Flanner stated "a frock from Schiaparelli ranks like a modern canvas." This description encapsulates a second means for understanding fashion as art: that specific garments, whether haute couture, ready-to-wear designer fashions, or garments created by recognized or unknown individuals, have creative elements that distinguish them as works of art.[23] Additionally, designers who take inspiration from particular artists or artistic movements (like Alexander McQueen, Christian Dior and Yves Saint Laurent) or who treat their designs as sculptural extensions of the body (Azzedine Alaïa, Iris Van Herpen and Hussein Chalayan) create garments that are often considered art.[24] As suggested by the introductory quotation, Schiaparelli is the most fruitful example of a historical designer whose work attests to this categorization, as many of her garments were influenced by her connections with surrealist artists. Her first artistic collaboration dates to 1931, when she commissioned artist Jean Dunand to paint trompe l'oeil pleats on an evening gown; in the following years, Schiaparelli became adept at blurring the lines of art and attire. Schiaparelli's iconic 1937 evening coat, adorned with detailed metallic embroidery and silk flower embellishments, was the result of a drawing gifted to her by Surrealist artist and writer Jean Cocteau. The garment features the iconic Surrealist motif of a vase that simultaneously appears as two side-profile faces (Figure 1.3). This optical illusion comprised of overlapping images reflects the paranoiac-critical method, a philosophical theory proposed

by Salvador Dalí. Thus, this garment becomes more than a feat of haute couture craftsmanship; it is the fusion of Schiaparelli's aesthetic with that of her Surrealist peers, becoming an artwork in its own right.

A contemporary example of fashion as art are the designs of Chinese couturier Guo Pei. Much like her predecessor Schiaparelli, the majority of her garments are considered haute couture, with the added appellation of being works of art. *Vogue* contributing editor Lynn Yaeger described Pei's designs as impactful and transcendent:"the very existence of such a work of art can lift us out of our ordinary lives – and if only for a moment, deliver us into the realm of the sublime."[25] The *New Yorker* fashion writer Judith Thurman echoed Yaeger's indirect acknowledgment of Pei as an artist, describing a specific Pei gown as reflecting the "idiosyncratic 'hand' of a great artisan."[26] Not only are her

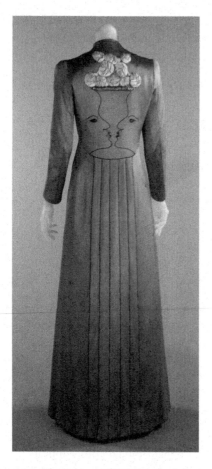

Figure 1.3 Elsa Schiaparelli's 1937 evening coat with Surrealist motif (Image: Philadelphia Museum of Art: gift of Mme Elsa Schiaparelli, 1969, 1969-232-7).

garments painstakingly made by hand, with several lauded for taking two years and fifty thousand hours to create, but her garments, particularly when paired with her towering platform shoes, become almost unwearable. When asked about this potential lack of functionality, Pei responded with: "I don't care; the creation is enough."[27] This narrative suggests that Pei intends her designs to function as creative, visual expressions of her imagination, inseparable from her cultural heritage and her own personal history.

The artistry of her designs is best captured in a suite of garments from her 2015 *Garden of the Soul* collection. Consisting primarily of dresses in shades of ivory and cream, Pei's designs were embellished with such a density of embroidery that the surfaces of skirts and bodices become sculptural, with blades of grass, flower petals and leafy tendrils lifting and spilling off the surface of the garment (Figure 1.4). The notion of sculpture is further invoked by each garment's silhouette; whether a skirt comprised of layers of rectangular-shaped silk "petals," or a bodice with voluminous, structured sleeves shaped like Chinese lanterns, Pei's exaggerated and fantastical silhouettes reject wearability

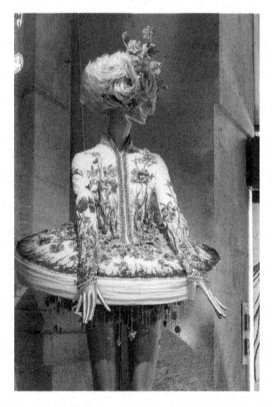

Figure 1.4 An ensemble from Guo Pei's 2015 *Garden of the Soul* collection (Image: Guo Pei).

to become works of art, sculpted in silk and lurex. Several of these garments also included hand-painted motifs, adding an additional layer of artistry to Pei's designs.

Most importantly, both Schiaparelli and Pei have referred to their design process as a form of artistic expression. In her memoir, Schiaparelli stated: "dress designing, incidentally, is to me not a profession but an art."[28] Pei expressed a similar sentiment, stating: "designing clothes, particularly couture, is a form of art."[29] Acknowledging their perspectives is significant, as it indicates both women *intended* to create garments that could be considered artistic. Schiaparelli and Pei approached the design process differently from other designers; they championed unusual motifs, elaborate and extensive embellishments, and the ability of fashion to express fantasies, ranging from Schiaparelli's depiction of surreal, optical illusions, to Pei's evocation of Chinese imperial dress. Both women, and their designs, demonstrate that specific garments function akin to an artist's canvas, thereby implying a second means for considering fashion as an art form.

Art to wear: fashion and the "wearable art" movement

It is necessary to briefly acknowledge an additional facet of fashion as art, one formally codified as "wearable art" or "art to wear" by the publication *Art to Wear* (1986). Although distanced from haute couture and designer fashions, much of the hallmarks of wearable art are highly reminiscent of haute couture, including "attention … paid to detail and to painstaking craftsmanship," "high-quality handwork" and "innovation."[30] More recent explorations of this classification emphasize the importance of wearable art in honoring women's contributions to textile arts, the ability for said garments to be simultaneously functional and non-functional, and the importance of a personal relationship between the maker and the wearer.[31]

Instead of segregating these highly imaginative garments due to their idiosyncratic qualities and their reliance on "craft" technologies (weaving, knitting, crochet and leatherwork), these garments should be treated as a viable and integral part of fashion as artistic expression, thereby nuancing the established understanding of what constitutes fashion as art. The thread that ties these garments, exemplified by the exuberant, loomed capes of Susanna Lewis and the sculptural, fabric vests of Joan Steiner, to the designs of Schiaparelli and Pei, is the unapologetic celebration of personal expression.[32] As explained by Julie Schafler Dale: art to wear is "distinguished by an intensity of personal content. They are about the artist who created them, unabashedly autobiographical, signaling an eruption of personal information from private spaces … these works are the physical embodiment of interior worlds and intangible ideas."[33] The notion of a singular and deeply personal viewpoint is particularly valid when assessing the works of Schiaparelli and Pei, as both designers actively impart their own individualistic and highly imaginative approach to fashion with each design they produce. The notion that fashion as art is both deeply personal and

a reflection of a designer's interior monologues adds an additional, but necessary, layer to understanding fashion as a form of artistic expression.

"New" looks and distressed duds: the artistry of the "New Look" and punk fashion

The previous two categorizations of fashion as art place emphasis on the materiality of the garment: it is either the garment's detailed craftsmanship or its creative and expressive appearance that suggests the appellation of art. A third category does not exclusively emphasize a garment's appearance or silhouette; rather it considers the garment's social, cultural and historical impact. Typically, this assessment is best conducted in hindsight, allowing another means for scholars to understand and appreciate fashion as art. This particular approach is more democratic than emphasizing the extravagance of a given garment, in both its creation and presentation; it implies that a self-fashioned, punk ensemble can be as important as Coco Chanel's iconic "little black dress."

To understand fashion as an art form based on its social and cultural impact, it's best to examine an iconic and influential design from the House of Christian Dior. One of the most important garments of the twentieth century was Christian Dior's 1947 "Bar" suit, the most well-known example of his "New Look." Although the garment is a masterpiece of couture craftsmanship, famed for its carefully hand-stitched darting and pleating, its true significance remains its impact on European and American society. Dior's "New Look" was in direct opposition to the prevailing streamlined and utilitarian fashions of the 1940s; Dior's "New Look" garments reveled in exaggerated femininity, with silhouettes emphasizing rounded, natural shoulders, a narrow waist and full, curving hips. Dior's designs were a study in extravagance; introduced to a world still recovering from World War II and a legacy of shortages and rationing, Dior lengthened skirts to mid-calf and incorporated elaborate pleating, which could require between 30 to 80 yards of fabric to produce.

Although Dior's sartorial innovations were drastic, their true impact went beyond mere structural and material revisions. As documented by fashion curator Alexandra Palmer, the "New Look" was not immediately embraced by women; in fact, it was rejected by many who saw Dior's lengthening of skirts as an expensive and unnecessary alteration to their existing wardrobes.[34] Dior's return to longer skirts was interpreted as a signifier of women losing newly gained independence, while the narrower waist was critiqued as potentially detrimental to women's health and wellbeing.[35]

In spite of the documented resistance to Dior's "New Look," it quickly became *de rigueur* for fashionable women, ushering in an even more significant revolution: a revision of the "ideal" female silhouette. Neither manufacturers nor department stores had the appropriate forms to recreate and display Dior's sartorial innovations, resulting in what Palmer describes as "a lacuna in the dressmaking and display sectors that reverberated through the fashion industry."[36] Mannequin manufacturers quickly began producing forms that

mirrored Dior's more restrictive measurements, resulting in a dramatic shift in not only the display of garments, but the expectations placed on women. Just as mannequins were molded to fit Dior's more restrictive garments, so were women's bodies, resulting in a powerful and potentially problematic reimagining of the female form.

Dior's "New Look" is as legendary as it is conspicuous; it literally changed the shape of fashion and serves as a potent example of how specific garments or silhouettes can alter social and cultural histories. However, a garment does not have to fit within the strict limitations of haute couture to be socially and culturally transformative. One such example, which reverberated throughout American and European society as powerfully as the "New Look," is the punk fashion movement. Inextricably linked to music, curator Andrew Bolton distilled punk in both London and New York City as "a frustration and dissatisfaction with the state of hegemonic mainstream culture, especially mainstream rock and roll."[37] British musician John Lydon echoed Bolton's distillation, characterizing London's punk scene as resulting from a sense of economic failure:"it felt like the whole country was going to collapse. There was no real movement … most of us felt hopeless – no future, no jobs, nothing."[38] From this frustration grew a distinctive aesthetic and approach to dressing, one that emphasized customization and individuality, expressed through the deconstruction, embellishment and reassembly of individual garments or ensembles. Bolton makes a clear distinction between the "street level punks" who initiated this type of aesthetic through experimentation and the recycling of discarded or outdated clothing, and the constructed, intentional designs of Malcolm McLaren and Vivienne Westwood, with their resulting creations classified as "commodity punk."[39]

Whether "street" or "commodity" punk, the movement and its raiments challenged the status quo, serving as expressions of protest and propaganda; as Jon Savage states, punk "liberated a generation to create its own culture."[40] Whereas Dior's "New Look" was the result of a singular vision, disseminated throughout the Western world (and beyond), punk achieved the reverse: it was a sartorial movement created and enacted by youth that permeated designer and haute couture fashions. The safety pin, an icon of punk dressing that decorated and literally held together garments, was transformed by designer Gianni Versace into a high-fashion, logo-emblazoned embellishment. The aesthetic of bricolage, cobbling together a look from disparate elements, even items of trash, has been subsequently referenced by designers John Galliano and Maison Martin Margiela. A movement that grew out of dissension and disruption, reflecting the frustrations of a generation, has subsequently been co-opted by mainstream fashion designers and brands, becoming a continually referenced aesthetic in contemporary fashion.

The punk youthquake may be the antithesis of Dior's "New Look" in material, form and aesthetic, yet these disparate fashions share a powerful commonality: the ability to drastically change established modes of dressing and subsequently revise the social and cultural fabric of the time. Dior's "New Look" reveled in luxury and economic affluence, celebrating material abundance and

a feminine reinterpretation of the female form. A lack of wealth and resources contributed to the creation of the punk aesthetic, which employed deconstructed and recycled clothing as a means of challenging the status quo. Although seemingly contradictory, Dior's "New Look" and the punk movement demonstrate how social and cultural transformation is another means for considering specific fashions as forms of art.

From Guo Pei's luxuriously embellished, fantastical ensembles to the pared down and deconstructed forms of punk attire, these disparate and often incompatible forms of fashion can, and should, be read as forms of art. This is not to suggest that every design to grace the runways of Paris or the streets of New York is a form of artistic expression. There are discrete categories for viewing fashion as art: the complex and carefully executed extravagance of haute couture, garments that meaningfully reflect and embody the artistic approach of their creators, and singular or series of garments that irrevocably revise not only the dress practices of a particular time, but that continue to serve as inspiration for future designers, continually reworked and reimagined through the cyclical nature of fashion. By examining the qualities and influences of fashions in determining their artistry, the categories of both art and fashion are expanded and diversified, allowing for fashions outside of the restrictive Western fashion system to be included and examined.

"Picking" from the past: African fashion and the notion of tradition

When discussing various forms of African artistic expression, particularly forms of African dress, the conversation inevitably includes the concept of tradition. Historian Mark Phillips provides an apt distillation of the term's academic implications, stating that "much of the sociological and anthropological discussion of tradition has been carried on as though tradition primarily concerned the unselfconscious continuance of social institutions and practices, often in non literate societies."[41] Anthropologist Christopher Steiner notes that, through the scholarship of anthropologists like Margaret Mead and A.R. Radcliffe-Brown, tradition became "synonymous with the term 'culture' itself," particularly when applied to non-Western peoples.[42] These established understandings of tradition have created an additional implication: that tradition exists in opposition to modernity and innovation, creating a concept of tradition that is mired in a stagnant past, one that cannot be reconciled through adaptation or invention.[43] This hardened terminology, and its subsequent dichotomy, has spawned a multitude of scholarly revisions and rejections of tradition, and yet the ideology persists throughout academic inquiry and investigation, particularly in relation to the African continent.

What is largely absent from scholarly debates on tradition is the viewpoint of contemporary Africans; Steiner does mention, albeit through the lens of white sociologist Norbert Elias, that Africans have purportedly viewed Western studies on "vanishing traditions" with contempt.[44] What remains unacknowledged

is that the concept of tradition has permeated African cultures, resulting in a term that is understood and employed by a diversity of Africans. How can the inherently biased and problematic legacy of tradition be reconciled with its contemporary use, particularly when employed by the individuals it originally essentialized? The answer lies in the theoretical postulations of historian and anthropologist James Clifford.

Clifford considers tradition an "elastic term," implying that when considering tradition, flexibility and malleability are key.[45] An element deemed traditional can still be susceptible to alterations and innovations, it simply suggests the phenomenon is meaningfully tied to a collective past, ultimately reflected through individual identities. Clifford acknowledges that "native societies have always been both backward and forward looking. Loyalty to a traditional past is, in practice, a way ahead, a distinct path in the present."[46] The importance of the past, and its role in creating the present and future, resonates with a Ghanaian approach to indigenous knowledge, expressed through the well-known proverb: "San kɔ fa," or "Go back and pick." It reiterates Clifford's assertion that many global cultures value a direct linkage with the past, one that is employed to simultaneously innovate and preserve specific forms and expressions. Instead of completely rejecting tradition, it is more fruitful to employ Clifford's explanation: "tradition is not a wholesale return to past ways, but a practical selection and critical reweaving of roots."[47] The notion of reweaving is particularly rich for the study of Ghanaian dress and fashion, as textiles are the result of a literal and metaphorical weaving together of past forms and materials with newly acquired substances and aesthetics, resulting in dress forms that reflect a particular moment, while celebrating an inherited history.

There is an additional facet to tradition that is implicated in the discussions of Steiner and Clifford, but never fully elaborated: the inherent timelessness of tradition. Although firmly rooted in the past, tradition is not fixed at a given point on an assumed, linear timeline. The historical practice deemed traditional, such as dressing in wax print fabric, may remain constant, yet the means for expressing said tradition are easily adapted and made relevant to individuals and groups throughout time. The historical origins of a tradition are equally indefinite; even if a specific date can be attributed to the introduction of a given tradition, it is often treated as though it has been practiced in perpetuity. Thus, in spite of constantly drawing upon the past, the lack of temporality in tradition ensures its ability to be easily passed on and made meaningful, through alteration and adaptation, by subsequent generations.

As the subsequent chapters will illustrate, contemporary Ghanaians actively employ a similar notion of tradition to discuss their designs, one that is permeable and encapsulates the past, present and future of Ghanaian culture and heritage. To honor these intellectual positions, while being fully aware of the concept's scholarly baggage and shortcomings, I have chosen to embrace the *Ghanaian* usage of tradition, albeit stripped of its nagging quotations. When employed by Ghanaians, tradition encapsulates a meaningful, historical practice that is fixed in its cultural relevance and assumed legacy, but adaptable in

its form of expression. In truth, it is the flexibility of tradition that ensures its continuity.

Cosmopolitanism: a space and its inhabitants

To fully understand the significance of Accra's historical and contemporary fashion culture, it must be situated within the framework of cosmopolitanism, a concept that is continually embraced, rejected and subsequently revised. To understand the relevance of cosmopolitanism, one must first acknowledge its diversity of expression; its inherent malleability. Carol Breckenridge, Sheldon Pollock, Homi Bhabha and Dipesh Chakrabarty argue in the introduction to their edited volume *Cosmopolitanism* that there exist multiple cosmopolitanisms, or at least that conceptions of cosmopolitanism can be expressed in culturally specific, localized terms, resulting in subtle variations on a shared concept.[48] Breckenridge et al. further emphasize the importance of change and transition to cosmopolitanism, implying that in moments of uncertainty or shifts in social order, cosmopolitanism becomes a means for unifying individuals, for emphasizing commonalities in spite of perceived differences. As cultures constantly experience shifts, cosmopolitanism thus becomes an important framework for understanding how individuals and groups see themselves in relation to others, as existing in the past, present and future.

Building on the recognized mutability and variations of cosmopolitanism(s), Thomas Turino emphasizes the importance of interconnectedness and localization to understanding cosmopolitanism in *Nationalists, Cosmopolitans and Popular Music in Zimbabwe*. According to Turino: "particular cosmopolitan lifeways, ideas and technologies … are situated in many sites which are not necessarily in geographical proximity; rather, they are connected by different forms of media, contact, and interchanges."[49] It is this conception of exchange between physically disparate locations that becomes the crux of cosmopolitanism.

The most significant contribution to the theorization of cosmopolitanism comes from Kwame Appiah, who in his publication *Cosmopolitanism: Ethics in a World of Strangers* (2006), frequently imparts childhood memories as vivid and descriptive indicators of cosmopolitanism in his childhood city of Kumasi, Ghana. Appiah humanizes philosophically removed conceptions of cosmopolitanism, arguing that these exchanges occur through the literal mobility of individuals and their sharing of physical, intellectual and cultural spaces. As Appiah asserts, cosmopolitanism cannot exist without engagement and interaction, adding an additional layer of complexity to the established understanding of this theoretical framework. In an attempt to distill the work of these scholars and philosophers, I consider cosmopolitanism to be a constellation of beliefs, actions and physical spaces, unifying in their forms, but localized in their expressions, that are constantly reacting to social and cultural shifts. These constellations exist only through active exchange and engagement; in spite of being physically disparate, they are interconnected. Cosmopolitanism is ultimately about

commonalities, and how certain ideas and forms are valued and enacted in specific locales across physical space and throughout history.

Fashion is a powerful vehicle for encapsulating and enacting cosmopolitanism; fashion is inherently global, for everyone dresses the body in some manner or another, and sartorial interventions are constantly experiencing revision, as both reactions to the past and projections into the future. Fashion is simultaneously localized; individuals draw upon their own histories and experiences to create expressions that reflect particular viewpoints, whether they be individual, social or cultural, that simultaneously resonate with a presumed global network. Of utmost importance, fashion is easily exchanged; fashion is intended to be transported and traded across perceived boundaries and geographical borders, suggesting that it is a prime indicator and means for enacting cosmopolitanism. This enactment, however, most successfully occurs when fashion is placed on a body, thus allowing for the full exchange and interaction that Appiah believes is central to a conception of cosmopolitanism.

The following chapters will attest to the validity of a quote from Ghanaian fashion designer Joyce Ababio: "Ghanaians have always been fashionable."[50] Each chapter is obliquely dedicated to supporting this assertion, which Ababio expressed with a casual confidence. Chapter 2 establishes the presence and significance of fashion in Accra, beginning in the early 1950s. The mid-twentieth century in Ghana was an era of expansion, diversification and sartorial experimentation; local and global forms of fashion were equally celebrated and promoted, indicating the unique ability of Accra's women to navigate the complexities of a multifaceted fashion system and attesting to their inherent cosmopolitanism, in both outlook and action. The subsequent hybridization of these disparate, yet overlapping, forms of dress ultimately led to the creation of specifically Ghanaian designer fashions. Chapter 3 focuses on two women who served as precursors to Accra's recognized fashion designers. Although the sartorial legacies of seamstress Laura Quartey and scientist Letitia Obeng are vastly different, they exemplify the continued contributions of countless, largely undocumented, women who actively contributed to the historical fashion culture of Accra. By acknowledging their impact, the contemporary understanding of African fashion is further complicated and historicized, providing a more complex understanding of the origins of Ghanaian, and more broadly African, designer fashions.

Chapter 4 explores the career and creations of Ghana's first formally trained designer, Juliana "Chez Julie" Kweifio-Okai, the "model" for subsequent Ghanaian fashion designers. Kweifio-Okai's contributions are significant, not only in their artistry and originality, but in their historical and cultural significance. Kweifio-Okai's most innovative creations will be highlighted, illustrating how her garments, particularly following Ghana's independence, challenged established conceptions of tradition and dress, particularly in relation to gender. The originality and boldness of Kweifio-Okai's designs allowed for future women to create even more avant-garde fashions, exemplified by Beatrice "Bee" Arthur, the focus of Chapter 5. Known for her unconventional approach

to design, Arthur pushed the boundaries of Ghanaian fashion, creating garments that are almost unwearable, yet laden with symbolism, challenging the divide between art and fashion. Arthur's designs are further imbued with her own complex identity, illustrating how fashion can reflect and encapsulate layers of personal meanings and histories. Her most recent collections, themed around the controversial subjects of sexual harassment and failing infrastructures, are examined to illustrate how fashion can also function as a means for social protest, empowering the creator and activating the body of the wearer in a complex conversation on resistance and the status quo.

Aisha Ayensu is the final designer to be included and is the subject of Chapter 6. Ayensu is the most successful and prolific of a generation of young designers who revitalized Accra's twenty-first-century fashion culture. Ayensu has developed a globally recognized fashion brand with a distinctive aesthetic, one that blends wax print and local forms of dress with global materials and styles, invoking many of the concepts originally expressed by Kweifio-Okai. Ayensu continues to emphasize a level of artistry in the creation and promotion of her designer fashions, distinguishing her brand as a purveyor of garments that challenge established dress codes, while maintaining a level of sophistication, elegance and Ghanaian heritage. Woven throughout these chapters is the framework of cosmopolitanism, as expressed through the artistry and originality of the designers and their garments. The final chapter looks to the future of Ghanaian, and more broadly African, fashion, examining how Ghanaian designers continually reconsider how to best capture their culture and heritage through fashion, and calling into question what actually constitutes distinctly "African" fashion.

Interspersed between the chapters are "vignettes," brief, personal reflections of events and interactions that I have experienced during my research process. They are meant to be enjoyable, illustrative and evocative, a means for sharing the complexities of research and the diversity of Accra's fashion culture. They serve as a means for acknowledging my own position and voice within this publication, for my experiences have certainly shaped how I understand, explicate and theorize Ghanaian fashion.

These vignettes, alongside the formalized chapters that document and examine the various ways in which women, both recognized and undocumented, shaped Accra's fashion culture, will illustrate the potency and centrality of fashion to Ghanaian culture, history and artistic expression, and that some of the most fashionable and cosmopolitan global citizens existed *outside* of the established metropoles.

The location: Accra, Ghana

Who says we shall not survive among these turbines? – Ama Ata Aidoo.[51]

My research is firmly rooted in Accra, the capital of Ghana. In casual conversations with Ghanaians, I jokingly refer to myself as an "Accra Boy," the designation given to Ghanaian men who grow up within the confines of the

city. The appellation of "Accra Boy" is a point of pride for many, as it implies an extensive knowledge of the city: understanding how to navigate the meandering streets that connect the city's ambiguous, haphazard neighborhoods; where to find the best "chop" houses; how to skillfully cajole a cheaper cab fare. These abilities reflect an overarching ease and confidence in existing within the city, an outward-facing, performed identity that blends seamlessly into the vibrant, everyday culture of Accra. The city thus becomes an integral part of an "Accra Boy's" identity. They purposely distinguish themselves from the countless Ghanaians who migrate to the capital in search of employment, economic stability and an escape from rural lifestyles; in contrast to these idealistic migrants, "Accra Boys" are born into city life.

Although I could never be a real "Accra Boy," the city became a crucial part of my identity. I repeatedly chose to remain bound to Accra, not out of a fear of rural life, nor from a lack of interest in Ghana's myriad art forms and cultural practices, but because I wanted to be part of the city and to feel a sense of belonging; that I was part of the dynamic, multicultural fabric that is Accra, and in doing so, I would better understand the city's vibrancy and complexity. It was during the ongoing process that I realized Ghanaian fashion and Accra are inextricably and perpetually intertwined, so much so that a discussion of Ghanaian fashion is ultimately about Accra's fashion culture. This is not to imply that cities like Kumasi and Tamale don't have their own fashion cultures; they certainly do, but the global conception of Ghanaian fashion is, in reality, what is produced, consumed, exchanged and performed in Accra.

When I began writing my book manuscript, my first words slowly coalesced to form the following reflection. It is my attempt to creatively and philosophically encapsulate what Accra means to me. It also functions as a grounding for the entire book; to understand Ghanaian fashion, one must understand the city, for it is the city, in all its successes and failures, that serves as the fertile ground for its flourishing fashion culture.

In 2012, my colleague and I embarked on an ambitious endeavor: to restore the dusty, barren front garden of Auntie Emily Asiedu's residence to its former verdant glory.[52] It was not an easy task. As I crisscrossed the city from one elite enclave to the next, gathering information on Accra's fashion designers, I also collected a sampling of plants: delicate, sherbet-colored orchids and slender birds-of-paradise from East Legon, speckled bromeliads from a seller alongside Ring Road and a shockingly red hibiscus from a location that I have since forgotten. While I amassed this impressive collection of flora, my colleague, an Agro-forester, planned the bed to ensure a balance of height and color, while allowing room for future growth. As a final touch, and to add an element of humor, I procured a smiling, oversized cement penguin whom I proudly positioned in the center of the fledgling flora. My friend and I had a mutual goal in mind: to create an enduring, physical expression of our love and gratitude for Auntie Emily, a plot of fecund and flowering beauty for her enjoyment, her own private Eden.

Every day I left the house, I would water the flowers. I had hoped that planting the garden during the start of rainy season would ensure its survival, but the rains refused to fall. I continued to nurse the juvenile plantings for several weeks, hoping that they would persist with my continued care. As my date of departure drew near, I attempted to enlist the help of Auntie's nephews, cajoling and even bribing them to water the garden, but I couldn't convince them of the dormant potential of this spotty, straggly space. On the day I departed, I resigned myself to accept the eventual demise of the garden. All our time, planning and hard work would slowly wither away, returning the plot to its former state of desolation, its eventual dusty barrenness ironically disrupted only by a smiling cement penguin, an alien, yet ever buoyant, interloper.

I returned two years later to find the garden teeming with life. Plants spilled over the raised bed in all directions and the penguin, now partially obscured, peered from behind flowering bushes; he was transformed from interloper to explorer, a monochromatic parody of Dr. Livingstone surrounded by his own jungle. I surveyed the garden: the orchids, unsurprisingly, had failed to germinate, yet the birds-of-paradise and bromeliads were thriving, thrusting their stalks and blooms toward the sky. I was amazed and delighted that Auntie Emily's Eden had not only survived, but flourished. I marked the garden's success with the addition of a second cement bird, a large and vividly pink flamingo.

Another two years passed. I no longer thought about the failure of the garden; I assumed that it would continue to survive in its own unexpected and haphazard way. By the time I returned again in 2016, the garden had reached a state of fluctuating constancy. The hibiscus and birds-of-paradise continued to thrive and jockey for their own space among their flowering neighbors. Weeds had begun to creep into the bed, but their delicate, periwinkle blue blossoms were more endearing than invasive. One plant made an ingenious decision; it had grown from a crack in the side of the bed, circumventing its own confinement and spilling onto the ground, its pure white flowers aggressively reaching toward the compound's front gate, a dramatic gesture of defiance. The birds had not fared as well as their more natural brethren. The flamingo had faded to a shade of dusky pink and the penguin's beak and wings had been broken by a careless handyman, reducing the penguin's enigmatic smile to its underlying metal wire and bits of unpainted cement.

One day during my 2016 trip, as I made the trek from Auntie Emily's Kokomlemle house to a designer's boutique in Osu, my mind continually returned to the sheer resilience of the garden. As I contemplated its survivalist tendencies and sheer vibrancy, I began seeing parallels between the garden and the city of Accra: diverse and exuberant spaces constantly in flux, both experiencing continual development and decline, expansion and destruction. Every time I return to Accra, new luxury hotels have sprung up seemingly from nowhere, sleek and imposing odes to modernist architecture that testify to the continued presence and importance of local wealth and foreign influence. Like the birds-of-paradise, these massive structures seem to widen their reach at any cost, casting their long, fortified shadows across Accra's existing urban landscape.

In other areas of the capital, buildings that originally dwarfed their neighbors are slowly being reduced to shadows of their original forms, their sturdy and seamless façades giving way to cracks and disintegrating edges. In Auntie Emily's neighborhood of Kokomlemle, I have watched this gradual decline over the years. The homes, with their broad verandahs and unexpected architectural flourishes (including Greek Ionic columns), served as markers of post-independence wealth and success; they now slowly crumble under the weight of family disputes and years of disrepair. Like the cement birds, these once bold and eclectic homes struggle to maintain their position in the face of new expansion, development and the growing competition for physical space.

And yet, like Auntie Emily's garden, the appearance of decline is deceptive.

The Museum of Science and Technology officially opened in 1965, originally intended as a dramatic and elaborate example of mid-century architectural design. I am unaware how long it functioned in its original capacity; in my memory, it was always a shell of its former self, a grandiose relic hinting at the optimistic modernism of Nkrumah's presidency. I distinctly remember my clandestine tour of the vacant space in 2012; a few articles of clothing were drying on a line outside of the museum, the inside was cavernous and awash with natural light. Near the entrance were rows of carved wooden sculptures, a temporary and informal storage area for itinerant street vendors. It was clear the space had been usurped by squatters, with blankets and the occasional mattress strewn haphazardly on the floor.

In spite of its general degradation, I was captivated by the building's two-story, octagonal, central atrium. I began to reimagine the space in my mind, populating it with silhouettes of elegant Ghanaians gathering around the multiple balconies to watch the presentation of an avant-garde fashion show. Even though the space was already being adapted and repurposed by its informal tenants, like the garden, there was a greater, yet dormant potential. I departed the space with similar sentiments as when I originally left Auntie's garden: hopeful, but resigned to the reality of decline.

In the summer of 2016, the museum was transformed by the faculty and students at the Kwame Nkrumah University of Science and Technology (KNUST) into a vibrant and interactive space for their annual thesis exhibition. The building, which had appeared neglected and forgotten only a few years previously, was suddenly catapulted onto an international stage, becoming the setting for what will likely be remembered as a turning point of twenty-first-century Ghanaian art. The scattered remnants of squatters were replaced by art installations, paintings and elaborate sculptures constructed from a range of media, including used underwear. For me, the most significant statement was relegated to the building's impressive atrium: a singular, bristling column of snail shells rose to the ceiling, growing from an amorphous base that covered the main floor like an encroaching stain or oil spill.

The exhibition was a monumental display of creativity, artistry and vitality. As the building was revitalized, Accra's art scene was also reactivated, flourishing

in its own unexpected, yet productive ways. Even the exhibition's title, *Accra in the Cornfields*, inspired by Ama Ata Aidoo's poem *Cornfields in Accra*, evoked notions of productivity, resilience and a bountiful harvest in the face of disbelief and inhospitable landscapes.

How can so much survive, and in many cases thrive, from what appears to be a vulnerable and tenuous state? And yet, the city does thrive, in spite of its assumed veneer of fragility and instability. Like Auntie Emily's garden, there are aspects of the city that are destined to fail, while others experience unrestrained success. Still other elements remain in a state of dormancy, quietly waiting to be renewed by the fertile imaginations of Accra's citizens. And like the plant that resisted confinement, there are aspects of the city that are completely renegade: breaking free from expectations and physical limitations to create their own pathway to success and survival. Accra is in a constant cycle of blossoming and withering, flourishing and decay, yet its growth and expansion continue in spite of tangible and measurable hindrances. The result, much like Auntie's garden, is vibrant, exuberant and unpredictable. It is an African capital. It is a global metropolis. It is Accra.

Notes

1 St. Ossei's runway collection was exhibited posthumously and included garments from his final collection, which outside of the event, remain largely undocumented.
2 Valerie Steele, *Women of Fashion: Twentieth-Century Designers* (New York: Rizzoli, 1991), 9.
3 Diana Crane, "Fashion Design and Social Change: Women Designers and Stylistic Innovation," *Journal of American Culture*, 22/1 (1999): 61.
4 Ibid., 67.
5 Victoria Rovine, *African Fashion Global Style: Histories, Innovations and Ideas You Can Wear* (Bloomington: Indiana University Press, 2015), 3.
6 In a contemporary context, the phrase "pedestrian" is often applied to fashion that is mundane, unimaginative or mainstream.
7 The linkage of being undressed or partly dressed to mental illness or madness is found in other West African cultures, such as the Yoruba of Nigeria, who believe a lack of clothing is "bizarre" and "indicates an incurable mental illness or an irreversible course." Rowland Abiodun, *Cloth Only Wears to Shreds: Yoruba Textiles and Photographs from the Beier Collection* (Amherst: Amherst College, 2004), 45.
8 Ruth Botsio is informally credited with introducing the popular mid-20th century hairstyle "the Pompador" to the women of Accra.
9 Christopher Richards, "The Models for Africa: Accra's Independence-Era Fashion Culture," *African Arts*, 49/3 (2016): 9.
10 Ibid.
11 Interview, Accra, 2012.
12 Joanne B. Eicher, *Dress and Ethnicity: Change Across Space and Time* (Oxford: Berg, 1995), 1.
13 Roy Sieber, *African Textiles and Decorative Arts* (New York: Museum of Modern Art, 1972), 10.

14 For further information on the history of fashion exhibitions, see Valerie Steele's "Museum Quality: The Rise of the Fashion Exhibition," *Fashion Theory*, 12/1 (2008): 7–30.

15 Andrew Bolton, *Manus x Machina: Fashion in an Age of Technology* (New York: Metropolitan Museum of Art, 2016), 13.

16 Ibid.

17 Polaire Weissman, "The Art of Fashion," *The Metropolitan Museum of Art Bulletin*, 26/3 (1967): 151.

18 Ibid.

19 Olivier Saillard and Anne Zazzo, *Paris Haute Couture* (Paris: Flammarion, 2012), 12.

20 Raphaëlle Roux and Florence Müller, "Christian Dior: Designer of Dreams," *Connaissance Des Arts Special Issue* (2017): 18.

21 Olivier Saillard and Anne Zazzo, *Paris Haute Couture* (Paris: Flammarion, 2012), 12.

22 Richard Martin and Harold Koda, *Haute Couture* (New York: The Metropolitan Museum of Art, 1995), 48.

23 Dilys E. Blum, "Shocking! The Art and Fashion of Elsa Schiaparelli," www.philamuseum.org/exhibitions/2004/64.html.

24 For a more detailed discussion on the overlap of Art and Fashion, see Mitchell Oakley Smith, Alison Kubler and Daphne Guinness, *Art/Fashion in the 21st Century* (London: Thames & Hudson, 2013).

25 Paula Wallace and Lynn Yaeger, *Guo Pei: Couture Beyond* (New York: Rizzoli Electa, 2018): 6.

26 Judith Thurman, Guo Pei, "The Empire's New Clothes," 2016, www.newyorker.com/magazine/2016/03/21/guo-pei-chinas-homegrown-high-fashion-designer.

27 Wallace and Yaeger, *Guo Pei: Couture Beyond*, 6.

28 Elsa Schiaparelli, *Shocking Life* (New York: E.P. Dutton, 1954): 75.

29 Farouk Chekoufi, "In Conversation with: Guo Pei," 2018, www.buro247.me/fashion/insiders/in-conversation-with-guo-pei.html

30 Jean L. Druesedow, "Foreword," in *Art to Wear*, ed. Julie Schafler Dale (New York: Abbeville Press, 1986), 8–9.

31 Melissa Leventon, *Artwear: Fashion and Anti-Fashion* (New York: Thames & Hudson, 2005), 8.

32 Julie Schafler Dale, *Art to Wear* (New York: Abbeville Press, 1986), 12.

33 Ibid.

34 Alexandra Palmer, *Christian Dior: History & Modernity 1947–1957* (Toronto: Hirmer Publishers, 2018), 22.

35 Ibid., 23.

36 Ibid., 16.

37 Andrew Bolton, Richard Hell and Jon Savage, *Punk: Chaos to Couture* (New Haven: Yale University Press, 2013), 12.

38 Ibid., 21.

39 Ibid., 13.

40 Ibid., 35.

41 Mark Salber Phillips, "What is Tradition When it is Not 'Invented'? A Historiographical Introduction," in *Questions of Tradition*, eds. Mark Salber Phillips and Gordon Schochet (Toronto: University of Toronto Press, 2004), 18.

42 Christopher B. Steiner, "The Tradition of African Art: Reflections on the Social Life of a Subject," in *Questions of Tradition*, eds. Mark Salber Phillips and Gordon Schochet (Toronto: University of Toronto Press, 2004), 92.

43 Ibid., 95, 96.
44 Ibid., 95.
45 James Clifford, "Traditional Futures," in *Questions of Tradition*, eds. Mark Salber Phillips and Gordon Schochet (Toronto: University of Toronto Press, 2004), 162.
46 Ibid., 156.
47 Ibid., 157.
48 Carol Breckenridge, Sheldon Pollock, Homi K. Bhabha and Dipesh Chakrabarty, eds., *Cosmopolitanism* (Durham: Duke University Press, 2002).
49 Thomas Turino, *Nationalists, Cosmopolitans, and Popular Music in Zimbabwe*, (Chicago: University of Chicago Press, 2000), 8.
50 Interview with Joyce Ababio, Accra, Ghana, January 31, 2012.
51 Aidoo, Ama Ata, "Cornfields in Accra," in *New Poetry Works*, ed. Robin Malan (Clermont, South Africa: David Philip, 2007), 14.
52 Emily Asiedu, lovingly referred to as "Auntie Emily," is a Ghanaian woman who runs an informal guest house for researchers and scholars in the Kokomlemle neighborhood of Accra. When traveling to Ghana, I have always stayed with her and she has become part of my Ghanaian family.

2 Accra's pre- and Independence-era fashion cultures

This chapter functions as an expansion and refinement of my doctoral dissertation and previously published article "The Models for Africa." In order to understand Accra's fashion culture, both in a historical and contemporary context, it is imperative to establish the sartorial foundation that fostered the development of Accra's innovative, groundbreaking and enduring designer fashion culture. Its material expressions, typified by designs that fuse distinctly nationalist and cosmopolitan identities, were the direct result of Ghana's Independence, which signaled a renewed interest in culturally significant forms of dress. These hybrid fashions, introduced primarily by Ghanaian women, have remained a mainstay of Accra's fashion culture, becoming the most visible expression of Ghanaian designer fashions on a global scale. It was not independence alone that fostered the creation of this new fashion sphere. By the early 1950s, a complex and progressive fashion culture was firmly established in Accra, one that encouraged the active borrowing, experimentation, adaptation and creation of a myriad dress styles. It was from this incredibly vibrant sartorial landscape, one that rivaled the fashion cities of New York, Paris and London in its expansiveness and inclusivity, that ultimately led to the emergence of cosmopolitan, nationalist fashions and Accra's active designer fashion culture.

In order to recreate the dynamism of Accra's foundational fashion culture, I rely on articles and photographs published by the Ghanaian newspapers the *Sunday Mirror* and the *Daily Graphic*, augmented by similar documentation from the popular magazine *Drum: Ghana*, an offshoot of the iconic South African publication of the same name. As established in previous publications, the *Sunday Mirror* and *Daily Graphic* were considered two of the most effective and highly publicized newspapers of the 1950s, overseen by a largely African editorial staff that was given surprising autonomy.[1] This implies a degree of accuracy and honesty in their reportage, while simultaneously acknowledging that many of the accounts, particularly in the *Sunday Mirror*, were targeted at Accra's elite population. This potential hindrance must be coupled with the acknowledgment that many Ghanaians in the 1950s, particularly in the more rural areas, would have had little experience reading English and limited access to such publications, indirectly implying that such publications provide a more accurate understanding of Accra and its elite fashion culture.

DOI: 10.4324/9781003148340-2

Elizabeth Ohene, an editor at the *Daily Graphic* from 1967 to 1982, nuances the rural importance of such publications. Growing up in the remote western village of Abutia, she reflected:

> there was usually one intrepid teacher in every village, as there was in Abutia, who would have a subscription to the Daily Graphic which would be delivered late in the afternoon. The newspaper would be read by everybody who could read English in the village, and there were not many such people in villages in the 1950s … I soon discovered that the paper was the source of information of all current events and one copy served many people.[2]

Ohene's reflection argues for the relevance of the *Sunday Mirror* and *Daily Graphic* for a variety of Ghanaians: rural and urban, educated and illiterate, elite and proletarian. It indirectly indicates the importance of the *Sunday Mirror's* photographs; even Ghanaians who could not read English were able to consider, admire and attempt to emulate the various styles of dressing captured on the pages of the *Sunday Mirror, Daily Graphic* and *Drum: Ghana*. These publications were silent yet powerful disseminators of a myriad sartorial expressions, thus providing the most accurate and accessible account of Accra's historical fashion culture.

In an attempt to understand the complexity and vibrancy of Accra's historical fashion culture prior to Independence, I have identified the following fashion spheres, which were firmly established in Accra by the early 1950s: world fashions, European fashions, international fashions and local fashions. These spheres are immediately evident in the earliest archived issues of the *Sunday Mirror*, maintaining their relevance through the Independence era and, for some, enduring well into the twenty-first century. These spheres are not rigid, autonomous categories; they are inherently permeable, with porous seams that allow dress styles and forms to overlap, inform and supersede one another, while still maintaining allusions to their particular demarcations.

It is the constellation of these spheres, each experiencing their own trends and transformations, that allowed for the introduction of a fifth sphere of fashion, one tied directly to Ghana's independence, that subsequently fostered the creation of Ghana's own designer fashion culture. These resulting fashions, defined as expressions of a decidedly cosmopolitan, nationalist perspective have maintained their relevance, being continually reworked by subsequent generations of Ghanaian fashion designers. This chapter will explore these initial, pre-Independence spheres of fashion and illustrate how the collective energies of Independence, distilled and expressed through Nkrumah's ideologies and the city's sartorially creative women, contributed to Accra's dynamic fashion culture.

In order to proceed, a delineation in time must be established. I choose to define Independence-era Ghana as the period from 1956 to 1966, with the understanding that the years immediately prior to 1956 are defined as

pre-Independence. The aforementioned span of ten years begins immediately prior to Ghana's independence from England in 1957 and ends with Nkrumah's official deposition from power. This era is further aligned with Accra's most significant sartorial shifts, which I believe unofficially began with the 1956 *Sunday Mirror* publication "Can You Ride a Bike in Cloth?" Published almost exactly a year prior to official Independence, the focus of the article is the potentially detrimental effects of industrial expansion on women's dress, specifically the concern that women will be unable to maintain proper dress decorum as they engage in new forms of transportation, such as bicycles, to participate in the expanded job market. Embedded in this article are several astute observations by the author, Augustus Bruce, that allude to the overarching sartorial sentiments of Ghanaians as they prepared for independence.

Bruce began the article by stating:

> With the granting of Independence to the Gold Coast, new vistas for the development of our national cultural identity will be opened up. And it may no longer be wise or prudent for us to continue apeing our white benefactors particularly in their modes of dressing.[3]

This is a powerful opening statement, as it predicts the ensuing development of nationalist, cosmopolitan fashions as a means for celebrating Ghanaian heritage, while superficially rejecting European modes of dressing. Bruce tempers this statement by subtly acknowledging the existing bias against modes of local fashion, observing:

> some of our women have adopted the traditional cover cloth and headkerchief, worn in slightly modified styles, as the dress they wear to their various jobs. But many of them do this with a measure of diffidence. They run the risk of being looked down upon.[4]

As established by scholars and echoed in later chapters, particularly by the recollections of Letitia Obeng in Chapter 3, many educated and professional women were criticized for wearing local, "traditional" fashions, as such forms of dress were associated with illiterate and unworldly women. Bruce's statement provides additional evidence that this was a significant bias many elite and professional women would have to overcome as they actively revised established, local modes of dressing. With remarkable foresight, Bruce offered a solution to this sartorial conundrum, albeit tailored to his transportation concerns: "our dressmakers will have to evolve a new style of our traditional cover cloth for those of our working girls who wish to own bicycles and still dress in the traditional styles."[5] He closed his essay with the following charge: "Here is the gauntlet thrown down to our local dressmakers. Who will take up the challenge?"[6]

Although the actual influence of Bruce's article is unclear, it functions as a point of origin for the ensuing alterations and introductions to Accra's fashion

culture. Bruce's observations encapsulate the contested nature of dress in Accra, particularly on the cusp of the Independence era, illustrating that Ghanaians were actively thinking about and engaging with existing and future spheres of fashion. Most importantly, the article illustrates that Ghanaians placed incredible importance on dress. At a time of political upheaval and cultural shifts, dress was viewed as a potent and immediate means for enacting change, particularly as a vehicle to reflect Ghanaians' newly formed, independent identities.

Before delving into the cosmopolitan, nationalist fashions that resulted from Ghana's Independence, and that were anticipated by Bruce's article, it is necessary to explore the vibrant, pre-Independence fashion culture of Accra and its subsequent spheres of fashion. Since the earliest, archived copies of the *Sunday Mirror* date to 1953, I employ this date as the unofficial beginning of pre-Independence, at least in relation to Accra's fashion culture. Between the years of 1953 and 1956, and enduring into the Independence era, Accra's four fashion spheres – world fashions, European fashions, international fashions and local fashions – can be identified and explicated through the *Sunday Mirror's* weekly reportage. By examining each of these four fashion spheres, the progressiveness and inclusivity of Accra's fashion culture will be demonstrated, further proving that Accra had a vibrant fashion culture long before the introduction of formally trained fashion designers.

World and European fashions

As defined by Eicher and Sumberg, world fashions constitute forms of attire that may be Western in origin, but that have superseded their original forms, becoming integral parts of fashion systems throughout the globe.[7] These garments are ubiquitous forms of clothing, such as pants, dresses and shirts. The existence of world fashions is evidenced by one of the earliest archived issues of the *Sunday Mirror*, which included the article "Being Fashion Wise," accompanied by photographs of Ghanaian women wearing a variety of seemingly European-inspired dresses.[8] The caption of one photograph identifies J. Odamtten as affiliated with the Accra Technical Institute, alluding to her potential role as a student or instructor in their dressmaking program, signifying that these dresses were not imported, but made in Accra by local seamstresses.[9] This is a clear example of the presence of world fashions within Accra's historical dress system: garments that conform to globally disseminated styles and silhouettes, produced and worn within a local context. In an additional example from 1953, a column titled "New Fashions in Vogue" documented that "funny looking trousers – baggy ones, long-shorts, jeans and what not. Also all very fashionable."[10] Again, there is no emphasis placed on the origin of these variations of pants, as they were considered an integral part of Accra's dress culture and, hence, are examples of Accra's world fashions.

A distinct but deceptively similar sphere of fashion is comprised of specifically European fashions, garments that are imported from Europe and whose foreign origins are maintained and emphasized as a means for indicating the

wearer's wealth, prestige and literal mobility. European fashions are limited to garments that are either created by European designers and dressmakers, or purchased from known, European department stores and boutiques. Although European fashions can come from a variety of nations, the majority of Accra's European fashions were either purchased or imported from England. The earliest evidence of a specifically European fashion sphere can be traced to a 1954 issue of the *Sunday Mirror.* An article titled "Latest Fashions in Women's Dress" included four photographs of garments by England's most celebrated designers of the era: Hardy Amies, Michael Sherard and John Cavanagh.[11] This reference to British designers and couturiers suggests that European fashions were promoted as a distinct fashion sphere, in this case through the direct referencing of recognized and exclusive British designers.

The following year, a photograph was published of an elegant model showcasing the latest style of evening gowns. Named the "Desiree," the caption ran:

> and what woman would not desire so elegant a gown. Designed by one of Britain's top dress experts. It clearly shows three important features: (1) slim sheath, easy fitting shape; (2) naturally placed waist and (3) a tiny, matching cape with stand up collar.[12]

Although the specific designer was not identified, its elite, British origins were emphasized, echoing the previously published feature on British fashions.

The strongest evidence for the relevance of European fashions comes from the Independence era, indirectly suggesting that the introduction of cosmopolitan, nationalist fashions did not lessen the importance of European fashions; on the contrary, they endured as a powerful means for expressing wealth, social status and prestige among Accra's elite citizens. This is most convincingly indicated by a column announcing "She Wore the Glamorous Dress," which proclaimed that a specific dress (Figure 2.1), worn by Mary Edusei, was the most glamorous of the year.[13]

Edusei was an infamously extravagant style icon, married to Krobo Edusei, an influential politician and member of Nkrumah's government.[14] The dress, which the *Sunday Mirror* described as "very expensive," was worn on the occasion of the Duke of Edinburgh's visit to Ghana Nautical College.[15] There, the *Sunday Mirror* claimed, it was the "cynosure of all eyes."[16] The author acknowledged that the dress was "specially ordered from Paris," providing direct evidence that Edusei procured the dress overseas.[17] To further illustrate her sartorial extravagance, the article stated: "in April and May this year she travelled all over Europe with her husband. She combed the continent for current fashionable dresses. Later, back in London with her husband, she made her choice of dresses and ordered them."[18] Although the article asserts that Edusei "doesn't belittle seamstresses here," it is clear that Edusei regularly commissioned the creation of European fashions, which she deployed as immediate indicators of her wealth and social status.[19] It is entirely possible that these designs were created by known fashion designers of the era, although a specific designer was not

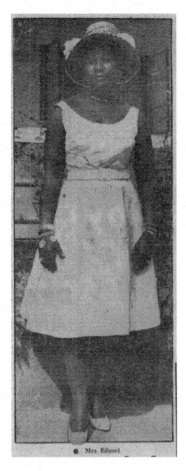

Figure 2.1 Mary Edusei wearing the "Most Glamorous Dress" of 1959 (Image: *Daily Graphic* archive).

identified. Edusei and her "glamorous dress" exemplify how a select, but influential, circle of politically and economically elite Ghanaian women participated in the procuring and informal promotion of European fashions, ensuring that in spite of Independence-era sartorial shifts, European fashions remained a stalwart indicator of exclusivity, social prestige and stylishness.

The aforementioned examples suggest that, although Accra's population may have been visually exposed to forms of European fashion, the consumption of distinctly European designs was limited to a coterie of affluent Ghanaian women who had the means and ability to travel overseas. This changed during the Independence era, as department stores that imported European goods and fashions began to open, beginning with the Union Trading Company (UTC) department store in 1956. The UTC was directly involved with one of the

most important European fashion events of the Independence era: a three-day fashion show that included designs from Queen Elizabeth's couturier Norman Hartnell. Described by the *Sunday Mirror* as "the first of its kind in Ghana," it was an unprecedented event; elite Ghanaians could access the fashions of a known and respected European designer without having to leave their country.[20]

The result of a collaboration between UTC, the British Overseas Airways Corporation (BOAC) and Hartnell, the three-day event was held from November 25–27, 1958 at the Ambassador Hotel in Accra. A month prior to the event, the *Sunday Mirror* published a promotional feature with the headline "Big Dress Show Soon."[21] The brief article began by announcing: "for the first time in the history of Ghana, dresses made by the Queen's personal wardrobe designer, Norman Hartnell, are to be displayed in Accra … Hartnell's designs will be flown specially to Accra for display."[22] Hartnell's inclusion in the event likely reflected the designer's own penchant for hosting overseas fashion shows and for developing "export collections" as a means for broadening his global appeal.[23] Although there is no evidence that Hartnell created a specific "export collection" for Ghana, he did something even more revolutionary: he included Ghanaian women as models for the event. This is evidenced by the aforementioned article's inclusion of a photograph of two Ghanaian women, identified as Rose Odamtten and Felicia Knight, under the subheading "They Will be Models."[24] This inclusion may seem superficial or inconsequential, but very few women of color were employed as models during the late 1950s, particularly African women. By including at least two Ghanaian models in his fashion show, Hartnell was recognizing the role of elite Ghanaian women in consuming European fashions, and suggesting that his exclusive designs were wearable by British expatriates and Ghanaians alike.

The following week, a second article promoted the forthcoming fashion event, with a particular focus on soon-to-be model Rose Odamtten, a radio announcer for the Ghana Broadcasting System. A photograph of her wearing a particularly unusual day dress was included, with the following explanation: "Here, Rose, who'll be one of the models for this show, is wearing one of the latest Hartnell designs and to give you a glimpse of what will take place" (Figure 2.2).[25] Hartnell's own fashion prowess was again acknowledged, being described as "the Queen's own designer."[26] This article builds on the previous promotion of the event by continuing to emphasize Hartnell's skill and exclusivity as a designer, but what becomes more pronounced is the suitability of his designs to Ghanaian women. By including a photograph of Odamtten modeling one of his garments, it powerfully asserts that his designs are both flattering and accessible to Ghanaian women. The continual and prominent inclusion of Ghanaian women as part of the show's promotional articles suggests that the show's target audience was not expatriates, but Ghanaian women, and that perhaps Hartnell was hoping to expand and diversify his fashionable clientele with this particular event. The continued reportage further indicates the enduring importance of European fashions to Accra, particularly as a means for showcasing a woman's elite social status and her inherent stylishness.

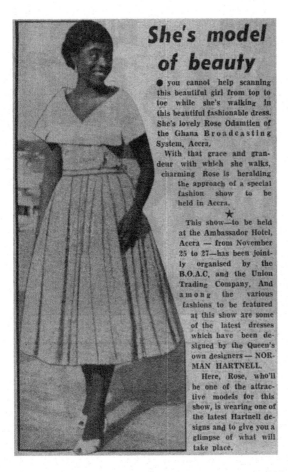

She's model of beauty

● you cannot help scanning this beautiful girl from top to toe while she's walking in this beautiful fashionable dress. She's lovely Rose Odamtten of the Ghana Broadcasting System, Accra.

With that grace and grandeur with which she walks, charming Rose is heralding the approach of a special fashion show to be held in Accra.

★

This show—to be held at the Ambassador Hotel, Accra — from November 25 to 27—has been jointly organised by the B.O.A.C. and the Union Trading Company. And among the various fashions to be featured at this show are some of the latest dresses which have been designed by the Queen's own designers — NORMAN HARTNELL.

Here, Rose, who'll be one of the attractive models for this show, is wearing one of the latest Hartnell designs and to give you a glimpse of what will take place.

Figure 2.2 Rose Odamtten wearing a Norman Hartnell design as a means for promoting the 1958 "Big Dress Show" (Image: *Daily Graphic* archive).

Following the three-day fashion extravaganza, a surprisingly brief synopsis of the event appeared in the *Sunday Mirror*. Although details of the event are limited, published photos indicate that Ghanaian women *did* perform as models for the event; Victoria Zwennes was shown wearing a jumper with shorts and Felicia (B.W.A.T.) Knight wore "an elegant coat for the colder climate … matched with a 'flower pot' hat."[27] The event's inclusion of Ghanaian women as models could be interpreted as a novelty or gimmick to generate interest and publicity, but additional evidence suggests a more complex narrative. Four months later, the *Sunday Mirror* published a photo essay on "Fashions at Ghana's 2nd Birthday." Observing that "Ghanaian girls are noted throughout the world for their fashion-consciousness," the essay included seven photographs representing the diverse and extravagant

fashions worn during the country's Independence celebrations.[28] One of the photographed women was Beatrice Dadson, identified by the *Sunday Mirror* as wife of the Parliamentary Secretary of the Prime Minister and "one of the leading 'fashion queens' in Ghana."[29] Dadson's elaborate white evening gown (Figure 2.3), which appears to have been festooned with elaborate ruching, was described as "one of the latest Hartnell fashions," which "caught the eye of many admirers at the Premier's anniversary cocktail party."[30] This easily overlooked photograph and caption provide evidence that, in addition to modeling Hartnell's designs, Ghanaian women did purchase his creations; it is entirely plausible that Dadson purchased her dress at the fashion event, or ordered the dress directly from Hartnell, with the forthcoming anniversary cocktail party in mind. Regardless of how she acquired the garment, Dadson serves as irrefutable evidence that Ghanaian women actively patronized known European designers, like Hartnell. It further suggests that the introduction of

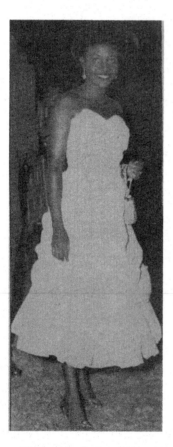

Figure 2.3 Beatrice Dadson wearing a Norman Hartnell design, likely acquired after his fashion exhibition, 1959 (Image: *Daily Graphic* archive).

foreign-based department stores made European fashions more accessible to Accra's elite population, perhaps becoming an indirect means for sustaining the relevance of distinctly European fashions as part of Accra's dynamic fashion culture.

These examples attest to the lasting importance and relevance of European fashions in Accra and that European designer fashions were actively consumed by a select group of elite Ghanaians. In spite of the rapid sartorial revisions that occurred during the Independence era, European fashions maintained their significance, potentially bolstered by the introduction of British-based companies that began directly importing European clothing into Accra. As cosmopolitan, nationalist fashions gained sartorial significance, European designs maintained their relevance, primarily as an immediate means to indicate one's wealth, social status and, most importantly, stylishness. By continuing to wear European fashions, particularly garments created by known designers like Hartnell, Ghanaian women were able to assert their awareness and ability to navigate Accra's multiple fashion spheres, while simultaneously demonstrating their active participation in a global fashion system predisposed to European fashions.

International fashions

On December 6, 1953, the front page of the *Sunday Mirror* announced "A Sari Style," accompanied by the following caption: "Indian wrap is a special Indian fashion. But Florence Mettle of Accra has given it a Gold Coast touch."[31] A full-page photo of Florence Mettle and her noteworthy attire was included (Figure 2.4), showing how she employed several yards of wax print fabric to recreate the standard sari style, which involves wrapping material around your waist, then draping the loose ends over the shoulder. Unlike the typical sari, Mettle's midriff was not exposed, as she wore a long sleeve, V-neck blouse underneath. Mettle's fashionable ensemble, which blended an Indian form of dressing with Ghanaian fabric, epitomizes the sphere of international fashions. I employ the term international literally, as it implies an exchange or relationship between two or more nations. In terms of Accra's historical dress culture, international fashions constitute forms of dress that are directly imported from other countries; these forms are frequently blended with local textiles, but a physical indicator of their foreignness must remain intact, as foreignness is tantamount to their publicized descriptions and overall sartorial value. Although superficially similar to European fashions, international fashions are more adaptable and were often imbued with a degree of exoticism and novelty, whereas European fashions, while equally maintaining their foreignness, were rarely amended and indicated extreme wealth and prestige. This distinction implies that, whereas European fashions were consumed by an extremely limited segment of the population, international fashions were more accessible, as they could be easily adopted by Ghanaians from all social classes. Accra's sphere of international fashions was also more inclusive, with dress styles and

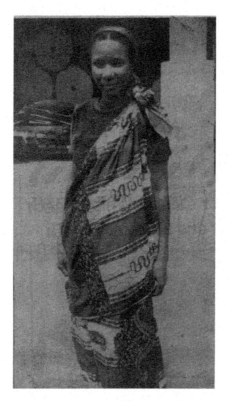

Figure 2.4 Florence Mettle and her Indian sari fashioned from wax print fabric, 1958 (Image: *Daily Graphic* archive).

silhouettes coming from a variety of countries and cultures, particularly the regions of Southeast Asia and Western Africa.

As Mettle's ensemble indicates, Indian forms of dress, specifically the sari, were integral to Accra's sphere of international fashions. The following year, the *Sunday Mirror* announced "Dressing in Indian fashion is now in vogue in the Gold Coast. Mrs. Mary A Prempeh and her friend Mrs. Adae are here seen dressed in Indian fashion."[32] The accompanying photograph showed two women wearing the prototypical sari form, although, as with Mettle's version, the midriff was not exposed. Interestingly, the two women's matching saris were not fashioned from wax print fabric; the material appears similar to the silk fabrics used in India to create saris, so it is likely that these entire ensembles were completely imported.

The popularity of the sari, as a form of international fashion, was likely due to its similarities with Ghanaian female wrappers and the "toga-style" wrappers predominantly worn by men. This postulation is confirmed in 1959, when the *Sunday Mirror* announces: "Now − It's the Indian Style" (Figure 2.5). The brief column asserts: "The Indian attire has so much captured the imagination

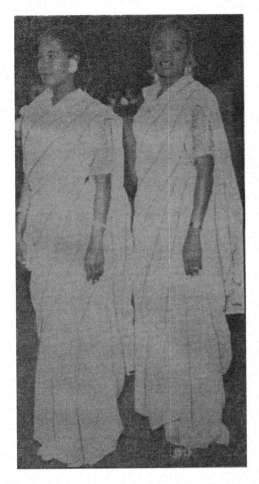

Figure 2.5 Mercy Neizer and Violet Asante wearing the "Indian style," a variation on the sari, in 1959 (Image: *Daily Graphic* archive).

of Ghanaian womenfolk because of its likeness to the Ghanaian dress."[33] The column further illustrates that international fashions were disseminated outside of the capital city, as the two women photographed, Mercy Neizer and Violet Asante, were identified as living in Kumasi. As with European fashions, the documentation of Indian fashions during the Independence era suggests that this sphere maintained its relevance to Accra's fashion culture even after the country's Independence. Additional evidence from the personal archive of Edith François, the sister of Chez Julie, suggests that Indian fashions were being worn as late as the 1970s, reiterating that, like all fashion trends, these spheres of fashion and their particular expressions experienced cyclical periods of waxing and waning popularity.

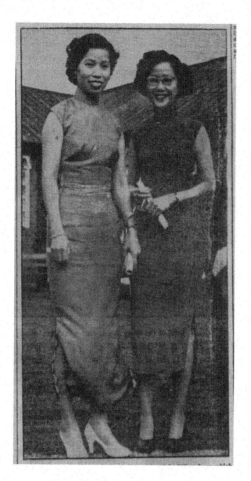

Figure 2.6 A photograph of two Singapore nurses highlighting their form-fitting dresses, with high collars and side slits, 1955 (Image: *Daily Graphic* archive).

India was not the only Asian country that inspired new modes of dressing in Accra; a photograph of two women (Figure 2.6), described as Singapore nurses, was published as part of the 1955 article "Travel Goods Change Fashion." While the article focused on the latest trends in luggage, the photograph's caption drew attention to the women's style of dressing, stating: "A new look in fashion for our women is the tight fitting dress which brings out body features. The upright collar and the gash in the side down to the hemp [sp] add a striking attraction."[34] Both women's dresses were variations on the qipao or cheongsam, an iconic form of Chinese fashion worn throughout Eastern Asia, primarily in the regions of China, Hong Kong, Singapore and Taiwan. The garment's hallmark features were its form-fitting silhouette, side slits of varying lengths and high, rounded collar, all features emphasized by the *Sunday Mirror*. The

following year, flight attendants for the BOAC Far Eastern Air Services were highlighted as wearing the "Oriental Style," with the *Sunday Mirror* further describing their uniforms as reflecting Chinese fashion.[35] The garments were again similar to the qipao, with a high, rounded collar and side slashes in the skirt, although the garments were not nearly as form-fitting.

The influence of the qipao went undocumented until 1958, when the front page of the *Sunday Mirror* announced "The Eastern Look," accompanied by a full-page photograph of two Ghanaian women wearing variations of this iconic form of East Asian dress (Figure 2.7).

The women's ensembles were similar to the kaba, with noticeable and important adaptations that were identified as hallmarks of the qipao, namely a high collar and form-fitting silhouette. These features were emphasized

Figure 2.7 Two Ghanaian women wearing the qipao-inspired "Eastern Look," 1958 (Image: *Daily Graphic* archive).

by the unnamed author, who stated: "these two Accra girls look very smart, a high neck on the cover-shoulder ... with little or no emphasis on the bust, tight wearing of the lower cloth which gives a 'trouser effect'."[36] The garments were sewn from "a silky and shining material with large floral designs," which suggests the garments were potentially sewn from imported Chinese silk.[37] The author summarized the ensembles as follows: "they take your mind to China and other Eastern countries, but are still essentially Ghanaian."[38] This assertion is particularly potent, as the writer is indirectly acknowledging the essence of Accra's international fashions. These two ensembles marry the kaba with features that evoke the East Asian qipao, illustrating how international fashions often function as a fusion of sartorial styles, while maintaining a degree of foreignness. Although the author asserts these ensembles are "still essentially Ghanaian," their inclusion of unusual fabric and the author's own emphasis on their Chinese and Asian associations suggest that the "Eastern Look" would have been considered an unusual and exotic fashion novelty – the ultimate expression of Accra's sphere of international fashions.

Much later, in a 1964 feature on "Tops of the Fashion," an East Asian style is again emphasized, this time described as "the latest commodity Ghanaian fashionistas have imported from the Orient – the 'slit.' And no wonder it's top of local fashion."[39] The corresponding photograph showed a Ghanaian woman wearing a kaba ensemble without the aforementioned hallmarks of the "Eastern Look"; it did not include a rounded, high collar nor a form-fitting bodice and skirt. What was emphasized, particularly through the young woman's pose, was the skirt's high side slit. It was this slit the newspaper acknowledged as the sartorial innovation, stating: "Doesn't she cut quite an electrifying picture, lending the traditional 'kaba with the slit?'"[40] In this instance, a high slit in a tailored skirt was directly associated with dressing in an East Asian style, suggesting that the understanding of sartorial subcategories was constantly revised and adapted. This amendment may seem inconsequential, but it nuances the scholarly interpretation of the contemporary phrase "kaba and slit," which colloquially refers to the kaba ensemble. The phrase "slit" may refer not only to a tailored skirt, but also to the inclusion of a literal slit, which was directly informed by the East Asian qipao or cheongsam. This acknowledgment suggests that the contemporary kaba may be a fusion of local, European and Asian forms of dressing, further complicating the kaba ensemble's sartorial origins and its associated terminologies.

Neighboring African countries played an equally instrumental role in the sphere of international fashions. One of the earliest examples of an inter-African exchange of fashion is from 1955: in a column titled "For the Light-Hearted" a *Sunday Mirror* contributor simply identified as "Gussie" reported that

> last Saturday was a day of fashions. A large consignment of visitors from Nigeria came to Accra for one of the biggest inter-tribal marriages of

recent times ... what was significant about the function was the lavishly dressed women from Nigeria who wore their native dress.[41]

A small photograph was included of two unidentified, Nigerian women who wore layers of wrapped textiles, paired with equally extravagant gele headwraps. A similar acknowledgment of contrasting African dress styles is the 1956 *Sunday Mirror* feature "Gambian Women Take Over This Page." As the unknown author explained:

> today, with the aid of these three pictures published here, the "Sunday Mirror" has taken you far away from your home ... to Gambia, from where the "Mirror" has collected these pictures showing the types of dresses and fashions Gambian women like and use.[42]

Although these examples suggest that Ghanaians were exposed to West African ways of dressing, they do not demonstrate that Ghanaian women were actively adopting them. This is illustrated by the 1959 *Sunday Mirror* feature "Comfort Goes the Senegal Way ...". The brief article highlights Comfort Briamah's fashionable ensemble (Figure 2.8), which the *Sunday Mirror* asserted "was the centre of attraction at the races during the Christmas holiday."[43] It was Comfort's wrapped hairstyle and wax print dress with ruffled sleeves that were identified as distinctly Senegalese, illustrating that fashions from other African nations were just as influential as their Asian counterparts.

A later, but equally important, example was documented in a 1962 issue of *Drum: Ghana*. Regular fashion contributor Beryl Karikari observed that Nigerian Aduke Watkinson, florist at the chic Ambassador Hotel, wore a Nigerian man's hat to a cocktail party. As she recounted:

> It look fabulous, and I wondered why no one had thought of it before. Needless to say, the hat caused quite a stir, among both the ladies and men. My friend Houda even asked Aduke to get one for her to wear to a wedding.[44]

Based on the accompanying photograph, the hat was likely of Yoruba or Hausa origin, as it was of a short, conical style with extensive embroidery; historically, these hats are associated with men's prestige and chieftaincy, so Watkinson's sartorial experimentation would have certainly made a potent statement. Reflecting on the growing importance of African fashions, Watkinson stated: "We can even borrow from the men ... there are great possibilities for adapting the N.T. Smock, instance."[45] N.T. likely stands for "Northern Territories," implying that Watkinson was suggesting that the batakari smock should be adapted for women's wear, an idea that would be realized by subsequent Ghanaian fashion designers. In addition to providing further evidence of the existence and relevance of international fashions in

Figure 2.8 Comfort Brimah's Senegalese style of dressing, 1959 (Image: *Daily Graphic* archive).

Accra, Aduke and her hat illustrate two additional, relevant details regarding Accra's sphere of international fashion, and the city's overarching fashion culture: that a variety of Africans from throughout the region were traveling, living and working in Accra, bringing with them their own fashions and sartorial preferences; and that women were interested and actively engaged in reimagining men's forms of dress as a means for asserting their own fashionable identities. Aduke's hat suggests that the active borrowing of men's prestige attire was occurring much earlier than previously acknowledged in existing scholarship and that in spite of actively challenging men's prestige and status, these sorts of sartorial experiments were ultimately permitted, and subsequently encouraged by women.

These forms of imported and culturally influenced fashions, specifically the sari and qipao-inspired ensembles, serve as irrefutable evidence of the dynamism and expansiveness of Accra's sphere of international fashions. These malleable forms of dress indicate that a formative South–South exchange system was firmly established in pre-Independence Accra, one that allowed the active exchange of both sartorial ideas and materials. British colonialism may have indirectly contributed to this exchange, as India, Singapore, Hong Kong, Gambia, Nigeria and Ghana were all British colonies; however, this acknowledgment does not negate the willingness of Accra's women to embrace and experiment with dress styles perceived as foreign. On the contrary, it speaks to the progressive nature of Ghanaian women and their sartorial openness. By adopting a diverse range of international fashions, Accra's women were able to invoke a degree of worldliness that was similar to adopting European fashions, but that was inherently more accessible, as it did not require actual travel, nor extensive wealth, to engage with.

Local fashions

The remaining fashion sphere of pre-Independence Accra was comprised of specifically local fashions. The core garments of this sphere are difficult to define, as they are often based on the forms and silhouettes of world, European and international fashions, adapted and reworked to reflect particularly local tastes and preferences. In spite of their hybridized influences, their physical manifestations remain wholly unique, implying that these forms of fashion are distinct to Ghana, and specifically Accra.

An important subcategory of local fashions are textiles and garments deemed forms of Ghanaian traditional dress, thereby constituting a local form of sartorial expression. Many of these forms are the product of continual adaptations and fusions; however, due to their historical longevity, their potential foreign origins are superseded by their enduring associations with Ghanaian cultural heritage and identity. This subcategory of local fashions includes a variety of dress forms and materials, such as kente cloth, batakari smocks and even wax print. The most iconic form of women's local dress is unquestionably the kaba, a reworking of a European silhouette, blended with historical forms of Ghanaian dress, that resulted in an ensemble that is completely local in its expression. It is important to include these forms of dress as part of Accra's local fashions, as scholars often divorce them from the realm of fashionable attire, thereby denying the revisions and adaptations that frequently occur to garments and dress styles that are subject to changing tastes and preferences.

The majority of pre-Independence local fashions documented by the *Sunday Mirror* reflect the aforementioned "core" garments of local fashions: manipulations of forms and silhouettes from existing fashion spheres that are so thoroughly unique, they indicate a decidedly local expression. A key element of these fashions is that they are given a name, part of a process defined by Eicher and Erekosima

as cultural authentication.[46] Through the simple relabeling of a form of dress, it becomes a localized expression and gains both meaning and relevance for a given community. This process of naming as a means of localizing forms of dress was documented by the *Sunday Mirror* fashion columnist Edith Wuver, who simultaneously provided an overview of the diversity of local fashions that were popular in 1955 and earlier. Wuver begins by questioning the necessity of naming fashionable silhouettes, suggesting that it provides men with another reason to criticize Ghanaian women and their predilection for fashion. She queries:

> How came the style "Opera" for instance, to have such a name? Was the lovely "round-neck" named after the whole Opera Cinema building or just the balcony within? Sounds like our stylists could not find a name unconnected with a cinema.[47]

Wuver then continues, acknowledging that former named styles included "Queen Elizabeth," a style of dress inspired by the queen's coronation gown; "gbe toi," a Ga phrase meaning "dog's ear," given to a sleeve that resembled the shape of a dog's ear; and "Hitler toi," or "Hitler's ear," an undescribed style of sleeve that did not resemble Hitler, but instead encapsulated Ghanaian women's frustration with the Second World War.[48] As Wuver described:

> What else could we do? All our men were gone to war, we were desperate and full of revenge but helpless. We therefore had to do the only thing as became us women. Call of our enemy, names – make styles of his name if we could. So we manufactured another one, "Hitler's tongue," the front of the blouse.[49]

This suite of named garments and silhouettes evince how local fashions were able to respond directly to significant moments and events, demonstrating the interconnectedness and active involvement of Ghanaians in global history. These local fashions serve as additional documentation that Accra's fashion culture is even older than what is literally illustrated in the *Sunday Mirror*; women were creating unusual, named silhouettes as early as the 1940s! It further indicates the power of fashion and how, locally, it can serve as a means for catharsis, in the case of the Hitler-named garments, or celebration and emulation, as with the Queen Elizabeth style of dress.

The most unusual and compelling example of a distinctly local, named fashion is the "Jaguar" (Figure 2.9). The origins and significance of its name remain mysterious; as Wuver reflected in 1955: "'Jaguar' for instance, was first heard of as the commercial name for a car. How it later came to be the name of an 'off shoulder' style is difficult to understand."[50] It is entirely possible that the prestige and luxury of owning a Jaguar automobile was being channeled through this particularly flamboyant ensemble; however, its importance lies not its name, but in its careful documentation, illustrating how quickly these local forms of fashion were celebrated and subsequently rejected.

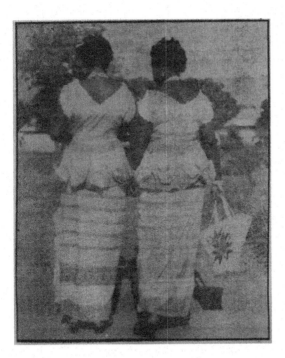

Figure 2.9 A back view of the "Jaguar," an expressive and controversial variation on the kaba ensemble, 1953 (Image: *Daily Graphic* archive).

The ensemble premiered on the front page of the *Sunday Mirror* in 1953 with the following announcement:

> a NEW style in women's dress called "Jaguar" has been introduced in Accra. Seen in the picture are two intimate friends ... introducing the new style which is likely to be the craze in Accra. As Christmas approaches, this new style is opportune.[51]

The accompanying photograph included two women wearing matching ensembles, consisting of a wrapped skirt and a particularly extravagant blouse. The form-fitting blouse featured a complicated, scalloped V-neckline on both the front and back. The most noteworthy element of the blouse was its peplum, festooned with what appear to be either rosettes or large gathers or ruffles of fabric, creating a dynamic and exuberant silhouette. A back view of the garment was provided on a later page, likely to aid in the copying of this latest style by individual women's seamstresses. Its stylishness was again reiterated with the following caption: "the new style has been hailed with every manifestation of delight by women of society and fashion in Accra."[52] This initial reportage made it resoundingly clear: the "Jaguar" had arrived.

In less than two years, the "Jaguar" was dethroned as the latest local fashion, indicating the fast-paced nature of this fashion sphere. In the same article on Accra's oddly named local fashions, Wuver acknowledges that the "Jaguar," which "set the fashion tongues wagging ... is being superseded by the 'Opera 4.15' which is an open neck 'cover-shoulder'."[53] Four months later, an unknown author launched a vitriolic attack against the "Jaguar." This brief editorial indicates a drastic shift in opinion regarding the "Jaguar," one that supports Wuver's assertion that it was no longer *en vogue*. The criticisms are so severe and the language so acerbic, that the editorial is worth quoting in its entirety:

> the "Jaguar" a new fashion garment which is rapidly becoming popular with our women, is of an ugly and objectionably looking design. It is not designed in conformity with any acceptable theory with regard to warmth, modesty or elegance. Worse still, it affords very little opportunity for variety and at once gives a very bad impression about the women who wear it. There has been a remarkable deterioration in the dress of our women. Consequently, brightness, variety and tasteful combination of colour have vanished from the life of our womenfolk. Taste and prejudice in dress are admittedly matters of tradition and custom. Now that women are taking their place in our society, it is time they started dressing themselves decently.[54]

It was likely the "Jaguar"'s flamboyant embellishments, the feature that originally made it so innovative and noteworthy, that ultimately led to its sartorial demise. Although the "Jaguar" was unable to survive its public predation by fashion columnists, it remains one of the earliest documented examples of the celebration, and subsequent rejection, of a specifically local form of fashion. It further demonstrates that, in spite of the hybridized nature of local fashions, their physical expressions were so thoroughly unique, that they were likely limited to the confines of the country, and potentially the capital.

There is an additional aspect of the "Jaguar" that adds potential nuance to the existing scholarship on Ghanaian dress: it is possible that the "Jaguar" was a variation on the kaba ensemble, the most iconic form of women's local fashions. As a hybrid form of fashion, the kaba ensemble was the direct result of exchanges and interactions between Ghanaian coastal women and European missionaries and merchants.[55] Originating in the eighteenth century, the ensemble blended the local form of a waist-wrapped textile with a sewn, European blouse. At some point in its history, likely following the introduction of wax print in the late nineteenth century, the kaba ensemble began to include an additional swath of fabric that functioned as a second wrapper or shawl. The kaba ensemble's precolonial origins belie its European influences; it became synonymous with Ghanaian traditional dress, and thus a distinctly local form of fashion. In a contemporary context, the kaba maintains its potency and associations with Ghanaian tradition; as one Ghanaian woman expressed to art historian Suzanne Gott: "kaba is our national custom. It's our real Ghanaian dress."[56]

While the kaba ensemble's three essential components – a sewn blouse, a wrapped or tailored skirt, and a second wrapper – have remained remarkably consistent, each element is inherently malleable, easily adapted in style or material to reflect changing tastes in fashion as an indirect means of ensuring the ensemble's sartorial relevance. In its entirety, the kaba ensemble has been equally susceptible to the changing tastes and preferences of Ghana's women, particularly in Accra. It is generally accepted that, by the early twentieth century, the kaba had fallen out of favor as a form of fashionable attire, particularly among Ghana's elite, educated women. As scholars have established, the kaba ensemble, particularly when formed from locally produced textiles or wax print, become associated with undereducated or illiterate women, who were pejoratively referred to as "cloth women."[57] While there is significant evidence to support this assertion, what remains unacknowledged is the limited scope of this opinion. Elite, formally educated, Ghanaians comprised a small portion of the country's population; while they may have found the kaba ensemble unfashionable, there was a large segment of the population that delighted in wearing and revising the kaba. Although the "Jaguar" is not defined as a kaba ensemble, it does include the iconic blouse and wrapped skirt, suggesting that it may have been a fashionable variation on this particularly meaningful, historically rooted form. There are additional photographs in the *Sunday Mirror* that show women wearing similar ensembles, from a variety of materials and with a range of unusual details, suggesting that, potentially, the kaba maintained its popularity as a local form of fashion for a majority of Accra's population.

There were additional local fashions that remained completely unnamed, but were equally original in their expression. In the aforementioned 1955 column by Edith Wuver, she observed:

> Presently the fashion in Accra is nylon blouse with pink brassiere showing through its transparency … at the moment it looks as if the law has been passed down upon us, girls in Accra, to wear nylon blouses by force. Whether in the native or Western attire, no matter what the "bottom" may be, the "top" must be nylon with all sorts of straps showing through.[58]

Wuver lamented the popularity of this unusual trend, stating: "the whole show looks more like a sort of uniform than fashion."[59]

While nylon blouses may have been a globally popular form of world fashion during the mid-1950s, pairing these transparent tops with a pink bra, a bold sartorial statement that would emphasize the wearer's physique, seems a rather unique variation on a global trend that was likely exclusive to Accra. Wuver's account of the ensemble's prevalence, coupled with her description of a woman wearing the ensemble while waiting for a bus, suggests that it was a more egalitarian and accessible fashion trend. Although there are other examples of variations on established forms of fashion that indicate decidedly local fashions, such as the "white forearm band" in 1955, the "nylon blouse craze" is the only

one that appears to have been adopted by a wider swath of Accra's population. Most importantly, Wuver indicated that this translucent trend could be either "Western" or "native" in form, suggesting that local fashions often constituted adaptations of materials or silhouettes from Accra's existing fashion spheres, as long as these sartorial departures were distinct to the capital.

Taken in their entirety, the complex and overlapping constellation of Accra's four spheres of fashion indicates that, prior to Independence, Ghanaian women sought a variety of sartorial means to indicate their active production and participation in a fashion culture. These myriad forms of fashion were harnessed by Ghanaian women to evoke a decidedly cosmopolitan identity, the crux of which is engagement and interaction. Ghanaian women's deft navigation and performance of these complicated spheres serve as testaments to their continued historical enactment of the values of cosmopolitanism, through the vehicle of fashion and in the capital of Accra. With Ghana's Independence imminent, Ghanaians desired to make a drastic sartorial shift: one that would promote a collective, nationalist Ghanaian identity, while maintaining consistent cosmopolitan identities. The result was a blending of the two, a potent new sphere of fashion that has subsequently influenced the majority of Ghana's fashion designers: the sphere of cosmopolitan, nationalist fashions.

"Fashion with the African Personality is in Full Bloom": Accra's nationalist, cosmopolitan fashions[60]

On March 6, 1957, Nkrumah announced the independence of Ghana from British colonial rule. After proclaiming "And thus Ghana, your beloved country is free forever," he charged Ghana's newly independent citizens with the following decree:

> from now on, today, we must change our attitudes and minds. We must realize that from now on we are no longer a colonial, but free and independent people ... We are going to demonstrate to the world, to the other nations, young as we are, that we are prepared to lay our foundation ... we are going to see that we create our own African personality and identity.[61]

The notion of the "African personality" became critically important to Nkrumah's philosophies and political polices. It was a concept that was equally referenced by several interviewees, including Letitia Obeng and Kathleen Ayensu. Ayensu characterized the Independence era as "the height of the promotion of the African personality"; Obeng shared a similar sentiment, stating that the Independence era was "the time when the idea of the African Personality was booming."[62] Although the concept of an "African personality" was routinely referenced by Nkrumah, to the point that it was internalized by women like Obeng and Ayensu, Nkrumah's actual thoughts on the "African personality" were ambiguous.

In his speech marking the inauguration of the Hall of Trade Unions in Accra on October 17, 1959, Nkrumah proclaimed: "To-day there is a new African in the world, a proud African, free and independent, who is determined, despite all obstacles, to assert his personality within the community of the world."[63] Nkrumah continually referenced the importance of the "African personality," while remaining vague regarding its particulars. Regardless of the indeterminate nature of his conception, the notion of an "African personality" was particularly potent during the Independence era, fueling Nkrumah's thoughts and actual policies as he worked to build Ghana as a shining example of African independence. It is this construction of the "African personality," coupled with the general excitement and pride expressed in the country's citizens, that led to the introduction of a new sphere of cosmopolitan, nationalist fashions.

As explained by historian George P. Hagan, the "African personality" primarily functioned as a means for Nkrumah to examine policy strategies for Africa and as an attempt to promote and preserve a unified African heritage; this was in direct contrast to the plurality of African heritages that existed on the continent, and in his own country. As Hagan acknowledged:

> the reality he was dealing with was a nation which would not hang together because of ethnic differences. And so long as Ghana would not unite, so long would his own foothold remain weak and uncertain and the quest for African Unity more precarious.[64]

It was paramount to Nkrumah's philosophical and political success that Ghana's heterogenous people could, at least superficially, unite. If this lofty goal could be achieved, then a unified Pan-African continent was well within reach. This was ultimately Nkrumah's goal; as expressed in the preface of *I Speak of Freedom*, he wrote:

> the essential fact remains that we are all Africans, and have a common interest in the Independence of Africa. The difficulties presented by questions of language, culture and different political systems are not insuperable. If the need for political union is agreed by us all, then the will to create it is born; where there's a will there's a way.[65]

Almost immediately, Nkrumah began promoting the notion of a collective Ghanaian populace, with a shared, national identity. In his 1959 speech celebrating the tenth anniversary of the founding of the Convention People's Party (C.P.P), Nkrumah remarked:

> That is why we insist that in Ghana in the higher reaches of our national life, there should be no references to Fantis, Ashantis, Ewes, Gas, Dagombas, "strangers," and so forth, but that we should call ourselves Ghanaians – all brothers and sisters, members of the same community – the state of Ghana.[66]

One particularly potent means for achieving this unification was through the promotion of specific dress forms as indicators of a consolidated Ghanaian populace. Nkrumah understood the power of dress and actively employed it as a means for conveying specific ideologies and values. As acknowledged by art historian Janet Hess, Nkrumah viewed dress and the body as "an important site for ideological expression."[67] She provides the example of Nkrumah's official portrait, which depicted the leader wearing a European-style shirt that subtly signaled his socialist leanings, while swathed in kente, a symbol of Asante leadership and chieftaincy. Nkrumah's active promotion of specific dress forms is supported by feature articles from *Drum: Ghana*, which focused on members of his inaugural government. In a 1959 article dedicated to the life and career of Kojo Botsio, he and his wife are pictured wearing matching kente ensembles (his wrapped, hers tailored into a kaba), while in another photograph, his son and daughter are shown in miniature versions of wrapped kente and kaba ensembles.[68] This example supports the primacy of dress to Nkrumah as one of several means for promoting his conception of a collective Ghanaian identity. The photographs illustrate that Nkrumah expected the members of his nascent government to dress in fashions that reflected his perspective, creating a pervasive sartorial representation of his conceptualized nation.

While Nkrumah powerfully utilized the dressed body, both his own and those of members of his government, to create a narrowly defined image of Ghanaian identity, the populace of Accra was simultaneously searching for ways to celebrate their cultural heritage and newly won independence through modified forms of dress. This energy and desire are encapsulated by the words of scientist and sartorial contributor Letitia Obeng, who reflected:

> During the Independence period, everyone was proud to be dressed in cloth ... the feeling was that everyone was excited and that we were going to be Independent. Being independent was different from being British, and how much different can you be, if not by from the way you look.[69]

Returning to the sartorial challenge issued by Augustus Bruce, it predicated this collective desire for new fashions that drew upon global influences and styles, while maintaining culturally significant materials and dress practices. This is supported by Hagan, who asserted: "In the issue of clothing, the nationalist movement played out its cultural dilemmas in a medium the people could understand."[70] As Hagan acknowledged, Ghanaians were part of a world culture, "thus while he had to find a way of expressing his distinct identity, he could not reject any aspect of world culture that was beneficial in terms of progress and development."[71] Hagan posits that "African dress had to live side by side with the European dress," but as this chapter has demonstrated, local Ghanaian fashions had already existed simultaneously with European fashions.[72] What actually changed was a fusion of these two spheres: the melding of European

and global fashions with decidedly local fashions, resulting in garments that encapsulated Ghanaian heritage and identity, while asserting a knowledge and awareness of globally informed fashion. In their physical form, these fashions were typically a blend of locally meaningful materials, such as wax print, with European or world silhouettes. Through this new sphere of cosmopolitan, nationalist fashions, Ghanaians were able to express their cultural heritage, which in turn mirrored Nkrumah's own philosophies, resulting in fashions that reflected a unified, Ghanaian identity, while simultaneously asserting their belonging to a global community.

Drum: Ghana fashion contributor Beryl Karikari provided a comprehensive and astute assessment of the sartorial revisions that resulted from Ghana's Independence in her article "The Africa Line." As an introduction, Karikari penned the following subheading: "Our mothers chose the cloths. Our young women provide the fashion ideas. The result: the exciting Africa Line."[73] Karikari's concise quote speaks volumes, as it encapsulates the enduring, cyclical revisions of meaningful textiles and forms of dress by Accra's fashion-conscious women that continue to be expressed through Accra's contemporary fashions. Karikari frames these initial sartorial innovations as expressions of nationalism, stating: "the women of Africa are attracting a new interest from women of foreign countries through their new and refreshing ways of wearing their national attire."[74] She continued by providing a brief summation of this period of fashion revisions and what, stylistically, was emphasized: "the last several years have seen more welcome changes come over our native dress, and mostly they have been for the better. The emphasis has been on comfort, elegance and local fashion."[75] Although her article acknowledged that fashion revolutions were occurring in Ghana and Nigeria, she asserted that "the revolution was born in Ghana and still is commanded from Ghana."[76] Ultimately, she concludes her summation with the following assertion: "Now, the current 'Lines' are born at home, and fashion with the African personality is in full bloom. And incidentally, never have the women looked more elegant."[77]

Karikari's employment of the "African personality" to characterize the sartorial revisions resulting from Ghana's Independence provides additional evidence that Nkrumah's promotion of the "African personality," however vague and undetermined, was lasting and highly influential. When coupled with the reflections of Obeng and Ayensu, Karikari's use of the "African personality" provides a better understanding of how Ghanaians internalized the concept, particularly in relation to fashion. Based on her descriptions and her subsequent interviews with influential designers and dressmakers (who incidentally include Laura Quartey and Juliana Kweifio-Okai), fashions imbued with the "African personality," which she also defined as the "Africa Line," were garments that reflected a national identity, particularly through the use of local materials and silhouettes. This is reflected in her interview with dressmaker Laura Quartey, who recounted that Ghanaians traveling abroad would arrive with "arm-loads

of wax prints" as material for fashionable garments, to "represent Ghana abroad as elegantly as possible."[78]

The physical alteration, and what made these Independence-era fashions revolutionary, is that they were literally and ideologically imbued with global approaches to design, encapsulating the wearer's cosmopolitan identity; this is initially indicated by Karikari's description of the "Africa Line" blending local fashions with comfort and elegance, characteristics often aligned with global fashions. In her interview with Juliana Kweifio-Okai, the designer acknowledged that her customers are asking for "cloth," a moniker for wax print and other local textiles, executed in "more creative styles," which were often informed by the global fashion system.[79] Kweifio-Okai's reflections indicate exactly how these fashions were fused; in regards to the latest, global trends, she stated: "the sack and the shift are still 'in', and quite frankly, are very suitable for our climate over here."[80] The implication is that designers like Kweifio-Okai were utilizing local textiles and materials to create globally informed fashions, such as a sack dress sewn from wax print or kente cloth. These garments, which actively blended local materials with global silhouettes and tailoring, resulted in the creation of cosmopolitan, nationalist fashions. This fusion is referenced more directly by an unknown *Sunday Mirror* contributor who, commenting on the latest Independence-era fashions, stated: "But all will not be the indigenous styles we are accustomed to. Now, it will be the traditional material with Western touch."[81] With the advent of this revolutionary fashion sphere, Ghanaians no longer had to navigate multiple fashion spheres to demonstrate their worldliness and belonging to a global fashion system; Accra's new, hybrid fashions encapsulated cosmopolitan values in a more immediate and visually understandable way, while actively promoting a distinctly Ghanaian identity and heritage. It should not be surprising then, that cosmopolitan, nationalist fashions, what Karikari defined as "the Africa Line," became a stalwart of Accra's fashion culture and the main focus of Ghana's fashion designers.

Although a variety of materials were employed to create cosmopolitan, nationalist fashions, including the easily adapted wax print and tie and dye fabrics, the earliest and most important material was kente cloth. The acknowledgment that kente was used as a material for fashions, as opposed to being exclusively employed as a textile for wrapping the body, is of critical importance. It refutes established scholarship and Ghanaian mythologies that kente was never cut, as it was far too valuable, economically and culturally, to be defiled by a pair of scissors. As extensive written and photographic evidence from the *Sunday Mirror* and *Drum: Ghana* illustrates, almost immediately following Independence, Ghanaians began to drastically alter this particularly meaningful textile to create globally informed fashions that celebrated a distinct, albeit constructed, Ghanaian identity. The result was one of the most immediately recognizable and potent expressions of cosmopolitan, nationalist fashions. This drastic revision of kente was more than a revolution, it was a reformation.

"… Something which is Essentially Ghanaian"[82]: cosmopolitan, nationalist fashions and the kente reformation

In an article addressing the "enthralling story of kente," *Drum: Ghana* author Morre Bossman makes a powerful claim, one that challenges much of academia's assumptions regarding kente cloth, particularly its characterization as a sacrosanct, inalterable textile. After acknowledging kente as a "symbol of the Ghanaian personality, and of Ghanaian culture," Bossman observes: "the remarkable thing is that, while this is very true, the kente has still managed never to become fossilized – a mere museum piece to be displayed only in a case and admired as a relic of tradition."[83] Bossman's perspective is indicative of how Ghanaians viewed kente during the Independence era: as a deeply meaningful form of dress, imbued with cultural heritage and identity, that was inherently adaptable. His characterization of kente resisting fossilization is particularly potent, as this description implies that kente was never meant to be rigid in its design and form; instead, it was both literally and metaphorically malleable. Bossman's words further suggest that forms of Ghanaian traditional dress, epitomized by kente, were equally mutable and adaptable.

Bossman's observations provide a potent basis for understanding the adaptations and revisions of kente cloth that occurred almost immediately following Ghana's Independence, transforming the textile into the earliest material expression of cosmopolitan, nationalist fashions. The proliferation of kente fashions during the Independence era resulted in what I characterize as a kente reformation. I have chosen reformation, as opposed to revolution, as revolution often implies a drastic, potentially violent upending of an established practice or system. Reformation, on the other hand, suggests a more positive change or improvement of an existing practice. Taken literally, it indicates that a reform has taken place, that an object or an institution is modified for its own benefit. During the Independence era, this is what kente experienced: the material itself was not challenged, nor was the technology or its production drastically amended. Through the act of cutting and tailoring, kente was literally reformed, maintaining the textile's allusions to Ghanaian identity and heritage, while becoming more wearable, through its fusion with global forms of dress. It therefore serves as the earliest and most potent example of cosmopolitan, nationalist fashions.

It must be acknowledged that the predominant, more conservative method for women to wear kente was as a wrapper around the waist, paired with a blouse that typically reflected the prevailing global fashions of the time (Figure 2.10). This form of dressing was actively documented and promoted by the *Sunday Mirror*, as evidenced by the article "Fashion Through the Day," which included a photograph of a Ghanaian woman dressed in formal attire: a tailored blouse, a kente wrapped elaborately around her waist, and a pair of elegant gloves. The image was captioned "for a wedding" and informed women that "there are occasions – like a wedding party – when you have to adorn yourself like the girl in kente cloth."[84] This article appeared *after* kente's first-documented,

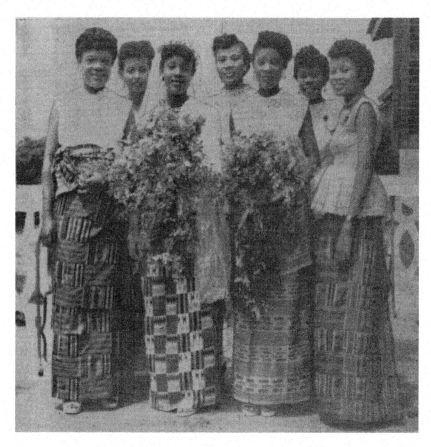

Figure 2.10 The wedding party of Miss Belinda Abloh, illustrating the archetypal mode
for women to wear wrapped kente, 1957 (Image: *Daily Graphic* archive).

tailored innovation, illustrating that this form of dress remained popular, and
likely more accessible to a broader range of Ghanaian women, as it required
the acquisition of a single kente cloth. This ensemble was inherently more
adaptable, as a wrapped kente cloth could be worn with an array of blouses,
thereby adding variety to a woman's wardrobe. Due to their visual and phys-
ical similarities to the kaba, these ensembles, with their blending of globally
inspired blouses with a kente cloth wrapper, would undoubtedly have been
considered part of the sphere of local fashions. Acknowledging the prevalent
mode for wearing kente, particularly during the Independence era, suggests
that the women who initiated and participated in the kente reformation
were likely of elite status, as they would have had the economic means to
experiment with kente as a material for fashion, and the social status to enact
and perform these potentially controversial sartorial revisions.

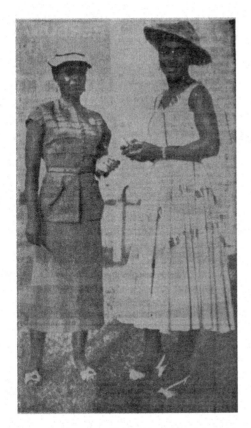

Figure 2.11 Alice Ababio's innovative, tailored kente dress, photographed at the Accra Races, 1958 (Image: *Daily Graphic* archive).

The earliest evidence of the kente reformation dates to March 16, 1958. The *Sunday Mirror* published photographs and descriptions of two distinct, tailored kente ensembles, irrefutably illustrating that kente cloth was actively cut and reformed into fashionable garments, specifically for women. The most innovative of the two garments was worn by Mrs. Alice Ababio on the occasion of the Accra Races, one of the city's most important events for sartorial display and experimentation (Figure 2.11).

Headlined "A New Role for Kente," the featured photograph included Ababio posing next to Evelyn Nunoo; the corresponding caption described Ababio's ensemble as a "flared afternoon dress with the skirt and the V neckline trimmed with strips of kente."[85] What makes this dress so remarkable, in addition to its early date, is its physical form. The full skirt of the dress, fashioned from an unidentifiable, likely imported material, is disrupted by strips of diagonally oriented kente cloth. The strips appear surprisingly narrow; this could be the result of a weaver who intentionally created narrow strips, but it could also indicate that full strips of

kente were cut in half in order to create these eye-catching embellishments. The actual cutting and manipulating of kente is supported by the garment's notched kente collar, which could only be achieved by cutting a strip of kente or a full kente cloth. By announcing "new role for kente," followed by "a new slant on women's fashions," the *Sunday Mirror* celebrated Ababio's sartorial experimentation, demonstrating that her revision of kente cloth was not viewed as a destructive act, but rather one of innovation.[86] As the first documented Ghanaian woman to wear a garment including cut and tailored kente, Ababio sets a particularly bold precedent for subsequent kente fashions and unknowingly introduces the incipient sphere of cosmopolitan, nationalist fashions.

In the same issue, a brief article titled "Kente Appeal Does the Trick" was published, accompanied by a photograph of two women wearing kente ensembles. The novelty of this photograph is that one of the women was British, the other Ghanaian. This distinction was emphasized by the article's subheading: "Anne goes the Ghana way."[87] The article explained that Mrs. Anne Rado, the wife of an Economics lecturer at University College, decided to "dress the Ghanaian way" at an Independence party.[88] The author documented that Rado's ensemble was sewn from "a costly type of kente called ADWIN ASA, meaning, 'end of ideas'," which remains one of the most time-consuming and admired forms of Asante kente cloth.[89] Although it is entirely possible that Rado's kente ensemble, which is stylistically similar to the kaba, may have been elaborately folded, it is more likely, particularly due to its form-fitting bodice and unusual neckline, that her kente ensemble was actually cut and sewn. Her fashionable attire is mirrored by her companion Juliana Lawson, who also wore an elaborate ensemble entirely from kente. This points to a previously unacknowledged detail regarding the kente reformation: that expatriates, with their inherent, cultural detachment from kente cloth, may have played an active role in reconceptualizing kente as a material, as opposed to a finite form of Ghanaian traditional dress.

In support of the instrumental role of expatriates in the kente reformation is a short-lived fashion column penned by Eileen Crilly. Aptly titled "Meet the Queen," Crilly's column was intended to provide Ghanaian women "with some bright ideas of how to put a kick into fashion in Ghana," all in preparation for the Queen of England's future visit.[90] Unlike many *Sunday Mirror* contributors, Crilly was an expatriate, described previously by the *Sunday Mirror* as an "Irish housewife ... with years of experience as a fabric and dressmaker overseas."[91] For several weeks in 1959, Crilly offered a variety of sartorial suggestions, ranging from a striped taffeta evening gown to a cotton skirt in a bright, harlequin pattern; the majority of her ideas were articulated through beautifully rendered illustrations. For one of her final columns, Crilly addressed "Wearing Cloth While Aboard." One of her suggestions was as follows:

> If you want to be really extravagant, have an evening coat made in kente
> cloth, and line it in grosgrain ... it will certainly create a sensation in

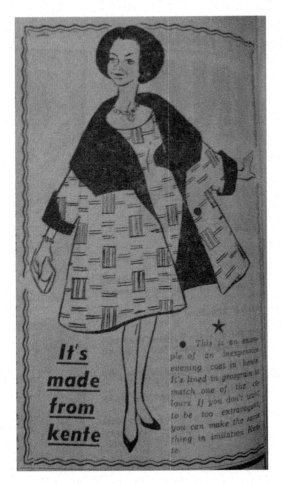

It's
made
from
kente

★

This is an exam-
ple of an inexpensive
evening coat in kente.
It's lined in grosgrain to
match one of the co-
lours. If you don't want
to be too extravagant
you can make the same
thing in imitation Ken-
te.

Figure 2.12 Ellen Crilly's illustration of a kente evening coat with matching sheath
dress, 1959 (Image: *Daily Graphic* archive).

London, Paris, Rome or New York! Wear it over a sheath dress of matching
kente. If your purse won't stretch to real kente then you can make the same
thing almost as effectively in imitation kente.[92]

An illustration of Crilly's luxurious proposal was included, with the heading
"It's made from kente" (Figure 2.12).[93]

Crilly's imagined ensemble, when paired with Rado's finished one, suggests
that although Ghanaians were active participants, and likely the initiators of
the kente reformation, expatriates played their own role, by encouraging and
wearing tailored kente ensembles. As an integral part of Accra's elite society,

their contributions should not be ignored; their existence and engagement with Accra's existing forms of fashion further demonstrate the inherently cosmopolitan qualities of Accra as a capital, and of its citizens.

By the early 1960s, the kente reformation appeared to be reaching a zenith, as the pages of the *Sunday Mirror* and *Drum: Ghana* were awash with images of tailored kente fashions and accessories. These included: Esther Sarkodee-Adoo, wearing a sleeveless kente dress with wide straps to a gala (1959); the evening gown worn by Miss Ghana 1960 Comfort Kwamena, which featured a satin bodice with off-shoulder, kente sleeves, along with a kente skirt; a pair of women wearing kente ensembles, complete with matching hats, to the society wedding of Felicia Otoo and J.C. Ashley (1962); the kente ensemble worn by Lady Korsah, wife of the Chief Justice of Ghana, on the occasion of Nkrumah's 1961 Lenin Peace Prize (1961); the tailored kente ensemble of Mrs. Marian Zeitlin to a party celebrating the United States Peace Corps (1963); Afua Apiaa's kente dress and stole, worn on the occasion of her wedding to former Member of Parliament Baffour Kwabena Senkyire (1963); Gertrude Quartey, posing for the front page of the *Sunday Mirror* wearing a blouse with kente strips trimming the hemline and sleeves (1964); even the official uniforms for the waitresses at the newly opened, luxury hotel, The Star. My personal favorite dates to 1960: under the headline "Did you See," the *Sunday Mirror* drew readers' attention to an unidentified woman's kente-wrapped umbrella, which matched the rest of her tailored kente ensemble (Figure 2.13). Described as a novelty, it epitomizes the extent to which kente became a material for fashionable attire, particularly during the Independence era.

Perhaps the most important and visible example of tailored kente, which is woefully under-documented, is the kente uniforms created for Ghana Airways female flight attendants. As I have explored previously,[94] Ghana Airways female flight attendants were considered paragons of their newly independent nation, with uniforms that were designed to encapsulate their heritage, worldliness and modernity. These values were first, and most directly, invoked through their kente uniforms, which were almost exact copies of their original, white uniforms, except sewn entirely from woven kente cloth. Purportedly used for special occasions, photographs of women wearing these uniforms often appeared in promotional articles from the late 1950s and early 1960s, extolling the importance of the country's airline, while simultaneously elevating the female flight attendants. These women and their extravagant kente uniforms function as the epitome of cosmopolitan, nationalist fashions: they seamlessly blended global forms of fashion with a particularly potent, locally woven textile imbued with Ghanaian heritage and newly earned Independence. These women, whether intentionally or inadvertently, literally embodied and enacted Nkrumah's Independence-era ideologies and played a significant role in the promotion of a distinct, yet constructed "Ghanaian personality." Their kente uniforms further indicate that the kente reformation began almost immediately following Independence and that kente could be cut and tailored, particularly when it served as a means for promoting Ghana.

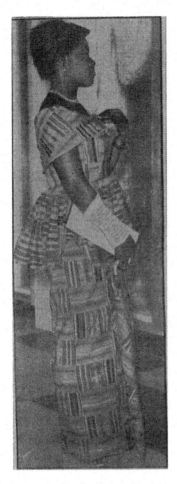

Figure 2.13 An unidentified woman wearing a tailored kente ensemble, complete with matching umbrella, 1960 (Image: *Daily Graphic* archive).

It is possible that some of these kente fashions may have been sewn from printed fabric, mimicking the appearance of kente cloth. *Sunday Mirror* contributor Crilly suggested employing "imitation kente" to create a more afford-able version of her kente coat.[95] *Drum: Ghana* writer Bossman documented that, by 1963, kente was being used for "women's shoes, handbags, belts, hats and hairbands ... not to mention stoles, skirts and even dresses. And for the men we have bow-tie, cummerbunds, waistcoats and hatbands."[96] In his descrip-tion, he refers to the "manufacturers of the odd accessories," implying that some of these accessories were produced on a larger scale, thus requiring the use of printed kente.[97] Although both examples suggest the existence and use of printed kente, evidence suggests that most garments, particularly women's

dresses, were executed with woven kente. The most convincing evidence that Independence-era kente fashions were sewn from woven kente is a 1962 *Drum: Ghana* article on the latest styles of women's shoes. The headline photograph is a cropped image of two feet, bedecked in kente high heels. As if anticipating the reader's doubts, the caption asserts: "here's a unique pair – real kente too."[98] In the body of her extensive article, Karikari specifically addressed the kente heels, stating:

> Everyone likes to have a special pair of shoes to dote on, and what would be more special, and unusual, too, than these Kente shoes, made right in Ghana! Actually, they are not as extravagant as they look. The cloth is easy to clean, hardwearing, and can be worn with many outfits. For instance, a matching Kente, or a plain weave dress of any of the colours in the weave.[99]

Karikari's documentation of the latest and most unusual adaptation for woven kente, a pair of high heels, provides further evidence that woven kente cloth was actively being cut and sewn into fashionable garments and accessories. Although the amount of kente needed to create a pair of shoes would likely be limited, the textile would still have to be cut and subsequently molded to the form. Karikari's example of kente shoes irrefutably suggests that Ghanaians were experimenting with new modes for wearing kente cloth and that, following Independence, kente developed a new role as a material for fashionable dress, as opposed to a mere form of dressing. Additionally, Karikiari's article emphasizes the inherent adaptability of kente cloth, echoing Bossman's sentiments that, in spite of the textile's inherent cultural significance, it is malleable and transformable.

In further support of Ghana's kente reformation, similar documentation of kente fashions appeared in *Drum: Ghana*. The first documented example of a tailored kente ensemble was included as part of the reportage on the 1959 Miss Ghana pageant. While six of the seven contestants wore a variation on wrapped kente, it was the winner, Elizabeth Hayford, who wore a tailored kente ensemble. Following her crowning, a *Drum: Ghana* photographer captured the winner in mid-handshake, providing the readership with a clear view of her extravagant gown. While her skirt may have been a variation on wrapped kente, her bodice was particularly form-fitting, suggesting it was tailored, a direct contrast to the bulkier, wrapped kente blouses of her competitors.[100]

A second example, dating from 1962, attests not only to additional, tailored kente fashions, but to the existence of another, largely undocumented fashion designer. As Karikari wrote: "pretty young dress designer and seamstress Mavis Amua-Sekyi has always been popular in Accra for her unusual and original dress designs, and is always way ahead when it comes to fashion trends."[101] Accompanied by her fashionable compatriots Houda Ampah and Diana Macdonald, who are often mentioned in Karikari's columns, Amua-Sekyi "hurried along to her shop" to investigate her latest creations.[102] These included a hat named "Oheneba," or "Princess," described as "a beautiful creation of black

net frills and golden plain kente cloth band." An ensemble, consisting of hat and suit, was nicknamed "Playgirl"; it consisted of a "straight skirt, sleeves, back of the pocket and hat-crown ... of a plain-coloured kente, while the bodice and hat-band were of richly patterned pieces of the same cloth."[103] These additional examples support that tailored kente reached a pinnacle during the early 1960s, with fashion columnists promoting and Ghanaian women wearing an incredible array of tailored kente ensembles and accessories. This is not to suggest that kente fashions lost their significance following Nkrumah's deposal; on the contrary, as with any material used for fashionable attire, the use of kente ebbed and flowed but, due to its cultural and historical significance, Ghanaian designers typically return to the textile, ensuring that it remains an important part of Accra's fashion culture.

Kente may function as the most extravagant and visually impactful evidence for this groundbreaking fashion sphere, but there were equally meaningful, and more economically accessible, materials that were employed to create cosmopolitan, nationalist fashions. Wax print fabric, a material suited for all manner of tailored ensembles that evoked an immediate Ghanaian heritage, was fused with globally informed silhouettes to create garments that were equally evocative of a cosmopolitan nationalism. Although not the earliest, the most compelling example is from Karikari's 1964 article "The Africa Line"; the featured photograph is of a young Ghanaian woman wearing a form-fitting shift dress sewn from a mix of *nsuo bra* wax print and imported cotton. The accompanying caption stated: "The 'Shift' goes Ghanaian. This one is made up in Ghana wax print."[104] Not only does the caption acknowledge that wax print is directly linked to Ghanaian culture and identity, it asserts that the shift dress has "gone Ghanaian" suggesting that a hybridized form has been created. The resulting garment honors established Ghanaian dress culture, while maintaining a recognition of global fashion trends.

The earliest identifiable wax print ensemble that reflects a particularly cosmopolitan, nationalist perspective dates to 1959 (Figure 2.14); it was exhibited as part of a runway show organized by Anna Sackey, her mother Yacoba Sackey and Marian Addy. As with previous examples, these three women were members of Accra's elite social circle; Anna was the daughter of the Chief Electrical Engineer and Addy was employed by the Ghana Broadcasting System.[105] Anna Sackey was described by the *Sunday Mirror* as an overseas-trained dressmaker and designer, although the extent of her training is unclear.[106] The fashion exhibition, which was held at the Accra Community Center, included 25 models showcasing over 70 garments.[107] The *Sunday Mirror* included photographs of 11 complete ensembles, one of which was unquestionably sewn from wax print. Titled "travelling outfit," the garment was described as "for the girl going abroad."[108] The ensemble consisted of a high-neck, buttoned blouse with three-quarter length sleeves and a pleated peplum, paired with an ankle-length skirt. The entire garment was sewn from the iconic "Alphabet" wax print, a design often associated with the values of education. The inclusion of this ensemble suggests that, by 1959, elite Ghanaian women were encouraging each other

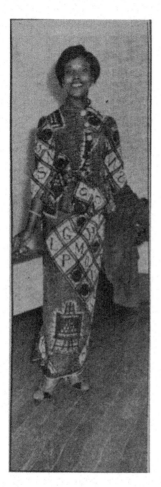

Figure 2.14 The "traveling outfit" designed by Anna Sackey, sewn from the iconic "Alphabet" wax print, 1959 (Image: *Daily Graphic* archive).

to wear such bold and expressive fabrics, serving as immediate signifiers of their cultural identity, particularly when they traveled overseas. This is a remarkable and important shift, as prior to Independence, wax print was purportedly viewed by elite women with disdain, as the material signified illiteracy and was associated with the working class; how unusual, then, for an elite woman to choose this fabric, as a symbol of education and literacy, to fashion her traveling ensemble. Additionally, wearing garments sewn from local fabrics, particularly wax print, was not readily practiced prior to Independence. This example further demonstrates how women were actively reimagining culturally significant materials and employing them as a means to assert their identity and heritage in a decidedly global context. As asserted in the *Drum: Ghana* article "Look Cute

in Cloth," women were beginning to view wax print as "a thing of infinite wonder, and variation – if it is handled with taste."[109] This subheading by an unknown contributor encapsulates how wax print functioned as an additional material for cosmopolitan, nationalist fashions; its inherent malleability allowed it to be combined with a variety of imported materials and refashioned into globally informed silhouettes, all while maintaining direct allusions to a unified Ghanaian identity and more broadly, the "African personality." With wax print reinvigorated as a material for fashionable attire, other local textiles, including batik and tie and dye, became additional materials for cosmopolitan, nationalist fashions; the result was a myriad ways for Ghanaian women to express their cultural identity and heritage, while demonstrating their awareness of the global fashion system.

With the advent of cosmopolitan, nationalist fashions, Ghanaians were able to actively participate in the reconstruction of Ghanaian culture and heritage, while asserting their global awareness and belonging, all through the malleable and immediately visible form of dress. These sartorial assertions would not have been formed if Accra did not have such an active and complex fashion culture firmly in place; as this chapter has demonstrated, Accra has been the site of a complex fashion culture since the mid-twentieth century, comprised of four major spheres: world, European, international and local fashions. Prior to Independence, the successful navigation of these distinct, yet porous, spheres was a means of indicating one's cosmopolitan identity. If a Ghanaian woman could seamlessly transition from wearing a French-designed dress one day, to an Indian sari the next, and kente to a weekend wedding, she would have epitomized cosmopolitanism, signaling her awareness of, and belonging to, a variety of dress cultures and the overarching, global fashion system. The navigation of these spheres functioned as an additional means of solidifying her elite social status and identity as a fashionably informed Ghanaian.

Cosmopolitan, nationalist fashions provided women with a more direct and accessible form for encapsulating these values. Although women continued to participate in all of Accra's fashion spheres, cosmopolitan, nationalist fashions ensured that Ghanaian heritage and identity could be maintained and promoted, while simultaneously asserting their participation in a globally interconnected fashion system. This new sphere of fashion, resulting from the fusions of global styles and silhouettes, often expressed through European approaches to tailoring and finishing, with locally meaningful textiles and forms of dressing, fueled the development of Ghana's designer fashion culture. The subsequent fashion designers, beginning with Juliana "Chez Julie" Kweifio-Okai, create garments that are evocations of this new sphere of fashion, tailored to reflect their respective eras and personal perspectives. With the threads of cosmopolitanism and nationalism woven throughout the majority of designer fashions produced in Accra, it suggests the enduring relevance of these values to Ghanaians, particularly in the capital. The progressive and innovative approaches of the subsequent fashion designers is not a novelty; it reflects the longstanding commitment of Accra's citizens, particularly its women, to foster an intricate

and engaged fashion culture that serves as a testament to individual creativity, informed experimentation, constant transformation and, most importantly, a maintenance of culturally meaningful dress practices.

The fashion event: *Fashion Night Out, Ghana*, April 19, 2012

Fashion Night Out, Ghana began like most other fashion events in Accra: excruciatingly late. In spite of my best efforts and the playful cajoling of my Ghanaian friends, I could not convince myself to show up appropriately late to any fashion show. At best, I might arrive an hour after the advertised start of an event, only to find myself waiting for at least another hour, if I was lucky. Although it could be intensely frustrating at times, waiting simply became part of my routine, affording me the opportunity to reflect on the day's events and to engage in a more careful observation of my surroundings. It also served as a subtle reminder that I was an outsider; my rigid, American punctuality was continually at odds with the more laidback approach to time that I encountered in Accra. On this particular evening, I convinced a fashion-forward colleague in political science to accompany me, so I wouldn't have to wait alone.

A few days prior to the event, I purchased a vintage Claude Montana vest from a secondhand clothing stall on the edge of the Kokomlemle neighborhood.[110] This seller was particularly skillful at selecting unusual, sometimes designer, garments. After a long day at the archives or conducting interviews, I often found respite in combing through his latest stock of clothing, which was either stacked in neat piles on a wooden table or hanging from a makeshift clothesline. I decided that, instead of wearing one of my typical wax print ensembles, I would wear my newly acquired black vest, paired with a secondhand, black silk shirt adorned with an "Alphabet" print. My colleague opted for a simple sheath dress, perhaps to counterbalance her conspicuous mohawk, which she had styled during a recent trip to Cameroon where it was considered au courant. We made for quite a pair, and we were both ready for a night filled with fashion, but first … we would have to wait.

Like many Ghanaian fashion shows, the event was held at a hotel, specifically the Coconut Grove Regency Hotel, located in the elite North Ridge neighborhood of Accra. What made the show distinctive was that it was held outside, in the hotel's courtyard. Models entered the courtyard from one of the hotel's main buildings, its façade obscured with black construction paper. The hotel's pool divided the runway into two sections, requiring the models to walk halfway around the perimeter of the pool before parading down a raised platform that functioned as the final, formal runway for press photography. Rows of chairs were arranged on either side of these walkways, with the majority of attendees seated on either side of the raised runway. It was a novel approach to a fashion show, but it made for a long and hazardous path for the models!

I'm not sure how much time passed before my colleague and I were instructed to take our seats, but it was well after six, the advertised start time, before the

show finally commenced. Luckily, the MC of the event, fashion influencer and former fashion designer Makeba Boateng, had reserved two front-row tickets for me, which meant I had prime viewing for the ensuing fashion extravaganza. While the local celebrities leisurely found their seats, I was surprised to see fashion designers Beatrice Arthur and Kofi Ansah in attendance. To my delight, Arthur sat across from me, so I was able to enjoy her uninhibited, dramatic reactions throughout the show.

After all the waiting and anticipation, the show finally began, but not with fantastical clothing. Instead, the first models emerged wearing form-fitting, all-black ensembles adorned with a variety of extravagant jewelry designed by Wendy L'Artisane. After several pairs of female models had walked the runway, bedecked with suites of beaded necklaces, bracelets and earrings, two male models unexpectedly emerged; the men were shirtless, sporting jeans that were impossibly low, bordering on indecent. Thus, another hallmark of Ghanaian fashion shows was met: the inclusion of at least one muscular male model in some state of undress. The reason for this titillating inclusion remains a mystery to me; perhaps because women are considered the primary consumers of fashion in Accra, it is perceived as a method to generate excitement (the appearance of these men often results in shouts of enthusiasm and applause from the audience). In this instance, the male models were incorporated to serve as brawny backdrops for L'Artisane's most elaborate statement necklaces. One male model wore a particularly eye-catching necklace comprised of three copper birds in flight, hanging from a strand of black and ivory-colored disc beads.

The next presentation consisted of shoes and accessories designed by the Ghanaian brand Sa4a, an ingenious rewriting of the Twi word safoa, or key. The same, all black-clad models paraded the runway, this time wearing high heels and bags constructed from a mixture of leather and wax print fabrics. Following the completion of this display, the show transitioned into exhibiting the expected fashion garments by Ghanaian and other African designers.

Interspersed between individual designers' presentations were brief acts of music, dance or other forms of entertainment, marking the third hallmark of Ghanaian fashion shows. I remember my surprise when, in the middle of the 2009 *Ghana Fashion Weekend*, couples emerged from backstage and performed a carefully choreographed salsa routine. My expectation was that a fashion show would consist solely of runway presentations in rapid succession, but Ghanaians preferred true events, with multiple acts of fashion and entertainment. At *Fashion Night Out*, the audience was first treated to a lip-synced performance from the Broadway musical *The Lion King*, complete with accurate recreations of Julie Taymor's iconic costumes. Later on, Boateng conducted a live interview, with less engaging results. At the time, I viewed these interludes as prolonged interruptions from the most crucial aspect of the evening: the fashion. Now, I understand that they were another means for capturing the audience's attention and disrupting the potential monotony of a continual parade of designs.

I must acknowledge that fashion shows, whether they are in Accra, Paris or New York City, are inherently unpredictable. Participating designers may

be advertised, but what they present is generally unknown. Additionally, Ghanaian fashion shows may promote the inclusion of certain designers who, for various reasons, don't actually participate. The overall quality and originality of garments are also difficult to predict; the 2009 *Ghana Fashion Weekend* was a veritable feast of original, intriguing and wearable designs, an event that, for me, remains unparalleled by subsequent Ghanaian fashion shows. In spite of the inherently fickle nature of these enacted fashion displays, I attended them, and countless others, because they functioned as the best and most immediate way to view a range of designers and their creations. Fashion shows also served as important sites for networking and reifying my legitimacy as a budding fashion researcher. Most importantly, they were fun. In spite of the waiting and the unpredictability, it was exciting to be an active participant in such a dynamic and enlivened fashion scene.

The garments presented at *Fashion Night Out* were primarily from wax print. Many of the silhouettes, like a pleated cocktail dress with sweetheart neckline, were certainly appealing and wearable, but the use of wax print was neither innovative nor unusual. Other garments combined fabrics and embellishments to the point of absurdity, making them almost unwearable and relatively unattractive. And then there was Ambassador Kouture, who presented edgy menswear inspired by military and colonial uniforms, garments rich with latent meaning, but as a Nigerian designer he fell outside the purview of my research.

Fashion Night Out exemplifies many of my fashion experiences in Accra: enjoyable, energetic and diverse, but not always directly elucidative to my research. There are many designers, on the African continent and overseas, who present perfectly pleasing and wearable garments, but that don't necessitate further intellectual inquiry. Or perhaps one designer is creating evocative and informed fashions, but their work doesn't directly relate to my current project. To me, fashion shows are more than dazzling events, populated by celebrities, journalists and fashionistas; they are an integral and necessary part of the research process. Whether they are enlightening, awe-inspiring or simply mundane, fashion shows remain a consistent and important component of Accra's fashion culture. Historically, they functioned as a means for championing local forms of dress in opposition to colonially informed fashions; they continue to serve as an unofficial barometer for issues relating to identity, cultural heritage, and what it means to be Ghanaian, and African, in the twenty-first century. And that is why, whether I'm five rows back, or seated pride of place in the front row, I will never turn down an invitation to a runway show.

Notes

1 Christopher Richards, "The Models for Africa: Accra's Independence-Era Fashion Culture," *African Arts*, 49/3 (2016): 9; Christopher Richards, "We Have Always Been Fashionable," unpublished dissertation (University of Florida, 2014).

2 Elizabeth Ohene, "Elizabeth Ohene Writes: My Graphic Story," March 4, 2020, www.graphic.com.gh/features/opinion/my-graphic-story.html

3 Bruce, Augustus, "Can you Ride a Bike in Cloth?" *Sunday Mirror*, Number 136 (March 11, 1956): 1.
4 Ibid.
5 Ibid.
6 Ibid.
7 Joanne Eicher and Barbara Sumberg, "World Fashion, Ethnic and National Dress," in *Dress and Ethnicity: Change Across Space and Time*, ed. Joanne Eicher (Oxford: Berg Publishers, 1999), 296.
8 "Being Fashion Wise," *Sunday Mirror*, Number 3 (August 16, 1953): n.p.
9 Ibid.
10 "New Fashions in Vogue," *Sunday Mirror*, Number 9 (October 4, 1953): n.p.
11 "Latest Fashions in Women's Dresses," *Sunday Mirror* (March 7, 1954): 3.
12 Nancy Laing, "The Finishing Touch," *Sunday Mirror* (October 23, 1955): 3.
13 "She Wore the Glamorous Dress," *Sunday Mirror*, Number 333 (December 27, 1959): 9.
14 The most controversial of Mary Edusei's extravagances was her purchasing of a gold-plated bed, which became a lurid story in Ghanaian, British and American newspapers. The bed purportedly cost £3,000, equivalent to $8,400 in 1962. At the time, Edusei was quoted as stating:

> People may think I'm extravagant … but I can enjoy the bed every night. I don't get much pleasure out of jewels. Besides, diamonds or jewels have to stay in a bank, but whoever imagined anyone trying to steal a bed?

For a more complete account of the event, see "Husband, Wife Battle Over Bed," *Desert Sun*, Vol. 35, Number 205 (March 31, 1962): 1.
15 Ibid., 9.
16 Ibid.
17 Ibid.
18 Ibid.
19 Ibid.
20 "Big Dress Show Soon," *Sunday Mirror* (October 26, 1958): 16.
21 Ibid.
22 Ibid.
23 Beginning in the 1940s, Hartnell began hosting fashion events overseas, in both North and South America and the Middle East. These events often included "export collections," garments that were inspired by a country's existing dress styles and design motifs, created specifically to appeal to a country's elite consumers.
24 "Big Dress Show Soon," 16.
25 "She's Model of Beauty," *Sunday Mirror* (November 9, 1958): 20.
26 Ibid.
27 "It's a Week of Fashion," *Sunday Mirror* (December 7, 1958): 9.
28 "Fashions at Ghana's 2nd Birthday," *Sunday Mirror* (March 15, 1959): 8.
29 Ibid.
30 Ibid.
31 "A Sari Style," *Sunday Mirror*, Number 19 (December 6, 1953): 1.
32 "Dressing in Indian Fashion …," *Sunday Mirror* (February 14, 1954): n.p.
33 "Now – IT's the Indian Style," *Sunday Mirror* (December 13, 1959): 7.
34 Laing, Nancy, "Travel Goods Change Fashion," *Sunday Mirror* (October 30, 1955): 2.

35 "Oriental Style," *Sunday Mirror* (May 27, 1956): 9.

36 "The Eastern Look …," *Sunday Mirror*, Number 242 (March 23, 1958): 1.

37 Ibid.

38 Ibid.

39 "Tops of the Fashion," *Sunday Mirror* (February 16, 1964): 12.

40 Ibid.

41 Gussie, "For the Light-hearted," *Sunday Mirror* (September 25, 1955): 9.

42 "Gambian Women Take Over this Page," *Sunday Mirror* (January 6, 1957): 9.

43 "Comfort Goes the Senegal Way," *Sunday Mirror* (January 4, 1959): n.p.

44 Karikari, Beryl. "Aduke's Hat Was Tops!" *Drum.* (July 1962): 37.

45 Ibid.

46 Tonye Victor Erekosima and Joanne Bubloz Eicher, "Kalabari Cut-Thread and Pulled-Thread Cloth," *African Arts* 14/2 (February 1981): 50.

47 Edith Wuver, "And the Conductor Wondered," *Sunday Mirror* (February 13, 1955): 6.

48 Ibid.

49 Ibid.

50 Ibid.

51 "A NEW style …," *Sunday Mirror*, Number 21 (December 20, 1953): 1.

52 Ibid., n.p.

53 Edith Wuver, "And the Conductor Wondered," 6.

54 "'Jaguar' is Not a Decent Fashion Garment," *Sunday Mirror* (June 5, 1955): 2.

55 Suzanne Gott, "'Life' Dressing in Kumasi," in *African-Print Fashion Now!*, eds. Suzanne Gott, Kristyne Loughran, Betsy Quick and Leslie Rabine (Los Angeles: Fowler Museum of Art, 2017), 140.

56 Suzanne Gott, "The Ghanaian Kaba: Fashion that Sustains Culture," in *Contemporary African Fashion*, eds. Suzanne Gott and Kristyne Loughran (Bloomington: Indiana University Press, 2010), 19.

57 Suzanne Gott, "'Life' Dressing in Kumasi," 141.

58 Edith Wuver, "And the Conductor Wondered," 6.

59 Ibid.

60 Beryl Karikari, "The Africa Line," *Drum* (December 1964): n.p.

61 Kwame Nkrumah, *I Speak of Freedom* (New York: Frederick A. Praeger, 1961), 106–107.

62 Interview with Kathleen Ayensu, Accra, Ghana 2017; Phone interview with Letitia Obeng, June 23, 2014.

63 Kwame Nkrumah, *I Speak of Freedom*, 189.

64 George P. Hagan, "Nkrumah's Cultural Policy," in *The Life and Work of Kwame Nkrumah*, ed. Kwame Arhin (Trenton, NJ: African World Press, 1993): 13.

65 Kwame Nkrumah, *I Speak of Freedom*, xi.

66 Ibid., 168.

67 Janet Hess, *Art and Architecture in Postcolonial Africa* (Jefferson, NC: McFarland & Company, 2006), 143.

68 "He Must See it Through," *Drum* (April 1959): 20.

69 Phone Interview with Letitia Obeng, Gainesville, Florida, June 23, 2014.

70 George P. Hagan, "Nkrumah's Cultural Policy," 16.

71 Ibid.

72 Ibid.

73 Beryl Karikari, "The Africa Line," n.p.

74 Ibid.

75　Ibid.
76　Ibid.
77　Ibid.
78　Ibid.
79　Ibid.
80　Ibid.
81　"Ntama," *Sunday Mirror* (no date): n.p.
82　Moore Bossman, "Kente," *Drum* (April 1963): 2, 3, 18, 20.
83　Ibid.
84　Lucy Payne, "Fashions Through the Day," *Sunday Mirror* (August 17, 1958): 5.
85　"New Role for Kente," *Sunday Mirror* (March 16, 1958): 5.
86　Ibid.
87　"Anne Goes the Ghana Way," *Sunday Mirror* (March 16, 1958): 8.
88　Ibid.
89　Ibid.
90　Eileen Crilly, "Meet the Queen," *Sunday Mirror* (July 26, 1959): 7.
91　"… Ideas of an Irish Housewife," *Sunday Mirror* (April 12, 1959): 8, 9.
92　Eileen Crilly, "Wearing Cloth While Abroad," *Sunday Mirror* (August 23, 1959): 10.
93　Ibid.
94　For a more comprehensive exploration of Ghana Airways' female flight attendant uniforms, see "High Flying Fashions: Ghana Airways' Female Flight Attendants as Exemplars of the Nation," in *Fashion, Agency and Empowerment: Performing Agency, Following Script*, eds. Annette Lynch and Katalin Medvedev (New York: Bloomsbury, 2019), 83–99.
95　Eileen Crilly, "Wearing Cloth While Abroad," 10.
96　Morre Bossman, "Kente," *Drum* (April 1963): 2, 3, 18, 20.
97　Ibid., 20.
98　Beryl Karikari, "Shoes are the main topic of this month's column," *Drum* (May 1962): 15.
99　Ibid., 14.
100　"Fairest of Them All!" *Drum* (June 1959): 21.
101　"Way Ahead of Fashion," *Drum* (August 1962): 27.
102　Ibid.
103　Ibid.
104　Beryl Karikari, "The Africa Line," *Drum* (December 1964): n.p.
105　"Ghana Dresses Find New Looks," *Sunday Mirror* (March 22, 1959): 8, 9.
106　Ibid., 8.
107　Ibid.
108　Ibid.
109　"Look Cute in Cloth," *Drum* (February 1962): 36.
110　Claude Montana is a well-known French fashion designer who was best known for his extravagant, 1980s fashions.

3 The forerunners of Ghana's fashion designers

Letitia Obeng and Laura Quartey

The focus of this chapter is on the contributions of two largely unacknow-ledged, and incredibly different, sartorial pioneers: Letitia Obeng and Laura Quartey, women who actively contributed to the reshaping of Accra's his-torical dress culture prior to the introduction of Ghana's fashion designers. They serve as exemplars of the countless, unknown or casually documented Ghanaian women who, possessing either a basic knowledge of sewing or exten-sive, informal training, actively participated in Accra's historical dress culture, adapting existing forms to reflect their own creativity and style preferences. It is these micro-revisions, often disseminated through informal networks of women, seamstresses, and their respective communities, that aided in the drastic sartorial revisions of Ghana's Independence era, eventually encouraging the development of Accra's dynamic designer fashion culture. While the stories of Obeng and Quartey are certainly unique, their contributions attest to the more universal and instrumental role of women in determining both the historical and contemporary fashion culture of Ghana. I have purposely chosen to high-light these women, in spite of limited documentation outside of familial and personal recollections, as their stories attest to the informal aspect of Accra's historical fashion culture. Their contributions further suggest that, although Juliana Kweifio-Okai may be Ghana's first formally trained fashion designer, there were likely many women who predated her who were equally influen-tial in altering Ghana's established dress practices. These contributions should not be overlooked because they were initiated by women who were not for-mally educated in fashion design, nor because of a lack of extensive, supporting documentation.

The sartorial revisions of Obeng and Quartey further attest to the exist-ence of Accra's fashion spheres and how they were constantly revised and amended. Obeng introduced significant adaptations to the kaba, a mainstay of local fashion, whereas Quartey's early designs attest to Ghanaians' engage-ment with European-inspired fashions, followed by her active promotion of Ghanaian, nationalist fashions. This chapter is evidence of their relevance and serves to accentuate the historicity of Accra's fashion culture. Its brevity is there-fore intentional, as it serves to indicate the dearth of information and extant

DOI: 10.4324/9781003148340-3

garments associated with Obeng, Quartey and the aforementioned anonymous fashion contributors.

"Because it was Mine, Not Anything Foreign": Letitia Obeng's promotion of the kaba and ntama[1]

When Letitia E. Obeng's (b.1925) achievements are discussed, her extensive education and scientific contributions are frequently highlighted, and rightly so. As the first Ghanaian woman to earn a bachelor's degree in science *and* to complete a doctoral degree, Obeng is a pioneering figure, characterized by *Drum: Ghana* as "a doctor of philosophy who took her broom among the academic cobwebs."[2] And yet, buried in the *Drum: Ghana* article's lengthy prose on her career is an unexpected acknowledgment:

> I bet that if you were to meet her in the streets perhaps doing her shopping, you would take a second look at her trim figure and her fashionable "kaba" which she has designed and made herself. In spite of her work in science she has always been interested in art and the arts.[3]

The author expanded on this assertion, later stating:

> she is a very imaginative designer of the "Kaba" – and I know it to be a truth that she was one of the first pioneers of the one-piece kaba with the deep frill round the hem. She and her sister Julie were wearing it when the rest of us were still wearing the old-fashioned type![4]

As if to prove the author's point, the article's introductory photograph captures an exuberant Obeng in mid-stride, bidding farewell to one of her children as she leaves for work. She is clothed in a form-fitting, kaba ensemble that she designed herself, complete with the customary second wrapper thrown jauntily over one shoulder.

As evidenced by the *Drum: Ghana* article, Obeng's accomplishments are not limited to the purely scientific. She played an instrumental role in revising and promoting the kaba ensemble as a form of fashionable dress, particularly for Ghana's elite, educated women. Before proceeding further, it is necessary to explicate a term that Obeng regularly employs in recounting her dedication to and experimentation with Ghanaian forms of dress. In her autobiography and an interview, Obeng refers to her Ghanaian dress as "ntama." When asked to define this term, Obeng described it as "the three-piece costume that Ghanaian women wear," although in conversation, she also used ntama to reference men's wrappers.[5] On the surface, this may appear contradictory, but in actuality it reflects the complexity of the Akan language. As documented by art historian Suzanne Gott, Asante Twi speakers employ the term ntama to reference both local textiles, including kente, adinkra and imported wax print, and women's

kaba ensembles.[6] To eliminate potential confusion, I will use specific, English terminologies to distinguish between the various textiles and forms of dress that Obeng discussed. It should also be acknowledged that, based on historical photographs and her own descriptions, it can be assumed that the majority of Obeng's kaba ensembles were sewn from wax print, although she did employ other local materials, such as tie and dye, to create at least one of her designs; this is likely another reason why she often referenced her ensembles as ntama, as they were both kaba ensembles and made from materials perceived as local.

From 1948 to 1952, Obeng attended the University of Birmingham in England, where she completed a Bachelor of Science degree in zoology.[7] It was this initial overseas experience that galvanized Obeng's interest in Ghanaian forms of dress. In both her autobiography and an interview, Obeng expressed that, after seeing African women in England wearing European fashions, she decided that local forms of Ghanaian dress, particularly the kaba ensemble, were more appropriate and flattering to Ghanaian women. To this observation, she added: "I didn't see any reason why I should be dressed in somebody else's fashion when I have my own."[8] These observations prompted Obeng to take the following stance: "I took a firm decision and solemnly promised myself to totally discard the use of the European dress, make my country's traditional costume my basic attire, wear it at all times and adapt it to serve me under all circumstances."[9]

The perceived suitability and attractiveness of Ghanaian dress were not the sole reasons for Obeng's dramatic shift in her personal attire. When Obeng left her country in 1948, she described being "fired with national pride," as Ghanaians had begun to agitate for independence from colonial rule.[10] Being overseas only served to strengthen these feelings. As she described in her auto-biography: "Removed from the colonial flavor, my perception of our traditions, customs, languages, traditional costumes, music, art, crafts, and our entire culture had sharpened intensely. More than ever, to me, they had all become unique, valuable, distinguishing and priceless national assets."[11]

Obeng's commitment to wearing Ghanaian forms of dress, primarily the kaba ensemble, did not preclude her ability to alter and adapt their existing silhouettes. As Obeng reflected: "the top section (kaba) was, at the time, usu-ally worn loose and not fitted to the body and it therefore did not court much elegance … it only needed to be 'upgraded in style' to emphasize its attractive-ness."[12] To counter the purported shapelessness of its earlier form, Obeng added a zipper to her kaba blouses, resulting in a more tailored appearance.[13] It also allowed for more freedom of movement, which was important, as Obeng wore her kaba ensembles for all occasions and throughout the year. This proved dif-ficult in winter months, as Obeng's cotton kaba ensembles were more suited to Ghana's tropical climate. As she humorously recollected, she had to wear several layers beneath her ensembles to stay warm, a clear testament of her resolute conviction to wear exclusively Ghanaian dress.[14]

Obeng's initial, overseas promotion of Ghanaian dress culminated with her university graduation. Female graduates were required to wear a white blouse

and black skirt under their robes; Obeng, upholding her active rejection of European attire, insisted on wearing Ghanaian dress.[15] She officially requested, and was granted, permission to wear a Ghanaian ensemble, which consisted of an unusual white kente wrapper with dark blue accents and a long-sleeved, white blouse.[16] Obeng was proud of her academic achievements, but the day held additional significance: "I had obtained official recognition, acceptance and endorsement of the use of my Gold Coast national costume for a strict formal event at a University Graduation Ceremony! I was elated."[17]

Returning to Ghana in 1952, Obeng was given a lecturer position at the University of Science and Technology in Kumasi, where she continued her relentless promotion of Ghanaian dress.[18] As she so astutely summarized: "we were going to be independent, [so] we need to feel independent, not wearing European dresses."[19] Her perspective, matched by her distinctly local style of dressing, was met with surprising resistance. In one telling anecdote, Obeng and her husband, along with a group of friends, went to a popular, Ghanaian-owned nightclub. Her friends, who were all dressed in European or world fashions, were permitted into the club; Obeng was refused entrance, based solely on her kaba ensemble.[20] As she reflected, "those who were attired in cloth wouldn't be admitted, that's how it was."[21] Luckily for Obeng, the owner happened to be visiting his club that evening, and after Obeng expressed her frustration, he immediately changed his policy: visitors wearing Ghanaian attire would no longer be prohibited from entering.[22]

A second anecdote elucidates how social class and education were inherent in the debate regarding the relevance and appropriateness of the kaba ensemble. Following the nightclub incident, Obeng became even more resolute in wearing her innovative kaba ensembles, to the consternation of the "more con-servative of the campus wives."[23] As Obeng recounted, one such woman asked her husband: "Why does your fiancée continue to disgrace herself by wearing cloth all the time as if she does not know how to wear a dress?"[24] This recol-lection, with its particularly judgmental assessment of Obeng's attire, correlates to established research on the history of Ghana's kaba ensemble. At some point during the late nineteenth or early twentieth century, this now iconic form of dress, along with its wax print material, became synonymous with unedu-cated or "illiterate" women, an attitude perpetuated by Ghana's elite, formally educated, population.[25] This resulted in the development of two opposing colloquialisms: "cloth women," or women without a formal, Western-style edu-cation and "dress ladies," women who were formally educated and who wore imported, European (or global) fashions.[26] This distinction was reiterated by Obeng, who shared "they used to describe women who wore cloth, who wore the ntama, as cloth women."[27] Acknowledging the active, pernicious assault against the kaba ensemble, particularly from Ghana's educated, elite women, attests to the significance of Obeng's most important sartorial contribution, particularly since it was held on a college campus!

In February 1957, on the eve of Ghana's Independence, Obeng organized the "Gold Coast Traditional Costume Show." The event was held in the College

Assembly Hall of the College of Science and Technology; although a considerable distance from the capital, the event reverberated throughout the country, with a detailed account and many photographs of the event repeatedly featured in the *Sunday Mirror*. In an interview, Obeng characterized the event rather simply, stating:

> I decided more people should know about it [Ghanaian dress]. Fortunately for me, I … was in charge of the Women's Hall; I had all these beautiful young women. So I decided to have a fashion show and they were all very keen on it. I made all the dresses they wore; I sewed them all and we had a beautiful evening.[28]

In her autobiography, Obeng provides a more extensive account of the event, stating it was the direct result of her "desire to popularise the ntama."[29] As she recounted:

> I designed the ntama styles and sewed a variety of nicely fitted kaba for many occasions: sleeveless kaba with a little collar as a secretary's outfit, a smart one with little straps, for early evening social events, an off-the-shoulder, strapless "will power" for formal evenings, and others with overlapping peplum, short and long flared out sleeves. All of them were designed to fit and show the curves on my lovely models. I folded or sewed the top cloth to make stoles which I lined with plain material, frilled or shaped in special ways. I had a student dressed the traditional densinkra style of Ashanti women, and another wore the oduku Fanti hair style. And with George involved in the textile field, I was able to display some kente and adinkra as well.[30]

Following the event, an extensive, multi-paged article titled "Experiment with Native Costume" was published in the *Sunday Mirror*. The author characterized Obeng as possessing "the strong conviction that the traditional costume is part and parcel of the heritage of the people of Ghana and that every Ghanaian should be proud of it and wear it without any misgivings."[31] The article further described the show as emphasizing the "simplicity in material and the style of the 'kaba,' and the moderate cost of complete sets."[32] The *Sunday Mirror* provided a detailed account of the event's format, stating it was divided into three parts. Based on the article's subheadings, it can be assumed that these sections were: dance costumes, traditional wear and funeral wear.[33] Although a significant portion of the article is illegible, it is clear that emphasis was placed on the inherent versatility, wearability and stylishness of Obeng's revised kabas, evidenced by the article's extensive kaba descriptions and its inclusion of five photographs of distinct kaba designs.[34]

In support of Obeng's memories, the article described a "boat-neckline 'kaba' worn with drop earrings, a halter-neck 'kaba' worn with round button

earrings, a 'kaba' with thin straps and another one with shoulder bare."[35] The article placed particular emphasis on the "will power" kaba, a design attributed specifically to Obeng, suitable for "dances, balls and gala nights."[36] Described as having "no support on the shoulder," this strapless kaba is likely the design worn by Obeng in the article's introductory photograph (Figure 3.1).[37] Although the material is indiscernible, the blouse, with exaggerated peplum, is indeed strapless, suggesting its unusual moniker is a cheeky reference to the design's inherent willpower to stay in place. The ensemble was paired with a fringed stole, lined with a contrasting fabric. This is in keeping with Obeng's own recollections and was further highlighted by the *Sunday Mirror*, which described several models wearing a "second cloth lined to give a two-way stole effect, which was very effective."[38]

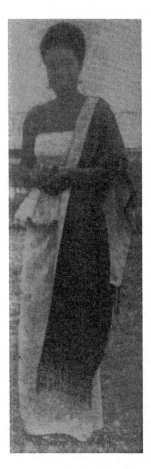

Figure 3.1 Dr. Letitia Obeng likely wearing her "will power" kaba at her "Gold Coast Traditional Costume Show" in Kumasi, 1957 (Image: *Daily Graphic* archive).

The diversity of Obeng's kaba blouses and her novel treatment of the kaba ensemble's second wrapper are just a sample of the many innovations that Obeng introduced as part of her fashion show. Although for specific kaba ensembles the second wrapper was transformed into a reversible stole, for "business wear" the "second cloth was discarded."[39] This seemingly banal observation has powerful implications for Ghana's established dress history. It is important to acknowledge this omission, as contemporary kaba ensembles often forgo the inclusion of a second wrapper, likely for a more fashionable and manageable silhouette; Obeng's fashion show suggests this alteration began much earlier, likely as a means for promoting the wearability of the kaba ensemble. The *Sunday Mirror* author further emphasized that the kaba ensembles were "well fitted to bring out their figure," implying that Obeng incorporated zippers into all of her designs.[40] While Obeng may not have been the first to introduce zippers as an integral part of the kaba blouse, the emphasis on the tailored appearance of her designs suggests it was considered a novelty at the time.

What is perhaps most telling and persuasive from the *Sunday Mirror's* reportage were the six black and white photographs that accompanied the article, showing both "old styles" of dressing, directly linked to specific cultural groups and their practices, contrasted with "new styles" of kaba.[41] This distinct dress dichotomy of "old" and "new" foreshadowed Nkrumah's concepts of Pan-Africanism and the African personality. As explained by scholar George P. Hagan, Nkrumah's dream of a united Africa would be unattainable if he could not first unite the people of Ghana.[42] A major factor working against this unification was what Hagan refers to as "tribalism," a loaded, problematic term used to describe groups of people in a single nation that self-segregate based on perceived or actual distinctions in cultural practices, language and religious beliefs. Nkrumah was concerned that "tribalism" would prevent his ultimate Pan-Africanist goals from being reached, so he actively sought to prevent such divisions from occurring.[43] By 1963, Nkrumah had passed legislation that prevented the formation of political parties based on religious or "tribal" affiliation. Hagan notes that this legislation "removed from application forms and all government forms, questions about one's tribe, region and religion," resulting in the promotion of a single, united, Ghanaian identity.[44]

During the Independence era, the kaba, through its active promotion by women like Obeng, became a form of dress that eradicated any perceived social and cultural divisions. Instead, the kaba symbolized a collective Ghanaian identity, albeit specifically for women. By endorsing the novelty of the kaba, in direct opposition to the "old" and "ancient styles no longer in vogue," which included the Fanti "tekua" and a Ga form of dressing described as "heavy white velvet … with large gold accessories," the *Sunday Mirror* and Obeng were early, and possibly unintentional, proponents of Nkrumah's collective, nationalist forms of dress.[45] To further indicate the potency of this event, the inherent accessibility of Obeng's kaba revisions must be underscored. Such extensive

photographs would have given both educated and illiterate Ghanaian women the ability to commission similar kaba styles simply by sharing the images with their respective seamstresses, or by copying the silhouettes themselves. Through Obeng's promotion of the kaba as a fashionable, adaptable and affordable form of Ghanaian attire, she undoubtedly contributed to the ensemble becoming the country's "national costume" for women.

Following the country's formal Independence from colonial rule, the *Sunday Mirror* reminded readers of Obeng's fashion exhibition. With the headline "Lovely Fashions!," there was no mention of the "traditional costumes" or "funeral wear" that were featured as part of the event; instead, the brief column focused explicitly on Obeng's "efforts to modify and adapt the traditional dress of Ghanaian women to suit all occasions."[46] Highly promotional, the column described the event as "an exhibition of new and attractive fashions which our women can wear with pride."[47] A previously unpublished photograph was included, featuring four women each wearing a unique kaba ensemble (Figure 3.2).

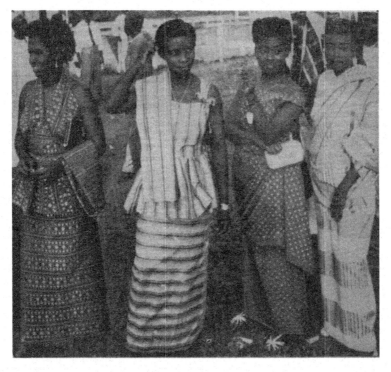

Figure 3.2 Four women, likely students, wearing a diversity of kaba styles from Dr. Letitia Obeng's "Gold Coast Traditional Costume Show" in Kumasi, 1957 (Image: *Daily Graphic* archive).

The column instructed readers to

> Look at the picture! Have a second look, and you will agree that the young
> girls look really attractive. That of course, is what first class fashionable dress
> can do to your appearance. Why not take a tip from these girls?[48]

As with the previously published photographs, the women wore dis-
tinctive kaba ensembles; one model wore a kaba blouse with a halter neck
and pleated peplum, another had narrow straps adorned with bows. All four
women's ensembles included the second wrapper, although in keeping with
promoting its inherent versatility, each woman displayed a different method
for wearing the second wrapper: over the arm; over the shoulder; around the
waist; wrapped in the style of a sari. The *Sunday Mirror's* repeated coverage
of Obeng's fashion show suggests that it was an influential event, promoting
the kaba ensemble throughout the country, but specifically for Ghana's elite,
educated population.

Following the offer of a six-month exchange program at Michigan State
University in 1958, Obeng continued her promotion of the kaba ensemble
overseas. As Obeng described, one of the highlights of her trip was being
interviewed by the university television station. As she recollected:

> I had of course been wearing my ntama all the time … and several girls in
> the dormitory and on campus had stopped to ask me about it. So I thought
> it was a fine opportunity to show its elegance and grace of the costume.
> The problem was that the interview was to be live and I would not have
> time to change to show the styles. A friend solved the problem for me.
> He found a lovely setting in a house and made slides of me wearing the
> different clothes. It was a successful show.[49]

Obeng's memoir included six photographs from this informally staged fashion
show, which unlike the photographs in the *Sunday Mirror*, were printed in
glorious color, hinting at the vibrancy of the original fashions she featured in
Kumasi.

The diversity of these kaba ensembles, in both silhouette and material, is
likely reflective of the renewed interest in Ghanaian forms of dressing following
Ghana's independence. At least two of the garments appear to be fashioned
from imported, European materials, likely silk and velvet, whereas the other
four showcase locally produced or locally meaningful textiles. A kaba ensemble
with a strapless "off-shoulder" neckline appears to have been sewn from a form
of imported wax print, consisting primarily of floral motifs. A second ensemble,
featuring a sleeveless ivory bodice, is paired with a skirt and wrapper of kente
cloth, in rather unusual, muted shades of green, gold and red. Although the
kente skirt appears to be sewn, it is an illusion; in an interview, Obeng clarified
that whereas the blouse was sewn, the skirt was merely wrapped and folded, as
she was not a proponent for cutting kente, particularly ones that were personally

and monetarily valuable.[50] What is most surprising is that the last two ensembles appear to be sewn from variations on tie and dye cloth. In a historical context, there is little evidence that tie and dye was considered a form of fashionable attire, making Obeng's use of the material rather unexpected. It could further evince Obeng's innovative approach to dressing, or that Independence resulted in a wider range of locally produced textiles gaining popularity among Accra's educated and elite citizens.

Following Obeng's Independence-era sartorial activism, it is unclear if her devotion to specifically Ghanaian forms of dress remained steadfast, although personal photos suggest she maintained an appreciation of Ghanaian fashion, which she clearly instilled in her children.[51] Her memoir is peppered with descriptive accounts of the cultural dress forms she observed throughout her travels, suggesting Obeng possessed a deeper appreciation of global dress and fashion, in its myriad forms.

Ghana's most sought-after dressmaker: Laura Quartey

As a researcher, I have been taught to continually question and interrogate the validity of primary sources. It is inherently easy for an individual to claim themselves to be the originator of a particular style or dress form, but their assertion might not be supported by existing historical documentation, casting doubt upon the veracity of their reflections and observations. Written accounts include their own forms of potential misinformation and bias, resulting in the continual questioning, and subsequent defending, of one's research. The scholarly need for substantiated evidence, from multiple sources and perspectives, is often in contrast with the primarily oral transmission of history found in many African countries, including Ghana. Accounts are passed down through family members, often retold with vivid, descriptive language that is both compelling and convincing. A conundrum is created: does one simply trust the detailed recollections of an individual, thereby championing the African voice, or is their perspective continually investigated, thereby negating the relevance of African oral histories?

I found myself in this exact quandary during my research on Laura Quartey, a largely forgotten, but purportedly influential dressmaker who predated Juliana Kweifio-Okai. My initial exchange with her daughter, Kathleen Ayensu, seemed too fortuitous; how could I have stumbled upon an earlier contributor to Accra's fashion culture with such ease and lack of effort? After conducting a formal interview with Ayensu, followed by a second meeting, complete with an exposition of carefully saved clothing, I was convinced. Ayensu's retellings were rich with descriptive details of her mother's career, coupled with names and dates that rivaled the archives I had explored in Accra. The garments were the most compelling; each was a testament to her mother's skill as a dressmaker, exhibiting impeccable finishing and an incredible range of luxurious, imported materials. I left feeling exhilarated, but also frustrated: I knew Ayensu's words alone would not satisfy the hallowed halls of academia. I had to find

some form of supporting evidence, and I discovered it in the most unexpected place: Johannesburg, South Africa.

During my postdoctoral fellowship at the Centre for the Creative Arts of Africa, I decided it would be prudent for me to explore the Bailey's African History Archive, with its comprehensive collection of *Drum* magazines. As I paged through countless issues of *Drum: Ghana*, I found the linchpin for demonstrating the relevance of Laura Quartey and the veracity of Ayensu's recollections: an article detailing Quartey's important role and contributions to Accra's fashion culture. Once I had made the connection, I excitedly emailed the scanned document to Ayensu, who shared my enthusiasm; she then asked: "Didn't you believe me?"

Outside of the *Drum: Ghana* article, there is minimal historical documentation of Quartey's career. Instead of dismissing her relevance, I have made the decision to champion the art form of oral history and the authority of Ghanaian voices, relying primarily on the interview conducted with Ayensu and my own observations of her garments. The result is an incomplete, yet compelling, account of Laura Quartey's sartorial contributions that attests to the relevance and importance of trusting one's collaborators. Quartey thus becomes a paragon for the countless, well-trained women who actively contributed to Accra's fashion culture, but who operated outside the country's popular media, their contributions catalogued by surviving family members and former clientele, waiting to share their stories and, ultimately, to be believed.

Quartey continually trained, albeit informally, in sewing and garment construction, forging an entire career, both in Ghana and overseas, through her abilities as an accomplished dressmaker. Laura Quartey (1928–2012) inherited her interest and skills in dressmaking from her mother, Kathleen Salome Odamtten (1893–1940).[52] A purportedly well-known and respected dressmaker in Accra, Odamtten regularly created garments for the city's elite citizens, including the wives of colonial officials. Quartey was unofficially trained by her mother, who taught her the basics of sewing and dress construction. As a young adult, Quartey attended nursing school in Kumasi, where she maintained an interest in fashion; she employed the skills taught by her mother to sew dresses for friends and classmates as a means of augmenting her income.[53] At some point in the late 1940s, Quartey's eldest brother, Dr. Charles Odamtten Easmon, invited her to live with him and his wife in Cape Coast.[54] It just so happened that Easmon's wife Genevieve (neé Dove) was trained as a milliner in the United Kingdom, having taken additional courses in dressmaking while her husband was completing his degree at the University of Edinburgh.[55] It was her sister-in-law who taught Quartey how to use paper patterns, expediting her sewing process, while adding a layer of refinement and tailoring to her garments. Following her marriage to Ghanaian engineer E.L. Quartey in 1952, she relocated to Accra in 1953. Within a year of her return, her career began in earnest, with her daughter reflecting that, since that time, "my mother has always been sewing."[56]

Operating primarily from her house in what Ayensu described as a "domestic business," Quartey became known among Accra's elite society as an accomplished dressmaker.[57] Her clientele was comprised mostly of expatriates and the wives of British, American and Ghanaian government officials: Lady Dinah Quist, wife of Sir Emmanuel Charles Quist, first Speaker of the Parliament of Ghana in 1957; Frieda Snelling, wife of Sir Arthur Snelling, the British High Commissioner of Ghana from 1959 to 1961; Helen de Freitas, wife of Sir Geoffrey de Freitas, the British High Commissioner of Ghana from 1961 to 1964; Alice Mahoney, wife of the United States Ambassador to Ghana from 1962 to 1965; Ruth Botsio, wife of Kojo Botsio, Ghana's first Minister of Education and Social Welfare and, under Nkrumah, the Minister of Foreign Affairs from 1958 to 1959 and from 1963 to1965; and Mary Edusei, the controversial wife of Krobo Edusei, who held various official positions during Nkrumah's presidency.[58] Later in her career, she even occasionally designed garments for Shirley Temple Black, who served as the American Ambassador to Ghana from 1974 to 1976.[59]

Quartey was not just a dressmaker to these elite women; she was their equal. Quartey was born into a prominent Ghanaian family and her husband was the first Electrical Engineer of the Ghana Electricity Department and the Chief Executive of the Volta River Authority (VRA), a position he held from 1966 to 1980. As an active participant in Accra's most influential and elite social circle, it was a combination of Quartey's social cachet and her skills as a dressmaker that helped establish her clientele of elite Ghanaians and expatriates.

The location of their homes played a crucial role in establishing Quartey's "domestic business."[60] From 1956 to 1966, the Quarteys lived at a bungalow in the Ridge area of Accra, which was home to a variety of government officials and civil servants. Ayensu recalled that their neighbors included the Inspector General of the Police, the Director of Ghana Prisons and the Head of Ghana Post and Telecommunications.[61] Quartey's physical proximity to these elite families allowed her business to informally flourish, while remaining inherently exclusive. When the family moved to their Ridge home, they commissioned an extension to be built, which functioned as Quartey's "atelier." With separate spaces for sewing, fitting clients, and a waiting area, this formal space elevated Quartey's dressmaking practice, imparting a sense of formality and luxury to her business.[62] The additional space was also practical; at the peak of her "Ridge period," Quartey employed six sewing assistants, indirectly attesting to her productivity and the popularity of her designs.[63]

Garments from this phase of Quartey's career focused almost exclusively on emulating European and American fashions, reflecting both the actual preferences of her diverse clientele and the influence of colonialism on Ghana's elite population. As Quartey related in her only known interview:

I remember a time before Independence … when I wouldn't make any native attire at all! It was then assumed by all that to make a nice fashionable outfit, it just **had** to be Western. National costume in wax prints were

preferred for work days only, and on the big occasions, we donned our Western dresses.[64]

This is supported by Ayensu's recollections that her mother sourced designs from *Vogue* pattern books, along with imported, couture magazines.

Although it is clear that Quartey actively borrowed silhouettes when necessary, Ayensu emphasized her mother's creativity with the following anecdote:

> They had a garden party once at the [Osu] Castle … In fact, every year they had one. And she [Quartey] would get up in the morning around five, "Oh God, I've got to make my dress, it has to be ready by four." So she was sewing behind the machine and when she thought she had finished, she tried the dress on. It was too long. So guess what she did? She decided to pull it up and she found it became like a puff. You see? So she cut the lining and turned up the dress so the whole bottom became a puff, what we called the "Balloon style." So mama was the first to wear the balloon.[65]

One of Quartey's earliest and most visible commissions, which has long been unattributed to her, was the execution of the first female flight attendant uniforms for Ghana Airways (Figure 3.3).

The uniforms mirrored the conservative, formal silhouettes that were a global standard during the 1950s, albeit adapted for the country's warmer climate. An entire passage was devoted to describing these uniforms in the *Sunday Mirror*:

> For their uniform, the airport's glamour girls wear tight-fitting, sleeveless and snow white dresses with lapel and collar, and straight skirt reaching

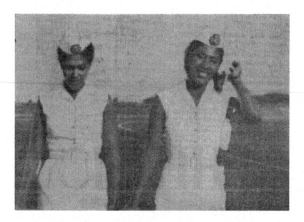

Figure 3.3 Two unidentified flight attendants wearing the first uniform for Ghana Airways, designed and executed by Laura Quartey, 1958 (Image: *Daily Graphic* archive).

about eight inches below the knee. Around their waists they use two-inch belts cut from the same white drill material and fitted with well-polished and shining brass buckles while glittering brass buttons are fitted down the front of their dresses from the neck to a little below the bust.[66]

Ayensu's own recollections illustrate, in intriguing detail, that her mother was indeed responsible for anonymously producing these uniforms.

> When Ghana Airways was first launched, the air hostesses used to wear pure white uniforms. My mom was the dressmaker selected to make the uniforms, so you'd see piles and piles of dresses and every air hostess was fitted individually. They used white cotton drill fabric; she'd cut them over the weekend and then we'd have to write in pencil each air hostess's name, so when the bus brought them for the fitting, we would know this is Janet's, this is Mary's.[67]

Ayensu continued:

> And then it had a stiff belt, the uniform was a straight skirt with a stiff belt, and the belt maker lived next to us, Auntie Sarah Moses. Her husband was the Director of Prisons, so this was his wife's business in the house. As kids, my sister and I would be dispatched to take the fabrics, folded with the measurements and the names on, to Mrs. Moses next door.[68]

Ayensu's recollections reinforce the interconnectedness of these elite women, and the informal nature of Accra's elite fashion culture. It further illustrates how fashions were produced and consumed prior to the introduction of Ghana's formally trained fashion designers.

Following Independence, Quartey's designs changed to reflect the burgeoning interest in distinctly Ghanaian fashions, resulting in garments that fused global styles with locally meaningful materials and dress forms. As Quartey observed: "Now the tables have turned and just the opposite is the case. Western dress is worn to work, but when we are required to dress up, it is generally cloth, with its many new variations, that we turn to."[69] Echoing Obeng's reflections, Quartey attributed this shift to a "developing sense of national pride. It is only natural that the African Woman should feel the dignity of wearing the native attire."[70] This sartorial shift was reflected in her own elite clientele, who began to regularly commission the creation of distinctly Ghanaian fashions, in addition to their European-inspired designs. As described by *Drum* author Beryl Karikari: "Mrs. Quartey has even made a wax print dinner jacket for a returning foreign diplomat. 'It was such a hit,' said Mrs. Quartey 'that I had many offers to go into the exporting of Ghanaian fashions.'"[71]

It was during this time that Quartey purportedly introduced an unusual, albeit thrifty, innovation, one that remains a significant part of Accra's fashion

and textile culture, particularly for foreign consumers: the introduction of patchwork wax print as a material for fashionable attire. As Ayensu shared:

> Because her turnover was quite big, there would be a lot of remnants after the dresses or outfits had been collected. One of the American ladies, I think her husband was head of AID, said "Oh, what are all these things? What do you do with all these things?" "Oh, I give them away, I throw them out," my mom said. "No, make me a skirt." So my mom made her an African patchwork skirt.[72]

Following this initial garment, Ayensu explained that her mother's clientele became increasingly interested in patchwork, resulting in its designation as a form of fashionable attire among a select group of Accra's elite citizens.

This potential contribution is important to acknowledge, as patchwork, or *nsaasaawa* as it is known in Asante Twi, has a history of being associated with necessity and frugality, as opposed to fashion and style. The material is made by sewing together leftover scraps of fabric, creating a larger piece that can be used as a wrapper or as material for a tailored garment; its very method of manufacture implies that it was an innovation born from necessity, as opposed to its visual impact. As documented by art historian Suzanne Gott, *nsaasaawa* was considered "the least desirable mode of African-print dress by those of limited means."[73] This is supported by the recollections of scholar Boatema Boateng, whose mother wore *nsaasaawa* only in the kitchen, as she did not want the soot and smoke to damage her "good" clothing.[74] As Boateng reflects: "my first association of *nsaasaawa*, then, was with thrift and utility and a way for women to stretch their wardrobes."[75] Quartey's use of *nsaasaawa* indicates that following Independence, wax print patchwork may have become a stylish, kaleidoscopic means for expressing Ghanaian heritage and culture, albeit by a particularly elite sector of Accra's population. It further demonstrates that the contemporary popularity of *nsaasaawa* among foreigners is not unprecedented, as Quartey's clientele included British and American expatriates. Most importantly, it illustrates the complexity of Accra's fashion culture. Many silhouettes and materials considered hallmarks of Accra's contemporary fashions are the result of earlier sartorial shifts and introductions, primarily as an indirect result of Ghana's Independence.

In July of 1966, following her husband's appointment as the Chief Executive of the VRA, the Quarteys moved to their second home: the VRA's official residence in the ambassadorial enclave. This change in address brought adjustments to Quartey's domestic business. Without her dedicated atelier and with the added responsibility of entertaining, Quartey ended her partnership with Ghana Airways, reduced her number of sewing assistants to one, and streamlined her clientele.[76] In spite of these amendments, Quartey continued to produce fashionable garments, as her proximity to Accra's elite society, albeit physically shifted, remained firmly intact. It is entirely possible that the family's move to the ambassadorial enclave actually enhanced Quartey's prestige as a

dressmaker, as she became accessible to an even more exclusive, niche community of cosmopolitan elites. As Ayensu poignantly reminisced:

> The wives used to come through the hedge; the High Commissioner's wife would pass through the hedge and into our compound to make her clothes … all the ladies would come, the Egyptian ambassador's wife would come, the Canadian ambassador's wife would come.[77]

This rather humorous recollection, which conjures images of wealthy, influential women traipsing through manicured yards, reinforces the inherently insular and protected, yet interconnected, community that formed Ayensu's clientele.

Following the establishment of Akosombo Textiles Limited (ATL) in 1967, Quartey's sartorial knowledge and social influences were acknowledged as a potential boon to the fledgling company. The following year, Quartey was hired as ATL's "Fashion Design Consultant," with the express interest of promoting their fabrics, specifically among Accra's elite population. Her official letter, as documented by historian Stephan Miescher, described her appointment as to "contact suitable artists and designers to produce textile designs for UTC."[78] She was also instructed to work directly with market women in both Kumasi and Lomé, Togo, collecting feedback in order to produce more sellable prints. Otto Huari, who was in charge of the United Trading Company's (UTC) textile department and who worked directly with Quartey, characterized her as "a gregarious woman, who had strong opinions and wore stylish wigs."[79] Although Huari insisted he had the final say on which designs would be printed, Ayensu recollected that "mum would have to sign off on every wax print or African print that UTC was printing in Ghana," attesting to the inherent importance and influence of her role within the company.[80] Huari also indicated that Quartey was charged with organizing ATL's fashion shows, implying that some of the designs included in the shows were likely her own. Quartey's position mirrored the one held by Kweifio-Okati at Ghana Textiles Printing (GTP), an indirect indicator of Quartey's status as an influential contributor to Ghana's Independence-era fashion culture.

It is unclear how long Quartey functioned in her role at ATL, but by 1984 Quartey and her husband had relocated to England, due to increasing political instability. By this time, Ayensu was living in the United States, attending law school. During one of her mother's visits, a rather amusing incident occurred, which serves as further evidence of Quartey's proficiency in sewing and garment construction. As Ayensu explained, she and her mother decided to visit the chain store Minnesota Fabrics. While there, her mother noticed a suede patchwork suit on display. Quartey impulsively removed the garment from its hanger and began inspecting the workmanship. Impressed, Quartey asked who made the suit; the employees then informed her that she could take classes with its creator at the store. After attending her first class, Quartey called her daughter and said "I graduated." Puzzled, Ayensu asked: "What do you mean?" Her mother explained that the class began with the instructor asking each

student to sew something on their machine; after examining what Quartey had produced, the instructor exclaimed "Madam, you do not belong in my class, you are already a graduate." He then offered to tutor her privately, so a few evenings every week the instructor would come to Ayensu's home and provide her mother with private sewing lessons. As Ayensu recollected:

> What the tailor accomplished with her was that he eliminated a lot of the handwork, such as stay stitching, tacking and hemming … so that when she was in the UK and didn't really have the quality help she had in Ghana, she could do a lot by machine.[81]

During her time in the UK, which represents the final phase of her career, Quartey found an entirely new clientele: Orthodox Jewish women. According to Ayensu: "90 percent of my mother's customers in the UK were Jewish ladies, because the Jewish have dress codes: long sleeves, maybe a high neck … so she learned all about Jewish culture."[82] Her connection to the Jewish community was through Joel Bull, owner of Joel & Son Fabrics, a well-respected fabric seller located on Church Street in the St John's Wood area of London. As Ayensu recollected, when her mother visited the shop, Bull would remark on her well-dressed appearance; after sharing that she made her own clothes, Bull began to send her customers, thereby helping Quartey build a largely British-Jewish clientele.[83] This speaks to Quartey's adaptability as a dressmaker and her willingness to create custom garments that reflected her clients' sartorial preferences; it serves as an additional, albeit informal, testament to her technical skill and her ability, as she became a sought-after dressmaker for an entirely new, albeit equally exclusive, community of women.

Quartey's inherent flexibility serves as an indirect indicator of the main distinction between Quartey, as a dressmaker, and Juliana Kweifio-Okai, as a designer: Quartey made fashionable attire that reflected her client's desires and preferences, whereas Kweifio-Okai created highly innovative designs that reflected her own unique perspective. Quartey's status as a dressmaker – an individual who has the technical ability to create custom, tailored clothing that reflects current fashion trends – does not imply that she lacked creativity or did not assert her own viewpoints in dressing her clientele. On the contrary, she regularly provided advice on what silhouettes were most flattering or stylish. Instead, it suggests Quartey's expertly crafted garments were the result of an exchange between customer and creator, commissions that relied on materials and design inspiration supplied, or at the very least approved, by her clients. This is not the case with Kweifio-Okai and Ghana's subsequent fashion designers, as they intentionally create garments that unapologetically assert their creator's sartorial preferences and experimentations. The artistry of Quartey's fashions, then, lie in their impeccable construction and tailoring.

Most importantly, Quartey did not describe herself as a fashion designer. This is most apparent in her *Drum: Ghana* interview; when a client encouraged her to begin exporting her designs overseas, she reflected that "being a busy

housewife, it was impossible."[84] Although this comment could be easily dismissed as an indicator of the patriarchal nature of Ghanaian society, it subtly speaks to Quartey's personal priorities. As a woman who had the social and economic means to establish her own designer brand, coupled with the technical ability to execute expertly tailored garments, she chose to maintain a more informal and exclusive coterie of sartorial devotees. Her lack of interest in becoming a fashion designer is expressed through her unintentional anonymity. When asked if her mother included labels in her garments, Ayensu responded: "No … in that respect she remained anonymous," adding that her mother would have asserted: "I don't waste my time. Everybody knows I made it."[85] Ayensu's own reflections support that her mother would not have considered herself a fashion designer. As she explained:

> I consider my mom more a dressmaker. A fashion designer can draw and maybe can't sew. I'd say mom was more a couturier. Yes, you can imagine, then you can translate. She wasn't the greatest of artists, but people trusted her judgment.[86]

Quartey continued to sew until her eighties, passing away at the age of 84. Although her surviving designs are limited, the garments function as material confirmations of her technical abilities and awareness of global fashion trends. Two of the garments, both casual dresses from the late 1960s or early 1970s, feature high-quality, imported fabrics. The off-shoulder dress with ruffled neck-line, sewn from a *Vogue* – Oscar de la Renta pattern, was fashioned from black cotton with detailed, machine embroidery (Figure 3.4). The second dress, with wide straps and a square neckline, employed a boldly printed cotton fabric, with an elaborate, oversized pattern of blossoming flowers in electric shades of purple, orange and coral. The execution of both designs illustrates an understanding of how to effectively cut and tailor materials with complicated motifs and designs, particularly in relation to the wearer's body. The off-shoulder dress demonstrates a particularly astute use of the fabric's scalloped edge, which Quartey employed as both a decorative flounce on the bodice and an additional, decorative tier on the skirt.

Ayensu's wedding dress, the most extravagant of the three extant garments, is a testament to Quartey's abilities. Inspired by a Norman Hartnell design for the British Queen Mother, the gown is fashioned from embroidered and plain tulle and satin, resulting in an ethereal garment that is simultaneously transparent and voluminous. The gown has elaborate puff sleeves, completely constructed from the aforementioned tulle (Figure 3.5), and scalloped flounces adorn the bodice and waistline of the dress. As with the previous designs, the gown captures Quartey's ability to cut and position fabric to its maximum effect. The embroidered tulle used for the sleeves is the same employed as the final overlay of the skirt, but Quartey's treatment of the material, particularly her isolation of specific designs for the sleeves, creates the illusion that they are two entirely different fabrics. What I remember most about the gown is

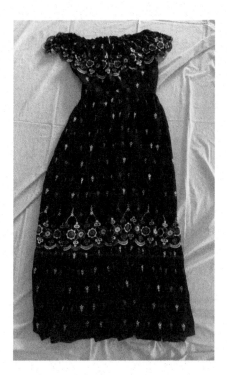

Figure 3.4 A circa 1970s' dress, sewn from a cotton fabric with machine embroidery, by
Laura Quartey (Image: Christopher Richards).

not its luxurious materials, nor its delicate gauziness, but its easily overlooked
hemline. It was carefully hand-finished with a narrow satin trim that elegantly
contrasted with the gown's tulle ruffle. It was the epitome of understated luxury
and exemplified the careful attention Quartey applied to her designs and what
likely garnered the trust and admiration of generations of clients; it should be
no surprise then, that Ayensu insists that her mother was most renowned for
her wedding gowns.

As a limited, albeit telling, collection, these three garments indicate the
continued relevance and importance of global, specifically European-inspired,
fashions, as part of Accra's fashion culture. Independence did not eradicate the
multiple spheres of fashion that were firmly in place in Accra; rather, it expanded
and diversified the city's sartorial landscape, allowing distinctly Ghanaian,
cosmopolitan fashions to exist alongside these previously established spheres.
This trio of garments has an even more powerful function: they acknowledge
an inherent bias in the current scholarship of African fashion – that, in order to
be meaningful or relevant, fashion contributors and their creations must reflect
a clear, and identifiably African, cultural heritage. Quartey's garments suggest
otherwise; her European-inspired designs are no less Ghanaian than Obeng's

Figure 3.5 A detail of the elaborate puff sleeves on Kathleen Ayensu's wedding dress, which was inspired by a Norman Hartnell design (Image: Christopher Richards).

variations on the kaba, or Kweifio-Okai's tie and dye ensembles. The adoption, emulation and reinvention of European-inspired, global fashions are critical and potent aspects of not only Ghana's fashion history, but of many countries throughout the continent. As scholarship becomes more accepting of dress forms that are not immediately, or even remotely, African in appearance, new histories will emerge, complicating and augmenting the sartorial narratives of influential locations like Accra.

In spite of this inherent scholarly bias, I would be remiss not to acknowledge the only known, documented design by Quartey that reflects a distinctly Ghanaian, cosmopolitan perspective. Dating from the early 1990s, the garment was originally created for a friend's wedding, but was later worn and photographed on the occasion of the Quarteys' wedding anniversary (Figure 3.6).

The formal evening ensemble is a variation on the kaba. It includes a princess line blouse with an exaggerated, partial peplum and voluminous, three-quarter length sleeves and a simple, ankle-length skirt. Sewn primarily from black crepe, the garment's most eye-catching feature is its inclusion of kente panels that extend the entire front of the garment. Instead of attempting to create the illusion of a single piece of kente, Quartey altered the orientation, using the kente border as part of the blouse's peplum hem, and again as a border

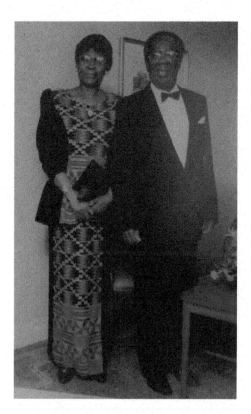

Figure 3.6 A photograph of Laura Quartey and her husband, Dr. Emmanuel Laud
 Quartey, taken on the occasion of their 40th wedding anniversary. Laura
 Quartey is wearing an extravagant kente evening ensemble of her own
 design (Image: Christopher Richards).

on the skirt. The juxtaposition of black crepe and complementary panels of
an iconic, Asante kente creates a dramatic effect, with an even bolder sartorial
statement: an immediate and irrefutable celebration of Quartey's Ghanaian
identity and heritage. When this garment is compared to Obeng's overseas pro-
motion of the kaba ensemble, it suggests that Ghanaians, particularly sartorially
inclined women, may turn to dress as a means for not only promoting, but
maintaining and preserving, their Ghanaian heritage.

 As underappreciated contributors to Accra's historical fashion culture,
Obeng and Quartey are paragons of the many women, both anonymous and
forgotten, who continually shaped and aided in revolutionizing Accra's vibrant
fashion culture. In an attempt to acknowledge these women, who continued to
contribute throughout the twentieth century, I will highlight a few who stood
out for their unusual designs and extensive training, further attesting to the
necessity of delving deeper into Accra's vibrant historical fashion culture. This

includes women like Caroline Sowah, whose career and edgy fashions were documented in a late-1960s' issue of *Drum: Ghana.*[87] Interestingly, the short article recounted that in 1959, when voted "girl of the month," Sowah informed the magazine that her ambition was to "contribute to the fashion revolution of our century – especially to perfect the Africa Line."[88] Sowah received fashion education in both London and Paris, with published photographs illustrating that she was adept at creating unusual silhouettes, exemplified by a square-neckline blouse with voluminous trumpet sleeves.

Mary Vroom Botsio, a member of the politically influential and elite Botsio family, had a two-page spread devoted to her fashions in a 1967 issue of the *Sunday Mirror.* Her designs, like the "VC 10," named after the British jet airliner, featured unusual V-shaped inserts and extensive embellishments.[89] Her garments also included a pair of pants and a skirt described as "hipsters" due to their low, curved waistline, which could easily have generated controversy among Accra's more conservative citizens.[90] Emeline Wuaku completed a two-year course in fashion design and ladies tailoring at the Barrett Street Technical College in London before returning to Accra in 1961. Although no fashions of hers were ever featured, the *Sunday Mirror* made it clear that she was one of the many women "designing, cutting, stitching and sewing night and day for your satisfaction."[91]

The one woman who likely matched Quartey and Kweifio-Okai in their skill and creativity was Nancy Tsiboe. Bearing the same name as her mother, who was the principal of Accra's Happy Home Institute, the younger Tsiboe received her first diploma in modeling from the Paris Academy in London, followed by a second diploma in fashion design from a Parisian-based institute, possibly the same school attended by Kweifio-Okai.[92] By 1968 Tsiboe, who was popularly referred to as "Miss Africa," had relocated to Kumasi and established the "Nancy Tsiboe Fashion House," where she designed garments that combined unusual silhouettes with culturally meaningful materials, like the "Sahara," a short dress with exaggerated sleeves sewn from Ewe kente cloth.[93]

Add to this seemingly unending list of creators the innumerable women, both named and anonymous, who regularly graced the pages of the *Sunday Mirror* for wearing their expressive and avant-garde fashions. Women like Felicia Johnson, whose "Paris pink nylon cocktail dress with ruched skirt trimmed with lace" received front-page coverage in 1957.[94] Or the women simply identified as Nancy and Mary, wearing matching kaba ensembles emblazoned with all sorts of phrases woven into the material, including "FUL / CAR" and "JAG," to celebrate Good Friday in 1958.[95]

It was this constant interplay and exchange between sartorial creatives and enactors, fueled by the social, cultural and economic upheaval spurred by Ghana's Independence and the renewed interest and pride in Ghanaian heritage and cultural practices, that created the space, and perhaps the need, for Juliana Kweifio-Okai, better known as Chez Julie, to emerge onto Accra's sartorial landscape. Her prominent and publicized career unofficially launched Accra's

enduring fashion culture, solidifying the nascent importance of cosmopolitan, nationalist fashions.

Informal fashion archives: the collections of Edith François and Kathleen Ayensu

Clothing is ephemeral. Fabrics rip and tear, stain, and gradually become threadbare; attempts at staving off the inevitable demise of a much-loved garment can be made, but in spite of an individual's best efforts, an article of clothing will inevitably disintegrate. The life of a fashion garment is even more capricious; in addition to the transience of its materiality, it often reflects a fleeting innovation of a particular moment in time, making it more susceptible to rapidly changing tastes. Like more utilitarian clothing, fashion garments are equally kept, worn, repaired and altered: sleeves can be removed, skirts are shortened, side seams are let out, all with the intent of extending a fashionable garment's life and ensuring its timelessness.[96] In truth, unless a garment is significant, either personally or historically (or both), it is rarely saved in its original form. This is particularly true in relation to Ghana's historical fashions; outside of devoted clientele and family, the creations of designers like Juliana Kweifio-Okai and Laura Quartey were not widely preserved. I remember a particularly poignant comment from Kweifio-Okai's sister, who admitted that after a major Ghanaian museum showed no interest in acquiring examples of her sister's designs, she simply gave many of her Chez Julie garments to charity, keeping only the most personally significant. This makes research on historical Ghanaian fashion particularly difficult and complex, as the only extant designer garments are found in the archives of individuals, spaces that are not entirely inaccessible, but that require much trust and collaboration to gain an entrée.

It wasn't until 2012, during my third and most extensive stay in Accra, that I became aware of Chez Julie. Her name was mentioned in passing, by an individual who described her nonchalantly as Ghana's first fashion designer. My curiosity was immediately piqued and, as I asked more questions, I was informed that the Chez Julie boutique was still in existence, located somewhere on Oxford Street. I was shocked by my own ignorance; I had walked, and subsequently avoided, Oxford Street on countless occasions. As the main thoroughfare of the Osu neighborhood, Oxford Street is constantly bustling with all manner of captivating characters: sellers hawking dashikis, jewelry and other cliché souvenirs, accompanied by the obrunis that purchase them; women purveying fresh fruits and vegetables; expatriates and Ghanaian elites populating one of the neighborhood's many iconic restaurants, boutiques and nightclubs; and Ghanaians in transit to, or actively engaged in, some form of employment. Add to this already frenzied jumble of agents a constant, yet fitful, flow of traffic, and you have Oxford Street. Entire publications have been devoted to this physical space, as a reflection of the uneven, yet persistent development of

Accra as an African cosmopolitan center.[97] And so I found myself navigating this throng of ever-moving bodies and vehicles to reach my destination: the Chez Julie boutique.

In my defense, it was a rather unassuming and nondescript shop. The building looked like all the others, expect for a sign that read in large, red letters: Chez Julie. I entered with a mixture of trepidation and excitement, feelings that often bubbled to the surface when I felt a moment of potential discovery or disappointment approaching.

After casually browsing the clothing, which included a variety of tailored shirts and dresses sewn from vibrant batiks and wax prints, I approached the shop attendant, provided her with my credentials, and asked if I could be given the owner's contact information. She steadfastly refused; instead, she suggested that I walk around the building and try my luck finding someone at the original family home. Confounded and frustrated by the woman's contradictory acts of secrecy and candidness, I walked down a small alleyway and through an iron gate, to find myself standing in the courtyard of a large, multi-storied home. I returned to this spot on several occasions, each time waiting for someone to emerge from the home, not wanting to appear invasive or discourteous. My persistence was eventually rewarded when, on one occasion, I was able to speak with a man who was assisting with repairs on the home. I tentatively explained my research interests to him and was surprised that he provided me with the name and phone number of Chez Julie's daughter Brigitte (I later found out this man was one of Chez Julie's sons). Brigitte and I have since laughed about this pivotal moment in my field research, as the family found it quite humorous that I, unknown and unannounced, arrived in search of their mother's personal history!

With Brigitte's assistance, I arranged a meeting with her aunt and Chez Julie's sister, Edith François. Following several interviews in 2012, subsequent visits to her home became akin to an informal pilgrimage; Brigitte and I, and on occasion her daughter, would journey together to "Auntie Edith's" house. Visiting Auntie Edith's is always a treat. Her compound appears austere and unremarkable from the outside, its high, white walls concealing a beautifully landscaped courtyard; her single-story home has a wide and welcoming verandah lined with pristine white pots, each holding a different type of flowering tropical plant. The space has a distinct spirit, one that reflects the refined elegance and graceful hospitality of its owner.

My first visit was particularly formal; we exchanged introductions, followed by an explanation of my research interests, all over a quintessentially British afternoon tea, complete with the most delicious meat pies I'd ever tasted. Once the tea service was cleared, Auntie Edith slowly began to reveal her extensive and comprehensive archive of Chez Julie ephemera. It began with a worn scrapbook, its black pages filled with all manner of newspaper clippings on Chez Julie. Page after page attested to Ghana's fascination with Chez Julie and her fashions, along with her sister's devotion to ensuring these fleeting moments were carefully and accurately preserved. The scrapbook was followed

by a slew of photographs, ranging from the carefully composed to the quick and informal, all attesting to the exceptional stylishness of Chez Julie's silhouettes. I was particularly drawn to the photographs that captured Auntie Edith wearing the same ensemble through various decades, the photographs transitioning from black and white to color; unbeknownst to me at the time, these photographs documented two of Chez Julie's earliest, surviving fashions: her kente kaba and Akwadzan. The photographs attested to Auntie Edith's continued adoration of these garments and their inherent timelessness.

And then came the actual garments. During that first visit, Auntie Edith showed me seven Chez Julie ensembles. Since I had no actual expectations of this visit (only fantasies of what could be), I was astonished by the distinctiveness and individuality of each garment. At least three were sewn completely from imported materials and appeared more global in their inspiration; two garments were sewn from locally produced tie and dye, and another dress was from a red and black wax print, presumably designed for a funeral. The ensemble that most captured my attention was an unusually shaped jacket and matching skirt, sewn from an emerald-green fabric printed with the *Dwennimmen* adinkra motif.[98] In hindsight, each garment attested to Chez Julie's innovative approach to fashion; the silhouettes, whether voluminous or streamlined, simplistic or intricately detailed, all spoke to a designer who valued experimentation. As someone well-versed in Accra's contemporary fashion culture, particularly young designers' penchant for wax print, I was struck by the diversity of materials in Chez Julie's designs that evoked Ghanaian heritage in immediate, yet unconventional ways. I quickly (and unprofessionally) photographed each garment on the living room floor, the resulting images forming a new archive that I found myself continually returning to as I documented Kweifio-Okai's career.

Amidst my digital photos of newspaper clippings, the remnants of a GTP calendar, and the hurried snapshots of Chez Julie fashions, there is one photograph that resonates deeply with me. It was a clandestine snapshot, one that shows a vacant, yet cozy, well-appointed sitting room. The polished coffee table, with its lace runner and decorative objects, is overwhelmed with stacks of ephemera; loose photographs, albums and scrapbooks litter the surface. For me, this rather mundane photograph is evidence of a critical moment: the beginning of a fruitful collaboration and academic journey, aided by the trust, generosity and dedication of Kweifio-Okai's family members. It is a reminder of the pivotal role of specific individuals in the research process and the power of these informal, yet informative, archives.

A more serendipitous encounter led to my collaboration with the daughter of Laura Quartey. It was during a visit to Sun Trade Beads in 2017, a shop known for its unconventional and exquisite beaded jewelry, that I found myself conversing with the shop's owner, Kati Torda, about my ongoing research on Ghanaian fashion. One of her other customers, a woman shopping for stylish, yet appropriate accessories for an upcoming funeral, interjected: "My mother was a fashion designer." I was surprised and immediately intrigued; past

experiences had taught that, oftentimes, the most informal encounters prove to be the most rewarding, so we briefly chatted and exchanged contact information. Approximately a week later, Kathleen Ayensu and I arranged to meet for a formal interview at the Kempinski Hotel, where she regaled me with detailed accounts of her mother's clients, creations and elite life in mid-twentieth-century Accra. I was unquestionably captivated, but my scholarly side remained secretly skeptical; in the hopes of assuaging all doubt, shortly thereafter I found myself traveling to one of Accra's outlying, exclusive enclaves, hoping to inspect and document a few surviving examples of this new, undocumented designer's garments.

Upon arriving at Kathleen Ayensu's home, I encountered another lush and captivating garden, reflecting its owner's penchant for orchids. This temperamental and delicate flower tends to grow rather effortlessly in Ghana, or at least that's what I'm told, and Kathleen's garden was a study in this confounding tropical peculiarity. The garden was arranged to highlight its number and diversity of orchids; in the middle of the garden was a large felled tree with orchids secured to its surface, their roots twisting and dangling in the open air. The garden felt fresh, as though most of the flowering plants were recent additions. It reflected that same latent potential that is symbolically embodied by the city itself, a stark contrast to the mature, established abundance of Auntie Edith's garden.

Kathleen's home was modern and refined, reflecting the tastes of someone well-versed in Ghanaian contemporary art. I distinctly remember a grand Ablade Glover painting that captured a variety of women in motion, their dark-brown faces and arms in contrast to their vibrant garments, formed from bold brushstrokes of tangerine, rust, salmon and gold. A short distance from this painting, Kathleen and I laid a white, cotton sheet on the tiled floor; with the stage informally set, she began to reveal a series of impeccably sewn garments, along with the stories that accompanied them. The garments of Laura Quartey had no semblance to Ghana, or even a generic Africa; they were primarily sewn from a variety of complex lace and eyelet fabrics, imparting a particular luxuriousness to her designs. What I remember most was each garment's attention to detail. Kathleen's wedding dress, a frothy confection of multiple, delicate tulles, had the most carefully and intricately sewn hems. It was a feat of craftsmanship, as were her other garments, tangible testaments to her mother's skill and training. Kathleen's archive even included fabric swatches, attesting to the variety of ensembles her mother had sewn for the weddings of influential and elite Ghanaian women (evidenced by accompanying photographs of the garments being worn). The garment I found most intriguing was not physically present; it was only visible in a single, enlarged photograph taken on the eve of a special occasion. The photograph captures Laura and her husband dressed in their finest attire; her husband wears a black tuxedo and Laura is dressed in a luxurious evening ensemble of kente cloth and black crepe. I immediately recognized the kente, as it was the same pattern and color scheme worn by paramount chief Nana Akyanfuo Akowuah Dateh II in an oft-cited Eliot Eilsofon photograph.[99] Quartey's evening ensemble attested to her experimentation with local forms

of dress, particularly kente, and provided additional evidence for her adeptness at tailoring, as the panels of kente on her blouse and skirt are perfectly matched, in spite of the blouse's complex peplum and contoured darts.

I left Kathleen's house feeling both exhilarated and confounded. Her carefully saved garments complicated Chez Julie's status as Ghana's first fashion designer, compelling me to consider the role of dressmakers and seamstresses as active participants in Ghana's historical fashion culture. The garments also forced me to acknowledge that many historical dressmakers and designers were likely creating British-inspired, global fashions; I thus had to contemplate how these locally made garments contributed to Accra's sartorial past. It was another turning point; a sign of more research to be done, all thanks to an informal exchange at Sun Trade Beads and the tenacity of a family in preserving their mother's sartorial legacy.

My research has benefited immensely from these informal archives that exist, carefully and lovingly stored away, in both the homes and minds of family members. I am continually struck by the generosity and hospitality of my collaborators, who invited an itinerant, alien researcher into their homes, plied him with tea and all manner of delicious, homemade refreshments, and willingly shared their personal recollections, both material and intangible. Not only have these families carefully preserved garments that are central to understanding the complexities of Ghana's historical fashion culture, they have documented these objects' lives, albeit unintentionally, through family photographs and memories that provide an incredibly rich account of the vibrancy and complexity of specific garments, their designers, and more of Accra's sartorial culture. This vignette is my soliloquy to these families and their continued trust in my research project; it is also a poetic call to fully acknowledge the power and importance of informal, often familial, archives and the acceptance (and pursuit) of those seemingly tenuous, yet serendipitous, research leads.

Notes

1 Phone Interview with Letitia Obeng, Gainesville, Florida, June 23, 2014.
2 Morre Bossman, "Letitia, Ph.D," *Drum* (December 1964): n.p.
3 Ibid.
4 Ibid.
5 Phone Interview with Letitia Obeng, Gainesville, Florida, June 23, 2014.
6 Suzanne Gott, "'Life' Dressing in Kumasi," in *African-Print Fashion Now!*, eds. Suzanne Gott, Kristyne Loughran, Betsy Quick and Leslie Rabine (Los Angeles: Fowler Museum of Art, 2017), 139.
7 Letitia E. Obeng, *A Silent Heritage* (Kew, UK: Goldsear, 2008).
8 Phone Interview with Letitia Obeng, Gainesville, Florida, June 23, 2014.
9 Letitia E. Obeng, *A Silent Heritage*, 159.
10 Ibid., 158.
11 Ibid., 158.
12 Ibid., 160.

13 Ibid.
14 Phone Interview with Letitia Obeng, Gainesville, Florida, June 23, 2014.
15 Ibid.
16 Ibid.
17 Letitia E. Obeng, *A Silent Heritage*, 161, 162.
18 Ibid.
19 Phone Interview with Letitia Obeng, Gainesville, Florida, June 23, 2014.
20 Ibid.
21 Ibid.
22 Letitia E. Obeng, 171.
23 Ibid.
24 Ibid.
25 Gott, Suzanne, "'Life' Dressing in Kumasi," 141.
26 Ibid.
27 Phone Interview with Letitia Obeng, Gainesville, Florida, June 23, 2014.
28 Ibid.
29 Letitia E. Obeng, *A Silent Heritage*, 179.
30 Ibid., 179, 180.
31 R.A, "Experiment with Native Costume," *Sunday Mirror*, Number 186 (February 24, 1957): 1.
32 Ibid.
33 Ibid., 8, 9.
34 All historical editions of the *Sunday Mirror* and *Daily Graphic* are archived in bound volumes. Unfortunately, this form of preservation prevents text located in the gutter (the area closest to the binding) of each volume from being legible without causing damage to the volume itself.
35 R.A, "Experiment with Native Costume," 9.
36 Ibid.
37 Ibid.
38 Ibid.
39 Ibid.
40 Ibid.
41 Ibid., 8, 9.
42 George P. Hagan, "Nkrumah's Cultural Policy," in *The Life and Work of Kwame Nkrumah*, ed. Kwame Arhin (Trenton, NJ: African World Press, 1993), 13.
43 Ibid., 13–15.
44 Ibid., 15.
45 R.A, "Experiment with Native Costume," 8.
46 "Lovely Fashions!" *Sunday Mirror* (February 9, 1958): 11.
47 Ibid.
48 Ibid.
49 Letitia E. Obeng, *A Silent Heritage*, 185.
50 Letitia E. Obeng, *A Silent Heritage*, 179.
51 A particularly stunning photograph of Obeng sitting on the rocky banks of the Niger River in Mali, likely taken in the 1980s, shows her wearing a skirt sewn from the iconic *nsuo bra* wax print pattern. The image can be found in her autobiography, *A Silent Heritage*, 362.
52 Interview with Kathleen Ayensu, Accra, Ghana, August 2, 2017.
53 Ibid.

54 Charles Odamtten Easmon (1913–1994) was an equally influential Ghanaian. He
 was the first Ghanaian surgeon general, the first dean of the University of Ghana
 Medical School, and performed the first open-heart surgery in 1964. He received
 his education at the University of Edinburgh.
55 Interview with Kathleen Ayensu, Accra, Ghana, August 2, 2017.
56 Ibid.
57 Ibid.
58 Ibid.
59 Ibid.
60 Phone interview with Kathleen Ayensu, February 20, 2021.
61 Interview with Kathleen Ayensu, Accra, Ghana, August 2, 2017.
62 Phone interview with Kathleen Ayensu, February 20, 2021.
63 Ibid.
64 Beryl Karikari, "The Africa Line," *Drum* (December 1964): n.p.
65 Interview with Kathleen Quartey, Accra, Ghana, August 2, 2017.
66 Oscar Tsedze, "Meet the Airport's Glamour Girls," *Sunday Mirror*, Number 243
 (March 30, 1958): 1.
67 Interview with Kathleen Quartey, Accra, Ghana, August 2, 2017.
68 Ibid.
69 Beryl Karikari, "The Africa Line," n.p.
70 Ibid.
71 Ibid.
72 Ibid.
73 Gott, Suzanne, "'Life' Dressing in Kumasi," 155.
74 Boatema Boateng, "Nsaasaawa," in *African-Print Fashion Now!*, eds. Suzanne Gott,
 Kristyne S. Loughran, Betsy D. Quick and Leslie W. Rabine (Los Angeles: Fowler
 Museum of Art, 2017), 158.
75 Ibid.
76 Phone interview with Kathleen Ayensu, February 20, 2021.
77 Interview with Kathleen Ayensu, Accra, Ghana, August 2, 2017.
78 Stephan F. Miescher, "Bringing Fabrics to Life," in *African-Print Fashion Now!*, eds.
 Suzanne Gott, Kristyne S. Loughran, Betsy D. Quick and Leslie W. Rabine (Los
 Angeles: Fowler Museum of Art, 2017), 89.
79 Stephan F. Miescher, "Bringing Fabrics to Life," unpublished version of essay, 13.
80 Interview with Kathleen Ayensu, Accra, Ghana, August 2, 2017.
81 Ibid.
82 Ibid.
83 Phone interview with Kathleen Ayensu, February 20, 2021.
84 Beryl Karikari, "The Africa Line," *Drum* (December 1964): n.p.
85 Interview with Kathleen Ayensu, Accra, Ghana, August 2, 2017.
86 Ibid.
87 "A Collection of Caro's Creations," *Drum* (May 1968): n.p.
88 Ibid.
89 "Abreast with Time," *Sunday Mirror*, Number 727 (July 16, 1967): 8, 9.
90 Ibid., 9.
91 "The Girls Behind Your Latest Fashions," *Sunday Mirror*, Number 412 (July 5,
 1961): n.p.
92 "She's Miss Africa …," *Sunday Mirror* (February 21, 1965): 1.
93 "New Dress Designs for our Women," *Sunday Mirror* (March 3, 1968): 8.

94 "She's All Set for a Date," *Sunday Mirror*, Number 203 (June 23, 1957): 1.

95 "Stepping out on Good Friday ...," *Sunday Mirror* (April 3, 1958): 10.

96 For more information on the importance of altered clothing, see the Fashion Institute of Technology's online exhibition *Fashion Unraveled*, https://exhibitions.fitnyc.edu/fashion-unraveled/?url=mended-and-altered/87.70.1-1.

97 For more information, see Ato Quayson's *Oxford Street, Accra* (2014).

98 Also known as ram's horns due to its swirling shapes, *Dwennimmen* is a symbol of humility coupled with strength.

99 This photograph was the opening image of *Wrapped in Pride: Ghanaian Kente and African-American Identity*, increasing its visibility and circulation.

4 "Paris-Trained, Osu-Domiciled"

Juliana "Chez Julie" Kweifio-Okai, Ghana's first fashion designer

On January 15, 1961, the *Daily Graphic* published the photograph of a well-coiffed young woman disembarking at the Accra airport.[1] She gazes directly at the camera with a hesitant half-smile; any assumed timidity or uneasiness is immediately dismissed by the woman's impeccable, confident attire. She wears a meticulously tailored ensemble: a jacket with exaggerated lapels over an empire waist dress of matching material. The accompanying headline heralded the arrival of "Julie – The Girl from Paris."[2] Twenty-eight-year-old Juliana Kweifio-Okai (née Norteye) was not Parisian, yet her return from Paris was a turning point in Ghana's history: it marked the beginning of the innovative and groundbreaking career of Kweifio-Okai, Ghana's first formally trained, post-Independence, fashion designer. By 1964, three short years after her Paris sojourn, *Drum: Ghana* had already declared "Chez Julie is a name known to us all, for really exclusive, high fashion."[3]

Expanding on previously published material,[4] this chapter will provide a detailed account of Kweifio-Okai's career and a robust assessment of her designs, including recently discovered garments featured in print media and in museum collections. Recreating an exact timeline of Kweifio-Okai's education and career is difficult; memories are often selective and articles in the *Sunday Mirror* and *Drum: Ghana* can be contradictory, particularly regarding specific dates and details, such as the intricacies of her training. Thus the following summation is inherently imperfect, but the potential deficiencies do not overshadow the remarkable sartorial trajectory of Kweifio-Okai and her celebrated fashion label. Through her cosmopolitan, nationalist designs, Kweifio-Okai seamlessly blended her Parisian training and globally informed approach to fashion with locally produced textiles and modes of dressing, creating garments that epitomized the newly independent Ghanaian woman. Kweifio-Okai revolutionized particular forms of historical dress, freeing them from their rigid and gendered original forms, offering Ghanaian women new and unconventional modes for dressing their bodies. She was a prolific and much-loved fashion pioneer who "paved the runways" for Accra's future designers, serving as "Ghana's ultimate reference point in the fashion business."[5]

Perhaps the greatest testament to Kweifio-Okai's fashions comes from her own clientele; when her daughter Brigitte Naa-ode Kragbé moved to Ghana in

DOI: 10.4324/9781003148340-4

2002 to manage the Chez Julie boutique, she recollected: "people would come and cry and tell me 'you've kept your mother's shop! I still have the clothes in my wardrobe, they don't go out of fashion.'"[6] Kweifio-Okai and the Chez Julie brand left an indelible mark on Accra's fashion culture, one that has remained largely unacknowledged, but that effectively permeates the majority of Accra's contemporary fashions.

"From Ministry Clerk to Dressmaker": the career of Juliana Kweifio-Okai and her label, Chez Julie[7]

Juliana Kweifio-Okai was born Juliana Norteye in 1932, the first daughter of 12 children. Her father worked as a civil servant with the colonial postal service; her mother was a homemaker who earned extra income by selling cloth and baked goods.[8] Due to the nature of his job, Juliana's father was frequently transferred to different cities throughout the Gold Coast, with his growing family in tow. After being transferred to work as a postmaster in Nsawam, the capital of the Akuapim South Municipal District, he decided his children should stay with their maternal grandmother and attend one of the city's mission schools.[9] Education was important to the Norteye family; all the children were encouraged to complete their schooling through Standard 7. Their parents' emphasis on education, particularly from an early age, undoubtedly influenced Kweifio-Okai and her siblings to seek tertiary education overseas.

When asked if Kweifio-Okai showed a penchant for sewing or dressmaking, Edith François, her younger sister, recollected: "I think it was a gift from God … even when we were growing up, she used to make toy clothes that we'd play with … When I was in school, she used to make my school uniform."[10] In addition to her informal, albeit practical, experience, François explained that Kweifio-Okai's domestic sciences teacher was particularly influential, not only educationally, but sartorially. "She was her role-model, she took from her. She was very fashionable. At that time, you would dress up [like the British]. If you are dressed up as a lady, you wore a hat, gloves, stockings, everything."[11] François' reflections are supported by a *Sunday Mirror* article which identified Kweifio-Okai's influential domestic sciences teacher as Mrs. Eleanor Sam.[12] A family photograph of Kweifio-Okai and her sisters Edith and Gladys wearing cowl-neck dresses attests to their emulation of British fashions. Her two sisters hold matching handbags, further suggesting the accepted notion that a "properly dressed" young woman is appropriately accessorized.

With her father's encouragement, Kweifio-Okai completed her high-school education, which was followed by jobs at the General Post in Kumasi and the Ministry of Education in Accra. She continued to sew, primarily as a hobby and to supplement her income.[13] It was during this time that Kweifio-Okai first appeared in the *Sunday Mirror* wearing one of her own designs. Published in November 1958 as part of the feature "These New Fashions," Kweifio-Okai was photographed wearing a dress she named "The Hall and Chamber Frock."[14] The sleeveless, knee-length silhouette reflected global fashions of the

time, but the contrasting fabric of the bodice, its distinctive details indiscernible, suggests a possible innovation. The unknown contributor foreshadowed Kweifio-Okai's successful career in fashion:

> Talking of fashion? This charming beauty has hundreds of them in her head. Be it warm or cold weather she has something new to wear. No wonder, for lovely Juliana Norteye is a fashionable dressmaker in Accra, who always has something smart to offer her customers.[15]

Around this time, Kweifio-Okai was awarded a partial scholarship from the Cocoa Marketing Board to continue her education overseas, specifically to gain formal training as a dressmaker. With her sister's assistance, Kweifio-Okai chose the Ecole Guerre Lavigne in Paris, France. François' recollections of this era are particularly relevant:

> There was something Nkrumah said, he wanted Africanization. So they [the government] put into process every promising Ghanaian who had talent … you'd be given a scholarship to go, train properly and come back … that was how I got … a government scholarship. So that's how it was.[16]

Kweifio-Okai departed for Paris either in late 1958 or early 1959. As François recounted, it was a particularly difficult transition:

> She had no clue what Paris was about, so she got to Paris and she couldn't speak French … everything was so strange, language-wise … She came in winter, so she didn't like the weather … she had culture shock, total culture shock … So she came to England and told me she was going back to Ghana. I said, "no way, there's no way you can go back, you're here already." So I took off and went with her to Paris … I had to coax her and encourage her that nothing is easy because I was also struggling to do something, so she really tried.[17]

François' words are particularly poignant, as they epitomize an entire generation of young, aspiring Ghanaians who challenged themselves to aid in revolutionizing their newly independent nation. A second recollection from François further attests to Kweifio-Okai's dedication, in spite of her personal struggles:

> I was to leave from Liverpool, to come back [to Ghana] and she came to see me off. She cried and said she was going with me. We went by train, got on the boat and I said "Julie, if you don't get down, the police will arrest both of us, so please I beg." She was so upset … By God's grace I could see her, on the dock, waving goodbye … I think she really resolved to go and finish quickly.[18]

It was this resolve that led Kweifio-Okai to complete her degree in two years, instead of the customary three. Following her graduation, Kweifio-Okai embarked on an informal tour of Europe, traveling to Germany, England, Austria, Belgium and Switzerland to further her knowledge of European fashion. Details regarding her learned skills are contradictory, but a 1961 *Sunday Mirror* documented that "she trained in dressmaking, designing and all aspects of fashions ... she developed her tastes in the application of cosmetics and the use of jewelry. She studied how to make artificial flowers too."[19]

Almost immediately, Norteye became the darling of Ghana's popular media. Six months after her return, the *Sunday Mirror* announced: "From Ministry clerk to Dressmaker, Julie – A Girl with Ambition ... She's 'queen' of fashions."[20] The adjacent photograph shows a smiling Kweifio-Okai sitting behind a desk, answering a telephone (Figure 4.1). Around her neck she wears a measuring tape; her left arm, adorned with a watch and wrist pincushion, rests on a dress pattern. As a portrait, the photograph silently asserts Kweifio-Okai's new role as a professional technically trained designer. In addition to reintroducing Kweifio-Okai to the citizens of Accra, the article attests to the rapidity with which she established her fledgling brand; at the time of printing, she had already opened a boutique and a school for dressmaking, with 12 girls under her tutelage.[21]

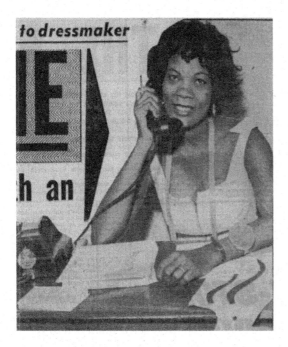

Figure 4.1 The informal portrait of Juliana "Chez Julie" Kweifio-Okai which asserts her role as a professional, technically trained fashion designer, 1961 (Image: *Daily Graphic* archive).

The aforementioned photograph's subtle allusions to Kweifio-Okai's technical abilities were no mistake; her training and subsequent approach to garment construction set her apart from Accra's established seamstresses and dressmakers. One aspect of her design practice that was particularly unique was pattern-making. *Drum: Ghana* writer Felicity Green observed: "I went to see Julie at work – and I was astonished to discover that she makes a separate pattern for every individual customer, measuring no fewer than TWENTY-TWO parts of the body in the process."[22] At the time, Kweifio-Okai offered the following explanation for her laborious technique: "I make separate patterns because, even if two people have the same measurements, there are bound to be slight differences."[23] This approach to dressmaking is particularly unusual in Ghana, as the majority of seamstresses and tailors use the "freehand" method, which involves cutting garment pieces with only a tape measure, chalk and scissors.[24] Kweifio-Okai's technical virtuosity, coupled with her unusual and innovative silhouettes, ensured that her designs quickly became the epitome of fashionable attire in Accra.

In addition to her formal training and unique designs, Kweifio-Okai possessed an incredible acumen for business and self-promotion. *Drum: Ghana* writer Felicity Green even characterized her as having a "shrewd business sense."[25] Kweifio-Okai organized annual fashion shows, with documentation suggesting they were consistently held at least through the 1970s, and possibly into the 1990s (her final publicized fashion show was in 1991). One of her earliest and most important fashion shows was part of the 1965 Organization of African Unity (OAU) Summit held in Accra. Under the official patronage of Ghana's first lady Fathia Nkrumah, the Council of Ghana Women organized what was described as a "one-night international fashion show, featuring designs from many parts of the world."[26] A week later, a published synopsis of the event attributed many of the Ghanaian designs to Kweifio-Okai.[27] Additional documented fashion shows from the 1960s include one held at Osu Castle and another as part of the first Ghana International Trade Fair in 1967.[28] *Drum: Ghana* documented one fashion show in 1970: held at the Accra Arts Centre, it was attended by over 300 people, and even included children's clothing.[29] Kweifio-Okai also exhibited her fashions outside of Ghana; during her 30-year career, she showcased her fashions in the United States, Finland, Canada and Cote d'Ivoire.[30]

Kweifio-Okai relied on Accra's popular media to indirectly advertise her latest designs. In one of her many front-page features, Kweifio-Okai is photographed with her friend Constance Wulff; the pair sport identical dresses, including matching necklaces, earrings and outrageous ruffled hats (Figure 4.2).[31] Although the article stated that these "sisters in fashion" did not plan their matching looks, this claim is rather dubious.[32] Instead, the women likely wore their matching ensembles, presumably sewn and styled by Kweifio-Okai, to make a particularly eye-catching statement, thus ensuring they would be photographed by the *Sunday Mirror*. Their duplicated dresses are similar to other Chez Julie designs from the 1960s. The silhouette is a simple sack dress with a boat neckline and three-quarter-length sleeves. The novelty is in

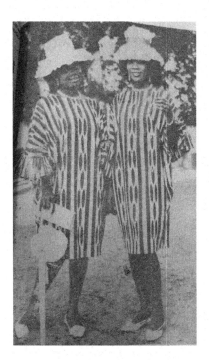

Figure 4.2 Kweifio-Okai and her friend, Constance Wulff, wearing purportedly unplanned, yet entirely matching ensembles, 1965 (Image: *Daily Graphic* archive).

Kweifio-Okai's treatment of the sleeves, which are trimmed with a profusion of ruffles. The fabric, too, is unusual; its pattern of vertical stripes alternating with clusters of elongated dashes makes for a particularly conspicuous statement. François even recollected that, when Kweifio-Okai devised a new design, "she would wear it and I would wear it, and then we'd go out," supporting this practice of self-generated publicity.[33]

In addition to her annual fashion shows and consistent coverage in popular media, Kweifio-Okai engaged in thoughtful collaborations that furthered the visibility of her designs and expanded her range of materials. Sometime after the formation of GTP in 1966, the company approached Kweifio-Okai to aid in popularizing their wax print fabric. According to François, when GTP released new fabrics, they would provide Kweifio-Okai with samples and she would organize a fashion show to feature these prints.[34] Selected designs would then become part of GTP's advertising campaigns, as evidenced by the remains of a GTP calendar discussed later in this chapter.

A second mutually beneficial collaboration was when Kweifio-Okai provided custom garments for the 1968 Miss Ghana winner Lovell "Rosebud" Wordie, who competed in the Miss World contest held in London that same year.[35] One of the garments Wordie was photographed wearing, a dress sewn from

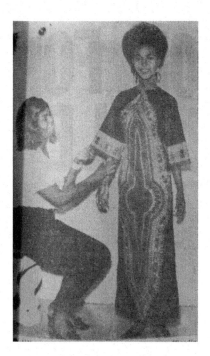

Figure 4.3 Kweifio-Okai and Lovell Wordie, winner of the Miss Ghana 1968 pageant, in a staged fitting for Wordie's garments, to be worn at the 1968 Miss World competition in London (Image: *Daily Graphic* archive).

the iconic "Angelina" wax print, can be conclusively attributed to Kweifio-Okai, as an image of Wordie being fitted for the gown by Kweifio-Okai was published in the *Sunday Mirror* (Figure 4.3).[36] It is likely that the majority of her garments, including her printed bathing suit, were designed by Kweifio-Okai and that the garments were sewn from GTP wax prints. It can be surmised that Kweifio-Okai made ensembles for several of the Miss Ghana recipients, a more indirect, but equally important, means for showcasing her fashions, particularly on a global stage.

Beginning in the mid-1970s, there is a noticeable decrease in fashion reportage, resulting in limited documentation of Kweifio-Okai and the Chez Julie brand. This should not be taken as a sign that Kweifio-Okai experienced declining success. Instead, it is likely the result of political and economic instability, brought on by successive coups and the subsequent military regimes that governed the country until 1992, when the first democratic elections were held. One of the primary leaders of this era, Flight-Lt. Jerry John Rawlings, instituted sweeping populist reforms, launching campaigns targeting Accra's elite, even creating committees that could examine the assets and bank accounts of individuals with amounts that exceeded a certain threshold.[37] Such public

anti-elitism likely had significant effects on Accra's designers, including Kweifio-Okai, as designer fashions, although a democratic preoccupation, are primarily consumed and commissioned by the elite. The Chez Julie brand persisted, operating outside the purview of Accra's popular media and its various military-controlled governments.

Kweifio-Okai marked the 30th anniversary of her brand in 1991 with a celebratory fashion show at the Golden Tulip hotel in Accra.[38] In addition to showcasing her latest designs, the fashion event highlighted her self-made, and purportedly underappreciated, jewelry and fabrics, including batik, tie-dye, "Splash" and screen-printed designs.[39] In 1993, less than two years after this noteworthy milestone, Kweifio-Okai passed away at the age of sixty. Her career as the sole designer for Chez Julie spanned a remarkable 32 years; that alone is an achievement, as few designers are capable of withstanding the capricious, fleeting nature of fashion, whether in Accra or another metropolis. It is a testament to Kweifio-Okai's continued relevance, sustained through her innovative, culturally meaningful designs that encapsulated the inherently dynamic, cosmopolitan identities of her clientele.

Following her death, Kweifio-Okai's daughter, a successful designer in Cote d'Ivoire, attempted to maintain her mother's boutique.[40] The venture proved to be prohibitively expensive, and the Chez Julie boutique was shuttered for several years. In the late 1990s, the successful Ghanaian designer Ricky Ossei, of the famed St. Ossei label, expressed interest in reopening the Chez Julie boutique. Kragbé recollected that he admired her mother's designs: "he would always stand at the window [of the boutique], looking. So as soon as he came, I knew he was the right person."[41] Ossei entered into an agreement with the family, even paying a year's rent in preparation for the reopening of the iconic, Osu-based boutique. Ossei planned to sell his own designs, alongside garments inspired by Chez Julie's original designs. Sadly, Ossei passed away in 2001, his proposal unrealized. Since the initiation of my research project, the Chez Julie boutique has been relocated and has two new locations, currently being run by Kragbé: one in the elite neighborhood of East Legon, the other inside the Palace Shopping Mall on Spintex Road. And thus, the legacy of Chez Julie persists through her daughter, with designs that emphasize the richness of locally produced textiles, particularly batiks, combined with impeccable tailoring and craftsmanship.

Using a loose chronological framework, this chapter will examine individual designs and clusters of garments as documented by popular media, family photographs and personal reflections. The majority of these garments fit into broader categories, reflecting shifts in Kweifio-Okai's approach to fashion design. Kweifio-Okai's most important designs, specifically her kente kaba and female Akwadzan, will be highlighted as indicators of her continued commitment to innovate, while actively preserving and promoting culturally meaningful forms of dress, exemplars of cosmopolitan, nationalist fashions. As an incomplete, yet robust, representation of her sartorial oeuvre, Kweifio-Okai's designs encapsulate Ghanaians' post-Independence

desires for celebrating their cultural heritage, while actively asserting their global awareness and belonging to an interconnected world. Whether directly inspired by French design or a careful fusion of European and African dress forms, Kweifio-Okai's designs continually reflected the ever-changing cosmopolitanism of Ghanaians, making her designs the epitome, and the apex, of Ghanaian cosmopolitan fashion.

"… A Parisienne Touch": Chez Julie's early designs[42]

As evidenced by the earliest documentation of Kweifio-Okai's designs, her initial fashions were inspired by European, presumably French, fashions. Her first *Sunday Mirror* feature following her celebrated return included photographs of two recent "Parisian" designs.[43] One dress, sewn from a floral print, featured an asymmetric halter neckline; the second dress, modeled by her sister Edith, included even more striking and unusual details, subtle testaments to Kweifio-Okai's newly perfected skills. François modeled the dress with skirt held out, drawing attention to its extensive and complicated ruching on the bias, which formed a subtle, chevron-like, patterning covering the entirety of the skirt. To achieve this effect, the skirt was assembled by alternating the direction of individual panels of ruched fabric, creating a textural pattern that appears to ripple. This method of assemblage is supported by the clear, vertical seamlines that are visible throughout. The upper portion of the bodice included additional, gathered fabric, whereas the rest of the bodice was left unadorned. A single rose, likely formed from the same material as the dress, was placed on the right side of the garment's drop-waistline. The presence of this flower supports the assertion that Kweifio-Okai received additional training to create artificial flowers as a form of embellishment.[44]

As is customary with the *Sunday Mirror*, a back view of the dress was provided, with François playfully looking over her shoulder to reveal the garment's surprise: its incredibly low back. The dress was styled with several strands of beads, which cascaded gracefully down François' back, and a pair of unusual three-quarter-length gloves, sewn from a spotted fabric or a material decorated with miniscule sequins. This dress in particular illustrates Kweifio-Okai's clear sense of a "complete" ensemble, one that is appropriately styled and accessorized. It further attests to her mastery of couture craftsmanship and her usage of completely imported, European fabrics to create her inaugural designs.

Although these dresses are the earliest documented designs following Kweifio-Okai's return, they are not her most celebrated. That accolade is reserved for the wedding gown with the "gay Parisienne touch." Through the examination of multiple articles from the *Sunday Mirror* and *Drum: Ghana*, the story of this particular design unfolds, illustrating how it captivated Accra's popular media, along with the city's elite citizenry and its followers of fashion. The gown's repeated features aided in legitimizing Kweifio-Okai's career as a French-trained Ghanaian fashion designer, serving as a means for promoting her fledgling brand.

On October 7, 1962, a smiling Kweifio-Okai graced the cover of the *Sunday Mirror*, striking a pose of delighted relaxation. The headline proclaimed "Julie's so glad IT IS OVER!" The accompanying article explained:

> For her brain-child, last week-end, gave bridal dresses in Ghana a completely new look. For weeks, this Paris-trained dressmaker sat down to design something new in bridal dresses; then she set to sew it. And when it was worn for the first time, the dress stole the show. Yes, "Julie" scores full marks, since the gown seems to be the talk of the town now. Says she: "I only gave it a bit of the French touch."[45]

The *Sunday Mirror* identified the "New Look" bride as Miss Olivia Dedei Kwaku and included a full photograph of the radiant bride, with none other than Kweifio-Okai attending to her train.[46]

Two weeks later, due to the apparent popularity of the design, a second article was published. Under the headline of "Fantabulous!" an unknown author wrote:

> At an Accra wedding two weeks ago, a bride's outfit set the women – and the men too – talking … and today, by popular request, the "Mirror" publishes the full-length back view of this first ever bridal gown designed and made by Paris-trained Juliana Norteye (Chez Julie) of Christiansborg, Accra. Yes, you have seen many bridal gowns before. But we bet this is something new … and quite a novelty![47]

Whereas the previous article published a frontal view of the gown, this second article focused on the back, particularly its train. Unfortunately, due to the age and condition of the original archived newspapers, coupled with the quality of the printed images, the garment's "fantabulous" qualities remain largely indiscernible.

Surprisingly, three months prior to the initial *Sunday Mirror* feature, *Drum: Ghana* published an article to which three photographs were appended, including one of Kweifio-Okai kneeling in front of an elaborate wedding dress (Figure 4.4). The caption read: "La Bell Julie adds gay Parisienne touch to wedding dress."[48] Although the article does not specifically mention the gown, the photograph attests to its extravagant, European-informed style. Due to the timeframe when this article was published, coupled with the similar descriptions of its "Parisienne" qualities, it is likely the same dress worn by Dedei Kwaku that received such acclaim in the *Sunday Mirror*. This photograph, with the wedding gown as its focal point, allows for an examination of the gown's possible "fantabulous" qualities.

The bodice of the wedding gown features a sweetheart neckline with complex pleating or ruching. The upper portion of the chest is covered with an elaborate lace overlay that forms a more conservative, boat neckline, in addition to full-length sleeves. The bodice is adorned with what appears to be a

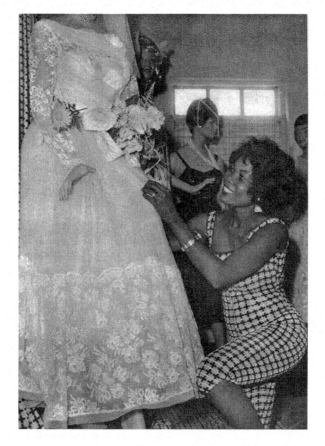

Figure 4.4 Kweifio-Okai making final adjustments to a wedding dress in her boutique, likely the same dress described as "fantabulous" and a "New Look" by the *Sunday Mirror*, 1962 (Image: Bailey's African History Archives).

single flower, providing additional support for the suggestion that Kweifio-Okai was trained in making decorative floral embellishments. The same lace on the bodice was used as a partial overlay for the full skirt, forming a wide band of lace along its lower portion. The entire skirt is likely fashioned from layers of tulle, as evidenced by its frothy, voluminous appearance. Additional flowers, likely artificial, appear to decorate the garment's waist, although it is unclear if they were part of Kweifio-Okai's design or a prop to create a more realistic display. Based on the photograph, it is possible that the gown's elaborate sewing techniques and luxurious, imported materials inspired its "New Look" moniker, although it ultimately remains unknown as to why it created such a sartorial sensation.[49]

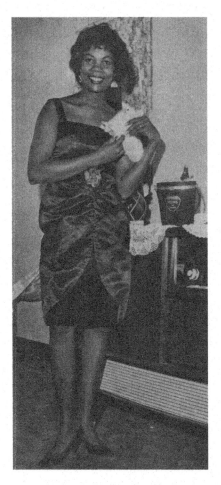

Figure 4.5 Kweifio-Okai modeling a European-inspired cocktail dress, complete with a handmade, artificial flower adornment, 1962 (Image: Bailey's African History Archives).

A second photograph from the *Drum: Ghana* feature shows a smiling Kweifio-Okai, modeling another one of her latest European-inspired designs. She wears a satin cocktail dress with a simple, square neck (Figure 4.5). The skirt is tailored to the body and forms a ruched, tulip-like overlay that reveals a knee-length underskirt of contrasting material and color. Similar to the aforementioned fashions, this dress included a fabric flower at the waistline, once again suggesting that Kweifio-Okai not only trained in crafting artificial flowers, but that she was actively experimenting with their use as a form of fashionable embellishment.

As a suite of designs, these cocktail dresses and wedding gown suggest that during her first year in Accra, Kweifio-Okai focused primarily on European, particularly French-inspired, fashions. This is likely because, as Ghana's first formally trained fashion designer, it was necessary for Kweifio-Okai to clearly distinguish herself and her creations from the existing culture of seamstresses and dressmaking. Kweifio-Okai differentiated herself by emphasizing her French training, creating complex designs that relied on specific sewing techniques including extensive pattern making, bias cutting, ruching, handmade, artificial flowers and other indicators of elevated craftsmanship. As the diversity of her garments expanded to include local forms of dress and textiles, her techniques remained constant, implying their importance to the Chez Julie brand and her identity as a designer.

Kweifio-Okai's early designs further indicate Ghanaian women's continued desire to wear European fashions. As demonstrated in Chapter 2, Ghanaian women were particularly adept at navigating multiple spheres of fashion, with European garments serving as indicators of wealth, stylishness and cosmopolitanism, particularly prior to Independence. By creating European-inspired fashions, Kweifio-Okai could appeal to Accra's most elite women, who were familiar with overseas designs and had an appreciation of European craftsmanship and materials. This is supported by François, who recollected that, initially, Kweifio-Okai imported her fabrics from Europe, including luxurious materials like Swiss lace.[50] Kweifio-Okai's immediate success suggests that her European-inspired fashions were not just accepted but embraced by Accra's elite society, fulfilling the media's lofty expectations of Kweifio-Okai as the "queen of fashions."[51]

It is important to acknowledge that these early, European-inspired fashions were not simply forms of mimicry; Kweifio-Okai employed the skills she had learned in Paris to create her own variations on silhouettes that may have been European in origin, but were made expressly for her Ghanaian and expatriate clientele. When asked directly about her designs "influenced by the boulevards and showrooms of Paris," Kweifio-Okai emphasized their distinctiveness: "I do not copy blindly. We cannot import every fashion into our Ghanaian setting. Those Western European fashion trends which need modification should be treated as such. But where they conform to certain needs I encourage them."[52] Not only did Kweifio-Okai emphasize her originality, she asserted her active role in literally reforming European-inspired silhouettes that she deemed unsuitable for the Ghanaian populace. Kweifio-Okai was more than an influential Ghanaian fashion designer, she was an arbiter of style, wielding her knowledge of fashion to influence the sartorial decisions of Accra's fashion-conscious women.

Although Kweifio-Okai's initial creations appear to be completely European-inspired, the 1961 *Sunday Mirror* article documented that "Julie had started working on several new creations to suit the African personality."[53] As Kweifio-Okai's most innovative designs, these garments fused French training and global silhouettes with local textiles and modes of dressing, becoming new,

post-Independence, forms of cosmopolitan, nationalist fashions that marked the onset of Accra's contemporary designer fashion culture.

"Creations to suit the African Personality": Chez Julie's cosmopolitan, nationalist fashions[54]

In 1964, *Drum: Ghana* published "The Africa Line," an article that explored the sartorial shifts instigated by Independence, specifically in Nigeria and Ghana. The writer interviewed Shade Thomas Fahm, Laura Quartey and Kweifio-Okai, women identified as being instrumental in the dress revolutions of their respective nations. Kweifio-Okai supported the author's assertion that "fashion with the African personality is in full bloom," stating: "I am delighted that at last our native dress has come into its own … I find that more of my customers are asking for cloth and for more creative styles."[55] The author added that Kweifio-Okai "hopes soon to work more with native fabrics and ideas and has some exciting styles in store for us."[56] The article was accompanied by several photographs of fashions from "native fabrics," including one attributed to Kweifio-Okai. Described as "Julie gives a new twist to the well-known 'Buba' style," the garment consisted of an ankle-length skirt, blouse with bell sleeves and a headwrap, all sewn from an identifiable wax print fabric.[57,58] This garment, the first documented wax print ensemble by Kweifio-Okai, alludes to the expanding significance of wax print in post-Independence Ghana as a stylish signifier of both Ghanaian and Pan-African identities. Due to the fabric's reinvigorated potency, and Kweifio-Okai's subsequent collaboration with GTP, wax print became integral to her designs. This section will explore several of Kweifio-Okai's wax print fashions, underlining her role in promoting wax print as a distinctly local form of fashionable dress, a perspective that is maintained by Ghana's contemporary fashion designers and consumers.

Although the foreign origins of wax print fabric are readily acknowledged by academics and traders alike, the material has maintained associations with African, and particularly Ghanaian, identity and heritage. This can likely be attributed to Ghanaians' early and longstanding interactions with the material. Ebenezer Brown Fleming, the Scottish merchant who first exported Dutch wax print to West Africa beginning in the 1880s, had strong, direct ties to the Gold Coast.[59] He was actively involved in adapting his designs to reflect the desires of his Gold Coast clientele. The ability of African women to directly influence the design and production of wax print is one factor that eventually led to its association with African identity; the other is the material's inherent adaptability. The initial wax prints that entered the Gold Coast market, largely imitations of Indonesian batiks, could be easily reinterpreted and localized by sellers and consumers. For example, one early Brown Fleming wax print included the Indonesian motif known as "lar," or the wing of a Garuda bird; divorced from its original meaning, the print became known as "Bunch of Bananas" or "Shell" in the Gold Coast.[60] These synchronous abilities, to influence the creation of

designs and to generate meaning through the reimagining and literal renaming of motifs, not only contributed to wax print's direct association with Ghanaian identity and heritage, but explains why the connection is so personal: Ghanaians have had a direct impact on wax print since its inception.

In spite of its accrued value and meaning over several decades, like any material directly linked to fashion, it fell out of favor, particularly with Accra's elite. By the early 1950s, there are virtually no photographs in the *Sunday Mirror* of women in wax print; the kaba ensemble, one of the main vehicles for wearing wax print, had also purportedly lost its sartorial appeal, becoming associated with women who lacked formal education, a clear indicator of one's social class.[61] This rejection of wax print changed with the granting of Independence; Ghanaians sought to express their newly found freedom through immediate, visual forms, particularly dress. As illustrated in Chapter 2, Accra's citizens began to embrace a new sphere of post-Independence fashion: cosmopolitan, nationalist fashions, which blended historical Ghanaian textiles and dress forms with global materials and silhouettes. Wax print was thus revitalized as a local or "native" cloth, becoming a once again beloved symbol of Ghanaian identity and heritage, albeit through innovative adaptations. This cyclical process of adoration and rejection, and the acknowledgment of novel approaches to wax print, is encapsulated by the pithy introductory quote from "The Africa Line" article: "our mothers chose the cloth. Our young women provide the fashion ideas."[62]

An additional post-Independence development that contributed to the reinvigoration of wax print was the opening of two factories on Ghanaian soil: GTP in 1966 and ATL in 1967. Being physically located in the country, the companies could literally produce more "localized" wax print: fabrics with familiar and meaningful patterns that were "Made in Ghana." However, because the fabric quality of GTP and ATL was initially perceived as inferior, imported wax print remained more desirable. Both companies needed to convince Ghana's market women and fashionable elite of the relevance and quality of their product; Kweifio-Okai and her brand became instrumental in this process.

A return to Kweifio-Okai's wax print "buba" ensemble suggests that she was one of the earliest proponents of wax print as a medium for designer fashions. Following her official collaboration with GTP, it is likely that the majority of her wax print designs, unlike her "Buba," were made with locally produced fabric. In a *Sunday Mirror* interview, Kweifio-Okai offered a recollection that encapsulates both her promotion of wax print and the general rejection of its localized version:

> I remember at that time, we were calling the material 'cedi cloth' because it was being sold for one cedi a yard … not many people were interested in African prints then. Those who did, preferred the imported ones from Holland.[63]

The author then asserted:

> it is against this background that Julie began what is considered as one of her greatest contributions to African and world fashion, and to Ghanaian industry. Soon she was combining an assortment of the GTP wax prints into unique designs and thus created awareness among Ghanaians about the beauty in wearing their own.[64]

It is true that Kweifio-Okai's designs likely contributed to the renewed appreciation of wax print, but more importantly, her adept use of the material, particularly her skill in manipulating its notoriously large motifs, resulted in innovative and flattering silhouettes that illustrated the versatility and wearability of wax print. Through this combination of originality and technical ability, Kweifio-Okai reinforced the importance of wax print to Accra's post-Independence fashion culture.

Kweifio-Okai's "Angelina" gown for Miss Ghana 1968 attests to her skillful use of wax print (Figure 4.3). The main motif of the iconic print is an elaborate, schematic representation of an embroidered neck yoke, a design inspired by the tunics of Ethiopian Christian noblewomen.[65] The pattern can easily be tailored into a ready-made tunic, but Kweifio-Okai took a completely different approach: she utilized the "yoke" pattern as the focal point for her design, with the motif extending from neckline to hemline. She then employed the pattern's border as "trim" on the garment's three-quarter sleeves, creating an overall design that required extensive cutting and tailoring. The result is a visually seamless design that cleverly isolates the pattern's most recognizable motifs, speaking to Kweifio-Okai's skill while offering new methods for tailoring a particularly iconic wax print.

Her 1970 fashion show at the Accra Arts Centre included at least three wax print designs, including one aptly named "four corners" (Figure 4.6).[66] The skirt and matching poncho were sewn from a presumably GTP wax print with a particularly unusual design: lines radiate outward from an unseen, central medallion; instead of ending, each line overlaps and interlocks with neighboring lines, creating a defined, yet dizzying, border of overlapping circles and undulating lines. Kweifio-Okai positioned the fabric so that the skirt's central feature is comprised of two of these adjacent borders, creating the illusion that the radiating lines wrap around the model's body, emphasizing her natural shape. For the matching poncho, Kweifio-Okai employed the same motif as an actual border. The presumably "four-cornered" poncho is worn with one corner in the center, creating an overall V-form with opposing corners draping gracefully over the model's shoulders. The radiating lines of the print converge along the poncho's neckline, gracefully drawing attention to the wearer's face. In spite of their differing orientations, the prints on the skirt and poncho complement each other, creating an unusual and eye-catching ensemble. Rather than cutting and tailoring a print to fit a particular garment, Kweifio-Okai designed novel

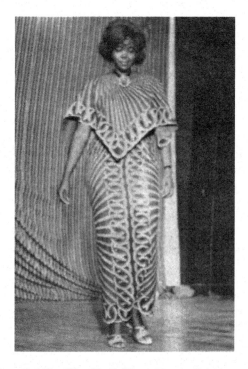

Figure 4.6 Kweifio-Okai's "Four Corners" design, unveiled at her 1970 fashion show, held at the Arts Centre in Accra (Image: Bailey's African History Archives).

silhouettes that would highlight the uniqueness of a print, while flattering the wearer's body.

The most direct evidence of Kweifio-Okai's continued collaboration with GTP is the remains of an undated promotional calendar featuring five ensembles attributed to "Chez Julie" (Figure 4.7). Photographs of the same models and garments were published in the July 10, 1971 issue of the *Sunday Mirror*, providing a relative date for these designs. The calendar is significant in that, outside of family photographs, it is the only documentation that illustrates her wax print designs in color, attesting not only to the vibrancy and beauty of GTP's prints, but to Kweifio-Okai's adeptness at using these complex multi-colored patterns to create innovative silhouettes. Her skill is best illustrated by an ensemble sewn from the iconic "Day and Night" print, which is comprised of two diagonally divided areas of contrasting patterns, in complementary, yet divergent, color schemes. As with previous designs, Kweifio-Okai cut her fabric on the bias, shifting the pattern's dividing diagonal line to vertical, creating a central line that divided her entire ensemble into two symmetrical halves. The result is a subtle illusion that implies two disparate fabrics were sewn together, as opposed to a singular print. This reorientation transforms the print's defined border into a decorative trim for the skirt, which Kweifio-Okai used to form

Figure 4.7 A circa 1970s GTP calendar featuring a suite of Chez Julie wax print designs; the "Day and Night" print ensemble is fourth from left, the *nsuo bra* fifth. (Image: Christopher Richards).

an unusual, tapered hemline. The result is a garment that functions as an advertisement for the skill and creativity of Kweifio-Okai and the versatility of GTP's wax print designs.

A third look, a dress with exposed midriff, exemplifies a different, but equally innovative technical approach: the isolation of specific wax print motifs as forms of embellishment. The wax print in question features the repeated motif of a small, solid sphere radiating dots that form concentric circles gradually increasing in size, creating a large, pointillist-like circle. The motif is often described as a sunburst or target; in Ghana, the fabric is called *nsuo bra*, or 'water comes,' as the motif evokes the ripples that form when drawing water from a well. For this garment, Kweifio-Okai removed several of the circular motifs from their background, employing them as a means for joining her long-sleeve midriff top to its matching skirt, creating a unified silhouette that simultaneously exposes and obscures the model's torso. Additional pairs of isolated spheres are attached to the finished edge of the sleeve, functioning as a dynamic form of trim. Both of these embellishments create an unusual illusion: that the wearer's body, specifically their lower arms and torso, functions as a replacement for the fabric's background. Kweifio-Okai uses the pattern's spherical motif to create an unusual, scalloped hemline, akin to the unique tapered hemline of her "Day and Night" ensemble.

Although these wax print manipulations may seem commonplace in Ghana's current fashion scene, this would not have been the case in 1971. Kweifio-Okai was the first well-known designer to actively alter and deconstruct wax print; the aforementioned ensembles are representative of her proficient and innovative use of the material, which ultimately contributed to its reinvigoration, and the subsequent promotion of Ghanaian wax print. Ultimately, Kweifio-Okai's wax print designs are indicative of Ghana's cosmopolitan, nationalist fashions: they are firmly rooted in materials embedded with Ghanaian history, meaning and culture, yet they are clearly informed by the global fashion trends of the time. In demonstrating that wax print was both a meaningful and suitable material for designer fashions, Kweifio-Okai solidified the material's role in Ghana's fashion culture, ensuring that, although it is both actively embraced and vehemently rejected by contemporary Ghanaian designers, it remains a fixture of Accra's designer fashions and its broader, sartorial landscape.

Designed in Lagos, sewn in Ghana: Kweifio-Okai's Nigerian-inspired fashions

Wax print was not Kweifio-Okai's only material for celebrating meaningful forms of African dress. Two features in *Drum: Ghana*, published six months apart in 1968, attest to the productivity of Kweifio-Okai and the expansiveness of her sartorial inspirations, particularly in relation to local forms of dressing.[67] The February feature, titled "Fashion – Chez Julie," included photographs of four distinct, named designs. Each garment was accompanied by a detailed description and suggestions for appropriate materials. Three of the designs were completely European in inspiration; the fourth design, a more casual ensemble titled the "Joromi Slacks-Suit," blended a global silhouette with a subtle nod to Ghanaian dress (Figure 4.8).[68] Consisting of a loose-fitting, short-sleeved tunic and matching capri pants, its eponymous feature was its extensive "joromi" embroidery on the neckline, sleeves and hems of both garments. The motifs are abstract and geometric, reminiscent of the designs found on men's batakari smocks, a subtle indicator of its Ghanaian inspiration, serving as a precursor to Kweifio-Okai's more pronounced adaptations of men's forms of dressing. Although the embroidery of the "Joromi Slacks-Suit" references local forms of embroidery, the ensemble is sewn entirely from imported material, as are the other three designs.

This is directly contrasted by the five designs featured in the July article "Chez Julie – In Person!" The majority of these garments were sewn from locally produced materials, specifically resist-dyed fabrics. Kweifio-Okai did not employ these materials in an expected or conventional manner; the overall silhouette for her blouse nicknamed "Kite" is similar to a kimono, with wide, loose-fitting sleeves that end at the wrist (Figure 4.9). The hemline is gathered at the waist, further emphasizing the voluminous and flowing nature of the sleeves, which likely contributed to its moniker "Kite." Evocatively described as having "rippling river-ebbing colours," it is likely the stich-resist material was

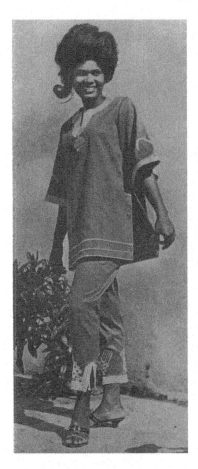

Figure 4.8 Kweifio-Okai's "Joromi Slacks-Suit," 1968 (Image: Bailey's African History Archives).

dyed with indigo, or a synthetic dye mimicking indigo, further suggesting the material was made locally.[69]

My personal favorite is the "Vampire Bat" (Figure 4.10); in describing the garment, the unknown *Drum: Ghana* author cheekily quipped: "Who's afraid of bats? Not Julie."[70] The silhouette is similar to a sack dress, with the addition of bell sleeves and a high, rounded collar. Although its color scheme is not mentioned, the material is likely an indigo-dyed, stitch-resist material, due to both the subtle irregularities of its motifs and its similarities to the "Kite" design. When examined together, the materials used for "Vampire Bat" and "Kite," particularly their abstract motifs, suggest that Kweifio-Okai may have acquired these hand-dyed fabrics from Nigeria, a possibility that is reinforced by a third design, the "Yaba."

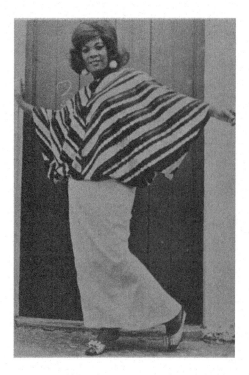

Figure 4.9 Kweifio-Okai's "Kite" design, 1968 (Image: Bailey's African History Archives).

The "Yaba" proves to be a compelling case study in the examination of Kweifio-Okai's historical designs and is the first documented fashion to incorporate a resist-dyed West African fabric. The design was debuted in an October 1967 issue of the *Sunday Mirror* under the headline "New Dress is Out."[71] The accompanying, anonymously penned column asserted: "a completely new dress craze has hit at the girls and this is called the 'YABA'."[72] The column continued: "According to Mrs Juliana Kweifio-Okai of Chez Julie in Accra, she designed the dress at Yaba in Lagos and that is why she calls it so. At any rate 'Yaba' was sewn in Ghana."[73] The column provides the following, somewhat vague description of the garment:

> the dress which is two piece has a long skirt which is sewn to fit with a rather long top. The mid-section of the front part is tucked in while the back, which floats, is sewn into the three-quarter sleeves. Made from the simple and inexpensive back print cotton, the "Yaba" is very catchy to the eye.[74]

The accompanying photographs, which show Kweifio-Okai again modeling her own design, are more telling. The front view of the "Yaba" shows a V-neck

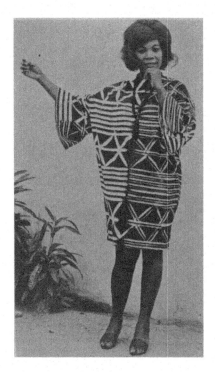

Figure 4.10 Kweifio-Okai's "Vampire Bat" design, 1968 (Image: Bailey's African History Archives).

blouse with three-quarter-length sleeves tucked into a tailored, ankle-length skirt (Figure 4.11). Kweifio-Okai employed bias cutting to transform the fabric's pattern of vertical stripes into a graceful diagonal. The sleeves ripple slightly on either side, hinting at their voluminous quality, obscured by the wearer's body. The back view reveals the design's unique feature: its billowing, cape-like sleeves (Figure 4.12). This form was likely created by seaming the sleeves along the shoulder, which would allow the front and back sleeves to be of differing lengths. For this version of the "Yaba," Kweifio-OKai made the back sleeves incredibly long, reaching almost to the ground. By employing a bias cut for the back portion of the sleeves, their fluidity is further emphasized, creating a dramatic sartorial statement. These billowing sleeves were shortened for the "Yaba" that appeared in *Drum: Ghana*, likely to allow for more mobility and versatility, and yet their diminished size still makes for an impactful, dynamic silhouette.

The *Sunday Mirror's* reference to "inexpensive back print" is confounding, as the fabric is clearly a form of resist dye, likely tie and dye.[75] When this original version of the "Yaba" is considered in concert with "Vampire Bat" and "Kite," a compelling narrative emerges. It is evident that Kweifio-Okai traveled to Nigeria prior to Fall 1967; during this trip, she was likely exposed to a variety of

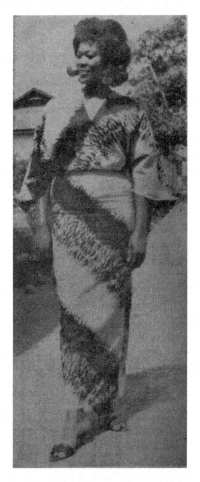

Figure 4.11 A front view of Kweifio-Okai's "Yaba" ensemble, 1968 (Image: *Daily Graphic* archives).

textiles and dress styles that influenced her own designs. The material used for "Vampire Bat" is particularly reminiscent of Yoruba stitch-resist, as its alternating bands of horizontal lines and its repeated star-like pattern are motifs frequently used in *adire* cloth. A strikingly similar pattern, with horizontal bands that alternate between a starburst motif and a series of vertical lines, was documented in 1971 as a pattern named "fingers."[76] Kweifio-Okai's "Kite" which features a more generic, diagonal pattern is almost identical to the *adire oniko* design *sabada*, which is achieved through a variety of fanfolds that are then tied, a more simplified technique for dyeing fabric that requires no stitching.[77]

Acknowledging that the textiles used for Kweifio-Okai's designs are comparable to Nigerian, specifically Yoruba, textiles provides a more nuanced

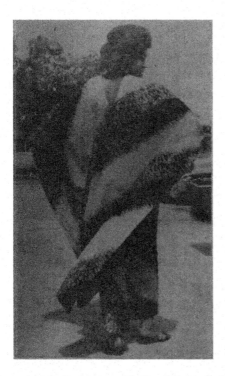

Figure 4.12 A back view of Kweifio-Okai's "Yaba" ensemble, 1968 (Image: *Daily Graphic* archives).

interpretation of a fourth garment from "Chez Julie – In Person." Simply named "Joromi," the high-neck, sleeveless dress was described as "ever popular, now fashioned into evening wear. Embroidered from neck to hem. Ideal for cocktails"[78] (Figure 4.13).

Unlike her previous "Joromi" ensemble, the motifs adorning the dress are unfamiliar; they do not share similarities to the embroidery on batakari smocks, nor do they appear to reference adinkra symbols, abstracted kente patterns or any other form of Ghanaian textiles. The central column of embroidery, divided into four rectangles, is sparsely decorated with spiraling lines, seven-pointed stars, the outline of a circle, and a repeating pattern of diamonds. The overall organization of the embroidery is highly reminiscent of *adire eleko*, an indigo resist-dyed textile that has an overall organization of squares filled with abstract, largely geometric patterns. The seven-pointed stars, which on the "Joromi" dress appear similar to palm trees, could be a variation on the floral design known as "leaves" or "stool," an eight-petaled, star-like pattern that is a common *adire eleko* motif. The repeated diamond pattern, which includes a dash or V-shape at each center, is also reminiscent of *adire eleko*, as patterns of diamonds and squares feature prominently in the hand-painted versions of these textiles.

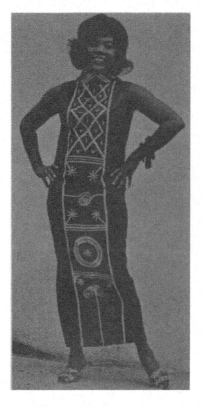

Figure 4.13 Kweifio-Okai's "Joromi" dress, 1968 (Image: Bailey's African History Archives).

The spiraling forms are more enigmatic. The lowest rectangle contains a narrow, vertical line that fans out at its apex, creating two symmetrical, spiraling forms. The central motif of the second rectangle from the top is also a spiral, formed by two horizontal lines that converge into a circuitous form. Although concentric circles are a common motif in *adire* cloths, a spiral, formed from a single unbroken line, is not. Meandering and sinuous lines play an important role in another Nigerian art form – *uli* painting, which decorated the bodies, public shrines and mud-walled compounds of the Igbo people, particularly in the early to mid-twentieth century.[79] Spirals, with particularly tight coils, are considered a predominant *uli* motif, and are strikingly similar to the spiraling forms embroidered on the "Joromi" dress.[80] It is plausible that Kweifio-Okai was exposed to *uli* painting during her trip to Nigeria, which may have informed her design's unusual, abstracted motifs.

Although the specific influences of Kweifio-Okai's "Joromi" dress are unknown, it is clear that the garment, along with "Vampire Bat," "Kite" and the original "Yaba," were all directly influenced by Nigerian forms of dress,

particularly *adire*. During the time of Kweifio-Okai's visit to Nigeria, *adire* was experiencing a period of reinvention and renewal. Following Nigeria's Independence in 1960, elite Nigerians and expatriates began employing *adire* as a material for shirts, dresses and other fashionable garments, in stark contrast to its previous use as a form of women's wrappers and men's sleeping cloths.[81] Synthetic dyes were introduced in 1964, resulting in new and bolder colors, that were also colorfast. Add to this the growing availability of imported cotton fabric, which allowed *adire* to be sold by the yard (as opposed to the prototypical two-yard women's wrapper), and you have what Jan Barbour characterized as an "*adire* revolution."[82] These innovations would have made *adire* more visible, and certainly more appealing to Kweifio-Okai, particularly as a viable material for her fashions. It is most likely that Kweifio-Okai purchased a variety of these "revolutionized" adire textiles to create the aforementioned designs, but there is another, particularly intriguing, possibility: Kweifio-Okai may have designed and dyed the fabric herself.

As documented by the *Sunday Mirror*, Kweifio-Okai actively made her own fabrics, including tie and dye, batik and "Splash." This is further supported by Edith François' informal archive, which includes photographs of a batik fabric designed and executed by Kweifio-Okai for François, and several surviving garments sewn from tie and dye attributed to Kweifio-Okai. It is entirely plausible that, during her trip to Nigeria, Kweifio-Okai not only observed this "adire revolution," but learned the techniques to make the patterns, particularly when it is acknowledged that the suburb of Yaba (the name of her first Nigerian-inspired design) is home to the Yaba College of Technology, which began offering fashion design courses in 1965. Kweifio-Okai may have interacted with instructors of fashion design and dressmaking at Yaba College, who in turn would have likely shared their local forms of dress, and possibly the techniques for producing them.

Although connections between Kweifio-Okai and Yaba College are pure speculation, as is the supposition that she made her own *adire*, it is clear that Kweifio-Okai's trip to Nigeria directly informed her 1967–68 designs, specifically the "Yaba," "Vampire Bat," "Kite" and "Joromi." This is significant, as African designers are often examined as solely innovating the dress practices of their respective cultures, unintentionally placing arbitrary limitations on the materials and forms they can reference and reinvent. Kweifio-Okai's Nigerian-inspired designs refute this inaccurate assumption, illustrating that she was engaged in adapting and innovating African forms of dress that were different from her own Ghanaian heritage, actively contributing to the established sphere of international fashions. It further suggests the interconnectedness of African cultures, specifically through the transportable and malleable forms of dress and textiles. This supports the assertion that the flows of African, and specifically Ghanaian, fashions were multidirectional; designers and fashion consumers were incorporating dress styles and textiles from a myriad cultures, both from within the African continent and beyond. In terms of Kweifio-Okai's own career, it demonstrates her expansiveness; as a designer, she was interested in

referencing a variety of local and global forms and materials, creating fashions that were the epitome of both cosmopolitanism and the Pan-Africanism that was being touted by many of Africa's leaders, Nkrumah included.

"It's Not Spoiled": Kweifio-Okai's kente kaba and Akwadzan[83]

Although Kweifio-Okai's Nigerian-inspired designs demonstrate her innovative and far-reaching approach to fashion, they likely had little impact on the established dress culture of Ghana, as they relied on materials and patterns that were foreign or culturally irrelevant to most Ghanaians. This was not true of all her fashions. In the late 1960s, Kweifio-Okai created two designs that reimagined established, culturally meaningful textiles and modes of dressing, directly contributing to Ghana's post-Independence sartorial revolution. These garments, the kente kaba and Akwadzan, are also the earliest surviving examples of Kweifio-Okai's designs, kept by François because of their personal significance and enduring stylishness.

In a summation of her sartorial contributions, the *Sunday Mirror* traced the 1990s' resurgence of tailored kente fashions to the initial efforts of Kweifio-Okai: "some elderly Ghanaians also recall that the current kente craze which involves the combination of plain fabrics and kente was introduced way back in the 60s under the Chez Julie trade name."[84] As documented in Chapter 2, the earliest ensemble that combined kente with imported fabric dates to 1958, its creator unknown. Although this original, innovative garment predates the establishment of Kweifio-Okai's brand, due to her recognition as Ghana's first fashion designer, it is understandable that she would be credited with the "kente craze" or "kente reformation": she was likely the first recognized Ghanaian designer to create tailored fashions from kente cloth.

Kweifio-Okai may have designed kente fashions that predate the kente kaba, particularly if she designed for Ghana's First Lady Fathia Nkrumah; however, François' ensemble is the only known extant kente ensemble attributed to Kweifio-Okai. Neither was it her last experimentation with kente, as documentation suggests she incorporated kente into many of her fashion designs.[85] As a garment, the kente kaba ensemble is particularly intriguing, as it is an inherently contradictory design, innovative in its material, yet conventional in its form (Figure 4.14). The short-sleeved kaba blouse, with its conservative, rounded neckline, is relatively understated. It possesses a single innovation: the addition of a wide band of kente sewn to the bottom of the blouse, forming subtle, horizontal pockets. Kweifio-Okai cleverly fashioned this band from the border of her chosen kente cloth, creating the illusion of a truncated kente, distilled into kaba form. The kente used for this ensemble features two main warp patterns: *babadua*, named after a bamboo-like cane, and *wotoa*, which evokes the appearance of a snail's shell.[86] Its weft patterns alternate between *nkyimkyim*, or zigzag, and a variation of *kawo*, or centipede.[87] The cloth's saturated colors are limited to blue, green, red and gold. This

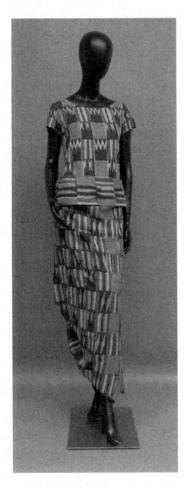

Figure 4.14 Kweifio-Okai's kente kaba ensemble, c. late 1960s – early 1970s (Image: Samuel P. Harn Museum of Art).

color scheme, coupled with its exclusively geometric patterns, suggests that it is a quintessential, mid-twentieth century Asante kente; this is important to acknowledge, as its iconic appearance contributed to the garment's inherent timelessness.

By the late 1960s, tailored kente ensembles would have been a familiar sight to Ghanaians, particularly via popular media, but François maintained her kente kaba was controversial, particularly with her husband's family. Upon seeing François' ensemble, her mother-in-law purportedly exclaimed: "Oh, you've spoiled your kente!"[88] François did not agree; in hindsight, she defended her sister's design by stating "you'll wear it and you'll wear it and you'll wear it and it's not spoiled."[89] François' comment indicates the importance of transforming

kente into a more wearable garment, maintaining the textile's relevance by diversifying its form.

François' divergence from her mother-in-law hints at an additional distinction: that the supposed controversy over cutting kente may have been generational. François and Kweifio-Okai, as representatives of a generation of newly independent Ghanaians, were seeking novel means for celebrating their heritage while demonstrating their worldliness. Tailored kente garments embodied this fusion, blending a culturally significant material with globally informed silhouettes and styles, resulting in cosmopolitan, nationalist fashions. Older Ghanaians may have viewed this as an affront to tradition, as it was a drastic departure from the accepted modes for wearing, and most importantly preserving, kente cloths.

Whereas Kweifio-Okai's kente kaba is innovative in its materiality, exemplifying Ghana's "kente reformation," the matching skirt is a study in classic modes of Ghanaian dressing, perhaps even a subtle homage to what Kweifio-Okai sought to transform. By the late 1960s, the kaba ensemble had been amended to include a slit: a sewn skirt finished with either a drawstring waist or zipper. The resulting silhouette appeared more finished and required less adjusting than its predecessor, the archetypal wrapper: a simple, rectangular textile that would be wrapped and securely folded or tied around the waist. Surprisingly, the original skirt for Kweifio-Okai's kente ensemble was designed as a wrapper, thereby perpetuating one of the very modes of women's dress Kweifio-Okai sought to transform! This apparent contradiction reveals the inherent value of kente cloth. Due to its expense and physical malleability, kente is regarded as an enduring form of inherited dress, a potential family heirloom that can clothe multiple generations. Once a kente cloth is tailored, its adaptability, and thus its permanence, is drastically negated. By incorporating a kente wrapper into her kaba ensemble, Kweifio-Okai ensured the textile would maintain its permanence. It also allowed for convertibility; the wrapped skirt could be worn with a blouse of imported material or substituted for a wrapper of contrasting color and pattern, thereby creating an entirely new look. By maintaining the textile's archetypal form, Kweifio-Okai reinforced its relevance to Ghana's fashion culture.

The conservative elements of Kweifio-Okai's ensemble, namely the understated design of the blouse and her inclusion of a wrapped kente skirt, seem at odds with the overarching innovation of tailoring kente. When combined with the textile's iconic pattern, this constellation of sartorial features reveals a key tenet of Kweifio-Okai's most influential and historically significant designs: timelessness. When characterizing her sister's clothes, François described them as "evergreen," implying that they are perpetually wearable, stylish and innovative.[90] I believe achieving a degree of timelessness was critical for Kweifio-Okai, particularly when designing garments that reinvented established forms of Ghanaian dressing. Kweifio-Okai was not attempting to erase sartorial traditions, she was literally reforming them to reflect Ghanaians' renewed interest in their sartorial heritage; in that transformation, she ensured their sustained relevance. This likely contributed to Kweifio-Okai's continued

experimentation with kente cloth, adapting the material to a variety of wearable and fashionable silhouettes.

Kweifio-Okai's most powerful sartorial reinvention was the introduction of her Akwadzan (Figure 4.15). Instead of physically altering a historically meaningful textile, the Akwadzan, named after the Ga term for wrapping a body with cloth, sought to expedite an established practice for dressing the body. In the published retrospective of her career, *The Sunday Mirror* dated its introduction to 1969, which was corroborated by François.[91] The first historical documentation of this design dates to 1971, when it was unveiled at the International Trade Fair in Accra. Announced under the headline "Something for the Men Too," the premiere of the Akwadzan was encapsulated as "for the first time in the history

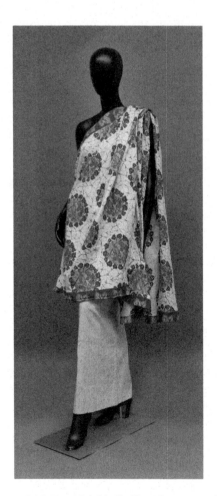

Figure 4.15 Kweifio-Okai's Akwadzan ensemble, c. late 1960s – early 1970s (Image: Samuel P. Harn Museum of Art).

of Ghanaian fashion, the men's cloth has been converted into a manageable outfit."[92] As implied by this celebratory quote, the purpose of the Akwadzan was straightforward: to create a garment that mimicked the appearance of a wrapped textile, but eradicated the need for any wrapping or adjusting. The inspiration for Kweifio-Okai's innovation was the "complaints from men about their inability to wear cloth in the correct way."[93] With the advent of the Akwadzan, the *Sunday Mirror* asserted: "No more will the house be full of pre-outing crisis of 'Oh this cloth! or 'I just don't know how to manage it!' Just slip your 'ntama' or 'Akwagyan' over your head and you're all set."[94] In terms of sartorial significance, the article compared Kweifio-Okai's invention to the introduction of the slit, or tailored skirt, as part of the kaba ensemble. The article further documented that Kweifio-Okai was considering mass-producing her Akwadzan, with the unknown author proposing two aspirational results: that "the 'Akwagyan' will attract foreigners too in just the same way as the Nigerian or Hausa robe has, and this might make it marketable abroad"; and "let's hope that we'll see more of our men in cloth at public gatherings."[95]

The surviving Akwadzan is sewn from an unusual wax print likely produced by GTP. The main motif, printed in saturated shades of maroon and chartreuse, is a repeated medallion containing the image of a bird among branches, bordered by a halo of heart-shaped leaves. The print's narrow maroon border contains a pattern of highly detailed chartreuse leaves with pronounced veining. The fabric's printed crackling, a hallmark of wax print, is particularly exaggerated; its meandering maroon lines are even more conspicuous against the fabric's cream background. This female version of the Akwadzan was originally designed with a complementary chartreuse skirt, creating a harmonious, yet bold, sartorial statement. Surviving press photographs suggest that, for men, the Akwadzan was sewn from both wax print and adinkra cloth, paired with matching shorts.

The straightforward appearance of the Akwadzan belies its clever construction. The design, which required eight yards of material to complete, is essentially a one-shoulder tunic with a finished, asymmetrical neckline.[96] Sewn to the left armhole are several yards of fabric which, when folded over the shoulder, create the illusion of a textile-wrapped torso. The underlying silhouette is relatively tailored, ensuring the wearer's right shoulder is the only exposed area of the body. The inherent complexity of the design was informally affirmed when, after promising the Akwadzan to the Samuel P. Harn Museum of Art, François attempted to have it replicated. After several seamstresses in Accra failed to execute a copy, François sewed a facsimile herself. The seamstresses' inability to duplicate the Akwadzan speaks to Kweifio-Okai's skill and originality as a designer, in addition to the intricacy of the Akwadzan's construction.

Not only was the Akwadzan continually described in press coverage as a form of attire exclusively for men, its appropriateness for men was emphasized to the point of exaggeration. The third and final photograph of the Akwadzan showed Chez Julie model "Big Boy" proudly wearing the male version, accompanied by the following caption: "Big Boy poses majestically in the 'Akwagyan' which seems to have lost none of the traditional cloth's manliness in its creation."[97]

In one sentence, the unknown author loads the Akwadzan with the stereotypical values often attributed to wrapped kente cloth, particularly when worn by chiefs or other socially powerful men. The quote also references the notion of tradition, a concept which is addressed more obliquely in the following quote: "the wearer has no difficulty in managing his cloth just as easily as his grandfather and with pretty much the same distinguishing effect."[98] In essence, the writer is asserting that the historical potency of wearing a wrapped textile is not negated by the Akwadzan; in fact, the legitimacy of the Akwadzan comes from its adherence to and maintenance of historical, purportedly male, dress practices. Even the article's headline, "Something for the Men Too," places the introduction of the Akwadzan in opposition to women's fashions, implying that Ghanaian men had been overlooked and forgotten by Accra's female-oriented fashion culture.

And yet, in spite of all the assertions of the Akwadzan's inherent "maleness," the only surviving example was worn for decades by François. When first reflecting on the design, François described it as unisex, immediately rejecting the rigid, gendered limitations placed on the Akwadzan by the press.[99] The acknowledgment that women could, and did, wear the Akwadzan complicates its recorded history and illuminates one of the most powerful, yet unappreciated, elements of Kweifio-Okai's approach to design: her desire to deconstruct rigid, gendered modes of local, Ghanaian dress.

As a form of historically rooted dress, the act of wrapping a torso in cloth, often referred to colloquially as an "over-the-shoulder" style, is primarily the prerogative of men, particularly of elite status. However, there are specific contexts in which women can wear the "over-the-shoulder" style. Identified by the Asante as the *dansinkran*, the female version of the "over-the-shoulder" garment is typically worn by women of advanced age or social status, specifically Queen Mothers or chief mourners at funerals.[100]

Historical documentation from the Independence era illuminates how Ghanaians viewed the *dansinkran*. As part of the reportage on Letitia Obeng's 1957 "Gold Coast Traditional Costume Show," a photograph was included of a young woman modeling an ensemble consisting of an elaborately wrapped headdress, a wax print wrapper, and an "over-the-shoulder" wrapper. The accompanying caption described the ensemble as follows: "you will think this young woman has just returned from a funeral. But this true-to-life picture shows the model depicting a Densikran woman returning from a funeral."[101] Its funerary associations are apparent, if not overstated, but the caption's title, "Old Styles," evokes an important distinction: that during a time of sartorial experimentation and alteration, the *dansinkran* remained static. Furthermore, the article characterized the *dansinkran* as part of the "ancient styles, no longer in vogue," which included the Fanti "tekua" and other forms of dress deemed representative of specific cultural groups.[102] In the context of Obeng's fashion show, the distinction is clear: the kaba was being revolutionized, whereas the other "costumes" were fixed and outdated, in need of preservation.

This sartorial separation continued well into the 1960s; the 1967 "Fashion Extravaganza," organized by the Young Women's Christian Association, was designed to "delve into the traditional attires of the various tribes of the country. There were also the usual Western styles on show."[103] In planning the fashion show, the article stated that committee "visited several villages to acquaint itself with the proper styles of the past."[104] Accompanying the article were two photographs that attested to the enduring dichotomy of "ancient," static styles with their revolutionized counterparts. One photograph depicted the attire of a "Dagomba princess" from the Northern region of Ghana; the other, a woman wearing a tailored dress with collar and scarf of kente, complete with complementary kente-covered buttons.[105] The Dagomba ensemble is presented as the antithesis to the tailored dress with kente flourishes. The *dansinkran* was again employed as a foil to more contemporary styles of Ghanaian dressing as part of the 1968 Royal Commonwealth Society celebration.[106] The author described the show, which included an array of Ghanaian fashions, as follows: "some of the mannequins were dressed in Ghanaian costume ranging from the old DensiKran [sic] to the with-it teenage style."[107] This lasting opposition, created and articulated by Ghanaians, is relatively unexplored, yet its purpose is clear: it establishes that certain forms of dress, including the *dansinkran*, are considered obsolete, existing outside the realm of sartorial reinvention. Other textiles and forms of dress, like kente and the aforementioned kaba ensemble, are equal in cultural significance, yet can be literally reconfigured to maintain their sartorial relevance. At a time when local textiles and forms of dress were being fused with global styles and materials, the *dansinkran* appears to exist in a category of stagnancy: in need of preservation, without innovation.

Likely due to its categorization, the *dansinkran* has maintained some relevance, primarily for the Asante and specific cultural practices, but at the time of the Akwadzan's creation, it was viewed as old-fashioned and unchanging, relegated to the periphery of Ghana's dress culture. This acknowledgment has two implications for Kweifio-Okai's Akwadzan. On a superficial level, it suggests the Akwadzan may have been a transformation of the *dansinkran* from a static form of traditional dress to a modern and wearable form of fashion, an exemplar of cosmopolitan, nationalist fashions. However, the documented unfamiliarity and diminishing relevance of the dansinkran likely had an additional effect: it underscored the masculinity of the "over-the-shoulder" wrapper, strengthening its status as a predominantly male form of attire. This suggests that Kweifio-Okai's female Akwadzan, a tailored revision of the "over-the-shoulder" wrapper, was a purposeful reinvention of a form of dressing considered the sole prerogative of men. This is supported by the aforementioned *Sunday Mirror* documentation, which addressed only the male version of the Akwadzan and its importance to men's dressing; the female version was completely undocumented.

As a design, the Akwadzan was revolutionary in both its gendered forms; together, they illustrate Kweifio-Okai's commitment to maintaining historically rooted forms of dress, albeit reimagined for post–Independence Ghanaians. As a men's garment, the Akwadzan functioned similarly to Kweifio-Okai's kente

kaba, transforming a historical mode of dressing into a more wearable, globally informed style that simultaneously promoted a collective, Ghanaian identity, the epitome of cosmopolitan, nationalist fashions. The female Akwadzan was a bold and chic transformation of an established and potent form of men's attire, diversifying what Ghanaian women could wear while challenging the inherent masculinity of the "over-the-shoulder" silhouette. Most importantly, the female Akwadzan attests to Kweifio-Okai's continued commitment to challenging rigid, gendered expectations of dress, a perspective that remained constant throughout her extensive career.

The feminist approach of Kweifio-Okai

Although the Akwadzan is a singular feat of fashion innovation, there are many designs from Kweifio-Okai's career that actively challenged gendered forms of dressing. Some of her adaptations were subtle, like the aforementioned "Joromi Slacks-Suit," which borrowed its embroidery designs from men's batakari smocks. Others, like her wedding pant suit, were potent and unapologetic rejections of accepted modes of dressing the female body. Likely created in the late 1960s or early 1970s, the same era as her Akwadzan and kente kaba, Kweifio-Okai's wedding pant suit was documented in a photograph from François' personal archive. The bride and groom stand with right arms interlocked, the bride's lace veil cascading gracefully to the right, gingerly held off the ground by one of her attendants. At first glance, the couple appear to be the quintessential bride and groom; a closer examination reveals an unexpected detail: the bride's ensemble is not the conventional white wedding dress; instead, she wears an elegant, wide-leg pant suit. Wedding attire, specifically variations on the wedding dress, were frequently the subject of articles in the *Sunday Mirror*; however, it was always assumed, and actively suggested, that the bride would wear a dress. Writing in 1958, *Sunday Mirror* contributor Lucy Payne documented several bridal innovations, including wedding gowns in shades of light yellow, blue or pink, but wearing a dress was constant, as evidenced by this observation: "although many brides still like to wear a full length dress (and one must admit it is most graceful and becoming), others prefer the short or 'ballerina' length, as it needs little or no alteration for evening wear afterwards."[108]

Another hallmark of the era was the *Sunday Mirror's* promotion of fashions that emphasized women's femininity and sexuality. In spite of active sartorial experimentation, the majority of Accra's women deemed stylish by the publication wore variations of dresses, skirts and wrappers; rarely were pants or slacks featured as a fashionable, or suitable, attire for women. A *Sunday Mirror* author even described the late 1960s as the "era of the minis and maxis," suggesting that skirts and dresses were the mainstay of Accra's fashion culture.[109] This is not to suggest that Ghanaian women did not wear pants, but broadly speaking, women's fashions were often relegated to innovations of narrowly defined silhouettes. Kweifio-Okai was a significant force in revolutionizing this image, as many of her previously mentioned ensembles included capri pants and slacks.

Her incorporation of pants into a bridal ensemble would have been highly unusual, if not controversial, in Ghana and overseas. The ensemble suggests that Kweifio-Okai developed an inherently feminist approach to fashion, as she began to introduce designs that championed new and empowering silhouettes for women. The ensemble further attests to the truly revolutionary and globally significant perspective of Kweifio-Okai. While the 1960s saw established European designers presenting all manner of unusual variations on wedding gowns, such as Yves Saint Laurent's 1965 knit cocoon-like bridal ensemble, it was Chez Julie who introduced pants.

Kweifio-Okai continued to challenge accepted, often limiting, forms of Ghanaian women's dress throughout her career, maintaining her awareness of global fashion trends and a commitment to locally meaningful textiles. This is illustrated by two ensembles purchased by historian Jean Allman from the Chez Julie boutique in 1992. Due to the lack of extant Chez Julie garments, these two ensembles potentially reflect the last designs produced by Kweifio-Okai. The ensembles consisted of an oversized, wax print jumpsuit and a loose-fitting, short-sleeved tunic top with matching culottes, sewn from an unusual "Splash" fabric.[110] Of these two ensembles, only the "Splash" tunic survives and is currently in the collection of the Samuel P. Harn Museum of Art. These two designs are in keeping with Kweifio-Okai's interest in innovative silhouettes; however, their loose-fitting, oversized forms, likely influenced by global trends of the early 1990s, were in direct opposition to the fashions promoted by Ghanaian popular media. Through the efforts of First Lady Nana Konadu Agyeman Rawlings and other influential, politically active women, the kaba experienced a resurgence in the early 1990s, evidenced by "The Great Kaba Show," a fashion event that was held throughout Ghana between 1991 and 1993. With ballooning sleeves, exaggerated shoulders and accentuated waists, kaba fashions became hyper-feminine; Kweifio-Okai's oversized silhouettes were in direct defiance of these trends, offering women a more unstructured and less sexualized form of fashionable attire. Her oversized designs are a stark contrast to the tailored silhouettes from her early career; however, the Akwadzan perhaps functions as a precursor to Kweifio-Okai's later interest in more unisex silhouettes. In keeping with the capricious nature of fashion, her oversized designs indicate that Kweifio-Okai's brand was ever-evolving, creating fashions that reflected her own unique perspective, while encapsulating in cloth what it meant to be a Ghanaian cosmopolitan.

A recently discovered tie-dyed tunic with extensive embroidery (Figure 4.16), bearing the Chez Julie label, illustrates several of the designer's hallmarks: her challenging of gendered forms of dressing, the expansiveness of her inspirations, and her promotion of local textiles, adapted for her discerning and cosmopolitan clientele. It epitomizes the Chez Julie brand, a suitable garment for summarizing her career. Likely designed in the early to mid-1970s, as evidenced by similar satin tie and dye (*gara*) garments published in 1975, the style of the garment was inspired by boubous, a form of men's dress worn throughout Western Africa.[111] Boubous are described as voluminous, untailored robes with

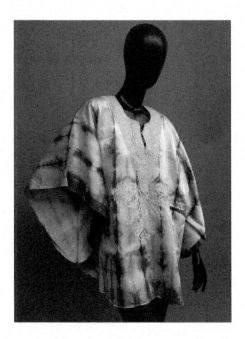

Figure 4.16 A tie-dyed satin tunic by Kweifio-Okai, circa mid-1970s (Image: Christopher Richards).

exaggerated, open sleeves and elaborate embroidery; they are typically sewn from locally produced textiles, often strip-woven cloth.[112] To create her variation on this form of attire, Kweifio-Okai chose an imported satin fabric, presumably white, which she then tie-dyed with blue to create a shimmering, vertically striped pattern. The result is a fashionable form of tie and dye that evokes wealth and prestige through its materiality, while celebrating a particularly local form of textile production. Kweifio-Okai's dyeing of imported satin fabric indicates that, as a designer, she was not limited to adapting local textiles and forms of dress to reflect global styles, she was actively altering imported materials to mimic local textiles, again refuting the implied directionality of sartorial exchanges between Africa and Europe.

As with many of Kweifio-Okai's designs, this garment attests to her continued experimentation with gendered forms of dressing. Kweifio-Okai made subtle, yet significant, alterations to the boubou's prototypical silhouette, transforming this men's style into an avant-garde fashion for women while ensuring it reflected socially accepted notions of women's modesty and appropriate dressing. Instead of using straight hemlines, Kweifio-Okai employed a subtly curved line, resulting in a more contoured silhouette that echoes the sinuous, flowing nature of the satin fabric. The curved hemline and sleeves are in direct contrast to the boubou's angular form, creating a clear distinction between the two silhouettes without contradicting their sartorial similarities.

The garment's most innovative element is easily overlooked and was partially unpicked by a previous owner, likely to allow for more room. Each side of the tunic has a single, diagonal stitch that runs from the hemline to the center of the garment; these stitched lines form actual, yet open sleeves and create further artful folds that echo the undulating form of the garment. This element of tailoring had an additional function: it ensured that the wearer's body would not be visible. The majority of boubous, with their expansive and freeform sleeves, often expose the wearer's bare torso (unless a shirt is worn underneath). For Ghanaian men, there are virtually no taboos associated with bare or partially exposed chests; however, since the nineteenth century, Ghanaian women, particularly in the Southern region, have been expected to cover their breasts and torsos with cloth or a tailored blouse.[113] In order to conform to these established dress codes, Kweifio-Okai added her symmetrical stitches, ensuring the body underneath is fully covered while maintaining the overall shape and voluminous qualities of a boubou. Once again, the tie-dye tunic is a study in contradictions: an adaptation of men's prestige wear for women, while maintaining notions of modest dressing for Ghanaian women.

Kweifio Okai's inclusion of machine embroidery along the slit neckline is an additional element that evokes both the elaborate ornamentation of boubous and the more restrained stitching that frequently decorates Ghanaian men's batakari smocks. The basis for the design is a chain stitch, a form of ornamentation that relies on repeated, looped stitches to create a chain-like appearance. By using a machine, the chain stitches on the garment are more uniform. The embroiderer carefully manipulated the stitches to form a complex pattern of minute, interlocking spirals that extend between two to three inches from the actual neckline. The overall pattern of the frontal embroidery is an extended V-form, terminating in a symmetrical, three-lobed, decorative medallion. Each lobe is comprised of a heart filled with additional spirals and a diamond motif, echoing its overall shape, and topped with plumes reminiscent of a peacock feather. The monochromatic, cream color of the thread creates a bold contrast to the tie-dyed satin, emphasizing the embroidery, while maintaining a complementary color scheme. This type of embroidery, referred to as "joromi" by her family and in the national press, can be seen throughout Kweifio-Okai's designs, an additional means for adapting hallmarks of men's dress into her revolutionary fashions.

This relatively simple garment, with its pairing of minimal, yet meaningful, tailoring and extravagant embroidery, speaks to the innovation and reverence inherent in many of Kweifio Okai's most significant designs. Unlike the adoption of male alhaji-style dress by Nigerian women during the 1980s, Kweifio-Okai made subtle alterations to the form and features of the male silhouettes that she referenced, inventing new garments that existed on the seams of men's established dress and women's avant-garde fashions, avoiding controversy while encouraging the preservation of established modes of dressing.[114] Women were thus afforded new modes for promoting their own heritage, reflecting the continued, post-colonial interest in celebrating local forms of

dress, albeit infused with global perspectives. Kweifio-Okai's use of tie-dyed satin illustrates how imported, global materials were as susceptible to revisions as their locally produced counterparts. This acknowledgment complicates the academic understanding of cosmopolitanism; it becomes a layered and multi-directional phenomenon that encapsulates a range of fusions and adaptations.

The range and diversity of Kweifio-Okai's designs speak to the continually transforming nature of the Ghanaian cosmopolitan and the importance of fashion in expressing this desired identity. Kweifio-Okai's initial designs, expertly executed variations on European fashions, evoked the colonial-era cosmopolitan: a woman who had the literal status and wealth to travel overseas to procure her fashions, but who could now purchase them in her own country. As established in Chapter 2, following Ghana's Independence, a new cosmopolitan sphere emerged: one whose members sought to wear culturally meaningful materials and dress forms, like kente cloth and the kaba, albeit adapted to incorporate global techniques, materials and silhouettes. As Ghana's first formally trained fashion designer, Kweifio-Okai was an active contributor to the formation of this new sphere of cosmopolitan, nationalist fashions. Although she did not act alone, her designs, along with the creative innovations of the seamstresses and tailors around her, helped strengthen this newfound form of Ghanaian fashion. Kweifio-Okai and her innovative designs did initiate Accra's designer fashion culture, setting into motion a vibrant, dynamic and complex network of Ghanaian designers, who have continually contributed to local and global fashion systems.

Chez Julie – a personal epilogue

After hearing such evocative stories of Kweifio-Okai's vivaciousness and tenacity and poring over photographs of her designs, which she often modeled (I gradually developed the ability to recognize Kweifio-Okai in grainy, newspaper images), I felt an undeniable connection to her. Even through printed quotes and photos, she exuded a distinctive personality: playful, yet astute. During one visit, I remember confiding to her daughter Brigitte "I would have loved to meet your mother." She smiled, and politely replied: "she would have liked you." After much personal reflection, I made the perhaps naïve decision to visit her grave; I did not inform the family, as I worried they might find the request unusual. I wanted the experience to be a solitary one, a quiet moment of tribute and gratitude.

I had never visited a cemetery in Ghana before and I incorrectly assumed the experience would be similar to America. Upon arrival, I immediately observed that the cemetery was populated not with grieving or reflective families, but with itinerant men who either lived in the cemetery or in surrounding, informal neighborhoods. As the only person, and a foreigner, in an otherwise deserted cemetery, I became the main focus of their attention. At first, I mistook them for employed attendants (and perhaps one of them actually was). After leading me directly to Chez Julie's tombstone, which rose high above its

neighbors, one man began to clean the brush and debris from around the large, towering monument; the men then began to quarrel, presumably fighting over who would benefit from my presence (and potential tip). Feeling a mixture of agitation and vulnerability, I sharply asked them to stop and provide me with a bit of physical space. I then shared a fleeting, but poignant, moment with Chez Julie. I still wish I could have met her and had in-depth, reflective conversations regarding all of her designs, but it was not meant to be. It is my sincere hope that this chapter, and its research, will aid in revitalizing the name of Chez Julie and by extension, the countless other women who tirelessly, through their own hands, re-dressed their nation and constructed the vibrant fashion culture of Accra.

The boutique: B'ExotiQ, Beatrice "Bee" Arthur

With its rather unassuming façade and nondescript location, walking into the B'ExotiQ boutique was akin to tumbling down the rabbit hole into Wonderland, or more aptly, entering a busy beehive awash in a visual riot of color, texture and assemblage. A motley swarm of stuffed toy bees hung from the ceiling, their black and yellow forms conspicuous against the shop's sky-blue walls. Visitors were further greeted by a cartoonish painting of oversized and smiling honeybees, flying in formation from their conical beehive. The boutique's propagation of bees was intentional. Arthur's friends often called her by the nickname "Bea," though Arthur chose to spell it "Bee." This prompted Arthur to investigate the significance of the honeybee, discovering it laden with symbolic meanings: reincarnation, industriousness, royalty (specifically Napoleon) and productivity. Arthur was particularly drawn to the importance of the queen bee and the hive's organization around female workers; thus a subtle alteration in the spelling of her nickname became a symbol of Arthur's brand and a symbol for herself: the empowered, busy bee.

In spite of the boutique's myriad elements, the appearance was never garish; it reflected a well-conceived and whimsical eccentricity that mirrored Arthur's personality and aesthetic. What remained the most eye-catching were Arthur's designs. The walls of the narrow shop were hung with neatly organized vertical racks of garments, with an additional, moveable rack positioned at the back of the shop, brimming with one-of-a-kind creations. Extravagant runway looks were mixed with more subdued silhouettes, adding an element of surprise to the act of browsing. Pairs of mannequins graced the boutique's two main windows, enticing visitors to enter, with an additional clear, acrylic mannequin set back and elevated from the floor. It was on these forms that her latest, most exuberant creations were featured. On one visit to her shop, I photographed a mannequin displaying a dress fashioned from a medley of wax print; half the dress was sewn from the iconic "bug spray" or "spray paint" print, with the other half featuring a pattern of seashells. The motifs shared similarities in shape and the inclusion of prominent, radiating lines, and yet the color schemes

were harmoniously divergent. The fabrics were joined with rickrack, further embellished with a strand of braided, orange hair weave, undulating from the straight neckline to well below the natural waist. The skirt was edged with a patchwork of wax print, batik and trim, while its batik straps were adorned with neon orange zippers. To complete the ensemble, the mannequin sported a patchwork handbag adorned with rickrack and was crowned with a wild hat sewn from rectangular scraps of wax print fabric.

Other garments could be relatively subtle by comparison. Adjacent to the aforementioned pastiche of print, the elevated mannequin displayed a strapless dress fashioned exclusively from locally produced textiles. The skirt was a linear-patterned tie and dye of blue, orange and white, juxtaposed with a blue and white batik bodice featuring a pattern of the adinkra symbol "gye nyame."[115] To create a more harmonious look, Arthur painted and outlined the three central "gye nyame" motifs with orange and blue glitter paint. Like most of Arthur's creations, the fabric was decorated with all sorts of hand-embellishments; motifs were outlined and accented, additional shapes and angled lines were added, and three squiggly lines of blue and orange glitter paint extended from the center of the waistline to the gathered portion of the skirt, which was finished with a cluster of blue ribbons. The sheer variety of garments on display, coupled with their extraordinary singularity, meant that every visit to Arthur's boutique felt like an adventure, a sartorial exploration into her carefully curated and uninhibited aesthetic.

In contrast to the organized idiosyncrasies of the public-facing boutique, Arthur's adjacent, private workshop was a literal jumble of fabrics, garments in process, and a seemingly endless amount of embellishments. Tables were piled high with scraps of materials and plastic bags overflowed with trimmings, fabrics and unfinished designs. The workshop's walls were a riotous collage of photographs, sketches and exquisite pieces of machine-embroidered appliqués which took the form of cartoonish butterflies, hibiscus flowers, matryoshka and adinkra symbols, symbols of her own hybrid identity. These elements were all carefully tacked to the walls without any semblance of order, creating a haphazard, yet deeply meaningful, reflection of Arthur's current sartorial ruminations. The sheer number and floridness of Arthur's appliqués made them the focal point of this unofficial installation; one matryoshka included details of turquoise, orange, black, pink, green and purple, while a butterfly with an orange-and-black-striped body displayed pink and teal wings outlined in silver metallic thread. In spite of their vibrancy, the appliqués were largely unfinished, denuded of Arthur's hand-painting: the matryoshkas stared blankly, minus eyes and their typical flourishing of patterning, while the hibiscus petals and stamen failed to sparkle and glisten with washes of glitter paint and rhinestones.

A portion of the wall was reserved for Arthur's sketches, which like her garments were full of miniscule details, often including meticulous renderings of specific motifs and potential embroideries. Her quick sketches, often done in pencil, featured individual silhouettes that were rather ambiguous or formulaic;

what distinguished each design was their variations on embellishments and the acknowledgment of multiple fabrics. Her more detailed designs, executed in black marker, reflected a more studied focus on silhouettes; one sketch included two designs: a short dress with a flared, pleated hem and tiered balloon sleeves; the other a mini dress with spaghetti straps and a removable train, secured to the wearer's waist with a large bow. The diversity of Arthur's silhouettes and individual embellishments attested to the breadth of her creativity and artistry. Her workroom was essentially an extension of her approach to design, the walls adorned and bedecked with all manner of meaningful and provocative embellishments. These sketches, appliqués and photographs were more than mere ornamentation, they functioned as vehicles for generating new ideas and fashions, almost vibrating with their own latent potential.

In this space, awash with inspiration, Arthur demonstrated her creative process to me. From a pile of fabric and clothing she unearthed a pair of bright yellow jeans that she had purchased for herself; as she explained, they did not accurately reflect her unconventional aesthetic and needed to be "enhanced." She laid the jeans on a table and began selecting a grouping of hibiscus flower appliqués that had been cut from an existing wax print fabric (evidenced by the crackled and off-centered colors). Sequins had been applied to several of the leaves and petals, but they were largely unadorned. Arthur placed a large appliqué of blossoms and leaves on one leg, then two smaller ones on the other, altering their orientation to achieve what she deemed most effective. The impact was immediate. The jeans went from being bold to audacious, with the saturated hue of the jeans heightened by its juxtaposition with the floral embellishments; conversely, the intense orange flowers and light teal leaves practically leapt off the surface of the yellow jeans. Arthur continued to play with the number and orientation of floral appliqués, illustrating that her design decisions were based largely on her personal aesthetic. As she explained, once the appliqués were decided, she would then further adorn the jeans with her trademark hand-embellishments, likely of glitter fabric paint. Then, just as quickly as the garment had materialized, the jeans and its disparate pieces were returned to a stack of materials, to be finished at a later date.

There was a third room that functioned as part of Arthur's boutique, although it was separated from the previous two rooms by a tinted glass door. This room was sparse and devoid of decoration; it held two sewing machines, a table and a clothing rack used as a place to pile fabrics and garments in process. It was here that Arthur's machinists would construct garments based on her instructions. I remember Arthur showed me a miniskirt fashioned entirely from zippers and kente cloth that, ironically, had a side zipper that needed to be replaced; otherwise it was unwearable. This garment was Arthur at her unbridled best: the skirt consisted of row upon row of diagonal zippers in shades of neon greens and blues. Fully functional, the zippers were further adorned with rows of sequins in various colors and zigzags of glitter paint. The center of the skirt featured a narrow strip of kente in light gold, green, blue and black, decorated with a variety of symbols painted in silver. The skirt was edged with a larger strip of

matching kente that was equally marked by Arthur's hand; the larger, geometric motifs were outlined with dark blue glitter paint, whereas the areas of plain weaving were used as a ground for Arthur's imaginative symbols. In one rectangular segment, Arthur's trademark Cyrillic "b" and English "q" shimmered subtly against its woven background, a glittering affirmation of her authorship and handiwork.

The "B'ExotiQ" boutique, with its interconnected, compartmentalized "cells," really was akin to a beehive, with Arthur proudly at its center. Although the slightly faded sign for "B'ExotiQ" can still be found on a side street of Accra, Arthur closed her boutique in 2013. Much like a trailblazing queen bee, Arthur moved the contents of her boutique to a new location: her personal residence, establishing a new "hive" for producing garments and household accessories. Arthur brought with her all the essentials to continue running her brand: her machinists occupy a building on the property that was converted into a workshop; two of the mannequins, regularly bedecked in the latest of Arthur's designs, nonchalantly inhabit a corner of her living room; and the plush, anthropomorphized bees have migrated to her kitchen, flying overhead as Arthur welcomes guests for coffee and conversation. The unsold garments that remain from her boutique are stored away in suitcases, brought out only upon request.

Although I mourn the loss of the B'ExotiQ boutique, fondly remembering the conversations I had with Arthur on the shop's informal porch, I recognize the transformative power this closure had on her creative process. Unfettered by the obligations of profitability and wearability, Arthur began producing increasingly artistic and imaginative garments that functioned primarily as works of art. As the following chapter will illustrate, the collections produced following her boutique's closure were perhaps her most potent, showcasing her commitment to use clothing to convey intensely meaningful, personal messages, while maintaining a degree of social critique and fashionability. In truth, the boutique may have closed, but a new hive for her creativity has been established. The gates are even marked with a few buzzing bees; how very apropos, how very Bee.

Notes

1 "Julie – The Girl From Paris," *Daily Graphic* (January 14, 1961): 15.
2 Ibid.
3 Beryl Karikari, "The Africa Line," *Drum* (December 1964): n.p.
4 For the original, shorter exploration of Juliana Kweifio-Okai's career and her most influential designs, see the 2016 article "The Models for Africa: Accra's Independence-Era Fashion Culture" in the journal *African Arts*.
5 "Chez Julie – Caught in the Act," *Sunday Mirror* (November 16, 1991): 11.
6 Interview with Edith François and Brigitte Naa-ode Kragbé, Accra, Ghana, June 14, 2012.
7 "Julie – Girl with an Ambition," *Sunday Mirror* (July 2, 1961): 8, 9.

8 Interview with Edith François and Brigitte Naa-ode Kragbé, Accra, Ghana, June 14, 2012.

9 Ibid.

10 Ibid.

11 Ibid.

12 "Chez Julie – Caught in the Act," *Sunday Mirror*, 11.

13 Interview with Edith François and Brigitte Naa-ode Kragbé, Accra, Ghana, June 14, 2012.

14 "These New Fashions," *Sunday Mirror* (November 23, 1958): n.p.

15 Ibid.

16 Interview with Edith François and Brigitte Naa-ode Kragbé, Accra, Ghana, June 14, 2012.

17 Ibid.

18 Ibid.

19 "Julie – Girl with an Ambition," 8, 9.

20 Ibid.

21 Ibid., 9.

22 Beryl Karikari, "The Africa Line," n.p.

23 Ibid.

24 Gott, Suzanne, "'Life' Dressing in Kumasi," in *African-Print Fashion Now!*, eds. Suzanne Gott, Kristyne S. Loughran, Betsy D. Quick and Leslie W. Rabine (Los Angeles: Fowler Museum of Art, 2017), 143.

25 Felicity Green, "Fashion – Chez Julie," *Drum* (February 1968): n.p.

26 "Big Dress Show to Open," *Sunday Mirror* (October 10, 1965): 1

27 "Tops of the Big Show," *Sunday Mirror* (October 31, 1965): 8, 9.

28 "Chez Julie – Caught in the Act," 11.

29 "Chez Julie's Fashion Show," Drum (1970): n.p.

30 "Chez Julie – Caught in the Act," 11.

31 "Sisters in Fashion," *Sunday Mirror*, Number 638 (October 31, 1965): 1.

32 Ibid.

33 Interview with Edith François and Brigitte Naa-ode Kragbé, Accra, Ghana, June 14, 2012.

34 Ibid.

35 Stella Adoo "Good Luck, Lovell," *Daily Graphic* (November 8, 1968): 9.

36 Ibid.

37 E. Gyimah-Boadi and Donald Rothchild, "Rawlings, Populism and the Civil Liberties Tradition in Ghana," *Journal of Opinion*, 12, No. 3/4 (Fall/Winter 1982): 64.

38 "Chez Julie – Caught in the Act," 11.

39 Ibid.

40 Interview with Edith François and Brigitte Naa-ode Kragbé, Accra, Ghana, June 14, 2012.

41 Ibid.

42 "Chez Julie – In Person," *Drum* (July 1968): n.p.

43 "Julie – Girl with an Ambition," 8, 9.

44 Ibid., 9.

45 "Julie's So Glad IT IS OVER!" *Sunday Mirror*, Number 478 (October 7, 1962): 1, 6, 7.

46 Ibid., 6.

47 "Fantabulous," *Sunday Mirror* (October 21, 1962): 6, 7.

48 "Julie Oo-La-La!" *Drum* (July 1962): 13.

49 "Julie's So Glad IT IS OVER!" 6.
50 Interview with Edith François and Brigitte Naa-ode Kragbé, Accra, Ghana, June 14, 2012.
51 "Julie – Girl with an Ambition," 8.
52 "Chez Julie – In Person," n.p.
53 "Julie – Girl with an Ambition," 9.
54 Ibid.
55 Beryl Karikari, "The Africa Line," n.p.
56 Ibid.
57 Ibid.
58 The pattern, which consists of hexagrams surrounded by curving fronds of foliage, is particularly old, with an earlier, more elaborate version of the print produced by Haarlemsche Katoen Maatschappi (HKM) between 1905 and 1919.
59 Helen Elands, "Dutch Wax Classics," in *African-Print Fashion Now!*, eds. Suzanne Gott, Kristyne S. Loughran, Betsy D. Quick and Leslie W. Rabine (Los Angeles: Fowler Museum of Art, 2017), 54, 55.
60 Ibid., 55.
61 Gott, Suzanne, "'Life' Dressing in Kumasi," 141.
62 Beryl Karikari, "The Africa Line," n.p.
63 Chez Julie – Caught in the Act," 11.
64 Ibid.
65 Leslie W. Rabine, "The Eternal Return of Fashion," in *African-Print Fashion Now!*, eds. Suzanne Gott, Kristyne S. Loughran, Betsy D. Quick and Leslie W. Rabine (Los Angeles: Fowler Museum of Art, 2017), 238.
66 "Chez Julie's Fashion Show," n.p.
67 Although it is likely that Kweifio-Okai began creating garments "to suit the African personality" well before the late 1960s, the earliest documentation of a Chez Julie design including local materials is from 1967.
68 Felicity Green, "Fashion – Chez Julie," *Drum* (February 1968): n.p.
69 "Chez Julie – In Person," n.p.
70 Ibid.
71 "New Dress is Out," *Sunday Mirror* (October 29, 1967): n.p.
72 Ibid.
73 Ibid.
74 Ibid.
75 I have found no references to "back print" used as a term to define tie and dye fabric.
76 Jane Barbour, "The Origins of Some Adirẹ Designs," in *Adirẹ Cloth in Nigeria*, eds. Jane Barbour and Doig Simmonds (Ibadan: Institute of African Studies, University of Ibadan, 1971), 62.
77 Nancy Stanfield, "Dyeing Methods in Western Nigeria," in *Adirẹ Cloth in Nigeria*, eds. Jane Barbour and Doig Simmonds (Ibadan: Institute of African Studies, University of Ibadan, 1971), 13.
78 "Chez Julie – In Person," n.p.
79 Liz Willis "'Uli' Painting and the Igob World View," *African Arts*, 23/1 (1989).
80 Ibid.
81 Nancy Stanfield, "Dyeing Methods in Western Nigeria," 9.
82 Ibid.; Jane Barbour, "The Origins of Some Adirẹ Designs," 53.

83 Interview with Edith François and Brigitte Naa-ode Kragbé, Accra, Ghana, June 14, 2012.

84 Chez Julie – Caught in the Act," 11.

85 A design featuring a kente skirt and scarf, paired with a sleeveless linen blouse, was included in Kweifio-Okai's 1970 fashion show at the Accra Arts Centre.

86 Doran H. Ross, "Asante Cloth Names and Motifs," in *Wrapped in Pride*, ed. Doran H. Ross (Los Angeles: UCLA Fowler Museum, 1998), 112.

87 Ibid., 124, 125.

88 Interview with Edith François and Brigitte Naa-ode Kragbé, Accra, Ghana, June 14, 2012.

89 Ibid.

90 Ibid.

91 "Chez Julie – Caught in the Act," 11.

92 "Something for the Men Too," *Sunday Mirror* (June 26, 1971): 4.

93 Ibid.

94 Ibid.

95 Ibid.

96 Ibid.

97 Ibid.

98 Ibid.

99 Interview with Edith François and Brigitte Naa-ode Kragbé, Accra, Ghana, June 14, 2012.

100 Suzanne Gott, "The Ghanaian Kaba," in *Contemporary African Fashion*, eds. Suzanne Gott and Kristyne Loughran (Bloomington: Indiana University Press, 2010), 13; Suzanne Gott, "Asante Hightimers and the Fashionable Display of Women's Wealth in Contemporary Ghana," *Fashion Theory: The Journal of Dress, Body and Culture*, 13/2 (2009): 153.

101 R.A, "Experiment with Native Costume," *Sunday Mirror*, Number 186 (February 24, 1957): 9.

102 Ibid., 8, 9.

103 "Fashion Parade," *Sunday Mirror* (July 30, 1967): 9.

104 Ibid.

105 Ibid.

106 "Ghana's Fashion Goes to London," *Sunday Mirror* (June 23, 1968): 1.

107 Ibid.

108 Lucy Payne, "Easter Wedding Bells," *Sunday Mirror* (March 20, 1958): 2.

109 "What's Fashion," *Sunday Mirror*, Number 797 (November 17, 1968): 1.

110 Little to no research has been conducted on "Splash"; it is a variation of wax print, typically produced at the end of a printing run, as color dyes run out. The result is a material with less defined patterns and motifs, with colors bleeding together, unintentionally mimicking tie and dye. This material, deemed an inferior product by wax print companies, would have normally been discarded. The fabric somehow gained popularity and was sold in various markets. The last time I saw "Splash" was in 2009; a Ghanaian was selling the material, along with other batiks, near the Koala supermarket in Osu.

111 Joseph Robertson, "The Fashion World of Juliana Kweifio-Okai," *Ghana Review*, 1/8 (1975): 18, 19.

112 Victoria Rovine, *African Fashion Global Style: Histories, Innovations and Ideas You Can Wear* (Bloomington: Indiana University Press, 2015): 29.

113 Suzanne Gott, "The Ghanaian Kaba," 13.

114 Misty Bastian, "Female Alhajis' and Entrepreneurial Fashions: Flexible Identities in Southeastern Nigerian Clothing Practice," in *Clothing and Difference: Embodied Identities in Colonial and Post-Colonial Africa*, ed. Hildi Hendrickson (Durham, NC: Duke University Press, 1996), 97–132.

115 Gye Nyame, also known simply as Nyame, translates as "except for God," suggesting that God is a supreme, all-knowing power. The popularity of this adinkra symbol further suggests the importance of faith and spiritual beliefs to the Ghanaian people.

5 "I don't do nice; it has to be interesting"

The designs of Beatrice "Bee" Arthur[1]

For Arthur's most notable and poignant photo shoot, Ghanaian model Felivian Ayariga occupies a crumbling nondescript space, its stark whiteness and angular, classically inspired architecture in absolute contrast to her vibrant attire. In one photograph, Ayariga wears a sleeveless dress with a bodice of textured, teal jersey and a skirt of bogolan cloth; the entire ensemble is adorned with embroidery and hand-painted details, in addition to literally dripping with cowrie shells. Ayariga's form is framed by a brick archway, balanced by an additional, darkened doorway that stands in direct opposition to her body. In a second photograph, Ayariga stands facing an open, iron gate, a thin cord trimmed with beads dangling from her outstretched hand (Figure 5.1).

Her dress is sewn entirely from square and rectangular patches of contrasting fabrics; there are swatches of linen in solid colors of yellow, cream and navy, combined with local tie-and-dye and stitch-resist indigo cloth. Intermingled among this already frenetic mixture of fabrics are pieces of wax print and other imported fabrics, including a large panel of zebra stripes. Various seams are embellished with decorative trim and the central panel is adorned with embroidery and additional ornamentation. The juxtaposition of Arthur's colorful, exuberant designs with a barren, invariant setting serves to emphasize the creativity, artistry and diversity of her garments. And yet, the partially obscured passageways, the weathered walls, floors and stairwells all hint at a deeper, more historically rooted meaning.

Titled "Victory Over Slavery," the setting for Arthur's photo series is the Portuguese-built Elmina Castle, a fort infamous for its role in the imprisonment and exportation of Africans from across the Western coast to become slaves in the New World. In several interviews, Arthur explained that, through this series of photographs by Dean Zulich, she hoped to transform a site associated with such intense pain, loss and tragedy into a more celebratory space, particularly for African and Diasporic women. Unlike the fort's former prisoners, Ayariga roams the space freely, standing in absolute defiance of the various doorways and passages that functioned as transitory spaces for the literal imprisonment and exportation of African people. The sharp contrast between Arthur's exuberant garments and the austere background articulates her message: the space is being challenged, its dark history surmounted by the proud and confident Ayariga,

DOI: 10.4324/9781003148340-5

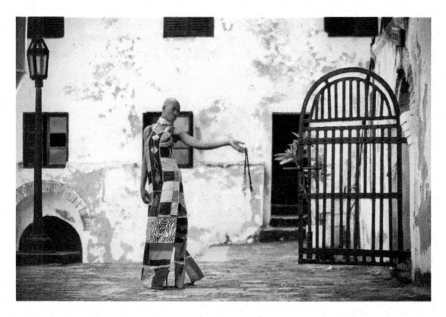

Figure 5.1 Beatrice Arthur's "Victory over Slavery" photo shoot, featuring Ghanaian model Felivian Ayariga and photographed by Dean Zulich (Image: Beatrice Arthur/Dean Zulich).

clothed in Arthur's equally emboldened designs. The images document their reclamation of space, with the former slave fort becoming a site for the celebration of beauty, creativity and the inherent complexity of African heritage.

This photo series serves as a metaphor for Arthur's multilayered, allegorical approach to fashion. Her designs are equally thoughtful in their production and are often laden with meaning and symbolism, particularly in relation to women's (and Arthur's own) power, agency and identity. The garments themselves, patchworks of local and imported materials that coalesce into assertive, exquisite designs, are an extension of Arthur's own identity, symbolizing and celebrating the multifaceted identities of African and Diasporic women.

Using Arthur's artistry as a point of departure, this chapter will delve into the complexity of her designs, emphasizing the importance she places on creating distinctive, artistic fashions that ultimately reflect her own multifaceted heritage and cosmopolitan values. Arthur accomplishes this through designs that teeter on the tenuous divide between wearable art and fashion; with the proverbial foot planted in both fields, Arthur employs unusual approaches to her designs, including lavish surface decorations and a penchant for the literal recycling and reworking of her garments, resulting in designs that are as meaningful as they are mercurial. With each of her particularly laborious garments marked with a swirling, hand-painted "bq," the initials of her brand, Arthur reinforces her role as both artist and fashion designer. Her final collections, *Hands Off – Eyes Only*

and *Dumsor*, will be explored as the culmination of Arthur's creative energies, with specific garments serving as forms of visual protest and social critique; these are the pinnacle of Arthur's nuanced, sartorial representations of cosmopolitan, nationalist fashions, tailored to reflect her own diverse heritage and artistic perspective.

The multicultural origins of B'ExotiQ

Beatrice "Bee" Arthur was born in 1970 in Odessa, Ukraine, to a Ghanaian father and a Russian mother.[2] Her early life was divided between these two countries, with Arthur spending the majority of her childhood in Accra: "I was boisterous … I was [always] getting into trouble, I had that kind of personality. Back in the day, my friends were all local kids, I spoke a local language, I ate local food."[3] At the age of 12, Arthur returned to Odessa to live with her grandmother, where she experienced an entirely different, yet equally localized way of living. She was taught a variety of handicrafts, including sewing, embroidery and knitting. These skills allowed her to begin experimenting with ways of dressing; as a teenager, Arthur would purchase readymade garments, altering their appearance through tailoring and embellishment, foreshadowing her playful and eccentric approach to fashion design.[4] Her time in Ukraine also instilled in Arthur the importance of continually revisiting an object's use:

> when you grow up in a Communist country, you are taught to recycle everything … you throw things away only when you can't use it for anything else. If you buy something that is drab, you start thinking … How can I reuse these materials?[5]

As a young adult, Arthur returned to Ghana in the early 1990s to study Sociology and Spanish at the University of Ghana. At the time of her arrival, Accra's fashion culture was experiencing a resurgence; fashion shows returned as a consistent fixture in the city's popular culture, with established and emerging designers alike repopulating the city's existing fashion culture.[6] In spite of Accra's changing fashion landscape, Arthur was frustrated. From her perspective, there was an absence of affordable, well-made and fun designer clothing.

It was during this period of sartorial disenchantment that Arthur met emerging designer Ben Nonterah during a student-led strike at the University of Ghana. Nonterah was a promising, emerging designer who briefly apprenticed with Mawuli Okudzeto before launching his own brand in 1994. Arthur found Nonterah's designs both attractive and interesting; beginning in 1995, she volunteered to assist with the finishing of his garments, becoming a self-described "accessory advisor and quality control."[7] An informal, mutually beneficial partnership was born: Arthur gained access to Accra's fashion industry and Nonterah's ability to produce in volume, while Nonterah benefited from Arthur's precise hand-finishing techniques and her unconventional approach to

design and embellishment. Following the completion of her degree in 1999 and her national service at the Ministry of Tourism in 2000, Arthur and Nonterah entered into a formal partnership, establishing the collective brand "BenigN & B'ExotiQ" in 2001.[8]

Shortly after formalizing the joint venture with Nonterah, Arthur met KORA Awards founder Ernest Adjovi during a trip to Paris. Adjovi invited Arthur to present her fashions at the upcoming KORA awards ceremony, which prompted her to begin immediately sketching potential designs, which she sent to Nonterah to fabricate. The resulting garments, a product of Arthur and Nonterah's combined efforts, featured Arthur's immediately recognizable forms of embellishment: beading, sequins and hand-painted details.[9] Their symbiotic collaboration proved successful; Arthur and Nonterah were awarded the 2001 KORA award for fashion, boosting their popularity and increasing their clientele locally and overseas.

The "BenigN & B'ExotiQ" brand continued until 2008, when Arthur and Nonterah ended their partnership to establish their own, individual brands: B'ExotiQ and Nonterah, respectively. That same year, Arthur opened her own boutique and premiered her B'ExotiQ brand at the 2009 *Ghana Fashion Weekend*. Arthur's first solo runway show was a riot of color and material, replete with hand-painted, embroidered embellishments and wax print appliqués. Never one to shy away from controversy, Arthur had male model Ernest Osei walk the runway wearing a woman's black embellished jumpsuit and high heels, which elicited audible gasps and much discussion from the audience.

Arthur showcased her label at a variety of African and European fashion shows, including the 2010 AfriCollection in Cameroon, the 2011 Dakar Fashion Week, and the 2011 Chris Seydou Fashion Week in Mali. In the Fall of 2011, Arthur decided to close her boutique, moving the production of her designs to her personal home. Arthur continued to participate in fashion shows, including the 2012 Malabo Fashion Week in Guinea and the 2013 African Fashion Reception in Paris. In 2012, she was awarded the prestigious African Women of Worth Award for Excellence in Creative Fashion Design. The following year, she was nominated for the Prix d'Excellence at the Festival de la Mode et Mannequin Africain (FESMMA) in the Republic of Benin. She premiered her purportedly final international runway collection at the 2013 Ouaga Fashion Week in Burkina Faso. Although no longer regularly producing collections, Arthur remains active in Accra's fashion community, collaborating and producing fashion events, acting as a stylist for her existing clientele and practicing her new-found passion: decorating homes with her colorful and self-described "funky" aesthetic.

Clothes that make me happy: the artistry of Bee Arthur

When Arthur introduced her own label in 2008, she began by producing two distinct bodies of clothing: garments that were wearable, but that had an

identifiable, artistic flair, and designs that were unapologetic expressions of her creative vision, often sacrificing functionality for sheer artistry. As Arthur explained:

> I studied the society, the market, I knew the[ir] taste and I knew what they wanted. Yes, there was my touch on the clothes, but they were not too artsy, not too heavy … so I had those clothes and that's what kept the machine going. And then on the other side, when I was financially stable and comfortable … it allowed me to make on the other side, on another rack, clothes that I didn't care if they would sell immediately or if it would take a year to sell; I was expressing myself and doing what made me happy.[10]

As Arthur succinctly summarized: "I made clothes that made me happy and clothes that made my customers happy."[11] The clothes that "made her customers happy" were simplified, conservative silhouettes sewn from brightly colored linen and wax print, embellished with modest flourishes of embroidery, trim and hand-painting. The garments "on another rack," the ones that made *Arthur* happy, are the primary focus of this chapter.

The freedom to express yourself: cosmopolitanism and cultural heritage in Arthur's fashions

As invoked by the words of Julie Schafler Dale, a specialist on wearable art, Arthur's designs are proud proclamations of her own personal expression, relying on deeply personal iconographies that are tied to her own past experiences and emotions.[12] For Arthur, a key component of her most potent designs are bold assertions of her multicultural identity. Even a casual examination of Arthur's designs reveals a profusion of both subtle and explicit allusions to Ghana and Russia, illustrating the importance of celebrating her identity. To understand the primacy Arthur places on her multiculturalism and its subsequent expression in her fashions, it is necessary to acknowledge Arthur's formative experiences surrounding her identity, particularly in relation to her perceived race and cultural heritage.

As a biracial youth growing up in two racially homogeneous countries, Arthur encountered hardships surrounding her identity, particularly in relation to her appearance:

> Very early in my childhood, I realized that I would always be different. Whether I spoke the language, ate the food, somebody would always point out to me that I'm not like everybody else. Growing up in Ghana, there were situations where somebody would tell me "go back to your country." This was my country … and for me that was extremely hurtful because until I went to stay in Russia [Ukraine], Ghana was my homeland.[13]

Arthur had similar struggles with her identity and appearance in Ukraine:

> When I went to Russia, I was different again and then the same thing: "go back to your country" … At some point I was avoiding the sun when I was in Odessa so I wouldn't get darker; I thought that if I looked lighter and my hair was straighter and [if] I talked and walked like them, they would accept me. I realized that no matter what I did I was still different, so it was a blessing when I finally realized that … I didn't have to do anything anymore to please anybody, I was free.[14]

This realization, that Arthur should not just accept, but embrace her differences, changed her outlook on life; reflecting on her current perspective, Arthur stated: "I don't feel bound by anything; there's nothing inhibiting me, restricting me. It's a blessing … because it gives you the freedom to express yourself."[15] Arthur's self-realization, achieved at a relatively young age, encouraged her to unapologetically express herself and to celebrate her multiculturalism, practices which eventually permeated her unconventional, heritage-infused fashions: literal mélanges of her own heritage, combined with materials that referenced a distinctly cosmopolitan identity. Arthur describes these garments as "fusions," directly reflecting her own self-conception: "I'm a mixture of so many things, so many religions, so many races, and that's exactly how my attitude towards art is … I can put anything I want, it's my rules, it's my outfit."[16] When addressing the material collage of her designs, Arthur stated:

> When I am expressing myself, I want to use something that is related somehow to a culture, I want something that is traditional, meaningful. I've worked with kente and bogolan because it's home, but if I came across a nice piece of cloth from Thailand or India or the UK, I could work with it and combine it with a piece of print.[17]

By selecting fabrics from an array of cultures, Arthur's designs function as literal testaments to the notion of cosmopolitanism; they incorporate a variety of culturally specific fabrics and design motifs, unified into a single, globally informed silhouette.

Regardless of the range of textiles she may incorporate into a single garment, Arthur's use of African, specifically Ghanaian, materials remains constant in her designs. In multiple interviews, Arthur explained that she chooses specific African fabrics because of their connections to her childhood. During one interview, Arthur reflected:

> When we went to the Vlisco shop, I said I loved this one [fabric] because it reminds me of my grandmother. I tend to like the traditional, the old patterns [because] a lot of them are related to sayings and to proverbs, so they have a history.[18]

Whether through the use of a named and recognizable wax print or the incorporation of embroidered adinkra symbols, a visual signifier of Ghana, and thus Arthur's own heritage, remains ever-present in the majority of her designs. In spite of the personal significance of Ghanaian materials, Arthur frequently alters their appearance, embellishing materials like wax print and kente with fabric paints, or deconstructing them into individual appliqués or embroidered designs. This technique, a perpetual reimagining of local forms, is an additional means for asserting cosmopolitanism. Arthur's embellished and reworked materials remain recognizable and culturally specific, yet their alterations are globally informed.

Arthur's cosmopolitan approach to design and materials is encapsulated by an early dress that, surprisingly, remains unaltered from its original form (including its BenigN 'N B'ExotiQ label) (Figure 5.2).

The long-sleeved dress, sewn from bright yellow linen, is relatively subdued compared to Arthur's later work. A proliferation of embellishments, alternating between appliqués and embroidered motifs, adorns the front and back portions of the dress. As Arthur explained, several of the appliqued patches were created

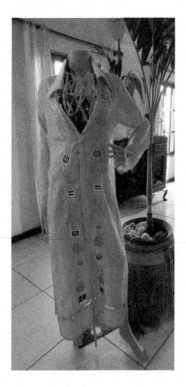

Figure 5.2 A dress bearing the "Benign 'N B'Exotiq" label that encapsulates Arthur's cosmopolitan approach to design (Image: Christopher Richards).

from bogolan cloth, while others, including a single eye, were from wax print fabric. The motifs of these appliqués have been isolated and altered to the point that they are almost unrecognizable, becoming decorative embellishments that subtly hint at their original form. Similarly, the embroidered motifs, sewn from silver metallic thread, are a combination of symbols from bogolan, adinkra, and even a letter from the Mandarin alphabet. These symbols appear in their original form, or are altered and hybridized by Arthur. As she explained: "I would paint half of the gye nyame, and the other half would be a portion of another symbol. So I started combining pieces from different symbols to create basically new symbols."[19] Arthur's distillation of meaningful, iconic textiles to a single appliqué, coupled with her reimagining of motifs and symbols through metallic embroidery, illustrate her technical approach to cosmopolitanism. She employs sewing techniques used by the global fashion industry to emphasize the similarities between meaningful materials and motifs, while ensuring the essence of their cultural identity remains intact.

Additionally, Arthur's juxtaposition of comparable, yet culturally specific, embellishments is inherently cosmopolitan. By re-presenting these culturally meaningful motifs as a constellation of embellishments, Arthur is literally blending seemingly disparate cultural forms into a unified, harmonious garment. Its simplified silhouette is also inherently global, a form of dress that can be easily adapted and localized by any number of cultures. Her embellishments and dress coalesce to create a garment that boldly asserts a decidedly cosmopolitan identity: a celebration of the global, while maintaining local significance and meaning. These values are imparted onto the wearer, reflecting their inherently global identity, while acknowledging ties to local cultures and knowledge systems.

"For me it was all about the fusion": the matryoshka dress[20]

Tied directly to her own cosmopolitan identity, Arthur places primacy on imparting visual retellings of her multicultural heritage. Many of her garments combine symbols and motifs that attest to her Ghanaian and Ukrainian heritage. The pinnacle of this self-expression is a garment simply referred to as the "matryoshka dress." Initially unveiled as part of her premiere collection at the 2009 *Ghana Fashion Weekend* (Figure 5.3), Arthur has continually reworked the dress, making key alterations that fundamentally enhance its allusions to Ghanaian and Russian cultures.

The garment itself, a strapless column dress of bright purple, is stylistically simple; the garment's primary focus is the column of four heavily embellished matryoshkas, or Russian nesting dolls, that emblazon its front, with a single matryoshka located on the back. Each matryoshka is an elaborate piece of appliqué embroidery created exclusively for Arthur by an accomplished machine embroiderer. As extravagant "patches," they are eye-catching in their original state; however, Arthur chose to further festoon them with innumerable embellishments, including fabric paint, glitter and all manner of trimmings.

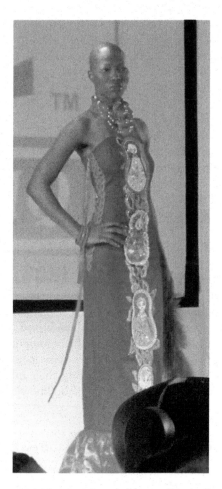

Figure 5.3 The initial appearance of Arthur's matryoshka dress, as seen at the 2009 *Ghana Fashion Weekend* (Image: Christopher Richards).

The body of one matryoshka is hand-painted with a large, abstract floral motif, while the face is surrounded by a halo of glittering circles in metallic green and silver. The entire form is trimmed with bright yellow lace, further accentuating the recognizable form of the nesting doll. A second matryoshka has a body buzzing with simplified, multicolored bees amid abstract spiraling tendrils, the entire form outlined by rickrack and gathered ribbon (Figure 5.4). The surface of the dress is adorned with a machine-embroidered motif of undulating vines and leaves that extend the length of the dress, which Arthur heavily adorned with her hand-embellishments. By placing the matryoshkas over this motif, the abstract vines become a background for the nesting dolls, forming a halo that simultaneously envelops and connects each matryoshka, forming a

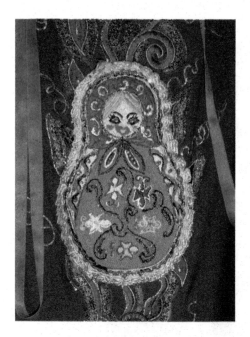

Figure 5.4 Detail of one of the embellished matryoshka patches on Arthur's matryoshka
dress, 2010 (Image: Christopher Richards).

kaleidoscopic column of color and pattern that radiates both Arthur's artistry
and cultural heritage.

Through exportation and tourism, matryoshkas have become synonymous
with Russian heritage and artistry; as the most prominent and recognizable symbol
on the dress, Arthur selected the matryoshka because of its immediate associ-
ations with Russian culture, a symbolic celebration of her own heritage. Like the
majority of Arthur's most potent sartorial motifs, the matryoshka is multilayered.
Arthur chose to represent each matryoshka in their most iconic form. Each figure
wears an abstract *babushka*, or headscarf, and their highly patterned bodies echo
the bright and decorative *sarafan*, or peasant dress; these elements are subtle yet
recognizable allusions to historical forms of Russian dress that are further linked
to notions of idealized femininity and maternity. As explained by Russian cul-
tural historian Joanna Hubbs, the matryoshka is the symbolic embodiment of
"Mother Russia" and an idealization of Russian maternity and femininity.[21]

Arthur's use of iconic matryoshkas as her primary symbol of Russian heri-
tage simultaneously evokes notions of idealized femininity and motherhood,
themes that are both overtly and subtly expressed throughout her collections.
By placing these idealized matryoshkas on a form-fitting, strapless dress with
titillating lace-up sides, Arthur further complicates the garment's meaning (and
by extension, the significance of the matryoshkas). The matryoshkas main-
tain their allusions to femininity and Russian heritage, but juxtaposed with a

Figure 5.5 The altered version of the matryoshka dress, as seen in her boutique, 2010
 (Image: Christopher Richards).

revealing silhouette, the ensemble becomes a celebration of a liberated, perhaps cosmopolitan, Russian woman, one who acknowledges and honors the past, while not being inhibited by it. The matryoshka dress thus becomes one of Arthur's first distinct attempts at marrying symbolic and stylistic representations of femininity with more overt and unbridled female sexuality, foreshadowing her later, *Hands Off – Eyes Only* collection.

When the dress was first presented in 2009, its main cultural allusions were to Russia, with no identifiable references to Ghana. By the following summer, Arthur had made a significant revision: she replaced the original tulle edging with a wide hem of solid red fabric, disrupted by alternating godets of batakari cloth in two distinct striped patterns (Figure 5.5). As an iconic, but often overlooked, Ghanaian material (for a more comprehensive discussion on the cultural and historical significance of batakari cloth, see the *Clothed in cultural heritage* section of Chapter 6), its inclusion transformed the dress from a

celebration of exclusively Russian heritage and liberated femininity to a symbolic fusion of cultures that cleverly mirrors Arthur's own identity.

As a material associated specifically with Northern Ghana and popularized by Nkrumah, Arthur's inclusion of batakari cloth evokes both historical Ghanaian dress practices and a conspicuous, yet constructed, image of Ghanaian culture. The batakari material is used for the trim's godets, a sewing technique that creates noticeable flares, exaggerating the garment's size and volume; godets are the most recognizable feature of men's batakari smocks, which aid in creating the illusion of a larger, more imposing figure. By adapting the smock's iconic features, namely its material and form, to create an exaggerated flounce, Arthur challenges the garment's associations with male prestige and potency, emphasizing the subtle femininity of a garment that is so closely tied to Ghanaian masculinity. Arthur's literal repositioning of the batakari's iconic godets from chest-level to sweeping the floor is a visual shift that may symbolically speak to the subjugation of male power, while stylistically serving to create a more fluid and flattering silhouette. Ultimately, the gown's batakari trim functions similarly to its matryoshkas: as a means for honoring historically significant cultural beliefs and practices, while simultaneously challenging their associations with established gender roles. The matryoshka dress illustrates the crux of Arthur's artistic fashions: to simultaneously honor and transform culturally specific motifs and materials into fashionable, provocative garments that celebrate Arthur's own heritage, and by extension, the qualities of being a cosmopolitan.

There is an additional, easily overlooked detail on the matryoshka dress that speaks directly to Arthur's identity and resonates with Africans and the African Diasporic community: the use of pink, braided hair weave to outline one of the four matryoshkas. Hair is a particularly important medium of expression for Arthur and she has become known for her unconventional hair styles; her platinum blonde hair, whether worn curly, in braids or wrapped into a beehive, often elicits comments from bystanders. When discussing the biases she encountered as a child and young teen, Arthur makes it clear that her hair was often the focus of criticism. Following her personal revelation, she recalled that her hair was an important element of her new-found freedom: "I don't have to do any of this, I can do anything I want, with my hair, with my dress, with my makeup."[22] Arthur views her hair as an extension of her creativity, and ultimately, her personal identity; it should come as no surprise that such a potent material, imbued with Arthur's own individuality and self-determination, is often found adorning her clothing.

Instead of selecting more natural shades, Arthur chooses hair weave in a myriad fantastical colors, including green, orange, pink, blue, yellow and platinum blonde (Figure 5.6).

Arthur's weave is almost always braided, although she employs multiple braiding techniques to transform the synthetic strands into a malleable form of ornamentation. Arthur's consistent use of hair weave as embellishment implies symbolisms beyond her own personal autonomy and heritage; her use of hair

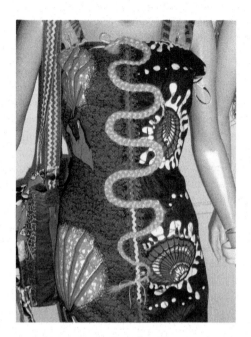

Figure 5.6 The front of a dress adorned with orange, braided hair weave, 2010
(Image: Christopher Richards).

weave is imbued with meaning for the global Black community. As a form of
dressing the head, braiding illustrates important cultural exchanges between
Africans and members of the Diasporic community. As established by Kennell
Jackson, West African emigrants brought specific braiding techniques, including
the addition of colored string, beads and hair extensions, to African–American
communities in the 1970s.[23] Kennell further argues that African and African–
American communities were indirectly influencing each other's hairstyles and
techniques during the late twentieth century, which is supported by the explo-
sion of African-inspired, hair-braiding salons in the United States and a super-
ficial survey of Ghana's beauty shop signs.

Not only do the materials and techniques used for braiding hair illus-
trate important connections between Africans and the Black Diasporic com-
munity, hair remains a powerful vehicle for communicating identity, social
status, age, resistance and self-acceptance among Black communities. This is
evidenced by the 2020 incident involving Texas teenager DeAndre Arnold,
who was suspended from school and his own graduation for wearing his
hair in locs. Arnold repeatedly stated that his hair was an immediate signi-
fier of his Trinidadian heritage; forcing him to cover or cut his hair would
be a direct affront to his identity. As Black hair continues to serve as a site for
the expression and contestation of identity and heritage, Arthur's persistent

use of hair weave as a form of ornamentation accrues additional significance. More than simply a means for appealing to global, specifically African-American consumers, Arthur's use of hair weave reiterates her identity as a Ghanaian, and more broadly, as a cosmopolitan, Black African. Embedded in her polychromic, braided embellishments are symbolic references to the interconnectedness of Black people, particularly in terms of a shared ancestry and heritage, and a celebration of their beauty, creativity and originality. Thus an easily overlooked braided trim in shocking pink becomes not only a signifier of Arthur's ingenious and unique perspective, but a further assertion of the complexity of her sartorial decisions.

The matryoshka dress is a singular creation. As part of her debut collection as a solo designer, it unapologetically announced Arthur's aesthetic approach to design and illustrates the multilayered complexities that can be explored through the medium of fashion. The garment attests to the intensely personal narratives that are embedded in Arthur's most extraordinary designs: garments she creates for specific collections or for international runway shows. Like the matryoshka dress, these garments incorporate elaborate embellishments and extensive hand-detailing, resulting in designs that are doubly significant, both for their laborious creation and symbolism. Arthur is particularly attached to these garments; as she explained:

> I get so emotionally attached to some of them that by the time I finish them, I can't even bring myself to sell them. Or I need to hang on to them for a long, long, long time and I actually choose to whom I give the design, so even if there are three people all offering to pay me good money, I decide which is the right person to wear my outfit.[24]

When asked about her connection to the matryoshka dress, Arthur stated:

> The matryoshka dress is not something I can't part with … basically … that dress is a prototype now. I wouldn't sell it because it's the first one and I spent so much time and effort, hours making that dress. I wouldn't sell that particular one, but I would make one for somebody who wants to buy it.[25]

Arthur's refusal to sell particular garments is an additional indicator that her designs are often direct expressions of her personal experiences and heritage; specific garments are so permeated with her identity that she cannot bear to part with them.

A second dress, photographed in her boutique in 2010, further illustrates Arthur's penchant for material and symbolic fusions that are often laced with humor. The main body of the sleeveless dress was divided into two vertical panels of contrasting linen fabric: one purple, the other red. The lower portion of the skirt consisted of four horizontal bands of contrasting fabrics, each joined together with Arthur's preferred openwork lace. Although Arthur

included wax print appliqués of flowers and leaves on the bodice of the dress, the most complex and potent element of the garment is its patchwork skirt (Figure 5.7).

The first two horizontal panels were of contrasting wax prints: the first an abstract pattern in teal, white and maroon; the second a simplified pattern of flowers and leaves in shades of lime green, navy blue and white. To each of these panels, Arthur added an additional wax print appliqué. The first panel included a single red hand taken from the iconic wax print "spray paint" or "bug spray," which depicts a hand in the act of pressing the nozzle of a spray can. Repositioning the hand downwards, Arthur placed an oversized red rhinestone in between its fingers, suggesting the disembodied hand is in the midst of "discovering" a rather impressively sized jewel. Positioned directly below Arthur's reimagined "hand and jewel" motif, on the second panel of wax print, is an appliquéd fish. Although the blue patterns of the print may evoke the appearance of water, the juxtaposition of a fish with botanical motifs is puzzling, if not humorous. In both instances, Arthur played with scale, orientation and a given motif's original context to create a complex layering of materials that challenge one's expectations of known and recognizable wax prints. These reconstituted wax prints, with their disrupting appliqués, attest to the whimsy that is often imbued into Arthur's designs.

Figure 5.7 Detail of a patchwork skirt that illustrates Arthur's penchant for humorous and meaningful appliqués and embellishments, 2010 (Image: Christopher Richards).

The third and fourth panels of the dress are formed from disparate materials: the third panel is a single piece of purple batik fabric, likely made in Ghana, whereas the fourth panel is sewn from five narrow columns of various fabrics, each joined by the aforementioned lace. The five fabrics are unified by their shared color scheme of indigo blue and white, but their patterns are distinctive. The two fabrics with circular geometric motifs, each repeated twice, are likely imports from Europe; the fifth panel is of a locally woven, indigo-dyed cloth featuring a stitch-resist pattern. Arthur appliquéd a single elaborately hand-painted fish to the center of this panel, evoking allusions to the sea, while echoing her inclusion of fish as decorative flourishes. What can easily be dismissed as a whimsical and eccentric design is a study in what it means to be cosmopolitan. Arthur combines handmade, locally produced textiles with industrially printed fabrics from Europe and China, creating a garment that attests as much to global trade networks as it does to the complexity of Arthur and her clients' identities. The dress further exemplifies Arthur's cosmopolitan approach to fashion design; she literally joins together, with stitches and trim, a variety of materials that maintain their connections to specific cultures, while fusing to become a single, harmonious garment. This dress, and the majority of her designs, are testaments to cosmopolitanism: fashions infused with localized perspectives and materials, while maintaining relevance and appeal in broader, global contexts.

"I like that things become something else": the recycling and revising of Arthur's designs[26]

Saving the matryoshka dress and other extravagant, deeply personal, designs ensures that the narrative of each garment remains intact and understood. Arthur's continued possession of these designs, both from personal desire and as a byproduct of her boutique's closure, encouraged the development of another practice: the continual revisiting and reworking of specific garments. As Arthur acknowledged: "you evolve as a person or an artist, so sometimes you see something and you think, I could give this another dimension that's fun."[27] By continually revisiting specific garments, Arthur is able to hone the symbolic significance of her most meaningful designs, resulting in garments like the matryoshka dress, which gradually transformed from a one-dimensional expression of her identity to a complex and multilayered embodiment of her dual heritages. This ability to revisit designs further increases the artistry of each garment, as Arthur can continually adapt and rework surfaces, resulting in more innovative (and sometimes less wearable) silhouettes, with an increased amount of painted and embellished surfaces. When asked to address her penchant for altering and enhancing her designs, Arthur stated:

> I like the idea of transformation. I love it … There are certain clothes that I like the way they are. I don't want to touch them; I feel they are perfect and they need not be altered, modified or tampered with. And then the other clothes, I feel like it would be interesting to see how they look, so

I can transform trousers into a dress or a blouse into a skirt ... I transformed a skirt into a hat for Dakar Fashion Week![28]

When Arthur was actively developing new collections, she would first mine her existing garments for possible materials and motifs that reflected her current theme.

Before buying new fabrics, I would go through the existing collection of clothes that I haven't disposed of or sold yet, to see if there is anything I can borrow or pick off or reuse. If I don't find anything because it doesn't correspond to the theme, then I would go out and start looking for new things, but first and foremost I would go through what I have.[29]

For one of her collections, titled "Tribal Flair," Arthur used existing gowns to create an entirely new suite of garments; she shortened the original floor-length gowns to create cocktail dresses, and removed triangles from the sides, which she reworked to become puff sleeves.[30] In true Arthur fashion, she adorned the reworked dresses with leftover Christmas garland, a quirky, unexpected exercise in reuse that is typical of Arthur's aesthetic.

A specific garment that testifies to Arthur's penchant for both keeping and reworking her designs is a halter dress I originally photographed in 2010, displayed in one of her boutique's windows (Figure 5.8).

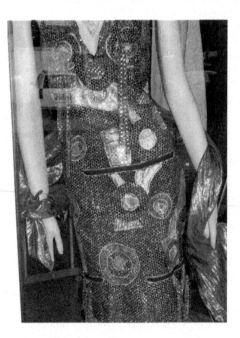

Figure 5.8 The original "Celebration" dress, as displayed in the window of Arthur's boutique, 2010 (Image: Christopher Richards).

I was reacquainted with the garment in 2016, as part of an extensive, private collection of B'ExotiQ designs (Figure 5.9). What makes the garment particularly unusual is its fabric: the primary motif is of a floating hand, gracefully balancing a tray carrying two glasses; one is full, the other is being filled by a bottle suspended in mid-air. The color scheme of gold, navy blue and white provides the fabric with a celebratory feel, one that Arthur chose to purposely accentuate through additional adornments and embellishments. The original "Celebration" dress had rings cut from the fabric's background pattern appliquéd onto its surface, with two rings strategically placed over the bust of the dress. From the center of these rings hung ribbons of sequined fabric, evoking tassels frequently worn by burlesque performers, indicating the edgy, empowering sexuality Arthur often references in her more artistic designs. Arthur echoed these forms by creating tassels that adorned the hem of the dress, along with additional rings, cut from the same sequined fabric, positioned randomly across the surface of the dress. Arthur applied gold metallic paint to emphasize specific elements of the print, namely the hand, tray, bottle and glasses. Her finishing touch was the inclusion of her signature on the lower right portion of the dress, stitched in gold thread and accented with her customary fabric paints. The result was a vibrant, glittering and kinetic design that playfully highlighted the unusual motifs of Arthur's chosen wax print.

Six years later, the dress had experienced considerable revisions. All of the tassels had been removed and replaced with a variety of ribbons and strands of glittery, gold braids, designed to asymmetrically drape from one side of the dress. The suggestively placed rings had been covered by additional appliquéd rings and strips of matching fabric. More appliquéd rings had been added, particularly on the bodice of the dress, and Arthur had filled any unadorned space with hand-painted, sinuous, silver lines, connecting her appliquéd rings. The straps and upper bodice of the dress were further covered with silver sequined fabric, creating a visual disjuncture between the garment's upper and lower portions. The hem had also been shortened, causing Arthur's original signature to become partially obscured.

The presence of Arthur's fragmented signature illustrates her acceptance of imperfection and attests to the importance of showcasing her sartorial adaptations. Instead of attempting to obfuscate these extensive revisions, Arthur ensured they were not only noticeable, but emphasized. The majority of Arthur's revisions used metallic silver as opposed to her original gold embellishments; instead of being edged with thick, gold stitching, Arthur's latest appliquéd rings were outlined with silver paint. The more recently added sequin fabric was also metallic silver, and the ribbons were all fashioned from materials completely different from what was originally used on the dress. This suggests that Arthur's revisions are not only deliberate, but that she wants to maintain a clear, visual record of her adaptations, celebrating her inherent talent for astute reuse. As exemplified by this dress, and supported by other examples of Arthur's designs (including the matryoshka dress and a garment from her *Hands Off – Eyes*

Figure 5.9 The altered "Celebration" dress, 2016 (Image: Christopher Richards).

Only collection), specific garments become ongoing projects for Arthur, being gradually reworked and revisited, either to perfect their symbolic meanings, to incorporate them into a new collection, or to reimagine them as something wholly new and distinct.

A sinuous signature: Arthur as artist

As the "Celebration" dress illustrated, even after considerable alterations, Arthur ensured one element remained intact, even if slightly fragmented: her signature. Whether embroidered or hand-painted, Arthur's signature is present on the majority of her intricately adorned garments, an effective and immediate means for literally marking her designs. Arthur's signature further asserts her identity as an artist and that each of her signed pieces is a sartorial work of art. As Arthur stated: "How many times have I been asked: how do you consider yourself? Ultimately, I am an artist. That's how I see it … For me, fashion is art."[31]

Arthur's carefully articulated signature is comprised not of her initials, but a pairing of the lowercase letters "b" and "q," an abbreviation of "B'ExotiQ," the name she used during her collaboration with Nonterah and for her individual label. In an early interview, Arthur explained that the signature is actually comprised of two Cyrillic letter "b"s, with one flipped and reversed to appear as the English letter "q," a subtle nod to her Russian heritage and a reference to her nickname "Bee."[32] Each letter typically has exaggerated features, including curled lines, added circles or accentuated "tails." The presence of her signature serves as an indicator that the garment is authentic and original, further imbuing it with a degree of individuality that attests to its inherent artistry. The importance of her signature likely grew from her partnership with Nonterah, functioning as a subtle, but ever-present assertion of her literal and figurative hand on specific garments.

A skirt of unknown date that bears the combined "Benign & B'ExotiQ" label, attests to Arthur's hand through its embellishments and surface treatments, asserting her role as creator of the garment (Figure 5.10). The base of the skirt is sewn from two contrasting panels of linen, in shades of chartreuse and magenta, divided by a narrow strip of pink, yellow and turquoise kente. The right, magenta, panel is adorned with a botanical motif of metallic embroidery and wax print appliqué. The left, chartreuse, panel is embellished with three diagonal, functional zippers, further decorated with spirals and swirls of glittery fabric paint in shades of green. The hem of the skirt is trimmed with kente cloth that has been cut to create individual petals, or pleats, joined to the skirt

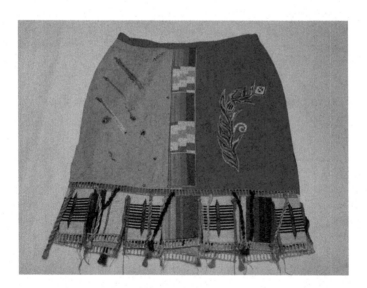

Figure 5.10 A garment bearing the "Benign 'N B'Exotiq" label, but adorned with Arthur's signature, c. early 2000s (Image: Christopher Richards).

by an openwork lace trim of neon orange. Braids of lime green, blue, yellow, purple and platinum blonde hair weave are attached to the lace trim, creating an additional layer of detail to an already exuberant skirt. The reverse of the skirt is adorned with an additional embroidered botanical motif, outlined in yellow thread. In the upper right corner of the skirt, written in red glitter paint, are Arthur's sinuous and iconic letters: "bq."

The skirt is something of a contradiction; its label, coupled with its lining, a custom batik featuring Nonterah and Arthur's logos (an abstract African woman for Nonterah and a bee for Arthur), confirms that it was produced during their partnership; however, its overall appearance and design aesthetic suggest it was created solely by Arthur. The key to understanding this skirt is Arthur's signature. Its glittering presence asserts that Arthur was likely the sole creator of this garment. A cursory survey of Arthur's most significant designs, including the aforementioned "Celebration" dress and the majority of designs from her *Hands Off – Eyes Only* collection, include Arthur's easily identifiable signature. The inclusion of these two seemingly innocuous letters is a direct means for Arthur to assert her own creative energy and to verify that she alone created the skirt, along with other garments that bear a "bq." Furthermore, the motif powerfully encapsulates Arthur's own ethnic heritage; the Cyrillic letter "b" indicates her Russian heritage, whereas the inverted Cyrillic "b" is read as an English letter "q," which speaks to her identity as Ghanaian (English being the official language of Ghana). Her insistence on creating a hand-painting or embroidered signature further references her Russian heritage, as she attributes her penchant for handiwork to her upbringing in the Ukraine. Arthur's signature is a symbolic distillation of her identity, which suggests that its presence is more than a confirmation of her hand, it functions as an additional, subtle symbol of her identity and her deeply personal approach to fashion.

"A lion does not need to roar to keep the crowd in awe.": Arthur's final collections[33]

Hands Off – Eyes Only

In her essay on African feminism, Senegalese curator, art critic and architect N'Goné Fall references a powerful West African proverb to encapsulate the role of African women within their patriarchal societies: "A lion does not need to roar to keep the crowd in awe."[34] Beneath the flashy "roars" of Arthur's designs, brazen in their vibrant and offbeat colors, materials and embellishments, exists a multitude of complex, layered meanings; her sartorial "roars" may capture the crowd's attention, but it is these embedded meanings that sustain the crowd's interest. Arthur's final collections, *Hands Off – Eyes Only* and *Dumsor*, are her most evocative and symbolically complex. Completed after the closure of her boutique, the two collections are free from the constraints of salability and

wearability, allowing her complex narratives to literally spring forth from the surface of her garments. Arthur champions her symbolic exploration of particularly poignant and political concerns that are ultimately challenged, and perhaps remedied, through her unconventional designs.

Initially presented in Paris, followed by a more comprehensive showing at the 2013 Ouaga Fashion Week, Arthur's *Hands Off – Eyes Only* collection did not begin with its politically charged message of women's predation and subsequent empowerment; rather, its initial impetus was her combined love of neon colors, 1980s' fashions, and her continued interest in historically significant wax prints. As Arthur reflected: "usually when I pick wax prints to work with, it's either because it's a reflection of modern times or I'll go for a very old cloth that reminds me of my mother, because it's related to my childhood and nostalgia."[35] During a visit to Makola market, Arthur found a fabric that featured a composite of two historically significant motifs: the hand (often seen with coins) and the eye, in an unusual color scheme of electric pink and yellow.[36] With wax prints featuring the hand motif being produced since 1905 and the inclusion of eyes in prints dating to as early as 1912, this fabric and its implied heritage resonated with Arthur.[37] Drawn to these motifs and their saturated colors, Arthur decided to create a collection highlighting this fabric.

Creating designs from a single fabric is contrary to Arthur's aesthetic approach; Arthur chose to employ this unusual wax print primarily as a form of embellishment, using printed, black funeral cloth as the ground for the majority of her designs. As she explained: "It was black and plain, so it gave me the opportunity to paste anything I wanted on it. It's like a canvas."[38] Her inclusion of various black funeral fabrics was not merely functional; the cloth has metaphorical significance for Arthur. As she elaborated:

> I think the funeral cloth is more authentic to our culture … Formerly, most of the funeral cloth was with adinkra symbols and adinkra means farewell, so I think it was more authentic than all the other fabrics that we have adopted as our own.[39]

Arthur's personal attachment to funeral cloth, due to its literal and symbolic associations with Ghanaian cultural practices, coupled with its functional appeal, resulted in the fabric becoming a subtle, yet ever-present, element of the *Hands Off-Eyes Only* Collection.

After purchasing her desired fabrics, which reminded her of the outrageous, neon-hued fashions of the 1980s, Arthur began constructing her collection. At the forefront of Arthur's mind was her desire to reinterpret her chosen, iconic motifs: "I wanted to give my own meaning to the hands and the eyes; I know what they mean for the clothmakers and printers, but I wanted to give it [them] my own meaning."[40] After creating the base silhouettes of her designs, Arthur realized they were all quite short and provocative. She began imagining these garments on women's bodies and the unwanted comments they would elicit

from men, particularly in Ghana. This reflection sparked an additional memory, of a conversation between her and a French friend. The woman explained that even in France, with its more progressive stance on fashion and women's equality, short and revealing clothing would often result in derogatory comments from men. Surprised by this shared experience, Arthur began to piece together the thematic focus of the collection: one that would acknowledge and provoke the male gaze, while simultaneously challenging it.

Initially, Arthur thought of using only the eye motifs, unofficially titling the collection "For Your Eyes Only."[41] As she reflected:

> It was going to be an ode to the eighties, rock and roll ... some of the dresses I actually finished, [but] they looked too simplistic. They were beautiful, but I wasn't looking for just beautiful. They were not telling me a story. I wanted more to it than just being pretty and nice. It was nice and I don't do nice, it had to be interesting. Even if it was interesting only to me. Even if I was the only one understanding the story.[42]

This desire for a deeper, more complex meaning led Arthur to begin playing with her chosen fabrics. She first realized that the eye motif could easily take on additional, symbolic meanings.

> When I took the eye, I realized: 'Why must an eye always be like that?' I can turn the eye any way I want ... if you turn it the other way, it [the eye] kind of looks like a vagina.[43]

After scattering her garments with eyes, altered to appear as vulvas, she began to play with the hand motif:

> I started placing the hands and then it looked like somebody trying to grope her [the wearer], his hands all over ... and then I said okay, this is going to be my theme. I started placing hands on the other dresses as well. And then, some of the dresses I didn't want to put hands ... no, I'm just going to put things that allude to genitalia, but without people realizing it [laughs].[44]

The resulting collection, a literal fusion of inspirations, exemplifies Arthur's approach to design: it features iconic, historically significant wax print patterns, is layered with all manner of embellishments, including ribbon, paint and appliqués, and most importantly, speaks to Arthur's personal experiences and philosophies. Before examining specific garments and their indirect yet ever-present amalgamation of symbols, it is necessary to briefly acknowledge the American feminist art movement and its inherent corporeality. By illustrating how Arthur's collection is both informed by, yet distinct from, established depictions of female genitalia, particularly in the United States, her bold innovativeness can be better understood and appreciated.

Beginning in the early 1970s with collaborative projects and exhibitions like *Womanhouse* and *Where We At: Black Women Artists*, women began to challenge the established, patriarchal and exclusionary art world.[45] Many of these early artworks and collaborative projects focused on women's lived experiences, illustrating the importance of women's artistic production through tangible, albeit sometimes transient, forms of expression. One of the most influential works of feminist art from this period is Judy Chicago's *The Dinner Party*. Created as a testament to the contributions of women throughout history, the work literally and metaphorically provided women with a "seat at the table," assertively proclaiming their significance to global history. The installation itself, comprised of elaborate table settings dedicated to 39 women, celebrated the importance of art forms stereotypically associated with women, including ceramics, embroidery and needlepoint. The most notable and controversial aspect of the installation was each plate's inclusion of lavish embellishments based on vaginal iconography. Chicago's work firmly established the importance of the vulva as a potent, yet contested, representation of women's sexuality, fertility and inherent power. Chicago's work, along with that of other feminist artists including Carolee Schneemann, Lynda Benglis and Ana Mendieta, continued to literally and figuratively reference the female body, with an emphasis on female genitalia. These artists not only depicted but highlighted the vulva, in order to draw attention to women's exclusion from the history of art, to reclaim their own sexuality, and to celebrate the power and beauty of the female body from an exclusively female perspective.

In a twenty-first-century American context, artistic representations of the vulva are often dismissed as either derivative or banal, as this imagery is so closely aligned with the artists and artworks associated with second wave feminism. It is a misnomer to make such claims, particularly when considering the artistic expressions of women outside of America and Europe, as movements of feminism have not impacted all women equally across the globe. In relation to the African continent, Senegalese curator, art critic and architect N'Goné Fall makes a controversial yet powerful assertion:

> apparently, the waves of Western feminist demands in the 1960s and 1970s had little impact on Africa. The social balance continued for the most part unchanged, and feminist theories remained faraway whispers. Women had too much to do in modern Africa to listen to their Western "sisters."[46]

Fall further suggests that it wasn't until the late 1990s, around the same time as Arthur's collaborative brand was established, that African feminist art began to influence and shape the global art system. It is within this context, with the understanding that African feminisms have been articulated more recently, and that the legacy of vaginal representations linked to feminism is not ever-present on the African continent, that a more careful examination of Arthur's *Hands Off – Eyes Only* collection is needed. Although Arthur was undoubtedly influenced by established artistic representations of vulvas, her designs should

be understood within a context of Africa, specifically Ghana, further acknow-
ledging the inherent power that often comes with publicly displaying female
genitalia.

One of the most simplistic yet compelling designs from the collection is
a black, long-sleeved garment, that could be worn as a tunic or dress, with
exposed "peek-a-boo" shoulders and central slits in the front and back of the
skirt (Figure 5.11).

These central slits provide a titillating glance at the wearer's body, specifically
the upper thighs, an area of the female body that is viewed in Ghana as being
particularly provocative. The wearer's bare shoulders function in a similar way;
they accentuate and expose areas of the wearer's body that are viewed as sen-
sual, and that are often the subject of the male gaze, or the site of potentially
unwanted caresses. By pairing long, full sleeves and an ankle-length skirt with
elements that expose the legs, thighs and shoulders, Arthur creates a garment that
is a visual paradox, simultaneously conservative and suggestive. This garment in
particular plays with notions of concealing and revealing, asserting the power of
the wearer in choosing what areas of the body to expose. It is a bold statement
on women's sexuality, championing a woman's ability to control how her body
is engaged with and admired.

The garment's main ornamentation consists of two radiating vulvas that
adorn the wearer's breasts and stomach, areas that are considered potentially

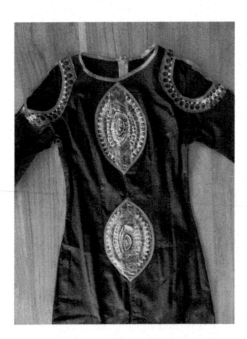

Figure 5.11 Detail of Arthur's long-sleeve tunic dress from the *Hands Off – Eyes Only*
collection, 2016 (Image: Christopher Richards).

erotic or erogenous. Each motif is heavily painted; the central, horizontal eye is outlined and accentuated with glittery pink and yellow fabric paint. There are concentric, almond-shaped rings, alternating between yellow and pink, that radiate outwards from the eye, with each ring comprised of tiny hearts (an apropos nod to love and sexuality). Arthur further emphasized these rings by outlining each with paint; an additional painted band of black glitter paint running the length of each motif, accentuating their verticality and placing additional emphasis on the central vulva motif. There is a third eye-turned-vulva appliquéd on the back of the garment. Outlined in pink trim, the motif is less embellished, but its positioning, located over the wearer's shoulder, again suggests an area that may be gazed upon by men. Although all three motifs were originally intended to be read as literal eyes, by shifting their orientation from horizontal to vertical, Arthur drastically changes their symbolism: they become glittering and potent representations of women's genitalia.

With this particular garment, as with others, Arthur employs her embellished vulvas to emphasize specific erogenous zones of a woman's body while intentionally disrupting the male gaze, literally and figuratively preventing these areas from being viewed or touched. In many West African countries, including Ghana, the vulva is considered to be particularly potent, as it is associated with a woman's ability to create life, signifying their role as creators of all humankind. Throughout West Africa, women have harnessed this inherent power as a means of resistance, threatening to expose their bodies to enact social and political change. Instead of relying on established terms such as "genital cursing" and "genital power" to discuss this particular practice, I will employ the terms proposed by comparative literature professor Naminata Diabate, who describes these cross-cultural enactments as "insurgent nakedness," "naked agency" or "defiant disrobing."[47] Key to Diabate's discussion is the notion of defiance, that the act of disrobing is directly tied to expressions of challenging established, patriarchal systems. Diabate defines naked agency as encapsulating the "confrontational exhibition of bodies in public" and "women's ability to act or react, intentionally or otherwise, in punishing offending males or signaling vulnerability, or both."[48]

Various forms of women's nakedness have been challenged in both colonial and post-colonial Ghana, most notably through Nkrumah's "anti-nudity campaigns," (1958–1966) which targeted Northern Ghanaian women's lack of dress as indicators of "backwardness," unrepresentative of the newly independent, purportedly unified and wholly modern nation state of Ghana.[49] Although these campaigns did not address specific, defiant acts of disrobing, they illustrate how women's undressed bodies were continually contested, by men and women alike.

In relation to Arthur's sartorial references to the vulva, female genitalia in Ghana are imbued with reproductive power and inherent, specifically maternal, respect; one of the most extreme verbal insults in Twi, is to curse a mother's vagina. The curse not only offends the mother in question, but also

the life that she has given; it implies disrespect and shame, as one should not refer to or visualize maternal genitalia. In relation to her unusual, subversive fashions, Arthur's representations of vulvas can be considered forms of "insurgent nakedness," as she is wielding their power to protest against men's predatorial actions toward women's bodies, without requiring the wearer to actually expose herself. Arthur's abstract, colorful forms also function as empowering talismans, literally impeding men's unwanted gazes or caresses, celebrating the protective power and inherent beauty of female genitalia. The garments in Arthur's *Hands Off – Eyes Only* collection engage in the cross-cultural act of feminist-based protest and corporeal celebration, employing a particularly astute form of protest that can be continually enacted with the mere donning of her designs.

A similar use of vulvas appears on a second dress which, not surprisingly, was a redesign of an earlier garment originally presented for a 2011 Vlisco fashion show (Figure 5.12).[50] Photographs suggest that Arthur's alterations to this garment were relatively minimal, likely because it fortuitously reflected Arthur's chosen color palette of pink, black and yellow, further demonstrating how she mines her own archive before finalizing a new collection. The most notable revisions were Arthur's removal of blue ribbons adorning each shoulder and the addition of her eye and vulva appliqués.

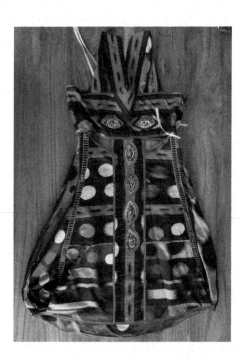

Figure 5.12 A reworked dress that Arthur embellished with eyes for her *Hands Off – Eyes Only* collection, 2016 (Image: Christopher Richards).

Like the majority of her dresses from this collection, the skirt is unusually short; its bodice is comprised of a bandeau top, connected to the skirt through the ingenious use of a single strip of fabric, exposing part of the wearer's midriff. Arthur employs additional strips of the same fabric to create complex straps that offer support for the bandeau top, while exposing additional skin. As the entire dress was sewn from one wax print, it attests to Arthur's skill in manipulating a single fabric by deconstructing its motifs and altering their orientation, creating the illusion that the garment was created from multiple, harmonious prints.

Arthur's use of appliquéd motifs is restrained, yet powerful. Arthur positioned two appliquéd eyes on the bandeau top, enhanced and outlined with matching glitter paints. By presenting these appliqués in their intended orientation, as literal eyes, Arthur makes their symbolism clear: they allude to the unwanted gaze of men, often focused on women's breasts. As with the previous garment, Arthur's use of appliquéd eyes and vulvas disrupts the act of gazing. In the case of this garment, any potential glare is returned by the inanimate but ever-present eyes, a direct confrontation to potentially unwanted, predatorial stares. There are additional appliqués on the garment's central strip of fabric, comprised of four appliquéd eyes, their orientation altered to suggest vulvas. Their linearity further emphasizes the presence of Arthur's eyes, while subtly alluding to the potential apotropaic power of their form.

A third, equally short, dress mirrors the positioning of the motifs on the aforementioned garment, thereby reiterating their symbolism (Figure 5.13). This halter dress is sewn from a wax print comprised of repeating rows of zigzags, alternating between black, pink and yellow. The dress is an additional indicator of Arthur's clever use of her chosen materials. Arthur ingeniously adapts the pattern to create a carefully articulated zigzag hemline; her incorporation of black lace trim along the neckline accentuated her overall design and, by threading the lace with yellow ribbon, created an additional means for securing the dress onto the body.

The main feature of the dress is its bold, confrontational eye; instead of relying on an existing, printed eye motif, Arthur created a cutaway in the shape of an eye, adding a central black "iris" and trimming the form with "lashes" fashioned from the zigzag pattern. Thus, Arthur created an actual, albeit enlarged, eye that, while confrontational, simultaneously exposes a portion of the wearer's chest. As with the previous garment, there is a vertical column of appliqués, although these alternate between eyes-turned-vulvas and abstract rectangular forms. The intermingling of these motifs, all outlined and heavily painted, is reminiscent of the iconic Ghanaian men's tunics that are adorned with amulets and assemblages, further solidifying the notion that Arthur's vulvas function as protective symbols of female identity and power.

A second dress sewn from the same zigzag print is perhaps Arthur's most direct and symbolically complex allusion to female genitalia. Like the aforementioned design, the dress has a cutaway revealing the wearer's cleavage, but this one is oriented vertically; the opening is edged in a wide, slightly ruffled ribbon fashioned from the same fabric used to create the dress (Figure 5.14).

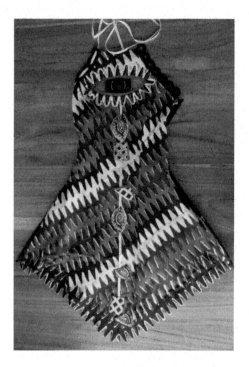

Figure 5.13 A halter dress from the *Hands Off – Eyes Only* collection featuring a "peek-
a-boo" eye motif on its bodice, 2016 (Image: Christopher Richards).

Arthur altered the direction of the design to exploit its linearity, creating the
illusion that the cutaway's trim, which forms her most obvious reference to
female genitalia, is simultaneously a halo radiating outward from its central
motif: a large, ornately painted eye that spans the width of the cutaway. This par-
ticular eye is the most heavily embellished of all Arthur's motifs. Not only has
Arthur outlined each feature of the eye with multiple lines, she has articulated
a multitude of eyelashes and exaggerated the texture of the iris, resulting in
an arrangement of lines that appear to emanate outwards from the pupil. The
result is two symbols that exist in tandem: the beaming eye and the glittering,
ruffled vulva.

By creating an embellished dress element that evokes the form of a vulva, as
opposed to altering a pre-existing motif, Arthur's symbolism is more conspicu-
ously and emphatically conveyed: the motif is a celebration of the female body
and women's sexuality, encouraging, if not inviting, onlookers to gaze at the
garment's resplendent representation of female genitalia. Although the vulva,
and the wearer's body, are technically on display, any potential gaze is disrupted
by the heavily adorned eye, which literally obscures the wearer's cleavage and
part of the vulva. This tension between display and concealment, between

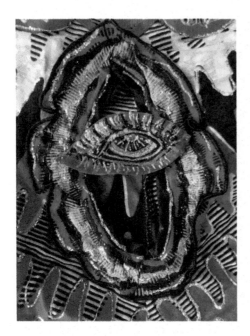

Figure 5.14 Detail of the vertically oriented cutaway that simultaneously references female genitalia and an open eye, 2016 (Image: Christopher Richards).

solicitation and obstruction, is consistent throughout the aforementioned designs. In examining the silhouettes, particularly the shortness of Arthur's hemlines and her extensive use of cutaways, it is clear that specific areas of the body are meant to be on display. Arthur is flaunting the female body, inviting the gaze, and yet features of these garments prevent the wearer from being wholly consumed. Arthur continually employs the eye as an unofficial apotropaic device; if anyone dares to gaze upon certain areas of the body, they will be met by a pronounced, unwavering eye, returning their gaze. Arthur literally reflects the gaze back onto the observer, creating garments that acknowledge men's unwanted glances by ultimately challenging them.

The male gaze is only one facet of the *Hands Off – Eyes Only* collection; unsolicited touching is symbolically addressed through several designs, resulting in garments that address a more sinister, predatorial action against women's bodies. One such dress, sewn primarily from Arthur's favored zigzag fabric, has a contrasting bodice of navy blue, with a pink hand positioned horizontally across the bust (Figure 5.15).

Due to its orientation and placement, Arthur creates the illusion that the wearer's breasts are being groped by a disembodied hand. Arthur's alteration of this iconic motif, the hand with coins, transforms its original symbolism of wealth and good fortune into a visual testament to men's pervasive sexual

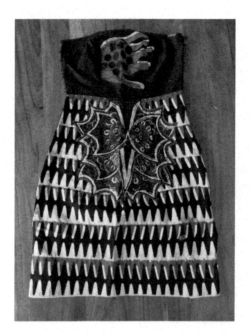

Figure 5.15 A bandeau dress from *Hands Off – Eyes Only* that evokes the unsolicited touching of women's bodies, 2016 (Image: Christopher Richards).

assault. The hand and its implied action are further emphasized by the stark contrast between bodice and skirt; whereas the skirt is highly patterned, the bodice has no patterning, placing sole emphasis on the hand. The emphasis is unsettling, as the hand and its implied action cannot be overlooked, resulting in the viewer becoming a complicit witness to this implied action.

A second dress, sewn from a patchwork of pink and yellow wax print, has straps constructed from wide swaths of the "hands with coins" fabric. When worn, the garment creates the illusion that the hands are placed on the wearer's shoulders, a particularly domineering gesture. Hands are repeated on the garment's cowl back, which exposes the wearer's body while literally placing hands on the wearer's back. As with the previous garment, the hand motifs are placed over areas of the body that are most susceptible to unwanted caresses from men: the shoulders, back and breasts. With these two garments, Arthur is literally and symbolically referencing the sexual predation of women's bodies, forcing viewers to consider the pervasiveness of this social issue and its erroneous attribution to revealing forms of dress.

In keeping with the collection's overall theme, these two garments are nuanced by the inclusion of an additional appliquéd motif; both feature an abstract flower-like form that adorns the front of each dress. Arthur crafted these elaborate multilayered appliqués from the same fabric, a wax print with

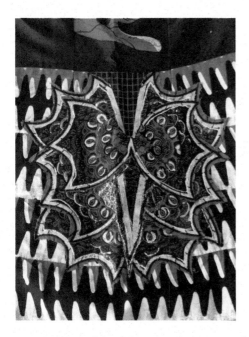

Figure 5.16 Detail of the elaborate and symmetrical appliqué adorning the front of the dress, 2016 (Image: Christopher Richards).

a repeated pattern of interconnected angular trefoils. Through deconstruction and repositioning, Arthur's appliqués suggest a multi-petaled flower, a butterfly, and an elaborate, abstract vulva. The strapless dress features the most articulated of these two appliqués; the motif is literally divided into two symmetrical halves, with layers of elaborately painted petals fanning out from its center (Figure 5.16).

The topmost layer consists of a pair of petals, that Arthur twisted before affixing to the surface of the dress, creating a sculptural element that adds additional visual interest. As with her other designs, the presence of the vulva is both empowering and protective; in these two instances, Arthur's reference to female genitalia is abstracted to the point of forming a shield-like motif, celebrating the beauty of the vulva's form and an additional means for offering the wearer protection from any unwanted advances or aggressions.

Taken in their totality, the extravagant designs of Arthur's *Hands Off – Eyes Only* collection are testaments to the thoughtfulness and complexity of her approach to fashion. The garments superficially serve as provocations, visualizing the various kinds of sexual harassment that women are regularly subjected to, while simultaneously functioning as a means of female empowerment, celebrating and protecting the wearer's body through design features and symbolic motifs. Arthur offers the clearest summation of her collection, stating:

women must be admired and desired, but touched only when they give permission … so I'm sexy, so I'm scandalous. You can look all you want. You can undress me with your eyes, even though it's offensive. But you don't touch me. That is, you don't cross that line.[51]

Arthur's reflection embodies her sartorial exploration of male predation with her unbridled and overt celebration of female sexuality, intermeshed to create a collection that simultaneously invites and refuses the gaze through complex, layered symbolisms. With each garment bearing at least one of her iconic signatures, Arthur further asserts that her garments are forms of wearable art, illustrating that her designs are more than just eccentric, stylish clothing, they are a vehicle for expressing her perspective on complex social and cultural issues.

Unlike the majority of her personal, elaborate designs, the entirety of *Hands Off – Eyes Only* was sold to a single individual, a client and collector of Arthur's fashions. Arthur described the woman as: "artistically inclined … and she happens to like my work, so she said 'you know what, I want all of them.'"[52] Arthur explained that the meaning was important to the collector: "at first glance she thought they [the dresses] were beautiful. When, with any piece of art, I gave her the story, it gave her additional insight and meaning, making her appreciate the clothes even more."[53]

The designs in Arthur's *Hands Off – Eyes Only* collection continue the reclamation of the female body in art, specifically through fashion. Arthur created a suite of elaborately embellished and intellectually charged garments that draw upon established forms of female protest, wielding iconic abstractions of female vulvas to scrutinize, and subsequently resist, men's sexual predation. Her vulva motifs, and her revealing silhouettes, have an additional function: to celebrate the inherent power and allure of women's bodies, championing women's agency to enact their own sensuousness and sexuality in direct opposition to men's unwanted advances. The collection evokes a particularly cosmopolitan narrative: the garments are rooted in locally sourced, culturally meaningful textiles, yet their transformed symbolisms are informed by global experiences, addressing social issues that are experienced by women across the globe. Her manipulation of historically significant textiles, isolating the "eye" and "hand" motifs and drastically altering their accepted meaning, illustrates the importance Arthur places on older, culturally relevant textiles, reinventing traditional forms of Ghanaian textiles and dress for a contemporary, globally aware audience.

Dumsor

The *Hands Off – Eyes Only* collection, with its layered symbolisms and complex constructions, served as a precursor for Arthur's final formal runway collection. Titled *Dumsor*, it consisted of Arthur's most unconventional and deconstructed garments, pushing the boundaries between art and fashion, while challenging the necessity of wearability in relation to clothing construction. The

fluorescent garments were presented in 2015, as part of the opening celebration of the high-end restaurant Urban Grill, located in the elite Airport Residential neighborhood of Accra. The name of the collection is a hybrid of two Twi words: "dum" meaning "to turn off" and "so," "to turn on." When combined, the phrase refers to the perpetual on and off of electricity that Ghanaians often experience, mostly attributed to a general lack of power supply. Beginning in 2015, then president John Mahama instituted a particularly severe measure for saving energy: a period of load shedding that involved 24 hours with no electricity, followed by only 12 hours with power. This restrictive and over-whelmingly detested measure increased the use of "dumsor" in common parlance, even earning Mahama the nickname "Mr. Dumsor" in popular media. Arthur's *Dumsor* collection was a cheeky response to the country's energy crisis, consisting of ten brightly hued, reflective garments that were designed to be seen even in the darkest of spaces. Presented in low light, to exaggerate each garment's light-sensitive qualities, Arthur's collection was an unapologetic political statement, proposing new forms of fashion for a life without reliable electricity.

The *Dumsor* collection is unique in that Arthur created exaggerated, layered stylings for each garment, presenting ensembles that are amalgamations of wearable articles of clothing and extravagant, often confounding, accessories; the resulting ephemeral assemblages represent Arthur at her most artistic. One example is a relatively simple dress consisting of a purple lamé bodice and white tulle skirt, embellished with an oversized flower of white feathers. Arthur hap-hazardly spray painted the white skirt with neon yellow lines, adding purple glitter paint to accentuate the flower's center (Figure 5.17). The shoulder straps of the dress were sewn from neon yellow reflective bands, creating a dress that is harmonious in color, while emphasizing its ability to reflect light.

When presented on the runway, the dress was overshadowed by its accessories (Figure 5.18). Arthur adorned the skirt with additional pieces of tulle, secured to the garment through a complexity of wrapping, weaving and tying. The bodice was covered with an overlay of white perforated fabric trimmed with feathers, almost completely obscuring the material underneath. The model wore a headdress of orange tulle, white feathers and platinum blond weave, with final additions of large rings attached to the bodice, each wrapped with neon reflective tape. A pair of sunglasses and sneakers decorated with the heads of plastic dolls completed the look. The resulting assemblage appeared frenetic in its organization: a look potentially cobbled together in darkness that ensured the visibility and safety of its wearer through its highly reflective materials.

Arthur readily acknowledged the disparity between individual garments and their presentation on the runway:

> some of them [the garments] look wilder and crazier because of the styling … the wigs, ribbons, all that wild stuff is purely theatrics, it's for extrava-ganza. When you take it off, a lot of the dresses don't look so crazy … there's a whole mise-en-scène. It's deliberate. I want it to be as spectacular

Figure 5.17 A stylistically simple dress from Arthur's *Dumsor* collection, embellished with neon spray paint and reflective tape, 2015 (Image: Beatrice Arthur).

and extravagant as possible, but if you take all that off, what remains is pretty wearable.[54]

What made Arthur's *Dumsor* collection so notable *was* its mise-en-scène, as each garment and its assorted accessories became a whimsical, yet critical statement on the complexities of living and working without electricity; Arthur's models were thus empowered to function and survive in this resource-starved environment, while still maintaining an implied sense of avant-garde fashion.

Recycling and reuse played particularly integral roles in the formation of each *Dumsor* ensemble. At least three of Arthur's ensembles incorporated safety vests, with their recognizable reflective strips, as either extant accessories or as material to create new, highly unusual, garments. In one instance, Arthur converted an orange safety vest into a pannier-like skirt with matching suspenders. Other ensembles featured mesh vests with horizontal bands of reflective tape, confounding whether the forms were constructed by Arthur or simply purchased and restyled. By ensuring these mundane uniforms remained intact, or at least recognizable, Arthur was able to symbolically evoke the need for increased safety and visibility during Accra's cyclical blackouts, albeit with a humorous, whimsical twist. Arthur's direct references to the ubiquitous safety

Figure 5.18 The simplistic dress and its theatrical styling for the runway presentation of *Dumsor*, 2015 (Image: Beatrice Arthur).

uniform further blurred distinctions between what constitutes runway fashions and forms of everyday dress.

Arthur continued to draw upon her own collection of existing designs as an additional means of recycling, adapting specific garments to reflect the themes of the *Dumsor* collection. A purposely mismatched jacket and skirt ensemble, sewn from wax print fabrics and decorated with Arthur's trademark painted embellishments, was altered through the addition of reflective tape trimming the cuffs and lapels. Whereas the jacket received relatively minimal revisions, a dress from the collection, also sewn from primarily printed fabric, was completely transformed through additional ornamentation. In keeping with her emphasis on recycling and reuse, Arthur layered the front of the dress with strips of raffia, burlap and sequin fabric, interwoven to create a complex honeycomb effect. Amidst this complex web of embellishments, Arthur added additional strips of reflective tape, arranged in a sunburst pattern that was only discernible when subjected to specific lighting conditions.

In keeping with Arthur's previous collections, historically rooted, local materials were crucial to each ensemble, even if they were concealed or deconstructed. Several of the garments include wax print, either as a form

of ornamentation or the garment itself. As a constant feature of her designs, wax print functions as a symbolic reference to Arthur's own Ghanaian heritage and a collective African heritage, ensuring that her garments resonate locally and globally. Arthur's inclusion of raffia and other grasses, a new material for her embellishments, is an additional means for evoking a collective African identity. In the context of the *Dumsor* collection, Arthur's use of raffia evokes generalized, stereotypical forms of precolonial African dress, creating a juxtaposition between perceived modes of historical African dressing and possible future forms of fashion.

Arthur introduced a second material that is particularly Ghanaian, grounding each ensemble in a local context while continuing her celebration of women, albeit through an indirect and unraveled reference. Two ensembles included large woven rings: one worn as an exaggerated "sleeve," secured to the shoulder through a complex web of reflective tape; the other as an oversized "necklace" encircling the wearer's torso, with the upper portion resting on the model's back. Both rings were spray painted with neon colors, accentuating their form. These "accessories," encircling the wearer's body, are reminiscent of planetary rings, infusing the *Dumsor* collection with an extraterrestrial, futuristic symbolism that plays into Arthur's fantastical approach to fashion.

The rings have an additional, localized significance: they are synonymous with Ghana's market women, as they were originally part of their wide-brimmed hats. These woven hats are primarily worn by women who sell in open-air markets, providing much needed shade from Ghana's unrelenting sun. In order to create these rings, Arthur literally deconstructed the hats, leaving only the outer brim. By extracting a recognizable element from these hats, Arthur recontextualizes these forms while maintaining visual allusions to their original function. Continuing her celebration of women's agency and empowerment from the *Hands Off – Eyes Only* collection, Arthur's deconstructed hats indirectly acknowledge the social and economic contributions of market women by elevating a signifier of their occupation to the level of high fashion. Arthur is celebrating their role in society, transforming their hat brims into a supplemental layer of fashionable protection in the face of Ghana's failing infrastructure. It is an additional means for Arthur to acknowledge and celebrate historically rooted Ghanaian dress, while innovating specific forms.

Arthur's *Dumsor* collection was a fusion of disparate, reworked garments, united by their neon-hued and reflective embellishments (Figure 5.19). As with her previous collection, *Dumsor* made a bold and unapologetic political statement while maintaining Arthur's commitment to whimsical and eccentric designs. Similar to *Hands Off – Eyes Only*, the *Dumsor* garments are more than a superficial, visual critique of a particular issue; they offer a solution. Each garment illustrates that Ghanaians, particularly women, can survive in spite of a lack of reliable electricity through ingenious sartorial adaptations. All the garments include an additional element of practical protection, ensuring the wearer's visibility in spite of potential darkness. The majority of designs from the *Dumsor* collection reimagine and innovate historically rooted, local

Figure 5.19 The finale of Arthur's *Dumsor* presentation, showcasing her collection in its
entirety (Image: Beatrice Arthur).

materials, creating new forms for established dress practices. As her purportedly
final collection, *Dumsor* was a fearless exploration of Arthur's hallmarks, taken to
their extreme: it was an experiment in wearable art; a reinvention of meaningful,
local materials; a celebration of women's social and cultural contributions; and a
sartorial expression of Arthur's own perspective and experiences.

Eternally funky: the legacy of Beatrice "Bee" Arthur and B'ExotiQ

In the context of Ghana's fashion culture, Beatrice "Bee" Arthur remains
wholly unique; creating on the seams of fashion and art, Arthur's designs
draw inspiration from a myriad cultures, while maintaining a constant focus
on African, and particularly Ghanaian, material culture. Her designs are trans-
gressive, defying sartorial limitations on what global fashion deems wearable
or stylish. Instead, Arthur creates garments that are layered with complex
meanings, addressing potent social and political issues while maintaining a
particular commitment, either explicitly or implied, to her personal per-
spective and multicultural identity. In spite of this focus, her designs remain
fashionable, illustrating a level of artistry and hand-embellishment that has

yet to be matched by her contemporaries, evidenced by her enduring, hand-painted signature on all of her most artistic creations. More than any other Ghanaian designer, her garments are not only products, but expressions of her lived experiences, encapsulating her cosmopolitan identity, simultaneously resonating with cosmopolitan-minded women from the African continent and beyond. Like designers before and after her, Arthur is not defying Ghanaian traditions, she is reinventing them, discovering new modes for the celebration of culturally significant materials, ensuring they maintain their relevance in an ever-changing fashion culture. To sum up her approach to fashion, it's best to allow Arthur to speak for herself: "it's a blessing that people considered me a weirdo because it's given me the freedom to express myself."[55]

The workshop: Christie Brown, Aisha Ayensu

I was beyond excited when Aisha allowed me to visit her workshop for the first time in 2014. Ghanaian designers are understandably trepidatious about revealing the inner workings of their brand, as they are often less glamorous than the luxurious and extravagant garments they produce for the runway; their workshops are stark, mechanical spaces filled with the constant vibration of machines and an abundance of fabrics, trimmings and garments in process. I understood the inherent vulnerability of sharing an "unseen" space, so I approached my forthcoming visit with a mixture of curiosity and reverence. Aisha's approval was also personally significant; it suggested that our professional relationship had reached a new level: she trusted me, a realization that felt simultaneously validating and humbling.

In keeping with the potentially stark disparities between a designer's workshop and their public image, Aisha briefed me that her workshop was in a former hospital located in Korle Gonno, a historically Ga neighborhood situated adjacent to Accra's coastline. The area is a tangle of short, intersecting streets, a labyrinthine space in which, during subsequent visits, I always lost my way, attempting to find the iconic marker that affirms "I have arrived": the ochre-colored, dirt soccer field of a nearby school that faces the Christie Brown workshop.

I will admit I was surprised when we first arrived at the building. Not only were the surroundings rather bleak, but the building itself appeared somewhat neglected, belying the true productivity and innovation that was occurring behind its façade. Located behind a cement wall, the two-story, peach-colored structure was faded, as were the advertisements for Lifebuoy toothpaste that lined the second-story verandah, the smiling models mere shadows of their original selves. As we neared the building I heard not the whirring of machines, but the sounds of laughing children. The first floor of the building was a school, with women outside selling snacks and drinks, likely for both the children and Aisha's workers. As we climbed a wide staircase, I remember asking Aisha: "Are there any ghosts?" Aisha laughed politely and reassured me there were not, and

as we neared the second floor I could hear the din of a busy workshop; my anticipation was palpable.

Aisha led me into a large and airy room that functioned as the main workspace for her brand. The large windows on two sides of the room added a natural brightness to the space, ideal for the intricacies of sewing, embroidery and embellishment. Aisha then introduced me to her staff; there were a total of ten workers, each busy at their own task: steaming a newly completed garment, hand-stitching fringe onto a skirt, or prepping fabric to be cut.

I was particularly drawn to one woman whose sole task was to construct bib necklaces, the now iconic and coveted accessory which helped rocket the Christie Brown brand to success. The woman sat at a table, a naked bib placed directly in front of her. Within her arm's reach were all sizes and shapes of canisters, each filled with a variety of wax print-covered buttons. There were domed buttons and flat, disc-like buttons; others were rectangular with rounded edges and, my personal favorite, a button comprised of two elements: a smaller, central button surrounded by a halo of contrasting material. Jumbled in their canisters, the result was a contained riot of color and pattern. The scene reminded me of a fantastical scientist's laboratory; instead of an anonymous white coat manipulating strangely colored chemicals housed in glass vials, a woman was using a plethora of buttons to "invent" a unique and beautiful accessory. Or perhaps, the entire scene was more like an elaborate patisserie, with each canister holding the delicate embellishments that would ultimately create a delectable and extravagant masterpiece. Regardless of the appropriate metaphor, I found the observation of this seemingly mundane activity transcendent.

The woman began to position buttons on the bib, carefully considering the placement of each in order to achieve the appropriate balance of shape and color. Only after the bib was brimming with buttons in an arrangement deemed beautiful by the maker were the buttons finally secured to the surface. I was mesmerized; to think that each bib necklace, the unofficial symbol of the Christie Brown label, passed through the hands of one worker, was revelatory. Perhaps this is part of Aisha and other designers' hesitancy to expose the production of their brands, as their small-scale fabrication goes against the rampant mechanization and mass manufacturing of international fashion conglomerates that is often deemed an indicator of a brand's success. And that is exactly why I found this moment so poignant; not only did it capture the artistry of Aisha's brand, it affirmed that Aisha was working in a manner that championed exclusivity and craftsmanship.

Riding back from the workshop with Aisha's husband, my sheer euphoria and the crisp, salty sea air lulled me into a trance-like state: I had entered the inner sanctum; Aisha trusted me enough to see the workings of her workshop! I was another step closer to understanding the totality of the Christie Brown brand and I was blissfully happy.

When I visited the workshop again in 2016, the remnants of its former life as a hospital had been largely removed. Aisha now had a beautifully

appointed office, with a rectangular board above her desk fashioned from a mixture of batik, wax print and plain cotton fabrics. This surface functioned as her "mood board," a place to consider potential fabrics, silhouettes and the overall look of a collection. At the time of my visit, Aisha was working diligently on her Autumn-Winter collection, so the board was draped with imported fabrics in rich jewel tones, primarily shades of gold, maroon, navy, cream and red. Amidst the splashes of color samples were notes to herself and sketches of upcoming silhouettes, including a particularly eye-catching full skirt with cross-hatch embroidered embellishments. Aisha's former office had been converted to the cutting room, and a third room had become the archive of Aisha's brand, housing the majority of her runway looks from past collections. During this trip, I spent considerable time rifling through the plastic-covered garments, inspecting and photographing her designs, in awe of the growing complexity and detail of her silhouettes. I peeked briefly into the workroom and saw the same scene as I had two years before, with the addition of more workers and new machines, now totaling 15. The workers were busy ironing, sewing, embroidering and, of course, assembling bib necklaces. Production continued largely unabated (minus the occasional disruption of electricity) and under a steady, reliable staff, Aisha's brand had flourished.

Aisha and I sat quietly in her office; she meticulously planning the work schedule for her employees, detailing each garment they must complete by a predetermined deadline, I gazing out the window, watching a handyman repairing the window of a nearby building. Once again, I was lulled into a state of quiet contentment. Although it was still a privilege to share Aisha's personal space, it no longer felt foreign. I found myself relishing this moment of silent introspection, which was promptly interrupted by a worker ushering in a garment in process, an asymmetrical blouse for the upcoming collection. Aisha immediately stood, slipped the garment over her head and regarded herself in the mirror. She considered the garment carefully, silently critiquing various elements of the garment before pro-viding verbal feedback and ultimately approving the blouse. As she later explained to me, Aisha was not considering how the garment looked on her body; rather, she was gauging if it reflected the particular aesthetics of her brand and the ever-present "Christie Brown woman." In that moment, I realized that the Christie Brown label is more than a popular luxury brand that reveals the tastes of Accra's elite women, it is ultimately a reflection of Aisha's own creative perspective, fueled by the desires of Accra's elite female consumers. Aisha's continued commitment to her unique and often uncon-ventional aesthetic has revolutionized Accra's twenty-first-century fashion scene, challenging women to accept new modes of wearing and celebrating iconic and meaningful materials.

The assistant left as quickly as they had entered, allowing Aisha and myself to return to our silent activities: Aisha poring over her complex schedule, and I gazing out the window, our minds both filled with thoughts of fashion.

Notes

1 Interview with Beatrice Arthur, Accra, Ghana, July 15, 2016.
2 At the time of Arthur's birth, the Ukraine was still part of the Soviet Union and did not become an independent nation until 1991.
3 Interview with Beatrice Arthur, Accra, Ghana, July 15, 2016.
4 Renée Mendy-Ongoundou, *Elégances Africaines: Tissus Traditionnels et Mode Contemporaine* (Paris: Alternatives, 2002), 86.
5 Interview with Beatrice Arthur, Accra, Ghana, 2012.
6 For more information on Accra's fashion culture during the 1990s, see Christopher Richards, "We Have Always Been Fashionable," unpublished dissertation (University of Florida, 2014).
7 Interview with Beatrice Arthur, Accra, Ghana, 2010.
8 Interview with Beatrice Arthur, Accra, Ghana, 2012.
9 Ibid.
10 Ibid.
11 Ibid.
12 Julie Schafler Dale, *Art to Wear* (New York: Abbeville Press Publishers, 1986), 12.
13 Interview with Beatrice Arthur, Accra, Ghana, July 15, 2016.
14 Ibid.
15 Ibid.
16 Interview with Beatrice Arthur, Accra, Ghana, 2010.
17 Ibid.
18 Interview with Beatrice Arthur, Accra, Ghana, 2012.
19 Interview with Beatrice Arthur, Accra, Ghana, July 15, 2016.
20 Ibid.
21 Joanna Hubbs, *Mother Russia: The Feminine Myth in Russian Culture* (Bloomington: Indiana University Press, 1993).
22 Interview with Beatrice Arthur, Accra, Ghana, July 15, 2016.
23 Kennell Jackson, "What is Really Happening Here," in *Hair in African Art and Culture*, eds. Roy Sieber and Frank Herrema (New York: Prestel Publishers, 2000), 181.
24 Interview with Beatrice Arthur, Accra, Ghana, 2012.
25 Ibid.
26 Ibid.
27 Ibid.
28 Ibid.
29 Ibid.
30 Ibid.
31 Ibid.
32 Interview with Beatrice Arthur, Accra, Ghana, 2010.
33 N'Goné Fall, "Providing a Space of Freedom: Women Artists from Africa," in *Global Feminisms: New Directions in Contemporary Art*, eds. Maura Reilly and Linda Nochlin (New York: Merrell, 2007), 71.
34 Ibid.
35 Interview with Beatrice Arthur, Accra, Ghana, July 15, 2016.
36 John Picton, in *The Art of African Textiles*, notes that the "Hands and Fingers" motif was one of the earliest documented patterns produced by the Haarlem Cotton Company (Haarlemsche Katoen Maatschappii), with a sample swatch dated 1905. The eye motif is equally historical; in *African-Print Fashion Now!*, Helen Elands

describes "the eye" motif as one of the earliest patterns directly inspired by West African culture, dating from 1901.

37 John Picton, "Technology, Tradition and Lurex: The Art of Textiles in Africa," in *The Art of African Textiles: Technology, Tradition and Lurex*, ed. John Picton (London: Lund Humphries Publishers, 1999), 27.

38 Interview with Beatrice Arthur, Accra, Ghana, July 15, 2016.

39 Ibid.

40 Ibid.

41 Ibid.

42 Ibid.

43 Ibid.

44 Ibid.

45 Maura Reilly, "Introduction: Toward Transnational Feminisms," in *Global Feminisms: New Directions in Contemporary Art*, eds. Maura Reilly and Linda Nochlin (New York: Merrell, 2007), 24.

46 N'Goné Fall, "Providing a Space of Freedom: Women Artists from Africa," 71.

47 Naminata Diabate, *Naked Agency: Genital Cursing and Biopolitics in Africa* (Durham: Duke University Press, 2020).

48 Ibid., 19.

49 Jean Marie Allman, "'Let Your Fashion be in Line with Our Ghanaian Costume': Nation, Gender and the Politics of Clothing in Nkrumah's Ghana," in *Fashioning Africa: Power and the Politics of Dress*, ed. Jean Allman (Bloomington: Indiana University Press, 2004), 144–165.

50 During 2011 and 2012, Vlisco sponsored fashion shows that corresponded with the release of new, quarterly collections. Vlisco would select several established and emerging designers, providing them with a random selection of their fabrics. Designers would then be charged to create a collection based primarily on these fabrics. Designed as a means to feature their latest patterns, Arthur was likely a controversial inclusion, as she was known for her radical garments that drastically altered the appearance of her chosen wax prints.

51 Interview with Beatrice Arthur, Accra, Ghana, July 15, 2016.

52 Ibid.

53 Ibid.

54 Ibid.

55 Ibid.

6 "The Spirit of the African Woman"

Aisha Ayensu and her brand,
Christie Brown

I first met Aisha Ayensu (née Obuobi) in 2012, at the launch of her original boutique, a tiny space that was part of a series of shops located on the edge of Osu. The event was intensely memorable, not because of the blousy white tents that proclaimed a special event was underway, nor because of the steady stream of elite Ghanaian women who gracefully breezed into Ayensu's new show-room, but because of a particular exchange that encapsulated the desirability of Ayensu's garments.

I entered the small boutique to find a well-known fashion designer donning a tailored peplum jacket of navy eyelet fabric, the length of both sleeves adorned with horizontal wax print fringe. The designer admired herself in the mirror as another woman tried on the same jacket, with less success. The woman turned to the designer and asked if she could try on the jacket she was wearing; the designer's response was succinct: "No, I'm sorry. This is mine." The woman reassured the designer she only wanted to see how that particular size would fit, but the designer was steadfast: "No, I'm sorry." The exchange quickly dissipated with the woman's friends remarking to each other, "She's not going to take it off." And she didn't. The moment was fleeting, and admittedly somewhat uncomfortable to witness, but it attested to the popularity and inherent exclu-sivity of Ayensu's garments, leading to the kind of conspicuous competition I witnessed at her boutique's opening and in subsequent visits to her shop. The desirability of Ayensu's garments, encapsulated by this brief exchange, has aided in ensuring the continuity of the Christie Brown label, which celebrated its tenth anniversary in 2018.

In spite of the brand's intense appeal, epitomized by the aforementioned sar-torial stand-off, a common critique of global (and African) fashion is that it is largely consumed by a limited segment of a given population, implying that the cultural and social significance of specific designs is exaggerated and overstated by scholars. The restricted accessibility of designer fashions is certainly true in Ghana; most individuals cannot afford to purchase one of Ayensu's exclusive creations, and yet her influence has rippled throughout the dress culture of Accra in surprising ways, further signifying her importance as one of Ghana's notable fashion designers of the twenty-first century.

DOI: 10.4324/9781003148340-6

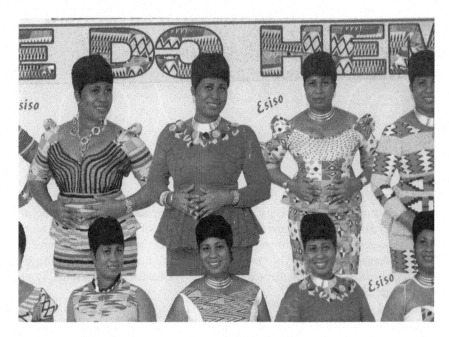

Figure 6.1 Detail of a seamstress poster titled "Me Do Hemaa" featuring a design with fabric-covered buttons as embellishments (Image: Christopher Richards).

The first indication of her influence was subtle: I began seeing echoes of Ayensu's bib necklaces in 2012, with design posters for tailors and seamstresses featuring a proliferation of fabric-covered buttons on the bodices of dresses (Figure 6.1). However, it's difficult to prove a direct correlation between Ayensu's designs and the seemingly sudden proliferation of wax print buttons as embellishment via these posters. A 2016 visit to a gift shop within the Paloma Hotel compound resulted in the most direct evidence that Ayensu's designs have indeed had a lasting and more democratic effect on Accra's sartorial practices. As I browsed through a case of kente jewelry and beaded accessories, a riot of pattern caught my eye. To my surprise, I saw what appeared to be a Christie Brown bib necklace; on closer inspection, the bib proved to be oddly shaped and its materials, particularly the fabric for the backing of the bib, were less luxurious than those used by Ayensu (Figure 6.2). The seller did not provide extensive information regarding the necklace's origins, but its mere existence suggested that Ayensu's design had permeated Accra's dress culture, sparking facsimiles that paled in comparison to their prototype. A similarly anonymous bib necklace, along with an angular variation on its form (both collected in 2016), were included in the exhibition and publication *African Print Fashion Now!* A cursory search for "wax print button necklace" on the website Etsy, a virtual marketplace for all manner of handmade and vintage goods, reveals

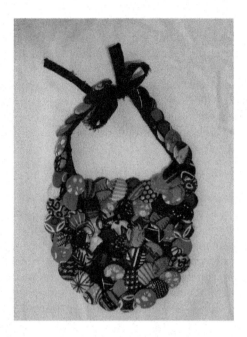

Figure 6.2 An imitation Christie Brown bib necklace, purchased at the Paloma Hotel's gift shop (Image: Christopher Richards).

even more variations on Ayensu's iconic accessory. Owning an original Christie Brown may prove prohibitive for most, but these imitations suggest that, in spite of her brand's exclusivity, her designs are not only desired, but have influenced both local and global fashion networks.

Since the inception of my research project in 2009, Christie Brown is one of the few brands that has maintained a level of success, development and innovation in relation to its production and designs. Ayensu is inspired by her daily experiences on the African continent, resulting in garments that reflect "the spirit of the African woman" and proudly proclaim African cultures and heritage as central to "the DNA of the clothing."[1] In spite of her reliance on iconic African materials, particularly wax print, Ayensu's designs are not essentialized; they promote a vision of Africa, and specifically African women, as cosmopolitan players in an inherently global fashion system. Ayensu harnesses her aesthetic trademarks to reimagine culturally significant materials, creating fashions that invoke Ghanaian heritage and history, albeit infused with a cosmopolitan flair that places her designs on the seams of local and global, historical and contemporary. Furthermore, her garments leave a significant mark on the sartorial practices of elite Ghanaian women by frequently defying established social and cultural mores. It is her informed and unique viewpoint, with an approach to design reminiscent of Kweifio-Okai, that has cemented her position as one of Ghana's most important and artistic fashion designers of the current era.

Following a summation of her career, this chapter will emphasize the artistry of Ayensu's fashions by focusing on the following design hallmarks: asymmetry, volume, embellishments, sartorial surprises and kinetic flourishes. Once her stylistically consistent, yet ever-maturing aesthetic is established, her use and treatment of culturally significant materials will be explored. By relying primarily on wax print fabric, with additional inclusions of locally woven smocks and Ghanaian batik, Ayensu employs her original and innovative perspective to celebrate materials infused with Ghanaian heritage and identity, creating designs that invoke an updated conception of cosmopolitanism.

The creation and development of Christie Brown

Like many Ghanaian designers, Ayensu developed an interest in fashion through childhood experiences. Ayensu was first introduced to sewing by her grandmother, Christie Brown, the eponym of her brand. Brown was a seamstress, and Ayensu fondly remembers watching her grandmother sew garments for her clients; Ayensu would mimic her grandmother, using scraps of fabric to assemble ensembles for her dolls. In spite of her early interest in dressmaking, Ayensu did not initially attend fashion school; instead, she graduated from the University of Ghana in 2008 with a degree in psychology. Immediately following the completion of her degree, Ayensu decided to embark on a fashion career, becoming the first of a generation of young female designers to establish their brands in the late 2000s. Ayensu initially struggled with production; her practical knowledge of garment construction was limited, forcing her to rely on a group of arbitrary tailors to produce her garments, resulting in mediocre and inconsistent finishing. Her frustrations precipitated her enrollment in the Joyce Ababio Vogue Style School of Fashion (now Joyce Ababio College of Creative Design), where she studied for several months, learning the basics of garment design and construction. In 2009, she was invited to showcase her fashions at the first Arise Africa Fashion Week in Johannesburg, South Africa. Participating meant she would be unable to complete her degree; however, following her debut at Arise Fashion Week, she was named "Emerging Designer of the Year." This award was a turning point in Ayensu's career; it added legitimacy to her fledgling brand and provided her with immediate, albeit virtual, global recognition.

The following year, Ayensu became the first Ghanaian to participate in the highly selective 2010 Arise L'Afrique-à-Porter, an event held concomitantly with Paris Fashion Week to introduce international buyers and media to emerging and established African designers. Ayensu continued to participate in local and global fashion shows, including the 2012 Arise Magazine Fashion Week in Lagos, Nigeria, the 2012 Ghana Fashion and Design Week in Accra, Ghana, the 2013 Labo Ethnik Fashion Weekend in Paris, France, the 2014 Mercedes Benz Fashion Week Africa in Johannesburg, South Africa and the 2017 Lagos Fashion & Design Week, in Lagos, Nigeria. As the Christie Brown label became more successful and globally recognized, Ayensu began limiting her participation in

international runway shows, instead introducing biannual, virtual look books. These extravagant and carefully curated series of photographs feature 12 to 20 ensembles, or "looks," that comprise the core silhouettes for each of her seasonal collections. Beginning with her Autumn/Winter 2017 collection *F[Men] ist*, Ayensu collaborated with emerging designer and illustrator Papa Oppong to produce elaborate presentations of her garments, through film and ephemeral, immersive environments. In celebration of her tenth anniversary, Ayensu's Spring/Summer 2018 collection *Conscience* included both a mysterious promotional film and an elaborate runway show, held in the garden of the luxurious Kempinski Hotel. Ayensu's willingness to partner with emerging artists and designers illustrates her commitment to continually reinventing her brand while maintaining a particular aesthetic that she has honed over the past ten years, allowing for the creation of stylistically consistent yet dynamic fashions.

In addition to her fashion presentations, Ayensu is regularly highlighted in a variety of African and international publications, including the following fashion magazines: *Glamour* (2010), *UK Harper's Bazaar* (2011), *Vogue Italia* (2011), *AfroElle* (2011), *African Report* (2012) and *Okay Nigeria* (2013). Ayensu's most notable feature in American popular media was the April/May 2012 issue of *VIBE* magazine, which included several photographs of singer Alicia Keys wearing Ayensu's now iconic accessories, specifically her trademark "fringe" necklaces assembled from narrow tubes of contrasting wax print. Keys was the first of several African-American celebrities to don Christie Brown designs, including actress Rosario Dawson and singer Michelle Williams. Perhaps the most important celebrity endorsement came from the American singer Beyoncé, who commissioned a suite of Christie Brown ensembles for her dancers as part of the 2014 *The Mrs. Carter Show* world tour. Ayensu's designs have also caught the attention of authors and academics: Christie Brown was one of a select number of Ghanaian designers included in Helen Jennings' coffee table book *New African Fashion* and her garments were featured in two exhibitions: *Kabas and Couture: Contemporary Ghanaian Fashion* (2015) at the Samuel P. Harn Museum of Art and *Black Fashion Designers* (2016) at the Fashion Institute of Technology Museum.

Ayensu's designs have continued to play a pivotal role in the visible dress culture of Accra. In 2014, Ghanaian Nicole Amarteifio created the web series *An African City*. Inspired by the acclaimed American television series *Sex and the City*, Amarteifio's retelling follows the lives of five wealthy and connected African women who return to the continent to live and work in Accra. The women are independent, educated and, for the most part, sexually liberated. They are also impeccably dressed, with each character changing outfits several times in a given episode. From the series premiere, when assertive Sade wore an extravagant, voluminous Christie Brown skirt of organza and batik fabric, the brand has played a pivotal role in fashioning the identities of these characters and creating a more nuanced representation of African women to local and global audiences. In turn, *An African City* has further cemented the Christie Brown label as a symbol of African women's prosperity, worldliness, confidence

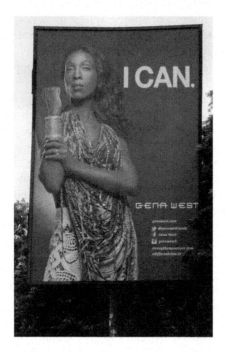

Figure 6.3 Billboard of Gina West wearing one of Ayensu's now iconic fringe necklaces, 2016 (Image: Christopher Richards).

and identity. The aforementioned unveiling of Ayensu's *Conscience* collection at the Kempinski Hotel attested to Ayensu's accrued importance as a Ghanaian fashion designer. Attendees were in abundance, with rows of Ghanaians and expatriates lining the sinuous path of the informal, alfresco runway. Like the enduring billboard on Liberation Road of Nigerian celebrity Gena West, who happens to be wearing one of Christie Brown's trademark fringe necklaces, Ayensu has become a fixture of Accra, a noted landmark in its unpredictable sartorial landscape (Figure 6.3).

"People come to us for our details": the artistry of Christie Brown

For the 2017 holiday season, Christie Brown released a series of seven promotional videos unveiling a capsule collection designed to "celebrate Christmas in unmatched style," that simultaneously promoted a holiday fashion party at the distinctive luxury development Villagio Vista. The videos, set to classic Christmas songs like "Jingle Bell Rock," followed a model bedecked in the latest Christie Brown designs as she "decorates" her apartment for Christmas. In the first video, as the model opens a wreath-clad door, she coyly looks

over her shoulder at the camera, drawing attention to her garment's asymmetrical sleeve. Upon entering her apartment, the model proceeds to strut and spin, using a Christmas garland as her impromptu accessory. The model's movements are highly exaggerated; as she prances, the full skirt of her dress swishes to reveal a contrasting fabric underneath. Later, the model sits and crosses her legs with aplomb, affording the viewer another opportunity to view her garment's boldly contrasting, yet complementary, lining. In the second video, the ensemble is new, but the exaggerated movements are continued. This time, the model dances to the music, swishing the voluminous fabric of her skirt from side to side. She twirls, pausing briefly to provide the viewer with an opportunity to appreciate the front and back of her garment, while causing the ruffles of her skirt to billow around her. Once seated, the model crosses her legs for a second time, exuding a confident sexuality as she highlights the obscured interior fabric of her skirt. Interspersed with these playful, sartorial choreographies are extreme close-ups, opportunities to appreciate the details of a given garment: rows of fringe and paillette sequins placed over wax print fabric, an elaborate lace collar, ruched tulle against an elaborate netting of embroidery. The model and her garments exude confidence, extravagance and a playful sensuality, yet these videos do more than represent the "Christie Brown woman"; they purposely highlight hallmarks of the Christie Brown brand: asymmetry, volume, detailed and elaborate embellishments, unexpected or hidden flourishes of color and print, and the importance of a kinetic silhouette that responds to the wearer's movements. It is Ayensu's careful and continued incorporation of these elements in her collections that distinguishes her designs from other Ghanaian and African designers, evoking a level of artistry that elevates her garments and encourages their examination through an art-historical lens. Furthermore, Ayensu deftly employs her hallmarks to emphasize and celebrate the African materiality of her designs, ensuring a carefully constructed identity is embedded throughout her collections.

Asymmetry

An important element of many Christie Brown garments is a degree of asymmetry. Whether it is subtle – the addition of a diagonal strap on a dress – or flamboyant – a voluminous ruffle in decrescendo that skims across a skirt, Christie Brown garments frequently feature a degree of thoughtful imbalance. Ayensu's use of asymmetry is twofold: to produce garments that create an unexpected, visual interest, reflecting a degree of artistic flair, and to challenge established local and global dress conventions. When asked specifically about the asymmetrical elements of her garments in 2016, Ayensu stated: "I'm so there with asymmetry right now. I like when edges are not quite so even or there's just something hanging off one edge and not the other. It gives another dimension to the clothes; it makes them interesting."[2]

Although subtly referenced in earlier collections, asymmetry became a key element in Ayensu's pivotal Autumn-Winter 2012 *Xutra* collection. Following its premiere, Ayensu published the following description of the collection on her website:

> the artistic fashion world constantly feeds on freedom of expression and need for experimentation. It is only the forced control in "structure" that allows art to emphasize how sophistication and complexity in detail can co-exist with simplicity, discipline and bare bone basics. Underneath the asymmetric structures of the XUTRA garments, lives sheer fluidity and movement. Just as architectural plans serve a functional and aesthetic purpose, this collection showcases the true intention of both function and fashion: multidimensional, yet wearable. For Christie Brown, this collection represents the essence of our "Xutra."[3]

Ayensu's reference to "asymmetric structures" indicates the importance placed on asymmetry, which served as the literal ground for her varied designs. The "structures" consisted primarily of garments with contrasting hem lengths, with most having high front hems and lower back hems. Other garments included high slits, an additional structural element that created a visual disruption and imbalance. The most conspicuous asymmetry, however, was not indicated through dress construction; rather, it was evidenced through her elaborate embellishment. Several dresses featured asymmetrically placed, cascading wax print forms; one such dress had a bodice completely covered with bands of wax print, gathered to one side of the skirt (Figure 6.4). A second dress featured bands that extended from the neckline, again draping only on one side of the garment. The most immediate expression of asymmetry, evoked through both construction and embellishment, was Ayensu's reinterpretation of Yves Saint Laurent's iconic 1965 Mondrian collection. The subtle difference between Ayensu's version and Saint Laurent's archetype was that Ayensu's solid black horizontal lines simply terminated at the point of intersection, creating balanced, yet asymmetrical, panels of wax print (Figure 6.5). Ayensu's selection of wax print in complementary colors with contrasting patterns added an additional layer of asymmetry to an already carefully imbalanced garment.

Ayensu's subsequent collections continued to include elements of asymmetry, particularly in relation to garment construction. For the Autumn-Winter 2013 *Dure* collection, skirts and dresses featured off-centered slits and asymmetrical folds of fabric, with one skirt comprised of a particularly uneven "stepped" hemline. It was Ayensu's Autumn-Winter 2016 collection, resplendent in its melding of jewel-toned jacquards, satins and lace with batakari and wax print, that included some of the most notable asymmetrical elements. Several of the garments featured dramatically angled necklines, while others reflected Ayensu's continued experimentation with contrasting hem lengths, including a pair of calf-length, wide-leg pants designed to showcase interior panels of wax print. Two dresses from this collection best illustrate Ayensu's expert use

Figure 6.4 A dress from the *Xutra* collection, featuring cascading bands of wax print fabric, 2012 (Image: Aisha Ayensu).

Figure 6.5 An Yves Saint Laurent-inspired dress from Ayensu's *Xutra* collection, 2012 (Image: Aisha Ayensu).

Figure 6.6 An asymmetric dress from the Christie Brown Autumn-Winter 2016 collection (Image: Aisha Ayensu).

of asymmetry. The first dress is sewn from unequal amounts of emerald satin and a wax print of undulating, curved lines; the materials are "joined" by a sinuous vertical line of black embroidery that begins at one shoulder and ends in an angled point in the middle of the dress, extending beyond the hem of the skirt (Figure 6.6). Mimicking the implied movement of the wax print pattern, Ayensu's embroidered line curves and expands, at points becoming openwork embroidery that masks the wax print underneath. Whereas the wax print side of the dress has an even hem, the satin portion is hemmed in two sharply curved points that extend beyond the "finished" edge of the garment. The pairing of a solid satin with a highly patterned wax print further emphasizes the asymmetrical shapes of both sides and creates a stark, yet purposeful and artistic, imbalance.

The second dress features a black lace bodice, contrasted by a gored wax print skirt, sewn from the same undulating wax print as the aforementioned dress. The garment's overall silhouette is symmetrical; however, it is embellished with an asymmetrical disruption: a section of black openwork embroidery that extends from the waistline to the hem (Figure 6.7). The shape is diamond-like; however, its form and openwork design echo the curvilinear lines of the wax

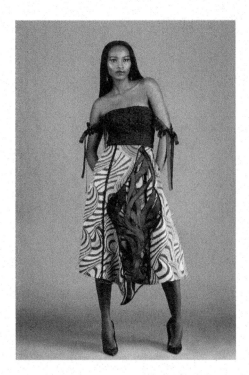

Figure 6.7 A wax print skirt with asymmetric embellishments from the Christie Brown Autumn–Winter 2016 collection (Image: Aisha Ayensu).

print. What makes this embellishment even more eye-catching is that it is only partially attached to the surface of the skirt; the openwork embroidery drapes freely, with one point falling beyond the hem.

Ayensu's most potent form of purposeful imbalance was not embraced by her clientele, yet it attests to her innovativeness and willingness to challenge established Ghanaian dress practices. For several of her Spring–Summer 2017 capsule collections, Ayensu introduced an unusual flourish: a dangling portion of fabric on one or both sides of a skirt or dress (Figure 6.8). This "hanging hem" was created by sewing an additional panel onto the finished edge of a garment, but with either one or two areas left unattached. To further emphasize this feature, Ayensu trimmed the facing edges with oversized rickrack, resulting in a subtle visual pun: it seemed as though the garments were being "unzipped." When displayed on a hanger, the skirts and dresses appeared as though they were incomplete or unfinished; when placed on a body, the lower panel drooped at an angle, drawing attention to the wearer's exposed calves. The skirt with only one "hanging hem" was particularly dramatic, creating a bold and, as I soon found out, unsettling asymmetry (Figure 6.9).

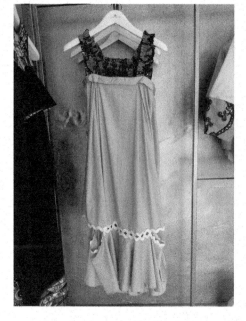

Figure 6.8 A "hanging-hem" dress from a Christie Brown Spring-Summer 2017 capsule collection (Image: Christopher Richards).

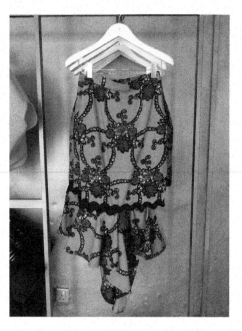

Figure 6.9 The one-sided, "hanging-hem" skirt from a Christie Brown Spring-Summer 2017 capsule collection (Image: Christopher Richards).

During one of my repeated visits to the Christie Brown boutique in summer 2017, I observed a middle-aged Ghanaian woman try on a "hanging hem" skirt in front of family and friends; the reactions were polite and good-natured, but overwhelmingly unfavorable. The comments focused on the garment's incomplete appearance, as though its stitching had come undone or was in desperate need of repair. As discussed in the Introduction, appearing disheveled or wearing tattered, unkempt clothing in Ghana is considered a social taboo, serving as a marker of being "abↄ dam" or mentally unstable. In spite of being an expertly executed design novelty, Ayensu's "hanging hem" invoked too many similarities with being improperly dressed, or in a state of undress. Practically speaking, the dangling band made walking more difficult. The garment's unfinished appearance, coupled with its ability to impede movement, resulted in the design being relatively unsuccessful among Ayensu's clientele. Although the original "hanging hem" proved to be too edgy, it was transformed for the Autumn-Winter 2017 collection into two pendent holes on either side of a high-waisted skirt. These "peek-a-boo" openings provided a glimpse of the skirt's wax print lining and the wearer's legs, a titillating and potentially more palatable variation on Ayensu's "unfinished" silhouette.

Whether celebrated or rejected by her discerning clientele, Ayensu's asymmetry remains an ever-present component of her designs, adding visual curiosity and interest to a given silhouette. Achieving an attractive imbalance, particularly in a form intended to be worn, requires a deeper understanding of how a given garment relates and responds to the body. The complexities of Ayensu's asymmetries indicate the artistry of her designs and indirectly attest to the additional importance of movement, as the majority of her asymmetrical flourishes are dynamic, designed to drape, gape, billow and flow on and around the body. Ayensu's unusual "hanging hem" is perhaps the most powerful sartorial imbalance, as it suggests that certain cultural and social values are more deeply embedded, and thus difficult to challenge. The "hanging hem" speaks to Ayensu's continued commitment to revise and challenge established dress practices, with a particular eye for inventiveness and originality.

Volume

From the 23 ensembles included in Ayensu's premiere collection, one stood out as an audacious anomaly: an electric blue bolero jacket with matching pencil skirt, paired with a wax print bandeau top, tied with a bow. The jacket featured puffed sleeves adorned with wax print-covered buttons, echoed by the skirt's pannier-like protrusions from the waist. This and other, less dramatic, designs foreshadowed Ayensu's continued experimentation with volume as a tenet of her aesthetic. When applied to forms of dress, the notion of volume often implies exaggerated and sculptural silhouettes that protrude into space. Although Ayensu frequently produces silhouettes that include ample amounts of material and layered ornamentation, her streamlined silhouettes can also be

voluminous, largely through the inclusion of dynamic elements that fluidly move throughout, and thereby fill, a given space.

Ayensu's most voluminous collection, in relation to creating ample silhouettes, was Spring-Summer 2018. The majority of the skirts were gathered at the waistline, creating incredibly full, billowing forms. Some designs were further accentuated with additional layers of lace or tulle, adding even more material volume to an already lavish garment. One such gathered skirt, sewn from a pastel-hued wax print, was trimmed with three tiers of gradated tulle, adding a textural element that further accentuated the skirt's sweeping dimensions (Figure 6.10). The blouses for this collection were equally voluminous; many featured balloon sleeves with shoulder seams and cuffs edged in ruffles. These silhouettes and details combined to create sumptuous ensembles that asserted a luxuriousness through their sheer material plentitude. Even the more simplified

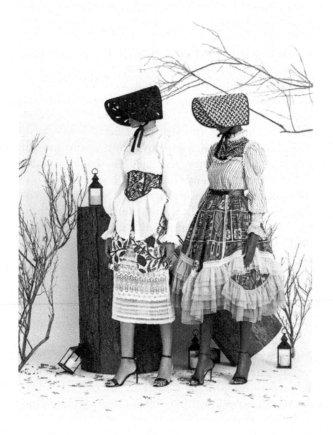

Figure 6.10 Two ensembles from Christie Brown's Spring-Summer 2018 *Conscience* collection; the garment on the right features a particularly voluminous skirt (Image: Aisha Ayensu).

and form-fitting silhouettes incorporated elements that added to their overall shape and volume. A form-fitting black lace dress was presented with a wide peplum jacket adorned with gathered and ruffled cuffs, thereby exaggerating the ensemble's overall silhouette. Materials in abundance are evident in several other collections, including the ample skirts, wide-leg pants and peplum jackets of Autumn-Winter 2017, and the billowing, ruffled and layered silhouettes from Spring-Summer 2016.

A wealth of material is not Ayensu's only means for creating visible volume; Ayensu includes dynamic elements in her garments that not only emphasize particularly significant materials, but create a fluid volume that varies according to the wearer's movements. One such example is the featured garment from Ayensu's Spring-Summer 2016 collection. Comprised of a halter dress with bodice of embroidered openwork (with a bandeau top worn underneath) and a skirt of wax print with a sheer overlay, the silhouette is relatively simple. The official photograph, however, captures the garment in motion; the overlay is billowing out and around the wearer, creating an unexpected, fleeting expression of extreme volume. Many of the garments from this collection are similar in that their voluminous elements are tied to motion, thereby only being fully appreciated when enacted by the body.

The most obvious effect of Ayensu's use of volume is that it enhances the brand's associations with luxury and exclusivity. Creating garments that require an ample amount of material is costly and time-consuming, which limits the number of garments that can be produced and subsequently purchased by consumers. The amount of yardage available of a particular print or fabric is also often unpredictable in Accra's markets, further restricting the production of specific ensembles and implicating an additional degree of exclusivity. The act of wearing a garment comprised of substantial material is also significant; across Western Africa, an abundance of material has long been associated with wealth, elite status and fashionable dressing. Among the Yoruba of Nigeria an abundance of material, for both men and women, evokes opulence, elegance, prestige, influence and serves as a direct indicator of social status.[4] Volume is equally valued in Ghana; men's batakari smocks, with their inclusion of multiple godets, create a voluminous silhouette that exaggerates the wearer's form, signifying wealth, prestige and political prowess.[5] Although rarely discussed in terms of volume and abundance, the wearing of kente also places primacy on material plentitude. Kente cloth, particularly when worn by men, is meant to indicate an individual's wealth and social status through the ability to acquire ample yardage of a prestigious, handwoven textile.[6] Ayensu's continued incorporation and experimentation with volume is a twenty-first-century reworking of this embedded cultural value; Ayensu's voluminous garments invoke extravagance, stylishness and, above all, wealth and social status.

Ayensu's deliberate and informed use of volume exhibits additional intentions; in a 2012 interview, Ayensu described her design aesthetic as championing "lines that are flattering on a woman's figure."[7] By creating materially lavish ensembles that accentuate the hips, waist and shoulders, Ayensu is celebrating

the female form, infused with a degree of confident sexuality. Although her voluminous garments often conceal certain areas of the body, by exposing and highlighting others through her exaggerated silhouettes, a hyper-feminine and idealized representation of the female form is expressed. In other instances, Ayensu employs volume to interrogate established conceptions regarding the female silhouette, emphasizing oversized design elements and craftsmanship typically associated with menswear and men's tailoring. This is best seen in the wide-leg pants and exaggerated sleeves of her Autumn-Winter 2017 collection, which was designed to challenge what is considered appropriate women's attire. Whether embracing or contradicting the stereotypical, ideal female form through her designs, Ayensu's manipulation of volume allows her to continually experiment with the female silhouette, ensuring the cultural significance of her garments extends beyond her use of meaningful materials.

As Ayensu said herself, one has to have "the spirit" to wear her designs. Ayensu's thoughtful sartorial exaggerations are visually bold and assertive, imparting a degree of confidence onto the wearer. By emphasizing volume and material plenitude, Ayensu ensures that her designs are "statement pieces," garments that make clear assertions regarding the social status and cultural identity of the wearer, while simultaneously reinterpreting historically rooted dress values.

"My thing is detail, detail, detail": hidden flourishes and bold embellishments

In 2016, I was given access to the Christie Brown archive, which includes a selection of designs from the majority of Ayensu's past collections. As I pored over each garment, I was able to appreciate their thoughtful construction, realizing that most possessed an exacting attention to detail. These details can frequently go unnoticed by the casual observer or consumer, but through careful consideration, a wealth of purposeful details become apparent. There are two broad categories of Ayensu's sartorial details: elaborate, decorative embellishments, and hidden or obscured flourishes, both typically of wax print. Ayensu employs these elements to emphasize and celebrate culturally valued materials, tied directly to her Ghanaian and African heritage, and to showcase the careful craftsmanship of her designs.

The most potent example of Ayensu's attention to detail is a military-inspired trench coat from her Autumn-Winter 2015 *Coup de Classe* collection (Figure 6.11). The coat is sewn from a durable, olive-green fabric and, outside of its gold buttons, appears relatively unremarkable. Upon closer inspection, a variety of details are revealed that function not only as sartorial surprises, but emphasize the garment's celebration of Ghanaian materials. The coat's belt is two-sided (although not reversible); the front is sewn from the same material as the coat, whereas the reverse is a wax print fabric of white, blue and rust. The belt is designed so that a narrow strip of wax print is visible, creating

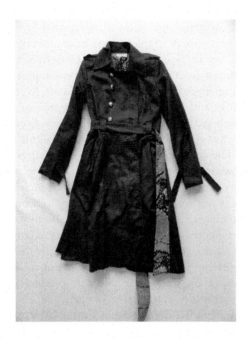

Figure 6.11 A military-inspired trench coat with wax print lining and trim, from the Christie Brown Autumn-Winter 2015 *Coup de Classe* collection (Image: Christopher Richards).

a subtle disruption in the coat's monotonous shade. When the belt is tied around the waist, its reverse side is revealed, providing an additional flash of wax print that ultimately functions as another example of Ayensu's "sartorial surprises." These minute, eye-catching details become the focal point of the garment, with the coat serving as a ground for Ayensu's bold, yet minimal, flourishes of wax print.

The real detail of the coat is only apparent when it is opened: the lining is sewn entirely from wax print, the same as found on the reverse of the belt. This is a particular feature of the coat that remains hidden, revealed only if the coat is worn open or when it is removed, resulting in yet another sartorial surprise. This is a particularly powerful detail, as it suggests the coat's wax print elements are primarily known only by the wearer. This results in a garment that is slightly subversive, as the outer appearance asserts a global silhouette, whereas the hidden details and lining suggest a specifically African identity.

There were several other garments that included interior, and therefore hidden, flourishes of wax print. A neon yellow, bolero-style top, likely from her Spring-Summer 2015 collection, had front edges trimmed with an array of wax print-covered buttons, creating a flurry of color and print. When

the garment is opened, the neck and front facings are exposed, which were sewn from wax print, a sartorial surprise that adds an additional layer of detailing to a deceptively simple garment. A strapless dress in cranberry, also from the Autumn-Winter 2015 *Coup de Classe* collection, has a permanently upturned hem of wax print, echoed by a one-inch facing encircling the interior of the bodice. This exacting approach to design, particularly Ayensu's consistent use of contrasting linings and facings, illustrates a degree of care and intentionality in creating each garment. It further illustrates Ayensu's commitment to incorporating wax print and other culturally significant materials into all her garments. The stark contrast between her outwardly assertive Afrocentric ensembles with garments that obscure or hide their African materiality is intellectually provocative. It suggests that her inclusion of culturally significant materials is not only directed outwardly, as a public assertion of Ghanaian and African culture and heritage, but can also function as a more self-serving and covert expression of personal identity. Many of these hidden details, exemplified by the trench coat, can be manipulated by its owner, implying that the wearer can determine whether or not to share the garment's African elements, bestowing the owner with a powerful degree of agency in asserting their own sartorially constructed identity.

In addition to her obscured and hidden details, Ayensu often adorns her designs with all manner of ornamentation. The embellishment of garments began early on, with her premiere collection including her now iconic wax print-covered buttons lining a pair of cuffed harem pants, the cuffs of a metallic jacket, and decorating the front of a sleeveless dress in graduated columns. By 2015, Ayensu had moved away from decorating her garments with buttons, instead using elaborate embroidered openwork, which has become an additional hallmark of her design aesthetic. Many of these embellishments, like the aforementioned openwork embroidery and fabric-covered buttons, serve as vehicles for emphasizing specific materials, typically wax print. Other forms of ornamentation are purely decorative; for her Autumn-Winter 2017 *F(Men)ist* collection, Ayensu's designs sparkled with bees and other insects fashioned from rhinestones and sequins. A skirt from her Spring-Sumer 2017 *Her Other Side* collection, heavily adorned with alternating rows of fringe and paillette sequins, was paired with a plain white blouse featuring a protrusion of wax print, also accented with large and lustrous palette sequins (Figure 6.12). These ornamentations, in addition to adding texture, dynamism, and a degree of exacting handiwork that recalls couture techniques, function as an additional means for distinguishing Ayensu's designs from her competitors, creating garments that elicit luxury and complexity.

Although Ayensu's embellishments may seem superficial, particularly her use of sequins, rhinestones and fringe, they serve as immediate proclamations of the craftsmanship and artistry of her designs. Additionally, these embellishments are thoughtfully employed, often in ways that further emphasize and enhance specific materials, particularly wax print. These two, seemingly contradictory, approaches to detailing – obfuscation and ornamentation – ultimately achieve

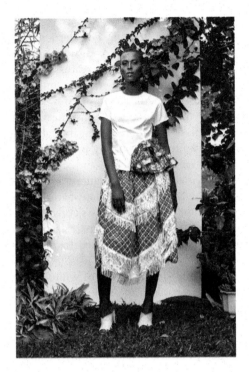

Figure 6.12 A dress from Ayensu's Spring-Summer 2017 *Her Other Side* collection with a profusion of embellishments, including fringe and paillette sequins (Image: Aisha Ayensu).

the same goal: to celebrate African culture and heritage. Whereas one method results in unapologetic and assertive sartorial proclamations, the other is more personal and intimate. The commingling of these two approaches in collections and individual garments further attests to the complexity of Ayensu's designs and the multifaceted nature of her fashions.

Sartorial surprises

Ayensu's collections abound with sartorial surprises: design elements intended to elicit surprise and delight in the viewer by emphasizing specific materials or areas of the body. Ayensu's continued commitment to creating sartorial surprises in her garments is expressed primarily through two techniques: the inclusion of unexpected, often contrasting, fabric that is either hidden or obscured by the construction of the garment, and details that disrupt the overall silhouette of a garment, particularly ones that reveal the wearer's body. Ayensu's sartorial surprises not only indicate her artistry as a designer, they draw attention to culturally meaningful materials that celebrate a cosmopolitan African identity,

blending global silhouettes and materials with historically significant African textiles and dress practices.

In 2012, Ayensu debuted her first resort collection. For the aptly titled *To Dye For*, instead of continuing to feature wax print, Ayensu chose to collaborate with well-known batik artist Grace Adover to create a collection that highlighted locally produced Ghanaian batik. It was an unexpected and potentially risky departure for Ayensu, as batik fabric often has negative connotations in Ghana, particularly for discerning, elite consumers. In spite of its laborious and layered process, batik is considered a cheaper alternative to wax print and is referred to as "me hw3 me nua" in Twi, implying that the majority of batiks look too similar to create distinctive and stylish outfits. Additionally, batik is often viewed as a material for foreigners, as evidenced by successful collectives, such as Global Mamas, that create batik products almost exclusively for foreign consumption. In spite of batik's convoluted and inherently unfavorable associations, Ayensu blended the material with lace and organza, creating extravagant ensembles that celebrated batik's artistry, originality and saturated colors.

At first glance, Ayensu's form-fitting, long-sleeved gown of white lace from her resort collection appears to include no batik fabric, save for the garment's stacked necklace of batik-covered buttons and chains (Figure 6.13). It is only upon viewing the back of the garment that one encounters an unexpected and colorful surprise: the skirt of the gown opens to reveal a train of batik in shades of yellow and brown, punctuated by abstract patterns of bright turquoise (Figure 6.14). The batik is almost electric in its color scheme, its saturated colors accentuated by their stark contrast to the white gown, making the train's reveal all the more surprising and impactful. When not in motion, the train is designed to pool around the wearer, creating a visual hint at the shock of color and pattern obscured by the wearer's body. An additional surprise is the keyhole neckline on the back of the gown, which subtly reveals a narrow portion of the wearer's body. This creates another contrast to the front of the gown, which is relatively conservative and unrevealing in its overall construction. The contrast between the front and back of this single gown encapsulates Ayensu's techniques for creating sartorial surprises, while simultaneously promoting batik as a distinctly Ghanaian material for designer fashions.

Ayensu's use of sartorial surprises began in earnest with the precursor to her resort collection, the Autumn-Winter 2012 *Xutra* collection. In a description of the collection, Ayensu described the designs as "multidimensional," implying that each garment had multiple elements, or parts, that coalesced into a successful, holistic look; Ayensu's sartorial surprises were one of these dimensions. The majority of the *Xutra* garments were constructed from black silk or velvet, punctuated by wax prints in shades of coral, maroon and brown. Similar to Ayensu's subsequent resort collection, the fronts of specific garments were designed to be monochromatic and subdued, whereas the back was the site for a variety of elaborate and decorative surprises.

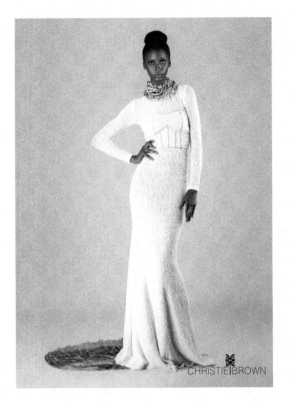

Figure 6.13 The front view of a lace gown from Ayensu's 2012 *To Dye For* collection (Image: Aisha Ayensu).

Ayensu created two black dresses with front panels that featured detailed pleating and tucking, yet due to their singular color, they appeared deceptively simple. This functioned as a stark contrast to the back of each garment, which featured a daringly open back, draped with a variation of Ayensu's fringe in the form of wide ribbons of wax print. When presented in motion, these ribbons fluttered and trailed behind the wearer, adding a degree of dynamism to the garment that ultimately highlighted Ayensu's inclusion of wax print. A third garment from the collection, comprised of a transparent, short-sleeved black blouse and black velvet skirt, superficially appeared to include wax print only in the form of a belt. When presented in motion, the skirt's slit revealed a lining of wax print, once again creating an unexpected sartorial surprise. All three garments illustrate Ayensu's technique of obfuscation to create a bold, visual impact, specifically for identifiably African materials. Additionally, Ayensu's silhouettes include details that disrupt the visual uniformity of her designs, particularly in ways that offer a titillating glimpse at the wearer's body. In addition

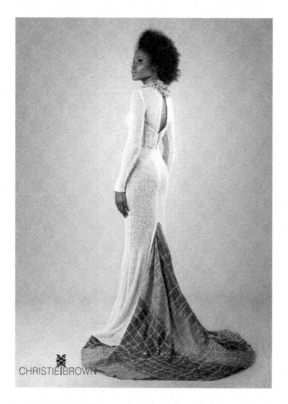

Figure 6.14 The back view of a lace gown from Ayensu's 2012 *To Dye For* collection (Image: Aisha Ayensu).

to exposing the wearer's backs, the sides of Ayensu's black dresses were designed to partially reveal the wearer's breasts, while the high slit of Ayensu's velvet skirt provided a glimpse of the wearer's thigh. In all three instances, the sartorial surprises are linked to design elements that assert a confident yet playful sexuality, further invoking one of the qualities of Ayensu's imagined "Christie Brown woman."

Sartorial surprises abounded in Ayensu's Autumn-Winter 2015–2016 *Coup de Classe* collection, demonstrating a growing sophistication in the design and construction of her garments. *Coup de Classe* featured several of Ayensu's most complex sartorial surprises, including a plaid button-down shirt that epitomized simplistic, mainstream fashion, until the back revealed a yoke of wax print, edged with matching fringe that obscured an open back (Figure 6.15). A sleeveless dress featuring an enlarged pattern of black and white houndstooth was contrasted with a back entirely of wax print, while two skirts and a dress from the collection, in shades of mustard and cranberry, had the edges of their side slits permanently turned up to reveal their inner

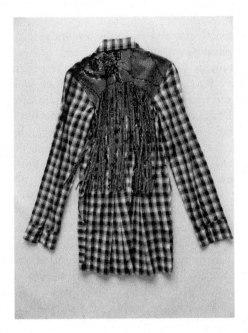

Figure 6.15 The back of a plaid shirt, which included a yoke of contrasting material, fringe and an open back, from the Autumn–Winter 2015 *Coup de Classe* collection (Image: Christopher Richards).

linings of complementary wax print (a more permanent variation on Ayensu's earlier *Xutra* skirt).

Whether in the form of wax print godets, bandeau tops layered under elaborate openwork, or slits that reveal layers of tiered tulle and wax print, Ayensu continues to play with the construction of her garments, ensuring that sartorial surprises remain a mainstay of her designs. These flourishes are much more than stylish gimmicks or testaments to skilled construction, they are a tenet of Ayensu's brand identity: the conflation of the local and the global. Ayensu attested to this when asked specifically about her use of global prints, such as houndstooth and argyle, in the *Coup de Classe* collection: "I'm always looking at ways to integrate our perspective into the global scene. Those prints [houndstooth and argyle] are typically fall, so my take on it was: how do I 'Christie Brown' these prints?"[8] By creating garments that at first appear global, only to later reveal a pronounced African element, Ayensu is literally seaming together materials and silhouettes that reflect global and African fashion to create garments that are unapologetically cosmopolitan, reveling in their symbiotic duality. This is why Ayensu's sartorial surprises are so important and effective – because they aptly and artfully reflect the tension between global and African fashion, along with the complex, multifaceted desires of Ghana's female consumers.

Print in motion

The majority of the aforementioned sartorial surprises are inconspicuous if not enacted by the wearer, implicating an additional hallmark of Ayensu's aesthetic: the importance of movement to her designs. When viewed two-dimensionally, as through publicity photographs, the dynamism of Ayensu's garments are often lost on the viewer; when placed on a body, Ayensu's sartorial details and flourishes are activated by the natural rhythm of the wearer, not only reflecting, but exaggerating, a person's gestures and movements. Whether on the runway or in the streets of Accra, Ayensu's designs billow, cascade and flutter around and on the body, another tenet that distinguishes her garments from the work of other Ghanaian fashion designers.

The most compelling example of how wearing, and thus enacting, one of Ayensu's designs changes one's perception of the garment is a high-waisted skirt from her Spring-Summer 2017 collection (Figure 6.16). The skirt includes many of the Christie Brown hallmarks: a wax print that is partially obscured by a layer of complementary lace, the inclusion of a luxurious, imported chiffon and extensive detailing. The main feature of this skirt is its series of elaborate pleats that create a bold ruffle encircling the wearer's hips, thereby forming gentle folds in the fabric that cascade across the body of the skirt. Although the pleats are discernible in photographs, their movement is not. When the skirt is worn, the pleats respond to the slightest movement, undulating fluidly as the wearer walks or shifts their body. Furthermore, each ruffle extends between two to three inches from the surface of the skirt, ensuring that the slightest movement will reverberate through the exaggerated folds. When one encounters the dynamism of these ruffles, the garment becomes bold and unapologetic: an assertive and performative garment that exaggerates and draws attention to the wearer's body.

Ayensu harnesses the power of movement to accentuate specific materials in her designs, typically fabrics that symbolize a Ghanaian, and more broadly an African, heritage. This technique was first seen in her 2010 premiere collection, where she showcased two dresses with horizontal wax print fringe that cascaded down the body, a skirt wrapped with horizontal fringe that would shift as the model walked, and a dress that was embellished with row upon row of wax print ruffles. It was Ayensu's *Xutra* collection that fully championed the power of movement as an unexpected means for emphasizing and celebrating wax print. It featured the aforementioned wide ribbons of wax print in a variety of forms: as short bands that draped across the shoulders or hips, as longer bands that extended from the neckline or bodice, draping around the body, and as ribbons that hung from the back of the garment, floating and swaying as the models paraded down the runway. Due to Ayensu's stark contrast in materials, her use of wax print as each garment's dynamic element was pronounced, illustrating how these potentially decorative elements, through their motility, became the focal point of each garment.

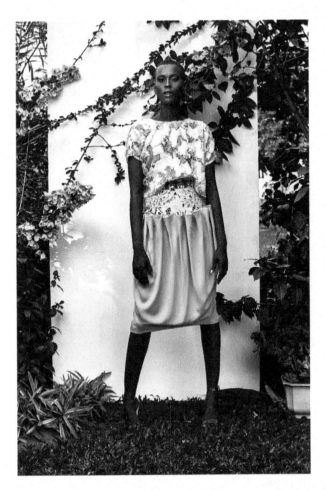

Figure 6.16 A high-waisted skirt with kinetic ruffles encircling the hips, from Ayensu's Spring-Summer 2017 *Her Other Side* Collection (Image: Aisha Ayensu).

Ayensu continues to champion kinetic silhouettes, although her recent collections emphasize material volume and abundance, as opposed to her earlier more streamlined designs. The nascence of this shift can be seen in the layered fabrics, tiered ruffles and wide-leg pants of her Spring-Summer 2016 collection, which a year later was surpassed by the fluidity and ampleness of her Spring-Summer 2017 collection, with each garment featuring at least one kinetic element. Ayensu has harnessed the literal flexibility of wax print and other African materials to celebrate and promote a distinctly Ghanaian perspective through her designs, emphasizing these materials through their pronounced and exaggerated movement. This technique is epitomized by a sleeveless, pale pink dress from her Spring-Summer 2018 collection. The dress included deep

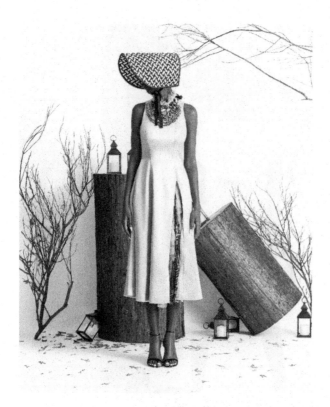

Figure 6.17 A sleeveless dress with extensive pleating and a "peek-a-boo" of wax print, from Ayensu's Spring-Summer 2017 *Conscience* collection (Image: Aisha Ayensu).

pleats, one of which is transformed into a high slit that reveals a wax print fabric hidden under tiers of transparent tulle (Figure 6.17). It is through movement, accentuated by a contrast in material and color, that the eye is continually drawn back to the wax print, a subtle yet effective means for emphasizing and celebrating the garment's Ghanaian, and African, influences.

Ayensu's hallmarks – asymmetry, volume, embellishments, sartorial surprises and kinetic flourishes – have aided her in becoming one of the most successful and innovative designers in Ghana and across the continent. Her hallmarks indicate the sheer artistry and complexity of her garments; Ayensu carefully constructs her designs to be visually pleasing and inventive, offering her consumers an ever-changing array of ensembles that reflect her carefully constructed vision of the "Christie Brown woman." This vision, a melding of Ayensu's personal perspective and her consumers' cosmopolitan identities and desires, reflects an additional function of Ayensu's hallmarks: to champion a Ghanaian, and more broadly African, identity and heritage through the materiality and

design of clothing. Ayensu employs her hallmarks, both subtly and flagrantly, to ensure the core value of her brand: "there always has to be something that ties it back to Africa."[9]

Clothed in cultural heritage – the material significance of Ayensu's designs

Wax print

Ayensu's main method for tying her garments "back to Africa" is her consistent use of wax print fabric. Ayensu continued her explanation, stating:

> so even for just a little detail on the piece, it always has to tie back. People come to us for a taste of Africa that's done in a very sophisticated way. The moment that's missing, what makes us different?[10]

As Ayensu's comment implies, she was one of many young designers during the late 2000s who was determined to reimagine wax print for a more globally connected, contemporary Ghanaian woman. Her premiere collection ultimately reflected this desire: to physically manipulate and symbolically reimagine wax print as a more accessible, relatable and global material, while maintaining and celebrating its cultural potency. The resulting garments blended wax print with luxurious materials like satin and chiffon; Ayensu further experimented with wax print as either the focal point or an accent of her garments. One dress was sewn entirely from the bold and iconic "Alphabet" print, whereas a khaki shirtdress included only a wax print belt. Ayensu has maintained a commitment to wax print fabric because she considers it a reflection of her ethnic identity and heritage. As Ayensu explained:

> I'm from the South [of Ghana]. My grandmother, Christie Brown, she's Ga [and also] from the South. Ga people don't really wear kente, it's an Asante thing. The Ewe have a kente they wear and the northerners, the fabric they use, batakari, is like kente. The people of the south, even for their festivals, they use wax print.[11]

For Ayensu, the combined Indonesian, Dutch and British origins of wax print fabric do not detract from its West African, and specifically Ghanaian, associations. As she astutely observed:

> I know that wax print didn't come from here; even though it's not from here, it's become our culture. No matter if it was brought from the Dutch, we've embraced it and it has become our thing. I guess that's the tradition bit in it.[12]

Ayensu's frank reflection illustrates the inherent complexity of wax print fabric. In spite of its foreign origins, wax print has become synonymous with a distinctly African identity. In Ghana, the material has been further localized, resulting in its frequent appellation as a traditional form of dress, implying that the material has deep cultural relevance and historicity, in spite of its relatively recent introduction into Western Africa.[13]

In addition to its associations with Ghanaian heritage and identity, wax print also has personal symbolism for Ayensu. "Growing up, everyone used to wear African print, especially the older ladies. I think that must have done something to me, because I just love it; it's what I grew up around."[14] Although Ayensu has thoroughly embraced wax print as a core element of her designs, she didn't always have such a fondness for the material. She recalls that as a child:

> We had to wear [wax print] for church on Sunday. We had to wear it, but not because we loved it. It was just boring. That's when I decided to explore it more. You were supposed to sew a kaba and slit, but maybe I would make a belt with [wax print]. I started playing around with the print more.[15]

It is this nascent desire to respect familial dress practices, coupled with a frustration regarding established forms of dressing, that spurred Ayensu to reinvigorate wax print during the late 2000s. This literal act of re-tailoring acknowledges the cultural and historical value of wax print as a material, adjusting its physical presentation to make it relevant for a younger, more global generation.

Following her premiere collection, Ayensu participated in the 2010 Africa Fashion Week held in New York, where she presented a more cohesive approach to wax print: as a material for bold flourishes and ornamentation. Instead of using large swaths of wax print, she restricted the material to primarily embellishments and accents. Ayensu paired these printed flourishes with luxurious fabrics in solid colors to maximize the wax print's boldness and to ensure it remained the focal point of the garment. Thus, the solid fabrics became the ground for Ayensu's innovative wax print modifications. Additionally, Ayensu chose not to focus on an individual print or prints, instead using a diverse array of contrasting wax prints to adorn her garments. The result was a globally informed collection that, with kaleidoscopic acuity, celebrated the beauty and unexpected harmony of wax print.

The majority of Ayensu's wax print embellishments were presented in two forms: long, narrow tubes that were used as fringe, or as fabric-covered buttons of various shapes and sizes. Both forms were used as adornments: the fringe was sewn horizontally onto dresses and skirts, creating dynamic cascades of wax print; the buttons were strategically placed on pockets and the edges of jackets, formed deliberate patterns on dresses and, most significantly, adorned crescent-shaped necklaces (Figure 6.18). At the time, these two modes of presenting wax print were highly innovative; Ghanaian designers frequently blend wax print with other local and imported materials, but these designs often rely on larger strips or panels of their chosen fabrics. Ayensu's use of disparate wax prints as

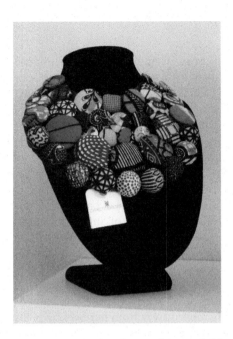

Figure 6.18 An example of one of Ayensu's bib necklaces, adorned with wax print-covered buttons, 2012 (Image: Christopher Richards).

embellishments on a given design introduced a new mode for highlighting the fabric. By using imported materials as the background, Ayensu's arranged, clustered and pendent wax prints became the centerpiece of each garment and, subsequently, of the entire collection. Her use of multitudinous and often disparate wax print further added a layer of visual interest to her garments; a dress with a central panel of horizontal fringe would literally undulate with shifting shades of bold colors and patterns. By pairing her use of wax print as embellishments with simple, globally informed silhouettes, Ayensu further ensured that each garment was relatable, with the ability to appeal to Ghanaians, other Africans and global fashion consumers.

These embellishments proved particularly successful when expressed as accessories, resulting in Ayensu's now iconic fringe and wax print button bib necklaces. The fringe necklace is constructed from multiple strands of piping in various lengths, sewn together at either end to create a layered, pendulous form. The bib necklace is formed from a predetermined crescent shape of solid-colored fabric, which is then evenly covered by various wax print fabric-covered buttons. When asked about the success of the bib necklaces, Ayensu initially rejected their acclaim:

we launched the bib necklace in 2010 and it didn't hit until 2011 or 2012, so to be very honest I don't think that necessarily worked. However,

I know that accessories are always a great entry point into any market ...
it's opened a lot of doors for us.[16]

Although the necklaces may have not been an immediate hit, during repeated
research trips to Accra, I regularly witnessed Ghanaian women proudly sporting
a Christie Brown bib necklace, often paired with imported, global fashions. This
points to a particularly significant feature of these accessories that ensures their
continued popularity: they can immediately transform any outfit into a bold
expression of African identity and heritage, while simultaneously marking the
wearer as a Christie Brown consumer. Her accessories are also more affordable
than her clothing, thus making them more accessible to a broader segment of
the population.

As noted in this chapter's introduction, the main drawback of both acces-
sories is that they are easily reproduced; the slew of imitations that have
permeated the boutiques of Accra and entered the global, African-inspired
fashion market indicates their inherent popularity and wearability (Figure 6.2).
In an attempt to combat the unregulated plagiarizing of her necklaces and
to maintain their originality, Ayensu began to introduce subtle variations: a
bib necklace trimmed in dyed feathers or accented with a gold chain. As the
imitations persisted, Ayensu gradually moved away from her necklaces, instead
decorating shirt collars with her iconic wax print-covered buttons (as seen
in her Spring-Summer 2015/2016 collection) or transforming the concept
of fringe into more exaggerated embellishments (like the wax print bands
featured in the Autumn-Winter 2012 *Xutra* collection). Her most recent
version of the bib necklace, included in her Spring-Summer 2018 collection,
was trimmed with a row of beaded fringe, a laborious form of handiwork that
proved too time-consuming to be duplicated (Figure 6.17).

As of 2018, Ayensu no longer produces her fringe necklaces, while her bib
necklaces remain a staple in her boutique, albeit in limited quantities (during a
visit to her boutique in 2017, only three bib necklaces were available for pur-
chase). Although Ayensu has distanced her brand from these iconic accessories,
their significance remains; they were some of Ayensu's earliest global successes
and represent, in condensed form, her approach to wax print: to celebrate the
material in its polychromed and patterned glory. Not only did Ayensu innovate
how wax print could be worn (as minute and commingled ornaments), her
accessories made it easier for women to wear wax print on a regular, even daily,
basis. This is a powerful alteration in local and global dress practices. With the
advent of Ayensu's accessories, women were no longer restricted to wearing
wax print in the form of a kaba or as part of a larger, globally informed fashion;
her necklaces allowed women to immediately transform any ensemble into
one that clearly invoked African culture and heritage. This ability is undoubt-
edly empowering, as it allows wax print to act as a vector for the celebration of
African identity in a global fashion context.

Whereas Ayensu's accessories highlight the beauty of an amalgamation
of prints and patterns, her fashions have taken a decidedly different turn,

emphasizing instead a carefully constructed and restricted employment of wax print. Beginning with her Autumn–Winter 2012 *Xutra* collection, Ayensu began to create her collections around a limited yet harmonious color scheme. For *Xutra*, Ayensu sourced her wax prints from Vlisco's 2012 *Silent Empires* collection, which featured abstract geometric patterns in a range of earth tones. The collection had the unusual feature of relying on several key patterns that were altered through the application of different colors to specific motifs, adding a subtle variation that created distinctive yet analogous prints. By relying on this collection of wax print, Ayensu ensured that her designs would be equally constrained and harmonious, becoming a celebration of the individual prints and their nuanced patterns.

Following a short period (the Autumn–Winter 2013/2014 and Spring–Summer 2015/2016 collections) in which wax print almost disappeared from her designs, Ayensu became even more astute and deliberate in her use of the material, beginning with her Spring–Summer 2016 collection. Inspired by memories of the film *The Sound of Music* and visions of an idyllic countryside, Ayensu created a collection replete with high necklines and long sleeves, trimmed with various forms of lace, bows and pleating. For the wax print elements, Ayensu selected three main fabrics produced by Vlisco: two with contrasting patterns in matching color schemes of navy blue, tan, lime-green and cream (Figure 6.19),

Figure 6.19 One of the two unusual wax prints Ayensu employed in her Spring–Summer 2016 collection (Image: Christopher Richards).

and a singular print of bright orange, blue and white. Two of the prints featured abstract floral patterns, whereas the third included paisleys. As with *Xutra*, by limiting the colors and patterns of wax print, the collection became more cohesive, further accenting Ayensu's chosen wax prints.

There was another noteworthy element to Ayensu's chosen fabrics: the aforementioned color schemes were highly unusual, and thus unexpected for wax print, which influenced Ayensu's decision to use them: "I did select it because it was unconventional; the colors were unusual because of the white base, but it also fit into the whole prairie theme for the collection."[17] This admission points to an unintentional shift in Ayensu's aesthetic: to complicate consumers' expectations of wax print fashions. By pairing the aforementioned wax print with light denim and other imported materials (including a transparent fabric that featured a kaleidoscopic print of zebras on an African savannah), the wax prints became even further distanced from their generic and expected forms, becoming more of a cosmopolitan, and thus globally informed, material.

The mixing of unusual wax prints with recognizable, global patterns began with Ayensu's previous collection, the Autumn–Winter 2015 *Coup de Classe*. Relying on two wax prints of rust, navy blue and white with contrasting motifs, Ayensu blended these fabrics with immediately recognizable, global patterns of houndstooth, argyle and gingham, creating a collection that treated wax print as another material for global fashions. When asked if these unconventional wax prints were selected for their potentially global appeal, Ayensu insisted they were chosen for their synergy with her seasonal theme, not for their potential accessibility. However, it is important to note the potentially unintentional implication of this sartorial strategy; by selecting atypical wax prints and blending them with iconic, global patterns, Ayensu is challenging generalizations and misconceptions regarding wax print. Her garments highlight the diversity of colors and patterns found in wax print and illustrate that, as a material, it can be employed with other patterns, asserting the absolutely cosmopolitan nature of wax print. This malleability and global nature of wax print is echoed by Victoria Rovine in a complex metaphor equating the material to an unknown, female "character study":

> she blends in thoroughly, obscuring her own history to become local everywhere … sometimes she is deliberately deceptive, passing herself off as someone she is not. But more often, she simply allows new identities and associations to be attached to her as she travels.[18]

Ayensu's designs further the localization of wax print on a global scale, making it appealing to consumers unfamiliar with wax print, while maintaining its deeply personal meaning for Africans and members of the Diaspora.

In her most recent collections, Ayensu has returned to using a wider range of wax print; while she still incorporates unusual and unexpected patterns, she has added iconic wax prints back into her collections, creating a more diverse range

of wax print fashions. She has maintained her careful construction of ensembles, ensuring her pairings of wax print and other imported materials are harmonious, artful and visually pleasing. As her accessories and garments indicate, the Christie Brown brand is ultimately a celebration of the history and materiality of wax print and its potent meanings for Ghanaians, Africans and members of the Diaspora. Perhaps Ayensu said it best; she described the Christie Brown woman as looking for garments that reflected the spirit of the African woman, while acknowledged that "she is part of this huge global village," so her clothing must reflect the same, multifaceted identity.[19]

Batakari cloth

The potency of Ayensu's material choices for her designs is best illustrated by a particular garment, one that deviates from her enduring interest in wax print fabric, but that encapsulates the *raison d'être* of Christie Brown. Ayensu's first formal collection was presented at the 2009 Arise Africa Fashion Week in Johannesburg, South Africa. Compared to Ayensu's subsequent collections, her 2009 garments lacked a careful, constructed cohesion; Ayensu used a variety of wax prints that contrasted in pattern and color and the silhouettes were erratic, ranging from sleek and simplified to voluminous and embellished. In spite of its inconsistencies, the collection included elements that would become hallmarks of the Christie Brown aesthetic, such as bold, asymmetrical flourishes and experimentations with obscured fabrics. One garment that stood out from the rest, in terms of its materiality and silhouette, is in hindsight the most significant design from Ayensu's premiere collection. Unlike the majority of her debut garments, this dress was not an entirely new construction; instead, Ayensu transformed a pre-made batakari smock, an iconic form of Ghanaian men's dress, into a provocative form of women's attire (Figure 6.20). This garment foreshadowed Ayensu's continued drive for innovation and originality, while using culturally significant materials to challenge women's established dress practices.

Batakari smocks are a form of tunic made entirely from narrow strips of handwoven cotton or rayon that are strongly associated with Northern Ghana and practitioners of Islam. The smocks can be sleeveless or made with long, draping sleeves, but their hallmark is the wide and plentiful godets, inset triangular pieces of fabric that create the garment's distinctive flares. Typically extending from the lower ribcage to the hem of the smock, the addition of godets creates a dynamic, ruffled effect that echoes the wearer's movements, a feature often exploited by contemporary Ghanaian dancers to exaggerate their own motion. The godets also add volume to the smock; some batakari include as many as 30 godets, which adds considerable material to an already ample garment, exaggerating the wearer's size and stature. As previously acknowledged, adorning the body with plentiful material is a way of asserting both wealth and social importance throughout Western Africa, and the batakari smock is no exception.

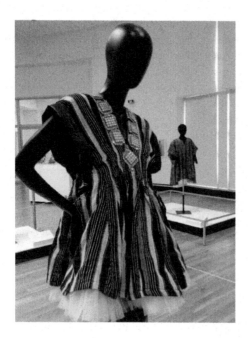

Figure 6.20 Ayensu's batakari cocktail dress from 2009, as exhibited at the Harn Museum of Art, 2015 (Image: Christopher Richards).

Historically, batakari smocks were subdued in pattern and color. The oldest documented batakari, frequently adorned with protective amulets, are typically patternless and a monotone cream. Other early versions included narrow vertical stripes of dark blue, suggesting that these older smocks were largely made from locally sourced materials, specifically cotton and indigo dye. The general structure of these early smocks implies a deep historicity, as they are similar in construction and material to textile fragments found at the Tellem archaeological site in Mali, dating from the eleventh to the eighteenth centuries. In Tellem Cave Q, dated to the fifteenth century, two gored tunics identified as Q71–1 and Q71–5 are similar in form to contemporary batakari smocks and potentially include small godets on both the front and back.[20] It should be acknowledged that strip-woven tunics with godets are not limited to Ghana; similar men's prestige garments have been found among the Yoruba in Nigeria, the Fon in Dahomey, and the Hausa throughout Western Africa.

In recent decades, the batakari smock has seen countless innovations, including the introduction of unusual colors, the mixing of contrasting strips to create a multicolored, patchwork smock and the use of ikat dying techniques. The result is a myriad new variations on this stalwart of Ghanaian dress. One aspect of the smock remains relatively unchanged: for over a century, it has been the sole sartorial prerogative of men. Although women can wear wrappers and blouses

of the same strip-woven material, the smock itself is strongly associated with masculinity, chieftaincy and men's authority, thus placing informal restrictions on who can wear a batakari smock.

The symbolic power of batakari smocks, particularly as an indicator of male potency, was undoubtedly strengthened on March 6, 1957, when Ghanaian Prime Minister Kwame Nkrumah announced to a sea of cheering Ghanaians, and to the world, that Ghana was free from colonial rule. As part of his speech, Nkrumah proudly declared: "we are going to create our own African personality and identity." Nkrumah and the five men who flanked him (Komla Gbedema, Kojo Botsio, Archie Casely-Hayford, N.A. Welberk and Krobo Adusei) evoked this sentiment through their dress, choosing to don classic batakari smocks of indigo blue and white. As a strong proponent for kente cloth as a symbol of Ghanaian heritage and collective identity, Nkrumah's use of the batakari smock on such a historically significant occasion begs further investigation. At the time, the smock would have been deeply connected to northern Ghanaian culture, bearing historical associations with chieftaincy, militancy and hunting prowess; by wearing the smock, Nkrumah and his supporters were likely asserting their authority over outside forces and their own status as leaders of their newly independent nation. This postulation becomes more acceptable upon acknowledging that Nkrumah frequently wore batakari smocks prior to Ghana's independence; communications scholar Barbara Monfils claims that the batakari was Nkrumah's official dress during his independence campaign and that he often wore a smock when speaking at rallies and political events.[21] This acknowledgment further complicates the symbolism of Nkrumah's use of the smock, aligning its inherent meaning with military might, suggesting that it reflected Nkrumah's continued fight for independence from colonial rule. Nkrumah wore the iconic garment on the eve of Independence to potentially assert that the fight had been won: Ghana was independent and Nkrumah was the victorious champion.

Whether the decision to wear batakari smocks to announce Ghana's independence was concerted or arbitrary, the outcome is clear: the smock became suitable attire for politicians and further entrenched with notions of masculine authority, power and prestige. Subsequent Ghanaian presidents, including Jerry Rawlings and John Mahama, regularly wore smocks for official business, including addressing the United Nations and meeting foreign dignitaries and presidents. On March 6, 2017, President Nana Akufo-Addo chose to wear an unusual, all-white batakari smock to celebrate the 60th anniversary of Ghana's Independence. Although his choice of clothing was highly criticized by the Ghanaian public, Akufo-Addo was likely attempting to celebrate Ghanaian culture and invoke similar sentiments to those proffered by Nkrumah's own dress 60 years earlier.

It is with this accrued symbolism and complexity that Ayensu chose to adapt a pre-made batakari tunic into a woman's garment that was provocative in both a literal and symbolic sense. Ayensu made simple, yet powerful, alterations to her batakari smock. Her first interventions altered the silhouette of the garment: she

added several pleats to the front and the back of the smock, creating a narrower, more pronounced, waist and an even fuller skirt. The pleating on the front of the smock was carefully planned to highlight the smock's pattern of narrow white stripes, creating the illusion of an hourglass shape, further accentuating the female form. The pleating also resulted in the raising of the hemline, making the tunic visibly shorter. The second adjustment was to the sleeves; Ayensu stitched the bottom of the sleeves together, creating a narrower armhole that transformed the rather formless sleeve into a discernible cap sleeve. With the structural alterations complete, Ayensu then embellished the garment: she edged the sleeves with navy blue satin and replaced the pockets with the same fabric to create a more luxurious finish; she added an abundance of tulle to the inside of the garment to make the skirt more pronounced and she adorned the neckline with square ornaments comprised of beads and sequins. For the runway presentation, Ayensu finished the garment with an informal belt of black grosgrain ribbon, tied in a bow.

The overall effect was a marked departure from the smock's original form and its culturally sanctioned symbolism. As a garment synonymous with chieftaincy, male potency and authority, Ayensu transformed the tunic into an overtly feminine and luxurious cocktail dress, resulting in an assertive challenge to an established form of Ghanaian men's attire. Gone was the illusion of creating a larger, more imposing figure; in its place was a svelte silhouette that, by emphasizing the waist and exposing the thighs, became an assertion of confident, female sexuality without belying its references to Ghanaian culture and heritage.

The most significant aspect of this garment, and the one that aligns it most strongly with its historical archetypes, is Ayensu's use of sequined adornments to encircle the neckline. In the late nineteenth and early twentieth century, select Asante men were known to wear batakari smocks adorned with animal horns and all manner of handmade leather pouches. Often square or rectangular and containing Koranic verses or natural substances, these amulets were believed to protect the wearer in hunting and in battle, resulting in their appellation as "war shirts." Ayensu mimicked the ornamentation of these particular batakari smocks through her use of embellishment, reinforcing her garment's connection to these historical forms, reimagining the defensive, empowering amulets as ornamental, extravagant forms. In essence, Ayensu transformed the batakari smock into a form of women's expressive attire that, by including daring elements, evokes similar notions of confidence and potency, but specifically for women. In this sense, her adaptation is not a mockery of the batakari smock, it is a revision that diversifies its original form, making it an equally empowering silhouette for contemporary female consumers. Ayensu's act of transformation further implies that these historical forms of dress remain relevant and valuable, resulting in Ayensu's challenging, yet celebratory, revision of the batakari smock.

Although Ayensu's batakari cocktail dress was a sartorial anomaly, it epitomizes Ayensu's approach to design: to reimagine historically and culturally significant Ghanaian materials for a contemporary audience and to boldly

challenge established and potentially limiting dress practices. Ayensu's daring approach, albeit nascent in her premiere collection, set her apart from other emerging designers, aligning her more with her predecessor Kweifio-Okai, who fearlessly broke with established modes of dressing to innovate the use and form of specific materials and dress styles. Like Kweifio-Okai, Ayensu's garments frequently defy what is deemed socially and culturally acceptable for Ghanaian women, making her garments powerful vehicles for asserting female agency and an informed, cosmopolitan identity. Although Ayensu's subsequent garments are not as blatantly challenging of gender norms as her batakari cocktail dress, the desire to question established dress practices and reflect a more diverse, global viewpoint is inherent in her designs.

After a seven-year hiatus, the batakari smock resurfaced in Ayensu's Autumn-Winter 2016 collection, in a more subtle yet equally transformative expression. Instead of reinventing the smock through specific alternations and additions, Ayensu reimagined the very essence of batakari: its woven strips of cotton cloth. Ayensu collaborated with weavers in the north of Ghana to create strips based on her pattern and color preferences, which she then used as a material to create globally informed fashions. The resulting garments indirectly evoked batakari smocks primarily through the heaviness and texture of the material, as opposed to immediately recognizable silhouettes and colorations. One such garment was a full skirt sewn from horizontal batakari strips of navy blue and pale yellow (Figure 6.21). The overall pattern was punctuated by horizontal black stripes, which upon closer inspection were not part of the woven textile, but openwork ribbon used to join larger sections of the batakari strips. By including this embellishment, which mimics the appearance of a batakari pattern while simultaneously challenging its materiality, Ayensu continues her evocation and innovation of the batakari smock. The inclusion of openwork ribbon also adds an element of playful enticement, as it offers small glimpses of the wearer's body. Much like her debut batakari dress, Ayensu's batakari skirt is imbued with a degree of allure and feminine sexuality, a direct challenge to its aforementioned associations with masculine power and prestige.

The remaining batakari garments from Ayensu's 2016 collection pushed the wearability and accepted understanding of batakari even further; by drastically altering batakari's physical form and blending it with wax print and other imported fabrics, Ayensu transformed this woven textile from a fixed and preconceived garment to a pliable material for global, Afrocentric fashions. One such garment, a long-sleeved shirt with an angled neckline and oversized cuffs, was sewn from a batakari of navy blue, yellow and turquoise stripes. The garment's unconventional color scheme, coupled with its unusual and angular silhouette, challenges structural preconceptions of batakari. By edging the garment's cuffs with wax print, the materiality of the garment is further complicated, as the unexpected pairing blurs the distinction between the two materials, casting doubt on whether the fabric is indeed batakari or another form of printed material.

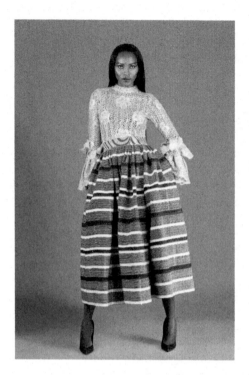

Figure 6.21 A batakari skirt from Ayensu's Fall-Winter 2016 collection (Image: Aisha
 Ayensu).

The featured ensemble of the collection, a riotous dress worn over a long-
sleeved blouse of elaborate lace, is the most sophisticated and complex reinter-
pretation of batakari, in both its form and materiality (Figure 6.22). Whereas
the bodice of the dress is fashioned solely from batakari of yellow, green and
blue stripes in varying widths, the skirt is an explosion of color, pattern and
texture: the skirt alternates between vertical strips of batakari, large-scale godets
of floral wax print, and panels of openwork embroidery that literally extend
out from the skirt's surface. Although easily overlooked by the garment's sheer
exuberance, Ayensu's use of godets evokes a similar structure to that of batakari
smocks, albeit adapted to a more conventional form of women's wear. By
incorporating this iconic element of Ghanaian dress, coupled with her use of
custom-designed batakari, Ayensu is actively reinventing the batakari smock as
an elegant, globally informed design for women. As with Ayensu's asymmetrical
batakari shirt, by pairing the batakari with additional materials, including wax
print, embroidery and imported ribbon, she further distances batakari from its
original form, asserting instead that it can be used as fabric, imbuing the textile
with new meanings that champion its inherent malleability and accessibility.
 When comparing Ayensu's 2016 batakari dress with her 2009 version,
another powerful consistency is revealed: her continued commitment to

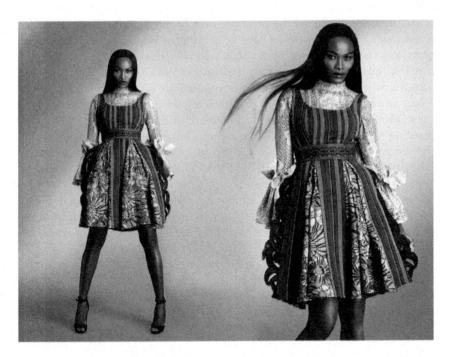

Figure 6.22 Ayensu's most complex reinterpretation of batakari smocks, in both form and material (Image: Aisha Ayensu).

challenge batakari's overtly masculine symbolism. Ayensu's original revision of the batakari smock retained its iconic form, colors and pattern, resulting in an unabashedly provocative and feminine design that more directly and assertively challenged its former status as a men's prestige garment. Seven years later, Ayensu's return to the batakari smock was a more subtle and sophisticated variation. Ayensu extracted the hallmarks of batakari, namely its godets, material, and vertical striped patterns, transforming them through alterations in color and silhouette to create an entirely new, globally informed garment. By adapting its iconic elements, Ayensu ensured the batakari was ever-present in her design, resulting in a more subversive, but no less impactful reinvention of the batakari smock. Whether through audacity or subtlety, these two designs simultaneously reference and dismantle the batakari smock, transforming its associations with masculine prestige and authority to indicators of Ghanaian cultural heritage and cosmopolitanism, specifically for women. Ayensu's batakari designs further suggest that historically significant textiles and garments can be innovated beyond alterations in pattern, color, dye techniques and materials; designers like Ayensu are adapting culturally relevant textiles for a contemporary, global audience, challenging restrictive sartorial precepts while maintaining a particular dress form's essence and cultural relevance.

As with her wax print accessories and embellishments, Ayensu's batakari cocktail dress has impacted the dress practices of Accra. Since its initial introduction, men's batakari smocks have been adopted by a variety of Ghanaian stylists and fashionistas as a trendy and culturally relevant form of women's dress. Exemplified by bloggers Tracy Iddrisu and Yawa Sarpong, Ghanaian and Diasporic women frequently wear the voluminous tunic paired with a belt, thereby emphasizing the waist and transforming the lower portion of the tunic into a "skirt"; this key intervention results in an overtly feminine silhouette mirroring Ayensu's original batakari creation. This alternation is as physical as it is symbolic; as Iddrisu asserts in her blog post: "did you ever think a SMOCK SUCH AS THIS COULD LOOK THIS STYLISH."[22] As Iddrisu's comment asserts, the batakari smock is becoming an alternative form of dress for women who want to be fashionable and celebrate their Ghanaian and African heritage. It is difficult to prove that Ayensu's design was the catalyst for this adaptation, but her original riff on the smock was undeniably influential, likely contributing to the acceptance and modification of this form of dress.

For the industry preview of her Autumn-Winter 2018 collection, the batakari again made an appearance in her collection; however, Ayensu chose to fashion her more tailored version from striped denim, a beguiling variation that maintained the smock's iconic silhouette, while challenging its materiality. The smock's neckline was embellished with elaborate, gold-rope embroidery, a new, more delicate approach to her initial reinterpretation of the ornamentation of historical batakari (Figure 6.23). This latest iteration of the smock attests to Ayensu's continued commitment to revise and reimagine historically and culturally significant dress forms. Her variations suggest a level of inventiveness, coupled with playfulness and reverence that indicate a willingness to experiment with materials and construction, while maintaining the very essence of a particular dress form. It is perhaps this informed and careful playfulness that ensures her designs are not only palatable, but coveted by Accra's elite and emulated by a broader, fashion-conscious community.

The future of Christie Brown

> The [Christie Brown] woman is growing. And she's developing. Whatever happens in the world, over time, affects her outlook on things. The brand will evolve, but it won't seem out of place because the brand is for her.[23]

In recent interviews with Ayensu, she has shifted the focus away from her individualized perspective, choosing instead to highlight the importance of her creative team and the "Christie Brown woman," a concept that she originated, but that can be adopted and innovated by others. This is ultimately Ayensu's goal: to maintain the integrity of her vision, but allow it to continually transform through collaborations with emerging designers and innovative artisans.

Which leaves one question: who *is* the Christie Brown woman? Ayensu provided a robust description of this idealized female in 2016:

Figure 6.23 Ayensu's most recent reinterpretation of the batakari smock, from her 2018
industry preview in NYC, 2018 (Image: Christopher Richards).

from inception, it's always been for that modern African woman, who is
very exclusive, well-traveled, sophisticated; she can afford all the top brands,
but she's looking for a brand that speaks to the global essence that she
carries, but has a true taste of Africa.[24]

Ayensu's description is that of a cosmopolitan: an individual with social and
physical mobility who actively participates and contributes to local and global
cultures. These values are embodied in her designs, which maintain a "global
essence" in their silhouettes, but remain distinct and identifiable expressions of
African culture and heritage. Although Ayensu insists that the "Christie Brown
woman" is elite and exclusive, her actual designs have proven to be more egali-
tarian. The many imitations of Christie Brown accessories and embellishments
reflect a growing desire, among Ghanaians and members of the African Diaspora,
to embody a heritage-based cosmopolitanism: to indicate belonging to a global
community, while maintaining a direct and visible tie to their culture of origin.

 After ten years of experimentation, collaboration and carefully honing her
vision, the Christie Brown brand has become an icon of twenty-first-century
Ghanaian fashion. Ayensu has unintentionally continued the sartorial trajectory
of Chez Julie, creating cosmopolitan-infused garments that promote historic-
ally and culturally significant materials through thoughtful and unconventional

reinterpretations. Like Kweifio-Okai, Ayensu has employed her fashions to further challenge established, gendered ways of dressing, expanding the forms deemed socially acceptable for women and freeing the Ghanaian female body from entrenched sartorial restrictions. Through her artistry and commitment to her complex hallmarks of design, she has established an undeniable and recognizable style, one that conflates elements of haute couture, such as her use of elaborate embroidery and luxurious, imported materials, with ready-to-wear, creating designs that revel in their own wearable extravagance. Ultimately, Ayensu has played a significant role in the integration of African fashion into the global fashion system. As Ayensu explained: "The brand was made for the African woman … however, it shows how global the vision of the brand is."[25]

Notes

1 Interview with Aisha Ayensu, Accra, Ghana, 2016.
2 Ibid.
3 A. Kunle, "2012 Arise Magazine Fashion Week: Christie Brown Presents 'Xutra'," March 10, 2012, www.bellanaija.com/2012/03/2012-arise-magazine-fashion-week-xutra-by-christie-brown/.
4 For more information on volume in relation to Yoruba dressing, see Rowland Abiodun, *Cloth Only Wears to Shreds: Yoruba Textiles and Photographs from the Beier Collection* (Amherst: Amherst College, 2004).
5 For more information on volume in relation to Ghanaian men's dress, see Fred T. Smith, "Frafra Dress," *African Arts*, 15/3 (1982), pp. 36–42, 92.
6 For more information on volume in relation to kente cloth, see Doran Ross, *Wrapped in Pride: Ghanaian Kente and African American Identity* (Los Angeles: UCLA Fowler Museum of Cultural History, 1998).
7 Interview with Aisha Ayensu, Accra, Ghana, 2012.
8 Interview with Aisha Ayensu, Accra, Ghana, 2016.
9 Ibid.
10 Ibid.
11 Interview with Aisha Ayensu, Accra, Ghana, 2012.
12 Ibid.
13 For discussions on the development and history of wax print, see John Picton, ed., *Art of African Textiles: Technology, Tradition, and Lurex* (London: Ben Uri Gallery & Museum, 1996); Anne Grosfilley, *African Wax Print Textiles* (New York: Prestel, 2018); Suzanne Gott, Kristyne Loughran, eds., *African-Print Fashion Now! A Story of Taste, Globalization, and Style* (Los Angeles: UCLA Fowler Museum of Cultural History, 2017).
14 Interview with Aisha Ayensu, Accra, Ghana, 2012.
15 Ibid.
16 Interview with Aisha Ayensu, Accra, Ghana, 2016.
17 Ibid.
18 Victoria Rovine, "Cloth, Dress and Drama," in Suzanne Gott, Kristyne Loughran, eds., *African-Print Fashion Now! A Story of Taste, Globalization, and Style* (Los Angeles: UCLA Fowler Museum of Cultural History, 2017), 274.
19 Interview with Aisha Ayensu, Accra, Ghana, 2016.

20 R. Bolland, *Tellem Textiles: Archaeological Finds from Burial Caves in Mali's Bandiagara Cliff* (Amsterdam: Royal Tropical Institute, 1991).

21 Barbara S. Monfils, "A Multifaceted Image: Kwame Nkrumah's Extrinsic Rhetorical Strategies," *Journal of Black Studies*, 7/3 (1977): 314.

22 For further information on bloggers' adaptations of smocks, see Tracy Iddrisu, "Smock Style," June 6, 2015, http://stylebytrey.blogspot.com/2015/06/smock-style.html) and Yawa Sarpong, "Styling the Ghanaian Smock (Batakari)," April 17, 2017, https://stilettosandpearls.com/the-ghanaian-smock/.

23 Interview with Aisha Ayensu, Accra, Ghana, 2016.

24 Ibid.

25 Ibid.

7 The future of Ghanaian, and African, fashion

There has been a subtle yet marked shift in the sartorial landscape of Accra, one that is being equally expressed across Africa, most directly illustrated by the Kenyan publication *Not African Enough*. It is the gradual distancing of young designers from print fabric and other identifiable markers of a generalized African identity and heritage. This movement is most successfully conveyed by emerging South African designer Thebe Magugu; in an article for *Vogue*, he spoke directly to challenging established tropes of African fashion: "when people hear South Africa, they attach certain stereotypes to it. They associate it with generic prints and proportions, and that's a part of a larger issue, which overlooks the vast contributions that South Africans have made to global culture."[1] Magugu uses prints sparingly, if at all, instead opting for solid colors that emphasize his marriage of precise tailoring with feminine detailing, blurring the rigid, gendered forms that often appear in global fashion. His collections may be void of any material indicators of his African identity and heritage, and yet each garment is unapologetically linked to South African history and the continued marginalization of its black population.

This rejection of African-affiliated materials is equally expressed in Ghana, as illustrated by designer Nana Kwame Adusei and his clothing brand Charlotte Prive. Adusei renounces wax print fabrics as a signifier of colonialism, stating: "the wax print companies have been making money for 170 years and the money doesn't come back to us."[2] Instead, Adusei relies on imported materials, including cottons, satins and lace fabrics to create garments that are rooted in his own Ghanaian heritage and aesthetic, but that are unapologetically global, becoming essentially indistinguishable from garments designed outside of the African continent. This desire to both diversify and disassociate from established conceptions of African fashion is echoed by Eritrean journalist Hannah Pool, who posits "there really is no such thing as 'African fashion' any more than there is 'European' or 'North American' fashion."[3]

Meanwhile, at a nondescript storefront in Soho, a pop-up event for a Japanese fashion brand showcased a variety of their latest designs; amidst handmade leather shoes elevated on hardened "New York bagels" and racks of oversized, boxy shirts and pants, there was a single anomalous rack of shirts and shorts, all sewn from a range of wax print patterns in divergent color schemes.

DOI: 10.4324/9781003148340-7

A nonchalant perusal of the garments revealed the fabric to be flimsy and coarse to the touch, an inferior imitation of the more luxurious, high-quality wax prints produced by companies like Vlisco and GTP. As for the printed motifs, they were largely abstracted and generic, save for one, which clearly referenced the form and texture of cocoa pods. The significance of this motif was completely unacknowledged; the fabric merely signified what some young African designers are currently challenging: a constructed, commodified "Africanness," divorced from any cultural meaning or historical significance. With each article of clothing priced at over $200, these garments were clearly attempting to profit on the renewed global interest in identifiably African modes of dressing.

A recent and notable indicator of how "Africanness" is perpetuated by the all-consuming global fashion industry is Maria Grazia Chiuri's African-inspired Resort 2020 collection for Christian Dior. Following its official release, the collection spawned endless online debates, ranging from claims of appropriation, to characterizations of the collection as a "plagiarized mess";[4] there were even humorous Twitter retorts that reiterated the following sentiment: "So our mother's been wearing Dior all these decades?"[5] To quell the controversy, Dior released a video featuring Nigerian model-filmmaker Adesuwa Aighewi engaging Chiuri and anthropologist Anne Grosfilley in a lively conversation regarding the collection. Chirui emphasized that the collection, which prominently featured wax print fabric, was about artistry and craftsmanship, and how specific materials and artistic techniques, such as indigo dye and glass beads, have been adopted and employed as elements of fashion by cultures throughout the globe. The fabrics used for the collection were even printed by Uniwax, a company based in Cote d'Ivoire, an additional signifier of Dior's purported commitment to supporting and contributing to Africa's existing industries. On the surface, it appeared to be an informed celebration of African textiles and fashion, with Aighewi even proclaiming: "I personally don't think it's cultural appropriation, I thought it was a very beautiful blend of the Western world and the Old World."[6] Ignoring the problematic nature of Aighewi's dichotomy of "Western" and "Old Worlds," it was the collection's arrival, and subsequent promotion at the luxury department stores of New York City's Fifth Avenue that resulted in a more disturbing, but expected narrative, encapsulating the pervasiveness of "Africanness" in global fashion.

My first encounter with the collection was at the legendary Bergdorf Goodman. There, sequestered in one corner of the store's expansive first floor, were faceless, peach-toned mannequins bedecked in layers of Dior's garments and accessories. Interspersed between these mannequins was a mixture of decorative elements: flat, monotone forms evoking tall blades of grass and exotic animals, their bodies decorated with geometric patterns. These forms coalesced around a large column, equally adorned with lines and patterns that glistened and twinkled in the bright light. The display was visually chaotic, with the prints and patterns of the display overlapping with the garments, melding into a riotous cacophony of navy blue, metallic gold, and shades of yellow, maroon and brown. The display was decidedly odd, yet it wasn't until the same garments and

decorative objects appeared in the windows of Saks Fifth Avenue that I could fully comprehend their intended references.

At around midnight, I found myself traversing vacant sidewalks, past construction workers and police officers, as I briskly made my way to the façade of the Saks Fifth Avenue department store. I made a conscious decision to view the windows at night, as I wanted to experience their maximum theatrical effect and to avoid the unending crowds of tourists. I also needed time; time to consider the window display and its impact, in its entirety. As I approached, the single border of lights surrounding each window bathed the displays in a lurid, pinkish glow. The majority of the windows featured two headless, articulated mannequins dressed in Dior garments and accessories; each pair was accompanied by a decorative element, all of which was placed into a predominantly white space, covered with a variety of patterns in metallic gold, accented by more of the same, pink-hued lights. In one window, the mannequins were balanced by a pair of baobab trees, adorned with a repeated pattern of miniature crescents, oversized ovoids and lines. A second window balanced its single mannequin with two lions, one sculptural, the other flat, both bedecked in complex, golden patterning (Figure 7.1). A third window included a pair of elephants accompanying the two Dior ensembles

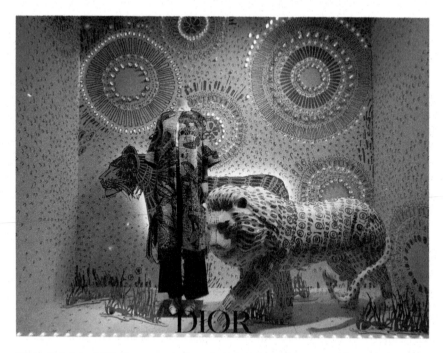

Figure 7.1 Saks Fifth Avenue window featuring Maria Grazia Chiuri's Resort 2020 collection for Christian Dior, New York City, 2019 (Image: Christopher Richards).

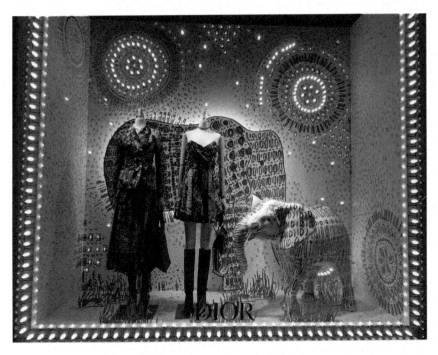

Figure 7.2 Saks Fifth Avenue window featuring Maria Grazia Chiuri's Resort 2020 collection for Christian Dior, New York City, 2019 (Image: Christopher Richards).

(Figure 7.2), while a fourth window's single mannequin was augmented by three giraffes, one in the act of nibbling a leaf from a particularly twisted and patterned tree.

Although not as visually overwhelming as the Bergdorf display, the same hallmarks were present: highly patterned and overly decorated surfaces, exotic flora and fauna, and of course, the garments themselves. The message I could not quite ascertain in Bergdorf's display crystallized in these windows. All of Dior's purported sensitivities and their partnerships with African-based designers and artisans were effectively annulled by these repeated, essentialized and reductive displays. For me, the windows marked the continued promotion of a constructed and limiting "Africanness" in the global fashion system, one predicated on stereotypes of the African continent as a wild and untamed savannah, populated not by people, but by elephants, lions and giraffes. The repeated patterns and designs that functioned as inconsequential ornamentation evoked local forms of dressing and bodily adornment, wrenched from actual bodies and reduced to mere decorations that immediately, but pejoratively signified an imagined, and continually reconstructed, Africa. In all its problematic patterning, it was the ultimate display of "Africanness," a further testament

of continued commodification and gross misunderstanding of African textiles, forms of dress and, ultimately, African fashion.

Returning to Pool's assertion that "there is no such thing as African fashion," perhaps the answer is not that "African fashion" doesn't exist, but that its scope has become too limiting and generic. In the twenty-first century, African fashion is typically characterized as being bold, colorful and highly patterned, relying heavily on wax print and locally produced, culturally significant materials, such as Malian bogolan and Ghanaian kente. These implied restrictions, resulting in a monolithic and circumscribed representation of "African fashion," has likely been one catalyst for young, African designers to reject these materials; the co-option of these textiles by established, largely European, brands has equally influenced this sartorial decision.

Instead, a selection of young, African designers are creating designs devoid of intense patterning and vibrant colors, thereby removing any immediately identifiable "Africanness." These garments are no less African than their kaleidoscopic counterparts and are often just as culturally relevant. At the same time, these flashy and immediately recognizable ensembles are, for many Africans, potent vehicles for expressing their rich cultural heritages and material legacies. These highly patterned and printed garments have also managed to captivate a global audience and generate renewed interest in modes of African dressing, redirecting the gaze back to the African continent. An appropriate framework for understanding African fashion, then, must be nimble enough to allow for both forms of sartorial expression, and for the potentiality of future revisions and innovations.

The question remains: is the concept of African fashion still relevant or can it be tailored to suggest a more accurate and inclusive understanding of the dress forms enacted throughout the African continent, and even overseas? As one of the first scholars to conceptualize African fashion, Victoria Rovine asserted that physical location is not critical to defining African fashion, as "living in Africa's diaspora may draw some designers closer to African styles and media."[7] Taking this as a point of departure and building on the sartorial expressions explored in this publication, I would argue that location is vital to understanding African fashion, as it champions the importance and individuality of local expressions of fashion. Instead of continuing to reduce distinctive, African-based designers to their continental affinities, it is necessary to identify African-based designers according to their specific country of origin, thereby acknowledging that each African nation has its own complex and individualized fashion system that exists in tandem with global fashion. Identifying African-based designers by their national or cultural heritage mirrors how European and American designers are referenced. The acknowledgment of a national identity, such as emphasizing that Christian Dior or Yves Saint Laurent are French designers, legitimizes their role in the history of global fashion and functions as a subtle indicator of their refined designs and elevated craftsmanship. By describing Juliana Kweifio-Okai or Aisha Ayensu as Ghanaian designers, it acknowledges and celebrates their culturally informed perspectives, while simultaneously situating their creations

within a particular historical and cultural context. Similarly, if Bee Arthur's Ghanaian and Russian heritages are recognized, Ghana's fashion culture is nuanced, championing the variety of perspectives that are enacted through its diverse fashion culture.

The acceptance and active promotion of African-based designers' cultural origins unfetters them from the limited, globally informed concept of "African fashion," allowing them to produce all manner of globally or locally inspired fashions, regardless of their geographical origin. It also champions each country's specific histories and serves as a subtle indicator of their complexities; as the first independent Sub-Saharan nation, Ghana's dress history and the sartorial expectations placed on its citizens were starkly different from those of other African nations. By framing and recontextualizing African-based designers according to their national identities, or perhaps even their own, self-described cultural identities, they are placed on equal footing with established, global designers, and the diversity and individuality of fashion as expressed on the African continent are championed.

What this interrogation of African fashion indicates is that the global understanding of African-based fashion needs either to be expanded or amended; the ultimate answer to this intellectual conundrum can be found in the oft-repeated Akan proverb: *Sankɔfa*, or "Go back and pick." The entirety of this book serves as evidence that African nations, exemplified by Ghana, have had complex and diverse fashion cultures since the mid-twentieth century; as other researchers have indirectly demonstrated, these vibrant fashion cultures likely extended further back into history, suggesting that African fashion, as expressed throughout the continent, has been an inclusive and divergent form of personal expression for over a century, if not longer. As directly indicated in Chapter 2, Ghana's historical fashion culture included world, European, international and local fashions, which continually informed and shaped one another. This suggests that, prior to Independence, the concept of fashion, as viewed by Africans, was flexible and varied. It was not until Independence that a more specific and limiting conception of fashion developed, one that indicated a person's African identity through locally meaningful and historically significant materials, like wax print fabric and kente cloth. Beginning with Juliana Kweifio-Okai, Ghana's female designers created fashions that encapsulated a cosmopolitan, nationalist identity, albeit tailored for their respective eras and reflecting their individual, unique perspectives. This understanding of Ghana's fashion culture is irrevocably tied to the nation's history, its people, and the construction of a unified, Ghanaian identity during the Independence era. The implication is that one cannot fully understand these sartorial expressions if they are viewed as examples of African fashion; this concept is too monolithic and reductive, as it does not recognize the social, cultural and political shifts that shaped and influenced the fashion cultures and designers of specific African nations.

By emphasizing African-based designers' cultural and national origins, it creates new avenues, or runways, for academic research on their respective

fashion systems. As evidenced by Ghana, contemporary designer brands were not formed as a response to the established, global fashion system; they exist and thrive because of the strong fashion culture that has nourished and sustained the production of designer fashions for over 60 years. In terms of a dynamic, historical fashion culture, Ghana is not unique; African nations such as Nigeria had equally complex fashion cultures and innovative designers, exemplified by Shade Thomas Fahm, the country's first formally trained fashion designer and a contemporary of Juliana Kweifio-Okai. By acknowledging these national and cultural distinctions, the narrative becomes more complex and inherently challenges the monolithic conception of African fashion; if academics and fashion contributors can acknowledge and understand the complexities of fashion cultures that exist on the African continent, as represented by each nation, or even by individual designers, what relevance does the concept of African fashion retain?

While these are my musings on the future of *African* fashion, what about Ghanaian fashion? Once again, history serves as a potent predicator of the future. As evidenced by Ghana's rich, historical fashion culture, fashion will remain a mainstay of Ghana's visual and material culture, with Accra as its center. New fashion designers will be introduced; they may choose to draw upon Ghana's material heritage, forming garments from kente, batik or wax print, or they may reject these materials, instead asserting their perspectives through imported fabrics, creating garments that more easily transition into the global fashion system. As I myself have witnessed, some of these new designers will gain immediate notoriety by introducing an innovative approach to dressing or treatment of a particular textile. Maintaining this initial success often proves difficult, resulting in only a few designers achieving sustained success.

That is ultimately what distinguishes designers like Juliana Kweifio-Okai, Bee Arthur and Aisha Ayensu from their counterparts: their remarkable staying power. It suggests that their viewpoint, however unique, resonated with enough consumers to ensure the viability of their brand. It speaks to their creativity and originality, their commitment to a particular perspective and, ultimately, to the importance of celebrating their own cultural heritage and identity, while maintaining direct linkages to a global fashion system. The acknowledgment and celebration of Ghana's material cultures, fused with the values of cosmopolitanism, is the proverbial thread that runs through these designers, their predecessors and their sartorial creations. The future will undoubtedly bring new modes for celebrating distinctly Ghanaian, cosmopolitan identities in ways that cannot be anticipated. What can be predicated, or at least encouraged, is situating these new sartorial contributions within their own fashion histories, championing the importance of understanding African-based fashion designers and their creations within their respective contexts: nations and capitals that have rivaled established fashion centers in their progressiveness and complexity.

Each designer or sartorial contributor, whether they were academically trained in fashion design or learned the complexities of sewing and garment instruction informally, serves as an individual case study for how fashion and dress forms can be treated as works of art, particularly for African cultures.

Letitia Obeng's simplistic revisions to the kaba ensemble were culturally and historically significant; she represents the many undocumented women who reinvigorated this iconic form of dress, signaling a dramatic shift in dressing encouraged by the country's independence from colonial rule. Her contributions are in direct contrast to Laura Quartey, who produced meticulously executed garments for specific women in a process akin to commissioning European couture. Although she actively contributed to the introduction of cosmopolitan, nationalist fashions during the Independence era, the artistry of her designs lies in their technical virtuosity.

As Ghana's first fashion designer, Juliana "Chez Julie" Kweifio-Okai is perhaps the most influential; in addition to initiating Accra's designer fashion culture, her designs were innovative and groundbreaking. Her Akwadzan is irrefutably art – in its construction, its reconfiguring of historical modes of dressing, and its unapologetic challenging of men's prestige attire. The majority of her fashions can be appreciated for their historical and cultural contributions, although specific garments, like her satin tie and dye tunic, speak to a level of artistry embedded in a range of her designs.

Beatrice "Bee" Arthur, the most unconventional of the included designers, literally treats her garments as artwork, viewing them as wearable canvases. Unlike the other designers, Arthur's complex heritage and her political and social stances are not only ingrained, but literally layered onto the surfaces of her garments, becoming symbolic expressions of her complex, multicultural identity and perspective. Her curvaceous signature, found on her most intricate and personalized designs, serves as the ultimate indicator that her garments are a form of artistic expression.

Aisha Ayensu, the most recent and influential contributor to Accra's fashion culture, creates garments that are the epitome of art as a form of dressing. Ayensu's use of detailed embroidery, coupled with her unusual silhouettes and deconstruction of wax print, speaks to the high level of artistry that is encapsulated in each of her designs. By reshaping wax print into eye-catching, sartorial flourishes, like buttons or kinetic ribbons, Ayensu has introduced new modes for presenting this culturally significant material. By purposely selecting wax print in unusual shades and patterns, she further challenges established local and global expectations of African-affiliated fabrics. Much like the originator of Ghana's designer fashions, Ayensu has reimagined culturally meaningful materials for a new generation, ultimately encapsulating a twenty-first-century version of cosmopolitan, nationalist fashions.

Returning briefly to the introduction, I choose to reiterate Rovine's assertion that "fashion matters." It matters particularly in Ghana, and in many African nations across the continent, as the most immediate, accessible and malleable form of artistic expression. The potency of African-based fashion and dress was acknowledged decades earlier by art historian Roy Sieber, who posited that

> the richness of invention and variety in the arts of personal adornment is
> *pan*-African and may, indeed, reveal the breadth and range of the aesthetic

life of traditional Africa with greater accuracy than the limited formulations that currently serve in the West as a basis for most studies in African art.[8]

What makes fashion and modes of dressing such a powerful medium of African artistic expression is the art form's inherent adaptability. Textiles and forms of dress can immediately respond to important social and cultural shifts, as best evidenced by Ghana's own kente reformation, which saw the proliferation of all manner of kente fashions throughout the capital. The material was not fixed nor stagnant; rather, it was quickly transformed to become a more wearable and immediately visible assertion of a unified Ghanaian identity, while maintaining (and perhaps enhancing) its allusions to wealth and prestige.

The flexible qualities of historical forms of dress suggest another crucial amendment to the scholarship on African dress and fashion: that traditional forms of dress, such as kente and adinkra in Ghana, should not be treated as mere forms of dressing the body, but as examples of historically rooted, local fashions. As recent changes in stylistic preferences of kente have indicated, the textile is equally susceptible to change and innovation, with weavers constantly attempting to create new and unusual patterns and color schemes, and incorporating a profusion of metallic threads. It is time to recontextualize these historical forms of African dress, which would further assert that fashion has always been an integral part of the creation and performance of African identities, one that existed prior to colonization. It validates what many Ghanaians have already recognized, as concisely stated by fashion designer and educator Joyce Ababio: "Ghanaians have always been fashionable."

Notes

1 George Cassidy, "Meet Thebe Magugu, the Designer at the Heart of South Africa's Cultural Renaissance," May 20, 2019, www.vogue.com/vogueworld/article/thebe-magugu-south-african-fashion-designer-born-free-generation.

2 Clare Spencer, "Wax Print: Africa's Pride or Colonial Legacy?" June 25, 2020, www.bbc.co.uk/news/extra/4fq4hrgxvn/wax-print

3 Hannah Pool, *Fashion Cities Africa* (London: Intellect, 2016), 14.

4 Zama Mdoda, "Dior's Appropriation Resort Collection is a Plagiarized Mess," May 13, 2019, https://afropunk.com/2019/05/diors-appropriation-resort-collection-is-a-plagiarized-mess/

5 Africanews, "Twitter Users 'Mock' French Designer Dior over African Wax Prints," August 5, 2019, www.africanews.com/2019/05/08/twitter-users-mock-french-designer-dior-over-african-wax-prints/

6 Christian Dior, "A Conversation between Maria Grazia Chirui and Adesuwa Aighewi – Dior Cruise 2020 show," May 6, 2019, www.youtube.com/watch?v=8Z6tMko4X6I&t=94s

7 Victoria Rovine, *African Fashion Global Style: Histories, Innovations and Ideas You Can Wear* (Bloomington: Indiana University Press, 2015), 8.

8 Roy Sieber, *African Textiles and Decorative Arts* (New York: Museum of Modern Art, 1972), 10.

Index